COGNITIVE MEDIA THEORY

Across the academy, scholars are debating the question of what bearing scientific inquiry has upon the humanities. The latest addition to the AFI Film Readers series, *Cognitive Media Theory*, takes up this question in the context of film and media studies. This collection of essays by internationally recognized researchers in film and media studies, psychology, and philosophy offers film and media scholars and advanced students an introduction to contemporary cognitive media theory—an approach to the study of diverse media forms and content that draws upon both the methods and explanations of the sciences and the humanities. Exploring topics that range from color perception to the moral appraisal of characters to our interactive engagement with video games, *Cognitive Media Theory* showcases the richness and diversity of cognitivist research. This volume will be of interest not only to students and scholars of film and media, but to anyone interested in the possibility of a productive relationship between the sciences and humanities.

Ted Nannicelli is Lecturer in Film and Television Studies at the University of Queensland, Australia. He is the author of *A Philosophy of the Screenplay* (Routledge, 2013).

Paul Taberham is Lecturer in Animation Studies at Arts University Bournemouth, UK. He published in *Projections: The Journal for Movies and Mind*, *Animation Journal*, and *The Routledge Encyclopedia of Film Theory*.

Previously published in the AFI Film Readers series
Edited by Edward Branigan and Charles Wolfe

COGNITIVE
MEDIA
THEORY

EDITED BY

TED NANNICELLI
AND
PAUL TABERHAM

R Routledge
Taylor & Francis Group

NEW YORK AND LONDON

First published 2014
by Routledge
711 Third Avenue, New York, NY 10017

and by Routledge
2 Park Square, Milton Park, Abingdon, Oxon OX14 4RN

Routledge is an imprint of the Taylor & Francis Group, an informa business

Library of Congress Cataloging in Publication Data
Cognitive media theory/edited by Ted Nannicelli and Paul Taberham.
 pages cm. — (AFI film readers)
 Includes bibliographical references and index.
 1. Mass media. 2. Humanities—Research. 3. Social sciences—
 Research. I. Nannicelli, Ted, editor of compilation. II. Taberham,
 Paul, editor of compilation.
 P91.25C596 2014
 302.2301—dc23
 2013037903

ISBN: 978-0-415-62986-7 (hbk)
ISBN: 978-0-415-62987-4 (pbk)
ISBN: 978-0-203-09822-6 (ebk)

Typeset in Spectrum MT
by Florence Production Ltd, Stoodleigh, Devon, UK

contents

figures

tables

acknowledgments

We would like to thank Edward Branigan and Charles Wolfe for their enthusiasm for this project and their help in bringing it to fruition; Erica Wetter and her editorial team at Routledge for commissioning the book and getting it ready for publication; Fiona Martin for research assistance; the Faculty of Arts and Social Sciences of the University of Waikato for a generous research grant; all of our colleagues who offered advice and feedback along the way; David Bordwell, Dan Fleming, Carl Plantinga, Alistair Swale, Murray Smith, and Malcolm Turvey; and last but not least our partners and families for their patience and support.

Ted Nannicelli and Paul Taberham

introduction

one

contemporary cognitive

media theory

ted nannicelli and
paul taberham

introduction

As we write this, cognitive theory in film and media studies is flourishing. What started in the 1980s, propounded by just a handful of scholars as an alternative approach to a theoretical orthodoxy in film studies, has become a thriving research tradition that is an increasingly visible and significant part of the broader field of film and media studies.[1] Consider, as just some indicators of cognitive theory's success in the field, the growth of the Society for Cognitive Studies of the Moving Image's annual conference, which alternates between North American and European locations each year; the establishment of the award-winning journal *Projections: The Journal for Movies and Mind*, the creation of the Cognitive/Analytic Scholarly Interest Group within the Society for Cinema and Media Studies, and the blossoming of links with researchers in a variety of other fields—including literary studies, philosophical aesthetics, and the psychological sciences—

which has led to the publication of recent books like *The Routledge Companion to Philosophy and Film* and *Psychocinematics: Exploring Cognition at the Movies*.[2]

Such achievements are just some of the cumulative results of years of high-quality research. More important than these visible markers of success is the extent to which cognitive theory has advanced knowledge in the field over the past thirty or so years. Perhaps this is most apparent when one considers the various single-authored monographs that have been written from a broadly cognitivist perspective. Consider, for example, the theory building that takes place in David Bordwell's *Narration in the Fiction Film*, Edward Branigan's *Narrative Comprehension and Film*, Noël Carroll's *A Philosophy of Horror*, Torben Grodal's *Moving Pictures*, Carl Plantinga's *Rhetoric and Representation in Nonfiction Film*, and Murray Smith's *Engaging Characters*.[3] These books —just a sampling of cognitive theory's research output—constitute major contributions to our understanding of central issues in film theory, such as narration, characterization, genre, and the nature of fiction film, and nonfiction film. Written in the 1980s and 1990s, these books all sit relatively squarely within film studies as a discipline, even though each draws upon research in related areas—cognitive psychology, literary studies, and philosophical aesthetics, to name a few. But as indicated by the more recent volumes we mentioned—as well as monographs published in the 2000s, such as Greg M. Smith's *Film Structure and the Emotion System*, Grodal's *Embodied Visions*, and Plantinga's *Moving Viewers*—cognitive theory is increasingly an interdisciplinary affair, one in which the brain sciences, especially, figure more prominently.[4]

As the title of our book suggests, "cognitive film theory" is no longer an entirely adequate name for a research tradition that includes the study of television shows, video games, digital animation, and moving-image art installations. Our use of the term "cognitive media theory" rather than "cognitive film theory" is prompted by the work we see our colleagues doing in film and media studies departments around the world. However, it is important to note that the "media" in cognitive media theory indicates a shift in cognitivists' objects of inquiry rather than a fundamental break with cognitive film theory and its underlying principles.

Furthermore, while cognitive film theory has always borrowed the methods and explanations of cognitive science and analytic philosophy, it has never before been pursued in collaboration with so many researchers based outside of film and media studies. Important recent contributions include literary theorist Patrick Colm Hogan's *Understanding Indian Movies*, psychologist Tim J. Smith's attentional theory of cinematic continuity, and essays by the philosophers Noël Carroll and William Seeley, and Katherine J. Thomson-Jones.[5] To put it another way, the lines between cognitive media theory and the empirical study of the psychology of moving image viewing on the one hand, and cognitive media theory and the philosophy of motion pictures on the other, have never been so permeable.

While these developments are welcome, they do raise a number of difficult questions. First and foremost, perhaps: What, exactly, is cognitive theory in film and media studies? Its adherents have always been at pains to point out that it is actually not a theory properly so-called, but rather a stance, a perspective, or an approach. In addition, there is a relatively straightforward historical story to be told about how that approach came to be called "cognitive theory." But what marks the boundaries of cognitive theory—cognitive *media* theory, as we would have it—today? What topics does it investigate, what sorts of questions does it ask, what research methods does it employ, and how does it understand its place within the field of film and media studies?

Cognitive theory's increasingly cross-disciplinary nature raises questions not only about what its boundaries are, but what they *should* be. In particular, we ought to acknowledge that while greater collaboration with the sciences presents enormous opportunities, it also requires us to engage in a kind of meta-theoretical reflection. That is, we need to carefully consider what sorts of questions about film and film viewing might be answered by appealing to scientific models and explanations and what sorts might not be. Cognitive theorists have tended to allow science a greater role in the field than other film and media scholars, without, we shall argue presently, falling prey to the errors of scientism—that is without appealing to science in ways that are excessively deferential or inappropriate to the questions at hand. Nevertheless, the question of what precisely science's role in film and media theorizing should be is an open one, and cognitivists diverge in their answers to it. Part of this book's purpose is to stage a debate about that question that steers clear of the extremes of scientism and science bashing.

More broadly, then, the aims of this book are threefold: (1) to compile, for cognitivists and those sympathetic to the cognitivist approach, a sampling of current work that gives a sense of the varied questions and projects with which researchers are currently engaged; (2) to show-case contemporary cognitive theory, for those who are unfamiliar with it or skeptical of it, as a pluralistic, self-reflective, interdisciplinary, and positive research tradition; and (3) to foster discussion and debate about what the relationship between film and media studies and the sciences should be.

The structure of this introductory chapter is as follows. In the first section, we offer a conceptual characterization of cognitive media theory. As Carl Plantinga has pointed out, one could also offer a histor-ical characterization of cognitivism.[6] However, we will forgo the historical characterization here for a variety of reasons. First, it has been done elsewhere and our space is limited.[7] More importantly, however, although a historical characterization goes some way to explaining how the name "cognitive film theory" came to be adopted, a conceptual characterization

makes evident the limitations of the term. In particular, while a focus on the cognitive processes of viewers is typical of much cognitive theory, it is neither a necessary nor a sufficient feature of work conducted within the research tradition. We offer a broader construal of contemporary cognitive theory that highlights four characteristic (rather than necessary or sufficient) features: (1) a dedication to the highest standards of reasoning and evidence in film and media studies and other fields (including, but not limited to, empirical data from the natural sciences); (2) a commitment to stringent inter-theoretical criticism and debate; (3) a general focus on the mental activity of viewers as the central (but not the only) object of inquiry; and (4) an acceptance of a naturalistic perspective, broadly construed. We elaborate upon each of these points presently.

As we have already indicated, contemporary cognitive theory collaborates closely with film researchers in other fields—particularly analytic philosophy and the psychological sciences. For some critics, these relationships are a source of suspicion. In particular, some scholars have recently accused cognitive theory of scientism. Therefore, we devote the second part of our introduction to addressing this and related criticisms. Our general argument is that most of these charges are premised on misunderstandings of what cognitive theory is and what it aspires to achieve. In particular, we stress that cognitivism has never understood itself as the sole way to approach theoretical questions about film, let alone as an attempt to replace humanistic inquiry with scientific investigation.

In the third part of the introduction, we support this counter-argument by drawing upon two contributions to this volume—the chapters by Tim J. Smith and Margrethe Bruun Vaage—in order to detail two models of cognitivist theory building. The model illustrated by Smith's essay draws upon experimental data, and it employs the methods and explanations of the natural sciences. The model illustrated by Bruun Vaage's chapter appeals to experiential and "textual" evidence, and it employs the methods and explanations of the humanities. Cognitivism, we claim, is a big enough tent to house both models of theory building.

In the fourth and final section of the introduction, we briefly summarize the rest of the contributions to the book. While our contributors' methods sometimes differ, all are working under the umbrella of cognitive media theory.

a conceptual characterization of cognitive theory

A fundamental challenge to developing an adequate conceptual characterization of cognitive media theory is that the name itself—"cognitive theory"—threatens to mislead. Our research tradition owes its name to its

historically close links with cognitive science, as David Bordwell's seminal essay "A Case for Cognitivism" makes clear.[8] But here it is important to recognize that cognitive science can be construed in at least two different ways. Broadly construed, it is a domain of inquiry—specifically, it is an investigation of cognition, encompassing attention, learning, memory, reasoning, problem-solving, and perception, that draws upon research in a variety of disciplines, including anthropology, artificial intelligence, linguistics, neuroscience, philosophy, and psychology. Narrowly construed, cognitive science is a specific understanding of how cognition works— namely, along the lines of the computational theory of mind, according to which the mind/brain is akin to a computer.[9]

Although this distinction between the broad and narrow construal of cognitive science is a somewhat nuanced point, it is important to stress that no film and media studies cognitivist (to our knowledge) has ever been committed to the latter. The closest anyone has come is Bordwell, in *Narration in the Fiction Film* and *Making Meaning*.[10] However, while it is certainly true that, influenced by developments in cognitive science in the 1970s and 1980s, Bordwell proposed an inferential model to account for the viewer's perception, comprehension, and interpretation of films, this does not commit him to holding a computational theory of mind, strictly speaking.[11]

More importantly, however, cognitivist theorists in film and media studies have generally followed cognitive science's gradual move from a focus on "cold" cognition (information-driven mental processes described in terms of inferential and computational models) to "hot cognition" (affect-driven mental processes). In cognitive film and media studies, this shift began over two decades ago, at least as early as Noël Carroll's work on viewers' emotional responses to horror films.[12] However, it was arguably a cluster of work during the mid to late 1990s—including Murray Smith's *Engaging Characters*, Ed Tan's *Emotion and the Structure of Narrative Film*, Torben Grodal's *Moving Viewers*, and Carl Plantinga and Greg M. Smith's edited collection *Passionate Views*—which initiated the investigation of affect in film viewing as one of cognitive film theory's most central and lively research projects.[13] Furthermore, film and media cognitivism now rarely refers to inferential (let alone computational) models of mental activity, tending to draw instead from the latest models of mind developed in neuroscience and philosophy of mind. Murray Smith's recent work, for example, attends to consciousness and qualia—"the distinctive subjective 'raw feels' that constitute conscious experience"—in a way that strict adherence to information-processing models of cognition would not seem to permit.[14]

Although such newer lines of inquiry in film and media cognitivism draw upon research that might still be said to fall under the umbrella of cognitive science broadly construed (that is, research in neuroscience and in

philosophy of mind), the term "cognitive theory" still has the potential to invite misunderstanding in a fundamental way because the "cognitive" here cannot be understood as marking a necessary association with cognitive science, whether construed narrowly *or* broadly. For even at the formation of cognitive film theory, one of its two major strands of research was not essentially linked with cognitive science (broadly construed): from the early work of Noël Carroll through to contemporary work by Malcolm Turvey, the traditional philosophical project of conceptual clarification has always been an important component of cognitivism.[15] This is not to say philosophy's *only* role within cognitive media theory is that of conceptual clarification, but it is a significant one.[16] Furthermore, more recent work in cognitive theory—such as Torben Grodal's evolutionary neuropsychological approach and the "neurocinematics" of Uri Hasson and his colleagues—draws upon newer fields that break with traditional cognitive science's information-processing approach.[17] Our point here, which has already been pithily made by Plantinga, "is that 'cognitive film theory' does not necessarily imply a commitment to cognitive science, strictly defined, and certainly not to cognitive science exclusively."[18]

Does the "cognitive" in cognitive theory pick out *anything* particular to the research tradition, then? Perhaps at this point some readers might share Gregory Currie's sentiment that "the label does not seem quite right."[19] For Currie, this thought partly stems from worries about what sorts of doctrines are implied by the term "cognitive" and, in particular, about Bordwell's work (notwithstanding its significant achievements) being taken to stand for the research tradition as a whole. As he puts it, scholars in the field

> must decide, at least, what their commitment to the label 'cognitive' entails for their view of psychological processes and mechanisms. Which of these processes are to be understood as interpretive (as is fairly obviously the case with acts of narrative reconstruction) and which automatic and brute causal (as may be the case with much visual processing and possibly also with some acts of empathetic contact)? What exactly is it to be a *cognitivist* if you recognize a significant contribution to filmic experience from processes of the latter kind?[20]

Because Currie wants (correctly, in our view) to stress that cognitivists are pluralists in their theoretical commitments (and because he is skeptical that perception is cognitively penetrable in the way Bordwell suggests), he proposes that a better name for their approach is "rationalism." "Here," Currie writes, "rationalism names a movement which values argument and analysis over dogma and rhetoric."[21] Other cognitivists have identified

similar features as characteristic of the project, and one of cognitivism's recent critics also suggests that "rationalist film theory" would be a more accurate term to describe at least its philosophical strand.[22]

Although we agree with Currie about cognitive theory's commitment to what he calls rationalism—to argument and analysis, as well as to clarity of exposition—we doubt this feature is sufficient to mark out the project as distinctive from all others in film and media studies. It may be the case that cognitive theory places greater emphasis on this feature than is typical in the field (although we will remain agnostic about this matter), but there are, of course, many film and media scholars who hold similar commitments yet would not call themselves cognitivists. Furthermore, some of those scholars are historians, which further suggests to us that the term "cognitive" still might pick out something specific about cognitive theory's domain of inquiry.

Putting Currie's question more broadly, then, what is it to be a cognitivist if one does not align oneself with cognitive science narrowly or, perhaps, even broadly construed? Currie's comments regarding cognitivism's commitment to "argument and analysis" offer a helpful way to begin to answer this question, if we regard these as distinctive features of cognitive media theory rather than as conditions for defining it. That is, part of what unites cognitivists—although this feature is not exclusive to them—is a shared set of assumptions about how theorizing proceeds. Specifically, we share a view articulated by David Bordwell and Noël Carroll, according to which

> [t]heorizing is a commitment to using the best canons of inference and evidence available to answer the question posed. The standards ought to be those of the most stringent philosophical reasoning, historical argument, and sociological, economic, and critical analysis we can find, in film studies or elsewhere (even in science).[23]

Note that this does not mean that cognitivists are united by any particular methodological commitment, but rather by a more general view regarding the nature of rational inquiry.

In addition, as part of that shared conception of rational inquiry, cognitivists are united by an emphasis upon inter-theoretical debate and criticism—that is, the sustained critique and refinement of one another's theories. In other words, part of what unifies cognitivism is a commitment to what Carroll calls a "dialectical" model of theorizing.[24] As he puts it,

> one of the most effective ways in which to argue in behalf of a theory and to defend it is to show that it does a better job answering the questions posed by competing views, or

by showing that there is a better way to pose the questions that animate existing views. That is why criticism is so integral to film theory, as well as other areas of inquiry.[25]

Thus, cognitivist theorizing usually includes some element of criticism of existing views, both in order to motivate a different perspective and highlight its advantages over those existing views. Indeed, it is not uncommon to read an essay by a cognitivist theorist that is entirely devoted to the criticism of someone else's theory; the aim of such work is not *ad hominem* attack but rather the shifting of the burden of proof back onto the proponent of a given theory.[26] The prominence and importance of criticism does, of course, differ from research project to research project, but the important point is that criticism is a vital component of cognitive theory in general.

In addition to these broad assumptions about the nature of theorizing and rational inquiry in general, cognitivists are united by their research foci. In particular, they share a general interest in how viewers respond to moving image artworks and why they respond as they do. Somewhat more specifically, cognitive theory is, as David Bordwell puts it, "mentalistic" insofar as cognitivists turn first and foremost to the human mind to investigate the questions they pose regarding viewers' responses.[27] Contrary to the claims of some critics, this does not mean that cognitive theory denies that individuals' mental lives are connected to and, indeed, influenced by society and culture. Indeed, no serious cognitive theorist ever has or ever would make this claim. Rather, cognitive theory maintains that inasmuch as individuals across different societies and cultures share the same evolved cognitive architecture, we can assume at least some "intersubjective regularities" in viewers' mental activity.[28]

Furthermore, cognitive theory approaches the study of viewers' mental activity from a naturalistic perspective. Naturalism, understood here as a philosophical outlook rather than an artistic tradition, describes a cluster of views with somewhat varying ontological and methodological commitments.[29] Thus, there are many ways—too many to canvass here—that one can be a philosophical naturalist, but the sort of naturalism typically embraced by cognitive theory is explicitly and helpfully described by Murray Smith in his contribution to this book. Naturalism is, in his words,

> the project of explaining human behavior based on the assumption that the human species is a part of the natural world, and that consequently the methods and knowledge of the natural sciences will play a central role in such an explanation.[30]

Although we maintain that cognitivists generally hold something like the naturalistic view described by Smith, opinion differs about the natural

sciences' precise role in theorizing film and media. Indeed, we have tried to structure this book in such a way that readers will be able to see the contrasting views and debates about this question play out across the volume. Consider, for example, Torben Grodal and Malcolm Turvey's differing views regarding evolutionary psychology's role in film and media studies. On the one hand, Grodal argues that evolutionary psychology's role in explaining viewers' reactions to particular genres like comedy is very central indeed. Grodal contends that his evolutionary neuropsychological account of comedy explains the nature of our engagement with comic entertainment. On the other hand, Turvey doubts that evolutionary psychology—or scientific theorization more broadly—can explain much we do not already know about human practices, the norms and conventions of which we seem to tacitly understand.[31] In his chapter, Turvey writes,

I am sure that evolutionary psychology, like psychology in general, has much to teach those of us who study the arts. Nevertheless, I am skeptical that it can become the major explanatory paradigm in film studies, let alone the humanities in general.[32]

We will let each of the authors elaborate their positions rather than trying to summarize them here, but note that, while each sits on an opposite end of a spectrum of naturalistic views, they are both naturalists in the broad sense we have described. They both think that science is in some way relevant to the study of our engagement with media artworks, insofar as we are part of the natural world and plausibly employ the same faculties we depend upon to perceive and understand the natural world in order to perceive and understand moving image artworks. In short, cognitivists tend to embrace a general naturalistic perspective, yet differ on the question of what role science should play in film and media theory. This should be unsurprising for a few reasons. First, this is a vexed question—one that is being debated throughout the humanities at present. Second, however, there may be a sense in which the question itself is poorly formed or misleading because different research questions demand different methodologies.

Indeed, it seems likely that this is part of the reason the debate which is currently playing out across the humanities appears intractable: it may be the case that there is no agreement on science's general role in the humanities because humanists pose many different kinds of research questions—some of which invite scientific methods and explanations and some of which do not. As Murray Smith puts it in a recent essay, "The questions we ask about film are of very different sorts—ontological, epistemological, ethical, and aesthetic. Each of these perspectives will call upon different methods, indeed probably different *mixes* of method."[33]

9

This is not a specifically cognitivist insight, but we assume most cognitivists would be willing to acknowledge it. For the most part, cognitivists are committed to the idea that research in film studies ought to proceed through the posing of specific research questions rather than the application of a particular doctrine or theory for the purposes of interpreting various films. Inevitably, those questions will vary in topic and scope, and, therefore, require theorists to adopt different methods or, as Smith notes, even mixed methods. Thus, at the same time as cognitivists generally adopt a naturalistic perspective, very few, if any, would suggest that science has a role to play in answering every question we could pose about film and media artworks.[34]

replying to the charge of scientism

This section attempts to show one characteristic feature of cognitive theorizing in action: inter-theoretical debate. Cognitive theory's embrace of naturalism, broadly construed, has been the source of much recent criticism. According to one prominent film theorist, D. N. Rodowick, cognitive theory is engaged in "a de facto epistemological dismissal of the humanities."[35] Although we have, heretofore, tried to stress cognitive theory's positive research contributions, this is a serious accusation and our task here is both to show that it is erroneous (and why) and to shift the burden of proof back onto our critics. We wish to make clear at the outset that for cognitivists, and others who share our understanding of theorizing, this sort of project stems neither from defensiveness nor from a desire to personally criticize those with whom we disagree. Rather, our criticism of the objections that have been mounted against cognitivism is an essential part of arguing in its favor.

The general charge embodied by Rodowick's claim is that cognitive theory is "scientistic," although this criticism has been formulated in slightly different ways. Sometimes the allegation is made off-handedly, as if its truth were self-evident. Consider, for example, Warren Buckland's claim, "Film scholars . . . dissatisfied with the scientism of cognitive film theory and analytic philosophy have in recent years turned to the French philosopher Gilles Deleuze . . ."[36] In such cases, though, it is hard to know what precisely is meant by "scientism" and what exactly the charge against cognitive theory is.

We take scientism to involve an exaggerated sense of science's explanatory power and an unwarranted deference to it on all matters. One particularly pernicious component of scientism is the view that the best explanation of any question will be a scientific one and that, consequently, scientific progress will eventually obviate the need for non-scientific forms of inquiry. Conceived this way, scientism has an essentially negative valence, and it is possible that this is not the sense in which the term is meant

by scholars, like Buckland, who casually describe cognitive theory as scientistic. However, in some cases, this is precisely the accusation leveled at cognitivism.

A somewhat more specific charge is that cognitivists are intent upon turning film studies into a science or, at least, are of the opinion that the study of film should be undertaken using the methods of the natural sciences. For example, Robert Sinnerbrink writes that, according to the cognitivist approach (to which he variously refers as the "scientistic" and "rationalist" approach to film), "film studies needs to be based on the best available science, preferably grounded in a philosophical naturalism, and capable of demonstrating cumulative results . . ."[37] Rodowick makes a somewhat bolder claim—namely, that in *Post-Theory*, Bordwell and Carroll's conception of "good theory building" involves a "common appeal to natural scientific models."[38] So, too, according to Rodowick, in their introduction to *Film Theory and Philosophy*, Richard Allen and Murray Smith hold that "One engages in theory building or not according to an epistemological ideal based on natural scientific models."[39] Similarly, John Mullarkey writes that cognitivists aspire to "[a] science of cinema [that] would be suitably empirical, basing itself on the latest models of human perception, the most rigorous and widespread historical research, and the closest examination of films from the best archives."[40] Furthermore, Mullarkey claims, "That so many voices have maintained a similar position [similar, that is, to Bordwell's cognitivism] (despite certain, relatively small internal differences) is a testament to the scientific method advocated for it by all."[41]

When cognitive theory is described this way, the sort of skepticism expressed by Sinnerbrink may seem appropriate: "Is art, including film, reducible to the kinds of explanatory theories provided by the best available science? Or does the art of film express forms of meaning that resist reduction to naturalistic explanatory accounts?"[42] However, Sinnerbrink presents a false dilemma here, which only arises because his and these other critical accounts of cognitivism misunderstand the approach in fundamental ways.

With respect to Sinnerbrink's description of cognitive theory, it is emphatically not the case that all, or even most, cognitive film theorists believe that "film studies needs to be based on the best available science." Because posing and attempting to answer research questions about the nature of film and media artworks and our mental activity during our engagement with them is, after all, a form of rational inquiry regarding an empirical object, it is true that cognitivists think that research in film studies should be based upon the best available *evidence* as well as careful logical reflection. But few (if any) cognitivists would suggest that the kind of evidence relevant to answering *every* research question about film would be *scientific* evidence.

Depending upon the kind of research question one wants to answer, it might be more appropriate to invoke, for example, historical, textual, or experiential evidence. It is *this* kind of evidence that is invoked, for example, in Noël Carroll's collection of essays offering interpretations of individual films, in David Bordwell's numerous pieces of historical and stylistic analysis, including *On the History of Film Style* and *The Way Hollywood Tells It*, in Murray Smith's in-depth study of *Trainspotting* (1996), and in Richard Allen's interpretive and stylistic analysis of Hitchcock's films.[43] And this is, deliberately, just to mention work by the editors of two frequently-criticized cognitivist books. In short, *pace* Sinnerbrink, cognitivists hardly suppose that film studies should be reduced to film theory, let alone that it should be based solely upon scientific evidence. On the contrary, many cognitive theorists also pursue other avenues of film research.

Insofar as the cognitivist approach *is* naturalistic, to the extent that it regards humans as part of the natural world, it is true that cognitivists think that science has *some* role to play in explaining the mental (and sometimes physical) activity of film viewers. But it is hard to see why this should be a controversial position. It is hardly tantamount to claiming that film studies should be based upon the best available science, that film studies is or should be a science, or that film theorization should proceed along the lines of "the scientific method," as Sinnerbrink and Mullarkey suggest.[44] Indeed, as we noted earlier, an important method in the theorizing of many philosophically-inclined cognitivists—including Carroll, Plantinga, Smith, and Turvey—is the clarification of concepts, which is not even a form of empirical inquiry, let alone scientific inquiry.

The error made here by both Sinnerbrink and Mullarkey seems to be this: noting that cognitivists insist that the study of film and film viewing is a form of rational inquiry that ought to be constrained by the best available evidence *and* maintaining that sometimes, depending upon the research question posed, our theories of film viewing will therefore draw upon scientific research, Sinnerbrink and Mullarkey erroneously conclude that cognitivists must think that the study of film is *always* a scientific inquiry. Put this way, though, it should be clear that the conclusion does not follow from the premises. The dilemma Sinnerbrink presents is false because few (if any) cognitivists actually hold the strong view that every component of the film experience is reducible to scientific explanation. Rather, as we shall discuss in further detail presently, most cognitivists hold the more modest view that science can help explain *some* of our questions about our mental activity during film viewing.

Even if it is granted that cognitivists do not maintain that every film-related question demands a scientific explanation or the invocation of scientific research, what of Rodowick's charge that the cognitivist approach to film theorizing, in particular, appeals to "an epistemological ideal based

on natural scientific models"? What of his accusation that the cognitivist approach to theorizing illicitly (and to the detriment of the humanities in general) "employ[s] the methods and forms of scientific explanation"?[45] Given that Rodowick's article won the Society for Cinema and Media Studies' Katherine Singer Kovacs Award for Outstanding Essay, it seems fair to say that this sort of worry resonates with many film and media scholars—and for good reason, if Rodowick's assessment of cognitivism is accurate.

Hopefully, though, we can assuage such worries by pointing out that Rodowick's criticisms of cognitivism, like those of Sinnerbrink and Mullarkey, depend upon serious misunderstandings of the cognitivist approach. Malcolm Turvey has already published an incisive reply to Rodowick's essay, but it is worthwhile reiterating and elaborating upon some of his points here. Rodowick characterizes Bordwell and Carroll's approach to theory building as based upon the methodologies of the natural sciences. As Turvey points out, this is patently false: "Both define film theory simply as an explanatory generalization about film."[46]

For example, in his introductory chapter to *Post-Theory*, Carroll writes, "let anything count as film theorizing, so long as it involves the production of generalizations or general explanations or general taxonomies and concepts about film practice."[47] Elsewhere, Bordwell asserts, "Most generally, 'film theory' refers to any reflection on the nature and functions of cinema."[48] Or consider the characterization of film theory Bordwell and Carroll offer in their co-authored introduction to *Post-Theory*, which we quoted in the previous section. It should be perfectly clear that the methods and explanations of the natural sciences do not figure anywhere into these conceptions of film theorizing, which hardly seem contentious.

Although Rodowick does not reference explicit passages to support his assertion that cognitivists base their approach to film theorizing upon "the epistemological ideals of natural scientific models," he suggests there is evidence for this claim in the introductions to *Post-Theory* and *Film Theory and Philosophy*. It seems likely that, in the case of the former, Rodowick has in mind Carroll's seemingly bold statement, "I am presuming that what can be claimed for science may be claimed eventually for film theory."[49] However, Carroll quickly clarifies his point: "I invoke discussions about scientific methodology in proselytizing for a dialectical conception of film theory, not because I believe film theory is a natural science, but only because the philosophy of science provides us with some of our best models for understanding theoretical inquiry."[50] More specifically, Carroll's view is that progress in theory building is made (even if some ultimate Truth is never gleaned) through a dialectical process of criticism and refinement of existing theories. He mentions scientific methodology only as an *example* of how the dialectical model has proved helpful.

Nevertheless, Rodowick claims that the dialectical approach, as Carroll presents it, is a kind of idealized vision of how research proceeds in the sciences: "a community of researchers united by common epistemological standards who are striving for a universalizable and truthful picture of their object."[51] However, the dialectical model Carroll advocates neither has roots in the sciences nor is specific to the sciences. On the contrary, as Carroll notes, this model "has been a basic route for theoretical inquiry since at least Plato."[52] While Carroll invokes the sciences as an example of a domain in which this model has proven productive, it hardly follows that the dialectical approach is itself a natural scientific model, as Rodowick would have it. Rather, Carroll's point is that film studies could benefit, as the sciences have, from approaching the task of theorizing "as a dialectical, incremental process for securing approximate truths through practices of, among other things, error elimination and criticism."[53]

There are, indeed, certain epistemological principles or norms grounding Carroll's proposal, just as Rodowick claims. But those principles are not specific to the natural sciences, nor has Rodowick given us any reason to think they might be. On the contrary, the epistemological principles at stake here seem to partly underwrite rational inquiry in general. Furthermore, as Turvey points out, they seem to be the same epistemological principles that subtend Rodowick's own project, which itself takes a dialectical approach inasmuch as it criticizes the cognitivist approach to film theorizing and offers his own view of theory—a "philosophy of the humanities"—as an improvement upon it. Thus, the correct conclusion to be drawn is not that the dialectical approach to theorizing advocated by Carroll (and other cognitivists like ourselves) appeals to epistemological ideals based on natural scientific models. Instead, it is that this approach depends upon epistemological principles that seem to unite theoretical work in a wide variety of fields and disciplines and, indeed, rational inquiry more generally.

Rodowick levels a similar charge at Allen and Smith, presumably because they discuss post-positivist philosophy of science at length in order to make the point that "those who model film theory on a 'naturalized' philosophical practice, which sees itself as an element of natural science, are rarely guilty of the epistemic ingenuousness of which they are so often accused."[54] But Allen and Smith then note a significant caveat that Rodowick ignores. After mentioning ways in which the sciences *might* inform work in normative domains such as ethics and aesthetics, Allen and Smith write,

> But it would be a serious mistake . . . to assume that such [scientific] theories could ever supplant the making of value-judgements within or between value systems: we might learn from perceptual psychologists about the effects

of rapid editing or Steadicam-style camera movement, for example, but this will hardly conjure up an evaluation of films using such techniques.[55]

For Allen and Smith, film theorizing is a multifaceted enterprise that aims to answer a variety of different questions. Answering some of those questions—for example, questions about how our natural perceptual capacities allow us to see motion in a projected series of still images—invites the use of the methods, models, and explanations of the natural sciences.

However, other questions—ones plausibly regarding artistic value, for example—are not the sort of questions that science *could* answer. This point seems manifestly clear in Allen and Smith's summary:

> "Film theory"—and philosophy of film—cuts across many different sorts of question ... and may therefore legitimately draw upon the methods of both natural and social scientific practice, as well as those of conceptual investigation and value theory ... What is ill-conceived is the attempt to unify all of the practices used to investigate [film] under the same rubric, whether of "science" or any other.[56]

Pace Rodowick, cognitivists like Allen and Smith are not suggesting that film theory, writ large, ought to be based upon natural scientific models. Rather, the suggestion is that *some* film theoretical projects are rightly viewed as scientific projects and *some* sub-fields of film theory are continuous with the natural sciences because the questions asked therein are the kinds of questions for which scientific methods and models are appropriate.

This is essentially the same point we made above: all cognitivists would agree that scientific methods are appropriate to some kinds of research question, but few, if any, would suggest that such methods are appropriate to answer every kind of question we could ask about film and media artworks. Ultimately, of course, the proof of Rodowick's claims or our counterclaims is in the pudding. But beyond the general introductions to two edited collections, Rodowick does not offer any examples of cognitivist theory-building modeled on the natural sciences, so it is hard to see why we should accept his assertions.

15

cognitive theory building: two mutually compatible models

To highlight cognitivism's theoretical pluralism, we will draw upon the essays in this volume to offer an example of cognitivist theory-building that does indeed employ scientific methods, and one that does not. The differences between the two cases should be clear, and the point is that, *contra* Rodowick's assertion, cognitivism is a big enough tent to house both

kinds of theory-building. First, though, at the risk of oversimplifying matters, let us avoid a lengthy digression regarding the nature of scientific inquiry and the question of whether there is a universal scientific method by assuming the following: suppose that scientific theory-building involves something like developing empirically falsifiable hypotheses that offer causal explanations of natural phenomena, testing those hypotheses, and refining them successively until one approaches an approximately true generalization that, if correct, will successfully predict the outcome of future experiments.

It should be immediately clear that one characteristic research method of the natural sciences—the empirical testing of hypotheses—actually happens quite rarely in cognitive film theory.[57] Certainly there are exceptions, such as Tim Smith's contribution to this book. As a psychologist who pursues some of his work in the cognitive tradition, Smith typically employs the research methods of empirical psychology, and his essay "Audiovisual Correspondences in Sergei Eisenstein's *Alexander Nevsky*" is a good example of this. Smith uses eyetracking data to test Eisenstein's claims about how sound and image direct the gaze of viewers during a sequence from his film. In his analysis of the data, Smith finds support for some of Eisenstein's claims as well as his own "attentional theory of cinematic continuity," according to which "cinematographic and editing conventions such as match-on-action editing . . . use natural attentional cues (for example, sudden onsets of motion) to attract and cue attention across cuts."[58] So here we have a clear example of cognitive theory-building that employs the methods of the natural sciences, although we hasten to add that this is hardly tantamount to scientism because in this case the object of inquiry is a natural phenomenon—namely, human perception.

More often, however, the method by which cognitivists typically analyze and critique hypotheses is *not* empirical testing, but rather "testing" against *experiential* evidence—in particular, our intuitions—as well as logical reflection. For example, as is evident in Margrethe Bruun Vaage's essay in this book, in current debates around the nature of our engagement with characters, researchers sometimes claim to improve upon previous hypotheses by appealing to empirical evidence from other fields. Bruun Vaage, for example, cites empirical evidence to argue that when we watch television shows, "We see the characters we know the best, those most familiar to us, as morally preferable."[59] Note here, though, that Bruun Vaage is marshaling evidence to advance an argument rather than actually empirically testing a hypothesis. Already, here, we see a difference between her research methods and those of the natural sciences.

Furthermore, though, in this kind of work on character engagement, appeals to empirical evidence are almost always supplemented by claims that the new hypothesis sufficiently meshes with experiential evidence.

The second half of Bruun Vaage's chapter is basically an analysis of *Breaking Bad* that attempts to help us clarify our own emotional reactions towards Walter White and to convince us that our "familiarity" with him is a plausible explanation for why we feel sympathetic towards him. In contrast, the explanations offered by scientists are under no such obligation to mesh with how we feel about things or how things appear to us from ordinary observation. Rather, scientific explanation seeks to uncover the natural laws or principles underlying our experience of the natural world—laws or principles that are typically hidden from view.[60] We would be wrong to reject the idea that the earth is round because it does not feel that way to us, but we would be justified in dismissing an account of character engagement that does not line up with our phenomenological experience of feeling something for a character.

In other instances, like Noël Carroll's work on character engagement, the research method employed is predominantly the clarification of concepts. In this case, Carroll argues against the hypothesis that the standard mode of character engagement is empathy, by attempting to show that responses to characters that researchers sometimes characterize as "identification" or "empathy" are more correctly understood as sympathy.[61] In such cases, the difference in the research methods employed by cognitive theorists and natural scientists should be patently obvious: natural scientists test hypotheses against empirical evidence—not experiential evidence like intuitions and phenomenological experience. Further, natural scientists do not analyze our use of language and clarify concepts embedded therein. Here we hope readers begin to see (and will continue to notice throughout the book) that cognitive theory is very much a pluralistic research tradition—one that draws upon a variety of methods and explanations including (but not *limited* to) those of the natural sciences.

To summarize, then, in the criticisms of cognitive theory we have addressed, scientism is a straw man that has the unfortunate effect of distracting us from a substantive and difficult question: What are the kinds of questions for which scientific methods and explanations are appropriate and how do we distinguish them (when we can) from the sorts of questions that do not admit of scientific explanation? This is a difficult issue and one that must be addressed on an individual, case-by-case basis for any given research question. When we put things this way, it is not surprising that despite their general agreement about overall approach, cognitivists sometimes disagree about more specific matters. Although some questions may be quickly categorized according to whether they can or cannot be answered by a scientific explanation, other questions will be more ambiguous. As a result, the appropriate methods for answering them may not be obvious. Even if we assume something like the modest naturalistic view sketched above, and agree that certain questions about the nature of, say,

human perception admit of scientific explanation, it is much less clear how scientific methods ought to figure into our investigations of normative matters, such as the ethics of film viewing or the evaluative judgments of television shows. Many of the essays in this book wrestle with this dilemma, advancing substantively different views despite being united by a common, fundamental approach. We hope readers find the debates as engaging as we do.

overview of the book

Part I looks at some of the controversies, limitations, and possible future directions for cognitive media theory. Murray Smith discusses why film scholars should care about the current developments in neuroscience, exploring some of the controversies surrounding contemporary research, and then considering some of the arguments presented against its extension into other fields. Malcolm Turvey assesses the explanatory value of evolutionary psychology for film studies, and asks what it can explain about film. While some claim that evolutionary psychology can illuminate a great deal about the arts, Turvey explains why he is skeptical about the likelihood that it will become the major paradigm in film studies, and the humanities more generally. Daniel Barratt reflects on the tendency amongst cognitive film scholars to stress the universal nature of film viewing, assuming that all viewers, the world over, engage cinema with the same set of cognitive mechanisms. Barratt surveys some of the research conducted on cultural-cognitive differences, and assesses the implications of this research for the field of cognitive film theory.

Part II features articles by psychologists who conduct original experiments that examine film experience using empirical data, rather than cognitive media scholars who work within the humanities and draw from research conducted by psychologists. Tim J. Smith presents a case study in which he conducts an eyetracking experiment to directly test the theories of filmmaker Sergei Eisenstein, who wrote intuitively about the viewer's visual tracking in a sequence from his film *Alexander Nevsky* (1938). Ed S. Tan suggests that emotions provoked by films are "refined" when compared to emotions provoked by real world interactions. Conducting a study that measures the viewer's levels of "action readiness," Tan explores the level to which viewers feel compelled to physically respond to onscreen events. Kaitlin L. Brunick and James E. Cutting draw from existing research to discuss how we perceive colors and develop preferences for particular ones. They then look specifically at children's animation and examine it with the use of quantitative data.

Part III returns to scholars within the humanities, and focuses on a range of forms of media content. Carl Plantinga comments that while we tend to think of moods as the "feel" of a film or film scene, we in turn

assume that moods are purely an aesthetic matter. However, he also explains how moods also factor heavily into the way in which we engage morally with films. Dirk Eitzen's article details and assesses the general aggression model—an influential theory that has driven research which tests whether violent media is likely to make its viewers more aggressive. This is done for the purpose of enabling scholars within the humanities to better understand and engage with empirical research on media effects, since they may have a valuable role to play in developing theories to explain the findings of such research. Torben Grodal advances a theory of comic entertainment, considering the evolutionary origin of the mechanisms that support and regulate comic entertainment. He also identifies those mechanisms. Patrick Colm Hogan also considers humor, but from a different perspective to that of Grodal. He begins by considering the cultural effects of colonialism, and then explores the general nature of humor and its relation to the characteristics of childhood. Following this, Hogan looks at humor in the context of colonialism, taking the US military occupation of Japan following World War II as a case study, while discussing Yasujiro Ozu's *Early Summer* (1951). In the concluding chapter of Part III, Paul Taberham suggests that those who draw from evolutionary psychology when discussing the arts are prone to being unduly dismissive of the avant-garde and modernist art. Detailing some of the major evolutionary accounts of the origins and functions of art, Taberham offers an alternative to existing theories that frames the avant-garde as a valuable phenomenon that exercises the mind in ways it is not exercised in commercial art or the natural environment.

The essays in Part IV take a cognitive approach to the investigation of specific forms of media. Using Alfred Hitchcock's *Rear Window* (1954) as an example, William Seeley and Noël Carroll consider how movies engage us cognitively and emotionally, and make a general case for the utility of cognitive theory in analyzing individual films. Andreas Gregersen, sketching out a cognitive poetics of video games, demonstrates how the formal design of video games fits with fundamental structures of human cognition. By focusing on video games and their players as interactive agents, Gregersen highlights the relevance of aspects of cognitive theory that have not been widely explored within the humanities, since movies are not interactive. Margrethe Bruun Vaage draws from cognitive film theory and recent moral psychology to explain how television series are able to exploit our tendency towards becoming sympathetic to immoral or morally dubious characters more effectively than movies, since the duration of television series has a bearing on our partiality. Concluding the book is Greg M. Smith's essay, which reflects upon future challenges for cognitivism as it continues to expand its purview beyond film.

Collectively, these essays offer a picture of contemporary cognitive media theory as a positive, pluralistic research tradition. United in their aim

to increase understanding of our engagement with a wide variety of media and their commitment to the basic assumptions underpinning the cognitivist perspective, the contributors draw upon the knowledge and methods of a diverse group of disciplines and fields. As we have argued, this does not entail that scientific methods of inquiry are encroaching upon humanistic methods of inquiry (or vice versa). Rather, in the cognitive tradition these two lines of inquiry not only co-exist peacefully, but are mutually informative insofar as the kind of research questions cognitivists ask cannot be answered by either sort of inquiry alone. Such pluralism does not come cheaply; it requires openness to consistent inter-theoretical debate and meta-theoretical reflection. We hope this volume not only highlights some of the great work being done by individual researchers, but, as a whole, also contributes to those more general tasks which are crucial to ensuring cognitive media theory's ongoing success.[62]

notes

1. On cognitive theory as a research tradition, see David Bordwell, "The Viewer's Share: Models of Mind in Explaining Film," in *Psychocinematics: Exploring Cognition at the Movies*, ed. Arthur P. Shimamura (Oxford and New York: Oxford University Press, 2013), 50.

2. Paisley Livingston and Carl Plantinga, ed. *The Routledge Companion to Philosophy and Film*, Routledge Philosophy Companions (London and New York: Routledge, 2009); *Psychocinematics*, ed. Shimamura.

3. David Bordwell, *Narration in the Fiction Film* (Madison: University of Wisconsin Press, 1985); Edward Branigan, *Narrative Comprehension and Film*, Sightlines (London: Routledge, 1992); Noël Carroll, *The Philosophy of Horror, or Paradoxes of the Heart* (London and New York: Routledge, 1990); Torben Grodal, *Moving Pictures: A New Theory of Film Genres, Feelings, and Cognition* (Oxford: Clarendon Press, 1997); Carl R. Plantinga, *Rhetoric and Representation in Nonfiction Film*, Cambridge Studies in Film (Cambridge: Cambridge University Press, 1997); Murray Smith, *Engaging Characters: Fiction, Emotion, and the Cinema* (Oxford: Clarendon Press, 1995).

4. Greg M. Smith, *Film Structure and the Emotion System* (Cambridge: Cambridge University Press, 2003); Torben Grodal, *Embodied Visions: Evolution, Emotion, Culture, and Film* (New York: Oxford University Press, 2009); Carl Plantinga, *Moving Viewers: American Film and the Spectator's Experience* (Berkeley: University of California Press, 2009).

5. Patrick Colm Hogan, *Understanding Indian Movies* (Austin: University of Texas Press, 2008); Tim J. Smith, "An Attentional Theory of Continuity Editing," Ph.D. dissertation (University of Edinburgh, 2006); Tim J. Smith, "The Attentional Theory of Cinematic Continuity," *Projections: The Journal for Movies and Mind* 6, no. 1 (2012): 1–27; Noël Carroll and William P. Seeley, "Cognitivism, Psychology, and Neuroscience: Movies as Attentional Engines," in Shimamura, 53–75; Katherine J. Thomson-Jones, "Sensing Motion in Movies," in Shimamura, 115–132.

6. Carl Plantinga, "Cognitive Film Theory: An Insider's Appraisal," *Cinémas: Journal of Film Studies* 12, no. 2 (2002): 15–37.

7. Ibid. Also see, especially, David Bordwell, "Cognitive Theory," in Livingston and Plantinga, 356–367.

8. David Bordwell, "A Case for Cognitivism," *Iris* 9 (1989): 11–41. Also see David Bordwell, "A Case for Cognitivism: Further Reflections," *Iris* 11 (1990): 107–112.

9. This gloss is drawn from Robert M. Harnish, *Minds, Brains, Computers: An Historical Introduction to the Foundations of Cognitive Science* (Malden, MA: Wiley-Blackwell, 2001); and Paul Thagard, *Mind: Introduction to Cognitive Science*, 2nd edition (Cambridge, MA: MIT Press, 2005).

10. Bordwell, *Narration in the Fiction Film*; David Bordwell, *Making Meaning: Inference and Rhetoric in the Interpretation of Cinema*, Harvard Film Studies (Cambridge, MA: Harvard University Press, 1989).

11. On the contrary, a careful reading of Bordwell's work reveals his agnosticism about computational theory of mind to be quite noticeable and, in fact, unsurprising because his local hypotheses about the viewer's inferential activity do not depend upon it. Indeed, on the question of whether an inferential/computational approach or an ecological approach offers a better account of natural vision, Bordwell recently wrote: "I retreat to the amateur's agnosticism." See David Bordwell, "Common Sense + Film Theory = Common-Sense Film Theory?," *Observations on Film Art*, blog, May 2011, http://www.davidbordwell.net/essays/commonsense.php (accessed May 27, 2013).

12. Carroll, *The Philosophy of Horror*.

13. Smith, *Engaging Characters*; Ed S. Tan, *Emotion and the Structure of Narrative Film: Film as an Emotion Machine* (Mahwah, NJ: Lawrence Erlbaum Associates, 1996); Grodal, *Moving Pictures*; and *Passionate Views: Film, Cognition, and Emotion*, ed. Carl Plantinga and Greg M. Smith (Baltimore: Johns Hopkins University Press, 1999).

14. Murray Smith, "Consciousness," in Livingston and Plantinga, 39–51; Murray Smith, "Triangulating Aesthetic Experience," in *Aesthetic Science: Connecting Minds, Brains, and Experience*, ed. Arthur P. Shimamura and Stephen E. Palmer (New York: Oxford University Press, 2012), 80–106.

15. See, for example, Noël Carroll, *Mystifying Movies: Fads and Fallacies in Contemporary Film Theory* (New York: Columbia University Press, 1988); Malcolm Turvey, *Doubting Vision: Film and the Revelationist Tradition* (Oxford and New York: Oxford University Press, 2008).

16. For examples of research in the cognitivist tradition that integrate philosophical and scientific inquiry, see Gregory Currie, *Image and Mind: Film, Philosophy, and Cognitive Science* (Cambridge: Cambridge University Press, 1995); and Carroll and Seeley, in Shimamura, 53–75.

17. Grodal, *Embodied Visions*; Uri Hasson, Ohad Landesman, Barbara Knappmeyer, Ignacio Vallines, Nava Rubin, and David J. Heeger, "Neuro-cinematics: The Neuroscience of Film," *Projections: The Journal for Movies and Mind* 2, no. 1 (2008): 1–26.

18. Plantinga, "Cognitive Film Theory," 21.

19. See Gregory Currie's chapter entitled "Cognitive Film Theory," in his *Arts and Minds* (Oxford: Clarendon Press, 2004), 154.

20. Ibid., 171.

21. Ibid., 170.

22. See Plantinga, "Cognitive Film Theory," 20; and Robert Sinnerbrink, *New Philosophies of Film: Thinking Images* (London and New York: Continuum, 2011).

23. David Bordwell and Noël Carroll, "Introduction," in *Post-Theory: Reconstructing Film Studies*, ed. David Bordwell and Noël Carroll, Wisconsin Studies in Film (Madison: University of Wisconsin Press, 1996), xiv.

24. Noël Carroll, "Prospects for Film Theory: A Personal Assessment," in Bordwell and Carroll, 56.

25. Ibid., 57.

26. A paradigmatic example is Carroll's *Mystifying Movies*. For a more recent example, see Ted Nannicelli, "Why Can't Screenplays Be Artworks?," *Journal of Aesthetics and Art Criticism* 69, no. 4 (2011): 405–414.

27. David Bordwell, "Poetics of Cinema," in *Poetics of Cinema* (New York: Routledge, 2008), 44.

28. Ibid., 44. See Daniel Barratt's essay in this volume for further reflection on this idea.

29. For a good discussion of the concept, see David Papineau, "Naturalism," *The Stanford Encyclopedia of Philosophy* (2007 edition), edited by Edward N. Zalta. Available at http://plato.stanford.edu/entries/naturalism/ (accessed April 24, 2013).

30. Murray Smith, "The Pit of Naturalism," in this volume.

31. See, for a broader discussion, Malcolm Turvey, "Can Scientific Models of Theorizing Help Film Theory?" in *The Philosophy of Film: Introductory Text and Readings*, ed. Thomas E. Wartenberg and Angela Curran (Malden, MA: Blackwell, 2005), 21–32.

32. Malcolm Turvey, "Evolutionary Film Theory," 48–49 in this volume.

33. Murray Smith, "Film and Philosophy," in *The SAGE Handbook of Film Studies*, ed. James Donald and Michael Renov (London: SAGE, 2008), 159.

34. Indeed, this is why Bordwell, the film scholar most closely associated with cognitive theory, refers to himself as a "part-time cognitivist." David Bordwell, "The Part-Time Cognitivist: A View from Film Studies," *Projections: The Journal for Movies and Mind* 4, no. 2 (2010): 1–18.

35. D. N. Rodowick, "An Elegy for Theory," *October* 122 (2007): 98.

36. Warren Buckland, "Introduction," *Film Theory and Contemporary Hollywood Movies* (New York and Abingdon: Routledge, 2009), 10.

37. Robert Sinnerbrink, "Re-enfranchising Film: Towards a Romantic Film-Philosophy," in *New Takes in Film-Philosophy*, ed. Havi Carel and Greg Tuck (Houndmills: Palgrave-Macmillan, 2011), 31.

38. Rodowick, 96.

39. Ibid., 97. *Film Theory and Philosophy*, ed. Richard Allen and Murray Smith (Oxford and New York: Oxford University Press, 1997).

40. John Mullarkey, *Refractions of Reality: Philosophy and the Moving Image* (Houndmills: Palgrave Macmillan, 2009), 30.

41. Ibid., 55.

42. Robert Sinnerbrink, *New Philosophies of Film: Thinking Images* (London and New York: Continuum, 2011), 8.

43. Noël Carroll, *Interpreting the Moving Image*, Cambridge Studies in Film (Cambridge: Cambridge University Press, 1998); David Bordwell, *On the History of Film Style* (Cambridge, MA: Harvard University Press, 1997) and David Bordwell, *The Way Hollywood Tells It: Story and Style in Modern Movies* (Berkeley: University of California Press, 2006); Murray Smith, *Trainspotting*, BFI Modern Classics (London: British Film Institute, 2002); and Richard Allen, *Hitchcock's Romantic Irony*, Film and Culture (New York: Columbia University Press, 2007).

44. It is also unclear how the sort of approach Mullarkey describes, one "basing itself on the latest models of human perception, the most rigorous and widespread historical research, and the closest examination of films from the best archives," could correctly warrant the description he gives it—"a science of cinema," 30. Perhaps Mullarkey is not himself confused about the nature of scientific inquiry, but rather intends to suggest that it is the scientism of cognitivists that erroneously leads them to believe that empirical historical research is a kind of scientific inquiry. But this is not a belief that cognitivists actually hold.

45. Rodowick, 97.

46. Malcolm Turvey, "Theory, Philosophy, and Film Studies: A Response to D. N. Rodowick's 'An Elegy for Theory'," *October* 122 (Fall 2007): 111.

47. Carroll, "Prospects for Film Theory," in Bordwell and Carroll, 39. Quoted in Turvey, 111.

48. David Bordwell, *The Cinema of Eisenstein* (Cambridge, MA: Harvard University Press, 1993), 11. Quoted in Turvey, 111.

49. Carroll, "Prospects for Film Theory," in Bordwell and Carroll, 59.

50. Ibid.

51. Rodowick, 97.

52. Carroll, "Prospects for Film Theory," in Bordwell and Carroll, 56.

53. Ibid., 61.

54. Richard Allen and Murray Smith, "Introduction," in *Film Theory and Philosophy*, 24.

55. Ibid., 26.

56. Ibid.

57. For an interesting argument regarding this point, see Turvey, "Scientific Models of Theorizing," in Wartenburg and Curran.

58. Tim J. Smith, "Audiovisual Correspondences in Sergei Eisenstein's Alexander Nervsky: A Case Study in Viewer Attention," 86 in this volume.

59. Margrethe Bruun Vaage, "Blinded by Familiarity: Partiality, Morality, and Engagement with Television Series," 86 in this volume.

60. See Turvey, "Scientific Models," in Wartenburg and Curran.

61. See, especially, Carroll, *The Philosophy of Horror* and Noël Carroll, *The Philosophy of Motion Pictures*, Foundations of the Philosophy of the Arts (Malden, MA: Blackwell, 2008).

62. We are grateful to Edward Branigan, Dan Fleming, Carl Plantinga, Alistair Swale, and Malcolm Turvey for feedback on earlier versions of this chapter.

the state of

cognitive media

theory: current

views and issues

"the pit of

naturalism"

two

neuroscience and the

naturalized aesthetics of film

m u r r a y s m i t h

It is hard to escape the brain these days—everywhere one turns, one encounters brain-scan images, claims about the neural basis of various human behaviors, and whole new subdisciplines based on the application of neuroscientific ideas or techniques to traditional domains of enquiry —as in "neurolinguistics," "neurophilosophy," and "neuroeconomics." Another such emergent field of inquiry is "neuroaesthetics," which seeks to illuminate our understanding of aesthetics by examining the brain processes and structures upon which aesthetic experience appears to depend. Among those neuroscientists who have been plowing this furrow, Semir Zeki and V. S. Ramachandran—both eminent in their own fields— have attracted the most attention. Zeki is known for his arguments concerning object constancy (our ability to perceive the integrity of objects, in spite of changes of angle, lighting, distance, and so on), visual abstraction (visual experiences of colors and forms, rather than of objects per se), and what the visual arts can tell us about these phenomena; Ramachandran caused a stir with his proposed eight "laws" of artistic experience.[1] Many other researchers are at work in what is consolidating itself as a research

program. All of these developments have taken place against the backdrop of, or are constitutive of, the gradual move from "cognitive science" to "cognitive neuroscience," a shift expressive of the changing self-understanding of the broader domain of inquiry.

Why should we care? What does, or might, this have to do with the study of film? There are several reasons why we film scholars might turn our attention to these developments in neuroscience. First, in addition to the specific field of neuroaesthetics, which has focused almost wholly on still depictions, there are now several teams of researchers tackling related questions on other art forms, including film: Uri Hasson and his collaborators, for example, have conducted early research in "neuro-cinematic studies."[2] Such research has one foot in an existing research tradition in film studies, namely cognitive film theory, which has gradually become more interested in neuroscientific research just as its "parent" research field, cognitive science, has come under the sway of the brain. Moving in the other direction, neuroscientific research on such fundamental mental capacities as perception, emotion, empathy, and memory is also relevant to film, as we will see in the course of this essay. Moreover, neuroscientific research (on film, on art, or on aspects of human psychology more generally) is pertinent not only to cognitive film theory, but to any approach to film with a significant psychological dimension, including phenomenological and psychoanalytic film theory. If Deleuze and some of his followers are prepared to allude to the brain, they ought, in good faith, to be prepared to follow those allusions to the place where research on the brain is actually conducted.[3]

The second reason that neuroscience matters to the study of film is that it matters to film practitioners—or to some of them, at any rate. In parallel with scholarly work on film and the brain, we also see filmmakers venturing into "neurocinema," that is, the application of neuroscientific tools to filmmaking. So far, this practice has taken at least three forms. First, brain scanning has been used as an extension of the venerable practice of test screenings, where scans provide another way of assessing the kind of impact possessed by particular moments in films; more generally, and not surprisingly, brain scanning is now being used as a tool in the advertising industry, spawning the idea of "neuromarketing." The second practical application of neuroscience in the world of motion pictures concerns what we might call "neural interactivity" in narrative film and in game design, wherein brain signals transmitted from headsets worn by players and viewers affect directly the game world and the progression of the narrative, as in the game *Focus Pocus*; or the direction of the narrative, as in the films produced by MyndPlay.[4] A third practical application of neuroscience involves the conversion of neural data into animated moving imagery: a technique designed to represent mental imagery in filmic form—in effect, to realize not merely brain scanning, but *mind* scanning.[5] These techniques

and the practices based on them are still in their infancy, and so it is too early to say much about their character or value. But that they exist at all is surely of note.

Perhaps there is a third, more general, reason for film studies as a discipline to take note of the burgeoning world of neuroscience. The current prominence of neuroscience is driven by the emergence of new technologies which are providing a picture of unprecedented detail of brain anatomy and function. Many scientists and philosophers believe that this new abundance of data will transform our understanding of phenomena across a wide range of fields. As we will see, there is much debate around these claims, but an adequate debate cannot be had without the participation of those individuals in possession of the requisite expertise—and in the case of "neurocinematic studies," that means both neuro-scientists and film scholars. Make no mistake: neuroscience will continue to spread into the making and the study of film. Film scholars can stay in their comfort zone and pretend it is not happening, or they can look outward with an open mind as well as a skeptical eye, assessing just what neuroscience might or might not have to offer film studies.

In this chapter, I make a start on that project of assessment. I begin by exploring some of the controversies surrounding contemporary neuro-science, and some of the arguments offered against its extension into new domains. With a sketch of these critical concerns in place, I turn to two aspects of our experience of films—startling in response to films, and empathic mirroring of characters' states—where, I argue, insights from neuroscience deepen and enrich our understanding of the phenomena at stake.

meet the neuroskeptics

Not everyone is impressed with or pleased by the rise of neuroscience. Jerry Fodor has given vivid expression to a longstanding tradition of skepticism among philosophers and psychologists of a functionalist stripe, who question whether the mind can be illuminated by evidence about the brain. Fodor decries in particular the vogue for brain-scanning, which he sees as an undisciplined "gold rush" for neural data unconstrained by the formulation of clear and testable hypotheses.[6] The classic functionalist worry, however, hinges on the "multiple realizability" of mental states—the idea, that is, that mental states do not depend on any one form of hardware or physical implementation. On a grand scale, this points towards the possibility of artificial intelligence, or the intelligence of organic entities with a different biochemical basis from our own; on a more modest scale, multiple realizability points towards neural plasticity—manifested, for example, in the ability of the brain to reconfigure itself after injury, restoring mental capacities through neural interconnections very different

to those preceding injury.[7] If mental function does not depend on some specific physical substrate or organization of material, why would we expect to learn much about mental phenomena by looking at the brain?

Peter Hacker (like Fodor, a philosopher) and Maxwell Bennett (a neuroscientist) have together advanced a still more wide-ranging critique of contemporary neuroscience, stressing the confusions that, they argue, arise from speaking of neural processes in the language of personal agency.[8] Hacker and Bennett refer to this as the *mereological fallacy*—whereby a property or a capacity properly attributable only to a whole person or organism (perceiving, thinking, experiencing, acting) is attributed to a part of that organism, namely the brain. Raymond Tallis, who writes of "neuromania," also focuses on problems arising from treating the brain in isolation from both the motor and expressive capabilities of the individual human body, and the "community of minds" that forms the context for individual cognition and behavior. Tallis also contends that neuroscience lapses into a form of behaviorism, allowing no space for the complexity, flexibility, and abstractness of human cognition, thereby failing to recognize the gulf separating human from other animal cognition. Tallis labels this purported failure "the pit of naturalism."[9] According to Tallis, while non-human animals are "wired into the world" by evolved instincts and reflexes, humans are "uncoupled" from the world; and they are unique in this regard.[10]

Critiques of neuroscience from within the philosophy of art tend to be more moderate, if not less serious. John Hyman's commentary on the arguments of Zeki and Ramachandran stresses the mismatch between the intended scope and ambition of these theories, and their actual limitations.[11] Hyman dubs Ramachandran's account "the Baywatch theory of art," arguing that while on the one hand it explains only a limited range of types or aspects of art, on the other hand it seems to explain the attention-grabbing nature of many phenomena outside the purview of art and aesthetics.[12] In a related vein, Vincent Bergeron and Dominic Lopes have underlined the very different definitions of "art" and "the aesthetic" operative in the work of neuroscientists and art theorists—often un-acknowledged differences which threaten to render useless the experimental work undertaken.[13] David Davies, meanwhile, highlights two ways in which neuroscientific research on art may miss its mark.[14] First, in an echo of Fodor, brain research may provide nothing more than an "implementation story" about already acknowledged features of aesthetic or artistic experience; on this view, learning that, say, the seat of some emotional response is the insula rather than the amygdala does not enrich our understanding of the aesthetic phenomenon. Second, noting the contrast between descriptive questions about the nature of our actual responses and normative questions about "merited" responses, Davies

stresses the centrality of the latter in philosophy of art and queries the ability of empirical research to address them. Things rather work in the other direction, according to Davies: experimental work must make normative assumptions which, if they are acknowledged and defended at all, will be on the basis of conceptual argument. Here Davies's argument joins with Tallis's in playing up the strongly normative character of human behavior—another dimension of our uniquely "uncoupled" existence.

The enthusiasm for all things neural, then, is matched by doubts coming from many directions. It is thus important not merely to set out certain areas of neuroscientific research and show, in a broad-brush way, how this research maps onto questions about film, but to pinpoint the specific, novel, and irreducible contributions that have or might be made by such research. I attempt this here by exploring what neuroscience might have to teach us about the ways in which filmmakers seek to elicit, and the ways in which spectators experience, two particular forms of affective response: the *startle response* and *empathic mirroring*. We can best appreciate the value of neuroscience, and in particular how it may go beyond providing "implementation stories," when we arrive at a fine-grained analysis of such specific phenomena.

startling sounds and sights

When we jump at a loud or unexpected noise or at a sudden, dramatic change in our field of vision, we are experiencing the startle response. Startling in this manner is a brainstem reflex: we cannot, at least under normal circumstances, exert significant control over it. We can no more stop ourselves startling at a loud, unanticipated gunshot than we can halt the shrinking of our pupils when we move into a field of bright light. The startle response depends on specific neural pathways—leading from the visual and acoustic systems through to the motor cortex.[15] Signals carried on this pathway cause the characteristic motor "jerk" of the torso and limbs, along with an eye blink and distinctive facial expression. Being evolutionarily ancient, the startle response is found in many species, and its evolutionary function is not hard to discern: in potentially threatening situations, the startle response propels us into a state of heightened attention.[16] In this sense, the startle response is very clear evidence of both "the continuity of species"—of the evolutionary continuity between humans and other animals—and of the way in which we (like other animals) are "wired into the world."

How have filmmakers drawn upon the startle response? In reading the paragraph above, many readers will doubtless have recalled examples from horror movies and from thrillers. The "startle effect" is a staple of such films, just as the crying human face is a key ingredient in the melodrama. Robert Baird suggests that the startle effect as an integral

31

feature of the horror film can be traced to producer Val Lewton, who referred to such effects as "busses," named after his first use of the technique in *Cat People* (Jacques Tourneur, 1942), where we are startled by the sudden and unexpected appearance of a bus from off-screen.[17] *Iron Man* (Jon Favreau, 2008) furnishes us with a more recent but similar example.[18] Tony Stark (Robert Downey Jr.) is being escorted by a group of American soldiers in a Humvee across a desert landscape in Afghanistan. The scene begins with a shot framing in the centre of the vehicle a boom box on which plays the AC/DC song "Back in Black," first heard at high volume, before settling after a few seconds into its function as diegetic background music. The camera tilts up from the boom box to reveal, through the windscreen, two other Humvees in front of the one in which the camera is situated (Figure 2.1).

Stark is a flamboyant character—a celebrated inventor equally well-known as a playboy. Incongruously, he cradles a cocktail (Figure 2.2), and after a few seconds, he starts to banter in good-natured fashion with the soldiers.

The soldier sitting alongside Stark in the back of the vehicle asks if he can get a photo with him; Stark assents and strikes a pose with him, while the soldier in the front passenger seat frames the shot. Cutting between Stark and the soldier in the back seat (Figure 2.3), and the soldier taking the shot in the front seat (Figure 2.4), the action focuses on the framing and staging of the photo. Across the thirty or so seconds that have elapsed since the scene began, then, the film has worked to focus the spectator's attention on the initially tentative, but increasingly relaxed and humorous, interaction between Stark and the soldiers. The AC/DC song, Stark's cocktail, and his irreverent jesting create a sociable atmosphere within the Humvee, an atmosphere that stands at odds with and distracts us from the treacherous environment outside the vehicle. A micro-narrative is created around the taking of the photograph, which we expect to be completed. A complex but stable overall rhythm emerges from the blending of editing, figure movement, and the AC/DC song; the auditory dynamics of the scene are similarly stable. All of these factors set up the startle response cue—a sudden and tumultuous blast as the Humvee in front of Stark's vehicle is destroyed by a rocket-propelled grenade or a missile (an explosion that resonates through every speaker in a surround sound system). The explosion is rendered visually across three rapidly-cut shots—beginning in the background behind the soldier taking the photo (Figure 2.5), continuing in a shot of the convoy (Figure 2.6),[19] and concluding with a return to the framing inside Stark's vehicle, as debris from the destroyed Humvee lands on top of it.

Now, it is obviously the case that our appreciation of this scene and the film as a whole depends upon a whole array of mental capacities that go far beyond the brief, involuntary, reflex-like reaction that is the startle

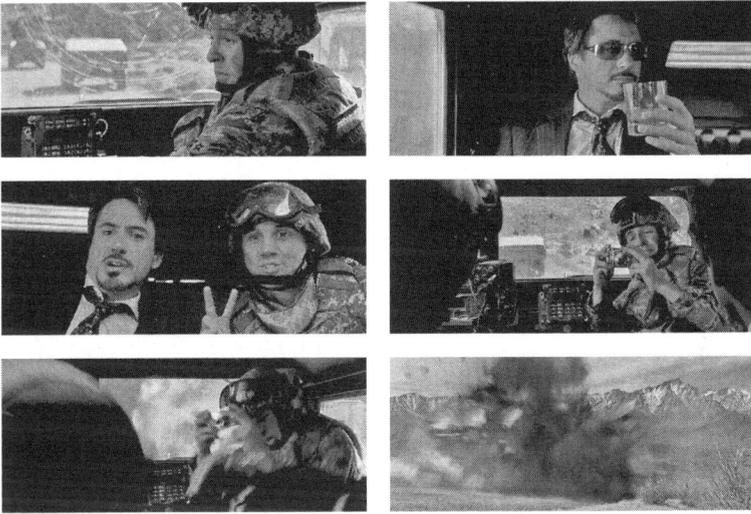

Figures 2.1–2.6 *Iron Man* (Paramount Pictures, 2008).

response. In order to make basic sense of the action, viewers need to understand the dialog, to interpret facial and vocal expressions, and to figure out the spatial relations among the agents and features of the setting. If their understanding is to go beyond very basic comprehension, spectators will in addition need to bring to bear a great deal of culturally-specific knowledge—about Marvel Comics, Robert Downey Jr., and the "war on terror," for example—on the unfolding action. None of this knowledge, however, makes startle cues like the explosion in *Iron Man*—and the primitive response that it triggers—any less significant, any less a designed feature of the film that exploits a real and important feature of human psychology. Here the startle cue performs a number of functions: it embodies a major narrative development (indeed, a plot point); it symbolizes in concrete form the danger posed by the Afghan insurgents; and it delivers a thrilling "whomp"—one of those powerful bodily sensations so characteristic of action and horror movies, very much akin to the visceral, stomach-in-mouth pleasures of fairground rides.

With such disreputable associations in mind, Baird notes that the startle effect has been "[m]aligned as mindless and a hallmark of B-movies and exploitation fare."[20] Cultural prejudice of this sort, however, should not stop us from seeking a deeper understanding of such genres, nor of the dispositions and capacities upon which they depend. Tallis and other traditionalists might be inclined to agree that the startle response is, precisely, "mindless"—a reflex response of the body bereft of flexibility and variability. But such a stance is untenable; unless we are prepared to embrace dualism, human psychology cannot be regarded as dividing conveniently into a wholly mechanical, bodily dimension and an entirely

33

voluntaristic mental dimension. Tallis emphasizes that the brain cannot be understood properly in isolation from the body.[21] But it is equally true that cognition itself cannot be understood properly when detached from its neural and bodily grounding, since the cognitive capacities an organism possesses depend, at least in some ways and to some degree, on that organism's (neuro-)physiology.[22]

In any event, the startle effect is not uniquely associated with the horror film or with other popular genres, even though it has certainly been exploited most frequently and routinely in these types of film. *Ran* (1985), Akira Kurosawa's free adaptation of *King Lear*, shows the effect at work in a much more "exalted" cultural context.[23] In the film, the Lear-figure Hidetora (Tatsuya Nakadai) has ceded effective leadership of the Ichimonji clan to his first son, Taro (Akira Terao), while Hidetora retains his role as titular leader of the clan. Initially in residence at Taro's castle, Hidetora leaves after arguing with him, eventually moving into the castle of his third son, Saburo (Daisuke Ryu). Taro and Jiro (Hidetora's second son, played by Jinpachi Nezu) together mount a sustained and bloody attack on Saburo's castle.

Across a lengthy sequence, we witness the extraordinary carnage of battle, and the gradual progress of the attacking armies towards the capture of Saburo's castle (Figures 2.7–2.10). All diegetic sound from the battle— the clash of armor, the galloping of horses, the cries of injury and death —is suspended, however; in its stead, we hear only Toru Takemitsu's mournful, Mahler-inspired score. Until, that is, we see Taro, leading the offensive army and entering Saburo's castle on horseback (Figure 2.11)— at which point he is shot in the back, a single, loud gunshot terminating the musical cue abruptly and marking the restoration of diegetic sound (Figure 2.12).

As in the *Iron Man* sequence, a striking change in the overall rhythm of the scene, initiated by the occurrence of an unanticipated event, as well as a sudden loud sound, prompt the startle response. And here, the force of the startle is both to underline a dramatic turning point and to remind us of the physical brutality of war. The startle effect begins a process of defamiliarization, whereby our appreciation of what is being represented is heightened by the shift in style. First, we witness slaughter on a mass scale, through the stylized, "operatic" phase of the sequence, when only the score is audible; then, with the re-entry of diegetic sound, the realistic potential of the visual imagery is drawn out. The startle generated by the gunshot marks the dividing line between the two styles; the effect of defamiliarization therefore turns on this moment.

Thus far in this discussion of the startle response, I have assumed that the response itself is an invariant feature of human physiology; what variation of function we see arises from the contexts in which it is spontaneously triggered or exploited by design, as in *Iron Man* and *Ran*. In

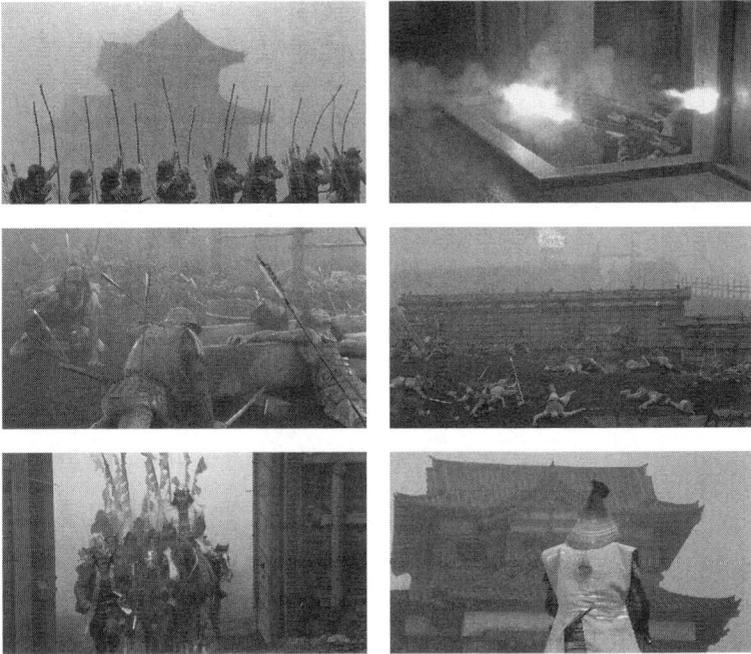

Figures 2.7–2.12 *Ran* (Greenwich Film Productions/Herald Ace/Nippon Herald Films, 1985).

fact, to some extent, context may affect the form as well as the function of the startle response. "Unlike the knee-jerk, the sneeze, or the flinch," writes Baird, "startle reflexes are modified by emotional and cognitive states."[24] According to Peter Lang and his collaborators, "the vigor of the startle reflex varies systematically with an organism's emotional state . . . the startle response (an aversive reflex) is enhanced during a fear state and is diminished in a pleasant emotional context."[25] Baird points to the "threat scene" as evidence of horror filmmakers' understanding, whether fully conscious or more intuitive, of this fact. In such a scene, a character is presented as fearful of a hidden, often indeterminate, off-screen threat; after depicting the character's anxiety for a period, the immediate space around the character is subjected to a sudden intrusion, typically from an unpredictable direction or in an unpredictable manner. The threat phase of the sequence primes us for the startle response; in an anxious and fearful state, we are more likely to be startled. (Baird suggests that this is why we find the startle effect much more frequently in horror and thriller films than in any other filmic context.) Threat scenes thus perform a balancing act between priming and misdirection: an unsettling, fearful mood is created, but within that broad affective context, our attention is taken away at the critical moment from the precise spatial location of the threat.

Baird analyses the bus scene from *Cat People* as an important historical exemplar of the threat scene. Alice (Jane Randolph) is seen making her way

through the streets at night. She senses that she is being followed by someone or something, and glances several times to screen left. After this pattern has been sustained over some seconds, a bus abruptly and noisily enters from screen right. The sequence from *Iron Man* is closer to this antecedent than the sequence from *Ran*: in the former case, general knowledge of war zones and particular knowledge about attacks on military convoys in Afghanistan puts us on alert. The relaxed social atmosphere in the Humvee—Stark's incongruous cocktail, AC/DC hammering away, the badinage and business around the taking of the photo—is designed to distract us from the possibility of an attack; our visual attention in particular is (mis-)directed to the right of the frame (where the photographer lines up the camera) and away from the centre of the frame (where the Humvee in front will explode). In the *Ran* sequence, the sense of threat is somewhat dampened and flattened by the suspended diegetic sound, and the fatal bullet is less visibly intrusive than the bus (in *Cat People*) or the missile (in *Iron Man*); even so, the basic constituents (character, implied threat, and sudden intrusion) are in place here as well.

There is also some evidence that the startle response may be subject to more idiosyncratic and elaborate cultural variations. Members of Malaysian, Indonesian, and some other Southeast Asian cultures recognize a condition called *latah*, which roughly translates as "jumpy."[26] Those suffering from the condition appear to have a strong innate predisposition towards being startled, but this predisposition is combined with some element of learned performance (playing up of the startle response) through "matching" (mimicry of the startling event) and "automatic" obedience to a command following the startle. In an interview with anthropologist Ronald Simons, Cik Alimah binti Mamad gives the following account of the behavior of a *latah*:

> When she's sitting quietly we can take a piece of wood and bang it, or we can poke her in the ribs over and over and she'll become *latah*. She gets startled! Then if we order her to hit or dance, she'll hit or dance. And she'll do whatever we tell her to do with what she's holding. Whoever is in front of her will be hit. That's what a *latah* does![27]

To some extent, *latah* resembles the practice of acting out and playing up startle and fear responses among Western horror movie audiences, especially among teenage female spectators; though in this context, the practice is not so elaborately developed, and appears to be restricted to the time and space of spectatorship. On the one hand, then, *latah* appears to be grounded in the startle response; on the other hand, *latah* appears to be a cultural extension of the response, where the effects of learning and context are evident. "The nearer the onset of the original response (speaking of microseconds), the more innate, 'hard-wired' the response,"

Baird argues; "conversely, the further from onset, the more learning, context, and personality [influence] behavior."[28] As with the film sequences discussed above, there is no difficulty, in principle or in practice, in recognizing both the invariant physiological basis and the variations achieved through particular uses and cultural elaborations of the startle response. For this reason, we can acknowledge that the response "wires us into the world" without denying that the response figures as just one part of the immensely complex and flexible cognitive and behavioral repertoire possessed by human beings.

mirror thrills

Another element in that repertoire is the set of interrelated capacities usually gathered under the label *empathy*—a term which is used to refer to a variety of phenomena, ranging from the conscious, imaginative effort to "perspective take" or put oneself in another's shoes, to affective mimicry and emotional contagion, whereby we "catch" the emotions of others through a process of low-level, non-conscious, involuntary mimicry.[29] This is one of the contexts in which the discovery of *mirror neurons* has been so significant. Mirror neurons are active both when subjects perform an action and when they observe that same action being performed. There is evidence that a neural "mirror system" exists in humans for "somato-sensory" experiences (tactile, proprioceptive, and pain-related sensations), basic actions (grasping objects, switching switches), and basic emotions (including disgust and sadness).[30] The mirror system, then, is the neural substrate that realizes our capacities for sensory, motor, and affective mimicry—the modeling of the basic emotions and intended actions of others via simulation, that is, by running these states on our own embodied minds. These abilities, in turn, appear to be central to the intensely social character of human existence: sensory and affective mimicry enable a rapid, almost seamless, grasp of the basic affective states of the individuals and groups with whom we interact, while motor mimicry enhances not only our ability to recognize with ease and facility the intentions of others (as these are embodied in basic actions), but also our ability to pick up new motor skills (such as those at stake in sporting activity or musical perform-ance, as well as in more utilitarian tasks). In this context, as Margrethe Bruun Vaage has put it, seeing is feeling: the mirror system allows us to simulate the sensations, emotions, movements, and actions of those we observe.[31]

Mirror neurons are not unique to humans—indeed, they were first discovered in macaque monkeys, and research on mirror neurons in humans is still at an early (and in many ways controversial) stage. The passage of discovery, however—from macaques to humans—nevertheless underlines, and indeed encapsulates metaphorically, the continuity of

species. No matter how massively humans may have evolved—biologically and culturally—in a distinctive direction, we share many ancient physiological, psychological, and behavioral traits with other animal species, particularly primates (as Darwin stressed in *The Expression of the Emotions in Man and Animals*).[32] This is an important example of the fruitfulness of setting human behavior in the context of other animal behavior:[33] were neuroscientists not prepared to propose and test hypotheses about humans based on non-human characteristics or behavior, no one would even be exploring the existence and nature of the human mirror system. In the present context, however, the key point about mirror neurons, and the sensory, motor, and affective mimicry that they implement and enable, is not so much that they tie us with our evolutionary ancestors and cousins, but that they *"wire" us into each other*. In the words of Vittorio Gallese, Christian Keysers, and Giacomo Rizzolatti—key players in the discovery of mirror neurons — mirror neurons enable a "direct experiential" form of understanding the actions and emotions of our conspecifics.[34] Or in the words of Marco Iacoboni, another member of the circle of Italian mirror neuron researchers: "[w]e empathize effortlessly and automatically with each other because evolution has selected neural systems that blend self and other's actions, intentions, and emotions . . . Our neurobiology . . . puts us 'within each other.'"[35] And, as with the startle response, filmmakers have not been slow to exploit this capacity.

127 Hours (Danny Boyle, 2011) provides a recent and vivid example of the way in which filmmakers may draw upon our ability to mirror the experiences of others.[36] The film relates the true story of Aron Ralston (played by James Franco), a mountain climber who goes on a solo biking and climbing trip in the Utah desert. While climbing in a narrow canyon, a rock fall results in one of Ralston's arms becoming trapped beneath a boulder. From the outset, the film is intent on giving expression to Ralston's sensory experiences—the intense pace of his life, the rush of pleasure he takes in climbing and biking, the dry heat of the south-western desert landscape, and so on.

The credit sequence of *127 Hours* is a montage of large-scale collective events, including sporting events such as a marathon, the Pamplona bull run, and a swimming gala; significantly, for our purposes, during these scenes of sporting spectacle almost as much emphasis is laid upon spectatorship of the events as on direct participation in them. The bold gestures and often extreme states engendered by sporting activity provide fertile ground for filmmakers and make our mirroring responses highly salient. The various forms of empathy—sensory, motor, and affective—are not, of course, prompted uniquely by witnessing sporting endeavors; any form of physical action, expression, or sensory experience can act as a prompt to empathic mirroring. But it is no accident that many films generate drama around and through sporting encounters.[37] Along with the

action film, the sports film is one of the major sites for the generation of what we might call "mirror thrills"—intense, bodily sensations triggered by and tracking those of the characters on screen.

Cues for such mirror thrills are present in concentrated form during the climax of *127 Hours*. By this point in the plot, Ralston has been trapped in the canyon for approaching five days. His water supply has run out, delirium from exhaustion has set in, and there is no realistic prospect of his being discovered by other hikers or climbers, such is the remote and obscure nature of his location. Ralston faces a stark choice: die a lonely death from heat exhaustion and dehydration in the canyon, or find a way to release himself from the imprisoning boulder. Ralston chooses survival— by amputating his trapped arm using a blunt penknife. The film goes to great lengths to get us to feel the excruciating quality of his situation— that is, both the literal pain of the trapped arm, and the larger anxiety arising from his isolated entrapment and impending death in the canyon. In the climactic scene of the amputation, all three types of mirroring come into play, because Ralston is both an agent and an object in this scene. That is, the film invites us to mirror the *sensations* of his trapped and dying arm (the constant weight of the boulder, the cutting and ripping of skin, the breaking of bone); the strenuous efforts—*motor actions*—of Ralston as he contorts his body to break his arm and cut himself free; and his facial and vocal *expressions* of pain (Figures 2.13–2.16).

What might Tallis make of my emphasis on the role of mirror neurons in explaining our experience of *127 Hours*? Tallis's writings are larded with discussions of human physiology, including neurophysiology, which run alongside his emphasis on the distance between humans and the rest of the animal kingdom. As a consequence of his emphasis on the most sophisticated aspects of human cognition, however, Tallis is in danger of caricaturing human psychology and the place of human existence in the

Figures 2.13–2.16 127 Hours (Fox Searchlight Pictures, 2010).

natural world. Attention to the "subpersonal" role of the various neural systems discussed here acts as a corrective to such a caricature. As we have seen, humans are "wired into the world" in the sense that a great many human reactions are spontaneous and unreflective; non-conscious, autonomous responses and literal reflexes represent an extreme on the spectrum of types of human response, but they can hardly be ignored. And more specifically, humans—like the members of many other species—are "wired into" the minds of their fellows by virtue of somatosensory, motor, and affective mimicry, psychological capacities realized by mirror neurons. These capacities allow us to track, virtually effortlessly, the basic emotional states of those around us, and assist us in imitating and in learning new motor skills. Of course such capacities do not describe the human mind exhaustively; neither can they be regarded as exemplars for all forms of human mental activity. But they cannot be written off as trivial or unreal facets of the human behavioral repertoire.

so what?

Let me conclude by offering some thoughts in response to an inevitable, and good, question: What exactly is it that the neuroscientific elements of the analyses I have offered can be said to add to our understanding? What can we learn about the startle response and empathic mirroring that we did not, or could not, know from the existing sources of knowledge at our disposal (including reflection on our experience, exploration of the practices and discussions of filmmakers, and psychological theories of these phenomena)?

First and most basically we gain knowledge about the very existence of the phenomena. Empathy has been disputed for as long as it has been an object of speculation; evidence of a mirror system provides a new form of evidence in favor of its existence. In this respect, the discovery of mirror neurons bears comparison with the emerging evidence of the existence of the Higgs boson particle; in each case, experimental evidence has provided empirical support for theoretical postulates. The startle response might seem less fragile as a postulate, so robust is the evidence from ordinary experience. But what is not obvious from such experience, or from the reflections of practitioners, of critics, or of viewers, is the *precise* nature of the startle with which we all have casual familiarity. How is the startle response realized physiologically and neurally? To what degree, and in what ways, is it affected by learning and by cultural context? How do these factors bear upon the role of the startle response in our experience of films? Experience and reflection are vital, but controlled observation and experimentation add a further, fine-grained level of detail to our understanding of the world. This fact points to the second way in which neuroscience adds something new to the sum of knowledge we possess about psychological

phenomena like the startle response and empathic mirroring. Neural evidence sheds light on the functional nuances of the phenomena that elude ordinary experience and reflection.[38] In this respect, neuroscience is like any type of scientific observation that transcends the limits of ordinary human perception; the brain scanner joins the telescope, the microscope, stop motion and x-ray photography, and so on—all technologies which allow us to see new aspects of our world, or to see familiar aspects of it in greater detail.

So neuroscience may furnish important evidence of the existence of a psychological process, and it may provide a nuanced picture of the character of such a process. Together these two considerations afford an answer to the worry, articulated by Davies and others, that neural evidence may amount to nothing more than an "implementation story"—the view, that is, that all we will learn from neural evidence is that certain types of cognition depend on this or that part of the brain, without learning anything about the character of those types of cognition, or the value that we attach to them in our theories of art and the aesthetic. The blunt answer to this worry is that *cognitive architecture is shaped by neural architecture*; or to put it more circumspectly, it is methodologically unwise to rule out the possibility that cognitive architecture is importantly shaped by our brain anatomy and chemistry. The way we think is shaped by the kinds of brain we have; the kinds of mind that we possess arise from our evolved physiology.[39] We see the world the way we do as a result of the physiology of our visual systems: animals with a different array of cones discriminate different colors in the environment. Neuroscientific research into memory has confirmed the hypothesis that memory is not a single, homogeneous capacity, but a composite of different information-retaining skills supported by different neural sub-systems; such research also shows how intimately related are the apparently very distinct processes of memory and imagination. Neuroscience has similarly moved beyond the traditional picture of the five senses, breaking several of these sense mechanisms down into distinct senses, as well as bringing to light the high degree of cross-modal interaction among the senses.

"How do the startle and mirror responses appear in light of these considerations concerning the relationship between cognitive and neural architecture?" In the case of the startle response, we have seen how the "vigor" of this reflex varies with the mood of the subject, and is subject to a modest degree of influence from learning; in the case of mirror responses, brain research is gradually giving us a picture of how the targets of empathic response (sensations, emotions, actions) may vary across primate species, and, among humans, may vary according to background and experience. None of these insights are transparent from experience or from systematic reflection upon our experience, our ordinary habits, and our artistic practices. In all these cases, neuroscientific evidence may feedback upon and

change our conceptual assumptions, rather than leaving them untouched. On this account, we do not possess a conceptual "grammar" which is simply given and timeless in all respects, a grid that empirical research can do no more than fill in with "implementation stories." Instead, neuroscientific research—empirical research in general—may call us to revise and even abandon the conceptual map and assumptions that provided our starting point.

We need to acknowledge a third way in which neuroscience may contribute to what we know. Even where neural evidence adds little detail to our picture of a phenomenon and only seems to confirm what we already knew, in reality it does or can do much more than that. It is important not to confuse here the *dramatic novelty* of some body of scientific knowledge with its strictly *epistemological value*. Scientific findings arising from controlled experiments that broadly confirm hypotheses derived from everyday experience and folk theory may not be very sexy, because they leave the landscape of ordinary belief and practice unchanged. From an epistemological point of view, however, such findings are significant, adding the kind of systematic and quantitative evidence provided by scientific methods to the looser, anecdotal, and experiential evidence already in our possession. The point here is not to denigrate these latter forms of evidence, but just to point up the limited sense in which we can be said to "already know" something based only upon them. Knowledge arises not only from the dazzling and unexpected finding, but also from the gradual accumulation and correction of detail, as well as the convergence among the different sources of knowledge upon which we draw.[40]

notes

1. Semir Zeki, *Inner Vision: An Exploration of Art and the Brain* (Oxford: Oxford University Press, 1999); V. S. Ramachandran and W. Hirstein, "The Science of Art: A Neurological Theory of Aesthetic Experience," *Journal of Consciousness Studies* 6, no. 6–7 (1999): 15–51.
2. Uri Hasson, Ohad Landesman, Barbara Knappmeyer, Ignacio Vallines, Nava Rubin, and David J. Heeger, "Neurocinematics: The Neuroscience of Film," *Projections: The Journal of Movies and Mind* 2, no. 1 (2008): 1–26. Other teams of researchers working on related terrain include Gal Raz, Talma Hendler, and their colleagues at Tel Aviv University, and Pia Tikka's NeuroCine research team at Aalto University, Helsinki.
3. See, for example, Raymond Bellour, "Deleuze: The Thinking of the Brain," *Cinema: Journal of Philosophy and the Moving Image* 1 (2010): 81–94, http://cjpmi.ifl.pt/1-deleuze/ (accessed November 19, 2011).
4. On brain scanning used as a vehicle of audience testing, see Curtis Silver, "Neurocinema Aims to Change the Way Movies are Made," *Wired.com*, http://www.wired.com/geekdad/2009/09/neurocinema-aims-to-change-the-way-movies-are-made/ (accessed November 19, 2011); on *Focus Pocus*, see Christina Des Marais, "Video Game Uses Brain to Control Action,"

TechHive, http://www.pcworld.com/article/241993/video_game_uses_brain_to_control_action.html (accessed November 19, 2011); on MyndPlay, see Charlie Burton, "Directed by Brainwave," Wired.co.uk, http://www.wired.co.uk/magazine/archive/2011/10/ play/directed-by-brainwave (accessed November 19, 2011).

5. Ben Johnson, "Scientists Turn Brain Activity into Moving Images," *Slate* 24, no. 9 (2011), http://slatest.slate.com/posts/2011/09/24/scientists_turn_brain_activity_into_ moving_images.html (accessed November 19, 2011).

6. Jerry Fodor, "Let Your Brain Alone," *London Review of Books* 21, no. 19 (1999): 68–69. In correspondence following the publication of this essay, Fodor remarks on "the difference between a scientist who has a hypothesis and one who only has a camera." Jerry Fodor, "Letter to Benjamin Martin Bly," in Letters, *London Review of Books* 22, no. 1 (2000), http://www.lrb.co.uk/v21/n19/jerry-fodor/diary (accessed November 19, 2011).

7. David A. Barrett, "Multiple Realizability, Identity Theory, and the Gradual Reorganization Principle," *British Journal for the Philosophy of Science* 64, no. 2 (2013): 325–346.

8. M. R. Bennett and P. M. S. Hacker, *Philosophical Foundations of Neuroscience* (Malden, MA: Wiley-Blackwell, 2003).

9. Raymond Tallis, *Aping Mankind: Neuromania, Darwinitis and the Misrepresentation of Humanity* (Durham, UK: Acumen, 2011). Tallis spoke of "the pit of naturalism" on an episode of the BBC Radio 4 show *Start the Week*, April 21, 2008. For a fuller treatment of Tallis's perspective on neuroscience and evolutionary theory, see the earlier version of the current essay in *Iluminace* 23 (2011): 59–79.

10. Raymond Tallis, *The Knowing Animal: A Philosophical Inquiry into Knowledge and Truth* (Edinburgh: Edinburgh University Press, 2005).

11. John Hyman, "Art and Neuroscience," in *Beyond Mimesis and Convention: Representation in Art and Science*, ed. Roman Frigg and Matthew C. Hunter, 245–261, Boston Studies in the Philosophy of Science 262 (Dordrecht and London: Springer, 2010).

12. Hyman is, of course, alluding to the American television series *Baywatch* (1990–99), and its icons of exaggerated physical beauty—especially in its female variant, as embodied in the show by Pamela Anderson. Colin McGinn offers the same criticism in a review of V. S. Ramachandran's *The Tell-Tale Brain: A Neuroscientist's Quest for What Makes Us Human* (New York: W. W. Norton, 2011), which includes a chapter on neuroaesthetics: "The discussion of art seems largely about another subject entirely—what elicits human attention." Colin McGinn, "Can the Brain Explain Your Mind?," *The New York Review of Books*, http://www.nybooks.com/articles/archives/2011/mar/24/can-brain-explain-your-mind/ (accessed November 19, 2011).

13. Vincent Bergeron and Dominic McIver Lopes, "Aesthetic Theory and Aesthetic Science: Prospects for Integration," in *Aesthetic Science: Connecting Minds, Brains, and Experience*, ed. Arthur P. Shimamura and Stephen E. Palmer (New York: Oxford University Press, 2012), 63–79.

14. David Davies, "'This is Your Brain on Art:' What Can Philosophy of Art Learn from Neuroscience?," in *Aesthetics and the Sciences of Mind*, ed. Gregory Currie, Matthew Kieran, and Aaron Meskin (Oxford: Oxford University Press, forthcoming).

15. For more detail, see Ronald C. Simons, *Boo! Culture, Experience, and the Startle Reflex*, Series in Affective Science (New York: Oxford University Press, 1996),

43

9–15; and Michael Davis, "The Mammalian Startle Response," in *Neural Mechanisms of Startle Behavior*, ed. Robert C. Eaton (New York: Plenum Press, 1984), 287–351.

16. Juan M. Castellote, Hatice Kumru, Ana Queralt, and Josep Valls-Solé, "A Startle Speeds Up the Execution of Externally Guided Saccades," *Experimental Brain Research* 177, no. 1 (2007): 129–136.

17. Robert Baird, "The Startle Effect: Implications for Spectator Cognition and Media Theory," *Film Quarterly* 53, no. 3 (2000): 12–24. *Cat People*, directed by Jacques Tourneur (Los Angeles: RKO Radio Pictures, 1942).

18. *Iron Man*, directed by Jon Favreau (Los Angeles: Paramount Pictures, 2008).

19. In fact, the onset of the explosion is visible in both the first and second of these three shots. But this is not an instance of true "overlapping" editing, in the Eisensteinian sense, since the very brief overlap is not consciously perceptible under ordinary viewing conditions. It is nevertheless very likely that the overlap is registered non-consciously, and may play an indirect role in our conscious experience of the action as rapid, disjunctive, and chaotic.

20. Baird, "The Startle Effect," 15.

21. See in particular Raymond Tallis, *The Kingdom of Infinite Space: A Fantastical Journey Around Your Head* (London: Atlantic, 2008).

22. For more on this theme, see my "Triangulating Aesthetic Experience," in Shimamura and Palmer, 80–106.

23. *Ran* (Japan/France: Greenwich Film Productions/Herald Ace/Nippon Herald Films, 1985). In describing *Ran* as a "free" adaptation, I mean to indicate that the film borrows many elements from *King Lear* and seems designed to bring Shakespeare's play to mind, but it does not seem intended as a "faithful" adaptation, in which overall fidelity to the play is a primary goal. See Paisley Livingston, "On the Appreciation of Cinematic Adaptations," *Projections* 4, no. 2 (2010): 104–127. Livingston notes the use of the phrase "free adaptation" in the credits for *Fellini − Satyricon* (directed by Federico Fellini; Italy: Produzioni Europee Associati, 1969).

24. Robert Baird, "Startle and the Film Threat Scene," *Images* 3, http://www.imagesjournal.com/issue03/features/startle1.htm (accessed November 19, 2011).

25. Peter J. Lang, Margaret M. Bradley, and Bruce N. Cuthbert, "Emotion, Attention, and the Startle Reflex," *Psychological Review* 97, no. 3 (1990): 377; quoted in Baird, "The Startle Effect," 20.

26. According to Simons, versions of this "culture-bound syndrome" are scattered in other locations outside Asia as well—"in a most improbable set of other places around the globe— Siberia, Maine, Yemen, and the Island of Hokkaido, to name a few." Simons, *Boo!*, vii.

27. Ibid., 162.

28. Baird, "The Startle Effect," 21. See also Carl Plantinga, *Moving Viewers: American Film and the Spectator's Experience* (Berkeley: University of California Press, 2009), 119.

29. On the distinction between affective mimicry and contagion, see my "Empathy, Expansionism, and the Extended Mind," in *Empathy: Philosophical and Psychological Perspectives*, ed. Amy Coplan and Peter Goldie (Oxford and New York: Oxford University Press, 2011), 101. In the case of contagion, we lack awareness of, and control over, not merely the mechanism by which we pick up the emotions of others, but awareness of even the fact that our

emotional state derives from or has been triggered by the states of those around us.

30. See David Freedberg and Vittorio Gallese, "Motion, Emotion and Empathy in Esthetic Experience," *Trends in Cognitive Sciences* 11, no. 5 (2007): 197–203; Christian Keysers, Jon H. Kaas, and Valeria Gazzola, "Somatosensation in Social Perception," *Nature Reviews* 11 (2010): 417–428; and Alison Motluk, "Mirror Neurons Control Erection Response to Porn," *New Scientist*, June 16, 2008, http://www.newscientist.com/article/dn14147-mirror-neurons-control-erection-response-to-porn.html (accessed November 19, 2011).

31. Margrethe Bruun Vaage, "Seeing is Feeling: Empathy and the Film Spectator," Ph.D. dissertation (Oslo: University of Oslo, 2009).

32. Charles Darwin, *The Expression of the Emotions in Man and Animals* (London: John Murray, 1872).

33. On this explanatory principle, see Helena Cronin, quoted in Matt Ridley, *The Origins of Virtue: Human Instincts and the Evolution of Cooperation* (London and New York: Penguin, 1997), 156; see also Frans de Waal, *Good Natured: The Origins of Right and Wrong in Humans and Other Animals* (Cambridge, MA: Harvard University Press, 1996),126–127.

34. Vittorio Gallese, Christian Keysers, and Giacomo Rizzolatti, "A View of the Basis of Social Cognition," *Trends in Cognitive Sciences* 8, no. 9 (2004): 396–403.

35. Marco Iacoboni, "Within Each Other: Neural Mechanisms for Empathy in the Primate Brain," in Coplan and Goldie, 57.

36. *127 Hours*, directed by Danny Boyle (Los Angeles: Fox Searchlight Pictures, 2010).

37. I discuss one such encounter—a tennis match in Hitchcock's *Strangers on a Train*—in my "Empathy, Expansionism, and the Extended Mind," 102–103. *Strangers on a Train*, directed by Alfred Hitchcock (Burbank: Warner Brothers, 1951).

38. On the integration of phenomenological, psychological, and neurological evidence, see my "Triangulating Aesthetic Experience."

39. On this theme see Daniel C. Dennett, *Kinds of Minds: The Origins of Consciousness* (London: Phoenix, 1997, particularly Chapter 3).

40. My thanks to Tereza Hadravova, Ted Nannicelli, Richard Nowell, and Paul Taberham for comments on this essay at various stages of its development. Thanks are also due to the editors of *Illuminace* for their permission to reprint portions of an earlier version of this essay published in the journal (Vol. 23 [2011]: 59–79).

evolutionary

film theory

three

m a l c o l m t u r v e y

In the 1990s, cognitive scientists began synthesizing the computational
theory of mind propounded by Jerry Fodor and others with evolutionary
psychology.[1] The basic premise of evolutionary psychology is that, just as
evolution by natural selection has produced universal human morpho-
logical adaptations, so it has created universal psychological adaptations
that together constitute our shared "human nature."[2] Steven Pinker and
other evolutionary psychologists—such as David Buss, Leda Cosmides, and
John Tooby—contend that, given its complexity, it is highly unlikely the
human brain evolved by chance. Rather, like other complex organs, such
as eyes, the brain is almost certainly the product of a long process of natural
selection, in which modifications to its structure caused by random genetic
mutations and re-combinations accumulated because they were fitness-
enhancing. They gave rise to behaviors that provided new or better solu-
tions to problems of survival and reproduction faced by our hominid
ancestors, thereby conferring on their original bearers greater reproductive
success and ensuring that they spread to fixation in future generations. Such
problems included (but were not limited to) "finding mates, parenting,

choosing an appropriate habitat, cooperating, communicating, foraging, [and] recovering information through vision."[3] Modifications to the brain enabled our forebears to better address these problems by gradually forming information-processing "modules" in their minds, "each with a specialized design that makes it an expert in one arena of interaction with the world."[4]

For example, according to Cosmides and Tooby, we have a module for detecting cheaters, those who fail to reciprocate an altruistic act, and in general our "cognitive architecture resembles a confederation of hundreds or thousands of functionally dedicated computers," each of which evolved to solve a particular problem.[5] This all occurred during the Pleistocene, the epoch that lasted from roughly 2.5 million to twelve thousand years ago, which is often referred to by evolutionary psychologists as the environment of evolutionary adaptedness.[6] This is because the evolution of complex design by natural selection takes a very long time, certainly much longer than the twelve thousand years since the end of the Pleistocene, which constitutes less than 1 percent of the two million years or so our ancestors spent as hunter-gatherers. Thus, while the information-processing modules that comprise universal human psychological adaptations evolved because they solved problems in the Pleistocene world of hominid hunter-gatherers, this does not mean they are still adaptive in the modern world. To use Cosmides and Tooby's immortal phrase, "Our modern skulls house a stone age mind."[7] Although we continue to face many of the same social problems as our ancestors and some of our psychological adaptations therefore remain adaptive, others have become non-adaptive or maladaptive due to profound changes in our environment and way of life since the end of the Pleistocene, such as the emergence of agriculture, cities, and industrialization.

Many of these claims have been challenged. Most famously, paleontologist Stephen Jay Gould and biologist Richard Lewontin criticized what they called "adaptationism," or the unwarranted "faith in the power of natural selection," arguing that many inherited traits might be by-products of adaptations rather than adaptations themselves.[8] Calling such evolutionary by-products "spandrels," after the spaces "that are necessary architectural by-products of mounting a dome on rounded arches,"[9] Gould went on to claim that "[t]he human brain must be bursting with spandrels that are essential to human nature and vital to our self-understanding but that arose as nonadaptations, and are therefore outside the compass of evolutionary psychology."[10] As Pinker has countered, however, Gould's argument is compatible with evolutionary psychology, which does not insist that "every aspect of the mind is adaptive," but only that the "major faculties of the mind . . . show the handiwork of selection."[11] Moreover, because the structures that can do what the eye, the brain, and other complex organs do "are extremely low-probability arrangements of matter," it is "absurdly improbable" that they could have evolved as

by-products of other adaptations.[12] Only natural selection can explain the evolution of *complex* design.

Gould and Lewontin also accused adaptationists of being unscientific due to their method of identifying a trait and then offering a plausible "story" of why it evolved under natural selection on the basis of its current utility, without considering non-adaptationist alternatives. Not only does this "confuse the fact that a structure is used in some way . . . with the primary evolutionary reason for its existence,"[13] but it means that evolutionary accounts tend to be accepted on the basis of their plausibility rather than on empirical evidence, and Gould derisively likened them to Rudyard Kipling's fanciful *Just So Stories* for children, about how the leopard got its spots, how the rhino got its skin, and so on.[14] Indeed, Gould maintained that the claims of evolutionary psychologists about the social problems faced by our ancestors in the environment of evolutionary adaptedness "usually cannot be tested in principle but only subjected to speculation" because it is impossible to find out much if anything about these problems.[15] "The chief strategy proposed by evolutionary psychologists for identifying adaptation is untestable, and therefore unscientific," he concluded.[16] Evolutionary psychologists responded, however, by pointing out that in fact they do make testable claims, by predicting the existence of previously unknown modules in the human mind on the basis of problems our ancestors were likely to have faced in the Pleistocene, and then conducting empirical experiments to see if people possess these modules, as was done in the case of the cheater-detection module.[17] Their method, in other words, is a form of "reverse engineering" in which they infer what the human mind is designed to do on the basis of the problems it must have faced in the past. Moreover, if Gould is right and accounts of how adaptations evolved under natural selection are "just so" stories because they cannot in principle be falsified, then the same must be true of his own claims about spandrels.[18]

In what follows, I do not challenge the major premise of evolutionary psychology, that "animals and humans are born with certain mental specifications and capacities that have been selected by evolution and that have enabled their ancestors to survive."[19] Rather, I focus on its explanatory value for film studies, asking: What can evolutionary psychology explain about cinema? Some outside of film studies have argued that evolutionary psychology can explain a great deal about the arts. The evolutionary theorist of literature Joseph Carroll, for instance, has claimed that "If evolutionary psychology can give a true and comprehensive account of human nature, it can ultimately encompass, subsume, or supplant the explanatory systems that currently prevail in the humanities."[20] I am sure that evolutionary psychology, like psychology in general, has much to teach those of us who study the arts. Nevertheless, I am skeptical that it can become the major explanatory paradigm in the humanities or in

cinema studies. One reason is that, as the philosopher Stephen Davies has recently shown in his survey of the debate about whether art is an adaptation or a spandrel, "claiming art as a central aspect of our common biological inheritance . . . depends ultimately on a leap of faith, rather than on appeal to incontrovertible scientific fact," due to the paucity of available evidence.[21]

Evolutionary film theorists, however, have (probably wisely) sidestepped this debate about whether art is an adaptation. Instead, in applying evolutionary theory to cinema, they have pursued two other strategies, and I will survey representative examples of both. Most have followed the more cautious route of first arguing that films are dependent on innate, universal perceptual and psychological capacities for their effects, and then appealing to the evolutionary histories of these abilities to explain how they likely emerged in the Pleistocene and why viewers the world over are therefore born with them. The trouble with this option, I will suggest, is that although evolutionary accounts of the origins of our inborn capabilities certainly tell us a great deal about human nature, they do not appear to illuminate much if anything about cinema. The other, bolder strategy is to invoke the evolutionary origins of the innate, universal capacities that film depends on not just to account for why they evolved in the past, but to explain human behavior toward cinema in the present. Evolutionary psychology, in other words, is marshaled to understand why we are all drawn to particular films and their features. The problem with this approach, I will show, is that it is much harder than is often realized to convincingly demonstrate that there is a direct path leading from the evolutionary histories of our native perceptual and psychological traits to features of films.

Evolutionary psychology offers explanations for why we have inherited certain perceptual, cognitive, and affective traits from our ancestors. Thus, the most obvious explanatory role it can play in film studies is to account for why we have inherited the perceptual, cognitive, and affective traits that cinema depends on for its effects. This is the approach taken by Joseph D. Anderson in his groundbreaking book *The Reality of Illusion*, which was the first major work of evolutionary (or, as Anderson calls it, "ecological") film theory. In his book, Anderson seeks to explain how a number of features of film interact with our evolved perceptual mechanisms to achieve specific effects. One example is the "illusion of smooth, continuous motion" that is experienced by viewers when a succession of still images is projected at the rate of twenty-four per second.[22] Another is editing. "The viewer has the capacity to integrate a succession of views" depicted in different shots that are edited together, suggests Anderson, because "an adaptation or series of adaptations to some environmental pressure . . . must have instigated [in our ancestors] the development of the capacity to integrate a succession of views that is now exploited by makers of motion pictures."[23]

David Bordwell also invokes the evolutionary history of several of our in-born capacities solicited by films, such as our ability to detect the emotional states of others. "The weight of the evidence shows that evolution has primed us to engage in encounters with others by making us sensitive to the slightest signs of their emotional states," he argues.[24] Murray Smith, too, focuses on emotion, and in order to account for why emotions evolved, he appeals to the evolutionary theory of emotions as enabling rapid reactions to a "changing and sometimes hostile environment." He writes, "[w]hether it's a wild animal or a car suddenly bearing down on us, it is mighty handy that we have an instinctive fear reaction to unexpected loud noises and fast movements—that we leap out of the way immediately, rather than calmly trying to assess the nature of the moving object."[25] Smith also turns to "evolutionary studies of facial expression" to point out that there are a "range of basic emotional expressions [that] are easily and quickly recognized cross-culturally (happiness, sadness, disgust, anger, fear, and surprise)."[26] This has important consequences for filmmaking and film viewing, according to Smith, not least of which is that it "sharpens our appreciation of the aesthetic sculpting of expression by particular artists."[27]

The work of these and other scholars has certainly provided a crucial corrective to the view that cinema and our responses to it are primarily, if not exclusively, determined by culture.[28] They demonstrate that films routinely depend on our natural, universal perceptual and psychological capacities to achieve their intended effects. Moreover, their work offers a wealth of information about the nature of these abilities and how they shape certain features of film. What is less clear is the explanatory value for film studies of drawing on evolutionary accounts of the origins of these capabilities. Doing so certainly explains why viewers are born with innate perceptual and psychological capacities, but what, precisely, does knowledge of their evolutionary histories reveal about cinema? In evolutionary psychology as conceived of by Cosmides, Tooby, Pinker, and others, postulating the adaptive problems that our ancestors likely faced in the Pleistocene can predict the presence of hitherto unknown abilities in the human mind that evolved to solve these problems, such as the cheater detection module. It promises, in other words, to make exciting discoveries about the design of the human mind. But what does knowing the evolutionary history of our inherited capacities enable us to predict, discover, or explain about film?

An evolutionary film theorist might argue that knowing, for example, that emotions evolved because they enabled our ancestors to respond rapidly to potentially dangerous features of the environment explains an important design feature of our emotions, namely, that they are rapid. This in turn accounts for certain design features of films that depend on the rapidity of our emotional reactions. If emotional responses had not evolved to be rapid, films would be designed very differently. The same is

true of the recognition of emotions expressed in faces and bodies. Obviously, if we had not evolved the ability to recognize the emotions expressed in the faces and bodies of others, films would be quite other than they are, an evolutionary film theorist might aver. Smith, for instance, points out that different filmmakers draw on our capacity for recognizing facial expressions in different ways. While Takeshi Kitano "has developed a style of performance which presents the face as a blank, expressionless mask" in order, according to Kitano himself, "to make the intentions and feelings of his character enigmatic," Robert Bresson has "displaced" facial and bodily expression so as to "remove his characters from the sphere of ordinary human psychology."[29] Wong-Kar Wai's films, meanwhile, "depend on a more naturalistic style of performance, but this is overlaid by a cinematic stylization which often presents characters obliquely."[30] None of these artistic strategies would function as intended if viewers did not have the ability to recognize certain facial and bodily expressions.

However, this does not show that knowing about the *evolutionary history* of a trait, as opposed to its *design*, explains something about film. The fact that our emotional responses can be rapid and that we can recognize facial and bodily expressions of emotion are hardly new discoveries enabled by knowledge of the evolutionary history of these traits. These design features of these capacities have been patently obvious for a long time, and did not require evolutionary theory to be uncovered. As Jerry Fodor has argued in criticizing evolutionary psychology,

> one can often make a pretty shrewd guess what an organ
> is for on the basis of entirely synchronic considerations.
> One might thus guess that hands are for grasping, eyes for
> seeing, or even that minds are for thinking, without
> knowing or caring much about their history of selection.[31]

The same is therefore true of the design features of films that depend upon these evolved psychological capacities. It is, for instance, hardly a revelation that Kitano and Bresson minimize facial and bodily expression while Wong hides it, and evolutionary theory is not required to reveal this. Furthermore, the evolved abilities upon which cinema depends for its effects might turn out to have very different evolutionary histories, but this would not change their design features, nor would it change the design features of films that presuppose them. Indeed, as far as I can tell, Anderson's, Bordwell's, and Smith's arguments about the ways that cinema engages our inborn capacities are in no way dependent upon which evolutionary accounts they select to explain their origin, and in fact would be unaffected if these accounts were eliminated. Thus, while appealing to the evolutionary histories of our perceptual and psychological traits explains how we came to acquire them and why they are universal, it does not appear to tell us anything non-trivial about film. This does not rule

out the possibility that, as with mental modules, evolutionary psychologists might discover new design features of the abilities cinema depends on by postulating problems they evolved to solve in the Pleistocene, and that this in turn might lead to fresh discoveries about the design features of films. But it does suggest that simply invoking the most plausible accounts we currently possess of the evolutionary origins of our perceptual and psychological powers does not reveal anything new about film.

A much more explanatorily robust and exciting evolutionary film theory has been proposed by Torben Grodal, who invokes the evolutionary origins of our inborn traits not just to account for their emergence in the past and why we are all born with them, but also to explain our behavior toward cinema in the present. According to Grodal, evolutionary psychology can explain why films have widely recurring, even universal features, because it can account for why we have universal preferences for these features. These universal preferences are due to our innate dispositions, which evolved among our ancestors in the Pleistocene because they were fitness-enhancing. As he puts it:

> The core emotional and cognitive elements that our embodied brains developed in a hunter-gatherer society are perhaps even more obvious if we examine the kinds of visual fictions that viewers prefer, rather than merely observing their social behavior in real life, because many of these fictions reflect core elements in the emotional heritage that enhanced human survival in the past.[32]

One of several examples Grodal cites is children's films. "If children's stories can be shown to have certain universal features," he claims, this is because "children themselves must have certain innate dispositions," and he points to "emotional concerns" common to the fictional narratives of several popular children's films as examples of such universal features. These include "fear and activation of . . . the hazard-precaution system, important for tuning the brain to precaution to danger . . . attachment to some parenting agency . . . the creation of reciprocal relations [and] the urge for exploration and play."[33] According to Grodal, because these emotional concerns can be found throughout children's fictions, it must mean that children have these concerns due to their innate dispositions: "these emotions are not merely social constructions but represent vital concerns for any child, and films that are able to offer salient representations of these concerns attract large audiences."[34] Because we all have these emotional concerns due to our innate dispositions, as children we prefer stories that cater to them, which is why children's films that offer "salient" representations of them tend to be popular and profitable. This does not mean, of course, that all children's stories in all cultures are the same, and Grodal acknowledges that a great deal of cultural variation may be found in them.

While "biology determines the fundamental framework of children's stories," history, culture, and society fill in this framework.[35] Nevertheless, Grodal believes that "the impact of cultural products depends on whether they serve a function in human brains and are transmitted for that reason."[36] Thus, while there are many historically, culturally, and socially variable ways of designing children's fictions and the characters in them, the most popular ones will be those that address the emotional concerns shared by all children due to their innate dispositions.

Let me say that I find the reasons Grodal postulates for why children might prefer certain kinds of fictional narratives to be plausible ones. It seems likely that children do find stories about empowerment and bonding with parental figures and friends to be pleasurable as well as useful in their own development, for the reasons Grodal cites. Moreover, the human disposition to form attachments is doubtless an innate one that evolved because it was fitness-enhancing for our ancestors in the Pleistocene. And because Grodal argues that our shared preferences for certain universal features of films are produced by this and other innate dispositions, evolutionary accounts of why these dispositions might have evolved under natural selection in the Pleistocene have predictive and explanatory value in his theory, unlike in those previously surveyed film theories that merely point to the evolutionary origins of our dispositions in the past.

To see this, consider Grodal's claim that, due to their different evolutionary histories, "women prefer love stories more than men do and men prefer pornography more than women do, although men also like romantic films."[37] Although, as with most of his arguments about people's preferences, Grodal provides very little empirical evidence to support this bold and provocative assertion, it is in principle testable. Moreover, the evolutionary account cited by Grodal to explain these gender-based differences in genre preferences matters to his theory. Men supposedly evolved to be moderately promiscuous (hence, according to Grodal, their greater interest than women in pornography), and to form love bonds with the women with whom they mated (hence men's moderate interest in love stories); while women evolved to form love bonds with men who would be likely to provide sufficient resources to enable them to raise their children (hence their greater interest than men in love stories). This account matters to Grodal's theory because if it turns out to be wrong, then Grodal's explanation for the differences in genre preferences between men and women is also wrong.[38] Nevertheless, it seems to me that Grodal has not convincingly demonstrated that innate dispositions and their evolutionary histories can explain our shared preferences for certain features that are universally present in fiction films. Doing so involves many more hurdles than Grodal acknowledges.

First, it should be recalled that, according to Grodal, "if children's stories can be shown to have certain universal features," this is because "children

themselves must have certain innate dispositions."[39] I think it is likely that children's fictions do have universal features, but nowhere does Grodal offer any evidence that they do. He mentions only five or six children's films, nearly all of which are from the industrialized West. Surely, an analysis of a much wider sample of both visual and oral children's narrative fiction from Western and non-Western cultures, from the past and the present (including from contemporary hunter-gatherer populations), is necessary before one can so confidently state that children's stories about empowerment and bonding are universal.

Second, even if Grodal was able to show that preferences for stories about empowerment and bonding are universal among children, this does not mean that they are universal because they are the *product* of innate dispositions, although they doubtless *depend* on such dispositions. Grodal, it will be recalled, argues that innate dispositions give rise to emotional concerns that in turn issue in universal preferences for narrative fictions that address these concerns. "To explain emotions as depicted in films, it is necessary to assume that humans have needs and emotions that are formed in a specific cultural context but that are supported by innate predispositions," he writes.[40]

Notice, however, that Grodal here says that needs and emotions are "supported" by innate dispositions rather than produced by them. This equivocation matters because if the emotional concerns that give rise to universal preferences for certain kinds of stories are merely supported by innate dispositions rather than produced by them, then it becomes unclear what causal role these innate dispositions and their evolutionary histories play in explaining these preferences. It could well be, for example, that children the world over prefer stories about childhood empowerment. But this might be due to the developmental fact that children are physically small and under the control of others, and that consequently, once they have enough self-consciousness about their lack of power, they enjoy consuming fictions about children with power and control. The same is true of attachment. Perhaps it is the case that most children desire to consume fictional narratives about bonding with parental figures and friends. But this does not mean that this wish is the product of the innate disposition to form attachments. It could simply be due to the reason Grodal himself cites, namely, that it gives children *who have already formed attachments* to parental figures and friends the security of knowing that such bonds are omnipresent. The presence of a cross-cultural universal, in other words, does not mean it is the direct product of something innate, although, as with all things, in a trivial sense it must at some level depend on something innate. Reading and writing, for instance, are skills found in many cultures, and they depend on inborn capacities, but we do not have an innate disposition to read and write. Rather, these skills are transmitted culturally. As the cognitivist theorist Patrick Colm Hogan has argued,

"cross-cultural patterns may arise from regularities in the physical environment, recurring developmental experiences that are not genetically programmed, emergent features of the phenomenology of self-consciousness . . . convergent results of group dynamics, network patterns, etc."[41] Simply pointing to an innate disposition that a universal behavior is at some level supported by does not in itself show that this disposition plays a causal role in generating the universal behavior. Thus, it remains unclear from Grodal's theory what causal role the innate disposition to form attachments, as opposed to other developmental, environmental, and cultural factors, plays in producing children's putatively universal preferences for certain kinds of fictional narratives, and Grodal does not propose any empirical tests that might determine this.

Third, even if Grodal could demonstrate that innate dispositions play an important causal role in producing the universal emotional concerns of children and others, it is unclear how these dispositions and their attendant emotional concerns translate into a fictional context. Grodal tends to assume that if we have emotional concerns that are produced by an innate disposition, and a fictional narrative represents those emotional concerns, then we will, all other things being equal, prefer that narrative above others. For example, he points out that "a central cultural activity is the game of hide and seek," and the evolutionary reason that "many young mammals, including human children, play games that involve a chase or hide-and-seek" is that "these games offer good practice in avoiding predators or in hunting prey."[42] He then concludes that "the reason so many film and television viewers choose to watch endless crime, horror, or hide-and-seek action dramas" is due to this innate disposition to play "games of chase."[43] "Films about hiding and seeking fascinate billions of viewers," he asserts, and he cites *Die Hard* (1988) as an example.[44]

The problem with this argument, of course, is that films are not games of hide-and-seek, although they may possess game-like qualities. In games of hide-and-seek, children actually practice hiding and seeking, which is why, presumably, they were adaptive in the Pleistocene and we evolved the desire to play them. But when we are watching films, we are not ourselves practicing hiding-and-seeking. Rather, we are watching other, fictional entities doing something that approximates hiding and seeking. How, therefore, does the fact that we are predisposed to play games of hide-and-seek—because such games were fitness-enhancing for us in the Pleistocene —explain our preference for fiction films in which we play no role other than to observe fictional characters hunting other fictional characters? The same question arises about children's fictional narratives and our predisposition to form attachments. Given that such stories are fictions about other, fictional people forming bonds, how does our desire to form our own attachments with real people explain our preference for these fictions?

To answer this question, Grodal briefly appeals to an idea that other evolutionary theorists of art have invoked to argue that the consumption of narrative fiction is an adaptation: namely, that stories provide us with fitness-enhancing information about the real world. Denis Dutton, for example, claims that:

> Just as there would have been a major adaptive advantage in learning from stories to deal with the threats and opportunities of the external physical world, so for an intensely social species such as *Homo sapiens* there was an advantage in the ancestral environment in honing an ability to navigate in the endlessly complex mental worlds people shared with their hunter-gatherer compatriots.[45]

In other words, even though they are fictional, stories impart valuable information about how to survive the physical and social worlds—information that would have enhanced the fitness of our fiction-consuming ancestors in the Pleistocene, thereby ensuring that their disposition to consume fictional narratives evolved into a universal human trait.

This theory faces several well-known problems, however.[46] Most obviously, it is debatable whether stories provide *reliable* survival information, precisely because they are fictions. Does a film like *Die Hard*, or its Pleistocene antecedents, really provide accurate information about how to survive physical threats? Moreover, do such tales provide information that could not be obtained elsewhere, such as in playing games of hide-and-seek? And if not, why would we have evolved the specific disposition to consume fictional narratives if the fitness-enhancing information they impart can be gained through other activities? It is worthwhile at this point recalling Gould and Lewontin's complaint that evolutionary thinkers often "confuse the fact that a structure is used in some way . . . with the primary evolutionary reason for its existence." Gould and Lewontin demonstrate that it is not sufficient to argue that a behavior is useful in order to show that it is an adaptation, as evolutionary theorists often do. For a behavior to have evolved under natural selection, it must have been both heritable *and* have increased the reproductive success of those who engaged in it relative to those who did not, so that the genes for this behavior were passed down to and spread throughout future generations, while the genes of those who did not practice it died out. It is very hard to see how it can be shown that this happened in the case of our ancestors' consumption of fictional narratives in the Pleistocene, making it a good candidate for one of Gould's "just so" stories.

Grodal, however, wisely sidesteps this problem by postulating "fascination" as a "mental adaptation," rather than the disposition to consume fictional narratives. Defining fascination as "the mental-affective propensity

to seek out information that is, or is felt to be, highly relevant to our lives," he argues that we consume stories because of the "existentially relevant" information they provide.

> The fact that we sometimes agree to play the hunted prey ourselves, or are fascinated by the spectacle of the hunt— whether in children's games or in horror stories, thrillers or action films—shows that the pleasantness of an experience in real life is not a good indicator of the fascination it exerts ... Clearly, the mental mechanisms that we call fascination have served some evolutionary, fitness-enhancing problem, enabling us to seek out, process, and cope with vital information even if it is unpleasant.[47]

This theory avoids the problem of contending that the consumption of narrative fictions is itself an adaptation, by arguing that we are fascinated by any information that is existentially relevant, and that it is this fascination, rather than a disposition to consume stories, that is an adaptation. However, it does not avoid the problem of the epistemic (un)reliability of fiction. Nor does it explain why we wish to consume fictions, let alone specific genres of fiction such as action-adventure films, given that existentially relevant information may be found in most if not all fictions as well as in various non-fictional practices. Grodal's theory, after all, is intended to explain our preferences for particular, putatively universal features of fictional narratives—such as the recurrence of hunter–prey scenarios—and all this theory does is explain our preference for information, whatever its source. Thus, it remains far from clear, from the innate dispositions invoked by Grodal, why it is that we consume fictions, let alone why we prefer specific fictional genres such as action-adventure films or children's films about bonding and empowerment. While it may be true that we are innately predisposed to form attachments with others, play games of hide-and-seek, and seek out existentially relevant information, Grodal has not shown how these innate dispositions and their attendant emotional concerns translate into preferences for specific fictional genres or their features.

Finally, it should be noted that, even if Grodal could somehow surmount these difficulties and demonstrate that evolutionary theory does explain our preferences for certain universal features of films, these features are extremely broad and overly familiar. At one point, Grodal writes that his theory demonstrates that "love stories are concerned with personalized bonding whereas mainstream pornography represents anonymous desire."[48] This is, of course, hardly news. This is not to minimize the importance of accounting for why we like such general, well-known features of films, or the project of showing how human nature plays a role in film viewing. But if all that evolutionary film theory can do is explain why, all

other things being equal, we are attracted to films such as *Die Hard* because of their hunter–prey scenarios or to films like *Free Willy* because they depict attachments between humans and animals,[49] then it is hard to accept Carroll's prediction that evolutionary psychology has the potential to become the dominant explanatory paradigm in the humanities. Instead, like the culturalist claim that editing is a reflection "of the fragmentation of urban life," which Bordwell has rightly accused of being "baggy" because it "accounts in the same way for all films using editing,"[50] evolutionary film theory, at least in its current form, "offers a chisel where we need a scalpel."[51] As with editing, there are any number of variations on the universal features of films identified by Grodal that need explaining in order to account for their appeal. Indeed, Grodal himself (perhaps inadvertently) draws attention to the limits of his evolutionary film theory when he notes that

> successful stories presuppose using central emotions and
> dispositions, but that does not mean that using these
> emotions is sufficient to make successful films or stories . .
> . [T]o make films or to tell stories is an art that demands a
> series of skills and it is of course very easy to make stories
> of attachment that lack salience or emotional appeal.[52]

What Grodal is pointing out here is that it is *not* the case that we prefer fictional narratives about attachment and hunting, but rather that we prefer *certain* stories about these things, which is why, for various intrinsic and extrinsic reasons, many films about hunting and attachment fail to win a popular audience or earn a profit. Thus, in order to explain our universal preferences for certain kinds of films, it is not enough merely to show how "they serve a function in human brains," for this alone does not explain their appeal. One must also explain all the other features, aesthetic and otherwise, that make them attractive to us. This suggests that, while evolutionary psychology has had the salutary effect of foregrounding the universally shared, innate dimensions of art-making and consumption, humanistic explanations of the manifold reasons why humans make and consume art will remain central to the study of film and the other arts for the foreseeable future.[53]

58

notes

1. For an influential overview, see Steven Pinker, *How the Mind Works* (New York: W. W. Norton, 1997).
2. Leda Cosmides, John Tooby, and Jerome H. Barkow, "Introduction: Evolutionary Psychology and Conceptual Integration," in *The Adapted Mind: Evolutionary Psychology and the Generation of Culture*, ed. Jerome H. Barkow, Leda Cosmides, and John Tooby (New York: Oxford University Press, 1992), 5.
3. Ibid., 6.

malcolm turvey

4. Pinker, 21.

5. John Tooby and Leda Cosmides, "Foreword," in Simon Baron-Cohen's *Mindblindness: An Essay on Autism and Theory of Mind* (Cambridge, MA: MIT Press, 1997), xiii.

6. "Pleistocene Epoch," in *Encyclopædia Britannica Online*, http://www.britannica.com/EBchecked/ topic/464579/Pleistocene-Epoch (accessed May 21, 2013).

7. Leda Cosmides and John Tooby, "The Modular Nature of Human Intelligence," in *The Origin and Evolution of Intelligence*, ed. Arnold B. Scheibel and J. William Schopf (Sudbury, MA: Jones & Bartlett, 1997), 85.

8. S. J. Gould and R. C. Lewontin, "The Spandrels of San Marco and the Panglossian Paradigm: A Critique of the Adaptationist Programme," *Proceedings of the Royal Society of London Series B, Biological Sciences* 205, no. 1161 (September 21 1979): 581.

9. Ibid.

10. Stephen J. Gould, "Evolution: The Pleasures of Pluralism," *New York Review of Books* 44, no. 11 (June 26, 1997): 51.

11. Pinker, 174.

12. Steven Pinker and Paul Bloom, "Natural Language and Natural Selection," in *The Adapted Mind*, 455.

13. Gould and Lewontin, 587.

14. Stephen J. Gould, "Sociobiology: The Art of Storytelling," *New Scientist* (November 16, 1978): 530.

15. Gould, "Evolution," 51.

16. Ibid.

17. John Tooby and Leda Cosmides, "The Psychological Foundations of Culture," in *The Adapted Mind*, 75.

18. For other criticisms of evolutionary psychology, see David J. Buller, *Adapting Minds: Evolutionary Psychology and the Persistent Quest for Human Nature* (Cambridge MA: MIT Press, 2005).

19. Torben Grodal, *Embodied Visions: Evolution, Emotion, Culture, and Film* (New York: Oxford University Press, 2009), 5.

20. Joseph Carroll, "An Evolutionary Paradigm for Literary Study," *Style* 42, nos. 2–3 (2008): 107.

21. Stephen Davies, *The Artful Species: Aesthetics, Art and Evolution* (Oxford: University of Oxford Press, 2012), 6.

22. Joseph D. Anderson, *The Reality of Illusion: An Ecological Approach to Cognitive Film Theory* (Carbondale: Southern Illinois University Press, 1996), 54. This illusion is probably due, according to Anderson, to the "indistinguishability of the small frame to frame changes in a movie from the continuous changes that occur in real motion in nature, resulting in the former being processed by the networks of the visual system as real motion," 61.

23. Ibid., 91. For a more recent and detailed evolutionary explanation for our capacity to synthesize shots, see James E. Cutting and Ayse Candan, "Movies, Evolution, and Mind: From Fragmentation to Continuity," *The Evolutionary Review* 4, no. 3 (2013): 25–35.

24. David Bordwell, *Poetics of Cinema* (New York: Routledge, 2008), 52.

25. Ibid.

26. Ibid., 13–14.

27. Ibid., 15.

28. A good example of culturalism in film studies is the claim that human perception is plastic and is therefore shaped if not determined by culture,

including film. The *locus classicus* of this view is Walter Benjamin's contention that "The film corresponds to profound changes in the apperceptive apparatus—changes that are experienced on an individual scale by the man in the street in big-city traffic, on a historical scale by every present-day citizen," in Benjamin, "The Work of Art in the Age of Mechanical Reproduction," in *Illuminations,* trans. and ed. Hannah Arendt (New York: Schocken, 1968), 250n19. This culturalist view of perception is widely held in the humanities. See, for instance, Jonathan Crary, *Techniques of the Observer: On Vision and Modernity in the Nineteenth Century* (Cambridge, MA: MIT Press, 1990). For summaries and criticisms of this view, see David Bordwell, *On the History of Film Style* (Cambridge MA: Harvard University Press, 1997), 141–143; Noël Carroll, *A Philosophy of Mass Art* (Oxford: Oxford University Press, 1998), 114–144; Noël Carroll, "Modernity and the Plasticity of Perception," *Journal of Aesthetics and Art Criticism* 59, no. 1 (2001): 11–17.

29. Smith, 14.
30. Ibid.
31. Jerry Fodor, *The Mind Doesn't Work That Way: The Scope and Limits of Computational Psychology* (Cambridge, MA: MIT Press, 2000), 86.
32. Grodal, 6.
33. Ibid., 27.
34. Ibid., 27.
35. Ibid., 35.
36. Ibid., 33.
37. Ibid., 56.
38. There is plenty of evidence, scientific and otherwise, to suggest that it is wrong. In his recent, accessible review of this evidence, Daniel Bergner concludes that the claim that "female eros is much better made for monogramy than the male libido . . . is scarcely more than a fairy tale" perpetrated in part by evolutionary psychology. *What Do Women Want? Adventures in the Science of Female Desire* (New York: HarperCollins, 2013), 7.
39. Grodal, 27.
40. Ibid., 56.
41. Patrick Colm Hogan, "For Evolutionary Criticism, Against Genetic Absolutism," *Style* 42, nos. 2–3 (2008): 203. Hogan offers other trenchant criticisms of evolutionary theories of art and literature in Chapter 8 of his *Cognitive Science, Literature, and the Arts: A Guide for Humanists* (New York: Routledge, 2003).
42. Grodal, 7.
43. Ibid., 8.
44. Ibid. *Die Hard,* director John McTiernan (Los Angeles: Twentieth Century Fox, 1988).
45. Denis Dutton, *The Art Instinct: Beauty, Pleasure, and Human Evolution* (New York: Bloomsbury, 2009), 118.
46. See Davies, 168–171.
47. Grodal, 141–142.
48. Ibid., 56.
49. *Free Willy,* director Simon Wincer (Burbank: Warner Brothers, 1993).
50. David Bordwell, *On the History of Film Style,* 143–144.
51. David Bordwell, *Figures Traced in Light: On Cinematic Staging* (Berkeley: University of California Press, 2005), 247.
52. Grodal, 30–31.

53. For further arguments along these lines, see my "Can Scientific Models of Theorizing Help Film Theory?" in *The Philosophy of Film: Introductory Text and Readings*, ed. Thomas E. Wartenberg and Angela Curran (Malden, MA: Blackwell, 2005), 21–32. I thank Ted Nannicelli and Paul Taberham for their helpful and insightful comments on an earlier draft of this essay.

the geography of

film viewing

what are the implications of

cultural-cognitive differences

for cognitive film theory?

d a n i e l b a r r a t t

introduction

A long-held assumption in the field of cognitive science is that the fundamental nature of human cognitive faculties is universal and that cultural differences are only superficial. If you open a standard psychology textbook, you will find chapters on human perception, attention, memory, language, executive functions, emotion, and consciousness. An implicit assumption running through these chapters is that the theories and models described apply to human beings across the globe. Research in the last decade, however, suggests that cognitive differences exist between Westerners and East Asians, where the "West" is generally taken to include the continents of Europe, North America, South America, and Australia, and the "East" is understood to include the countries of China, Japan, Korea, and Taiwan. A leading figure in this research field is Richard E. Nisbett and much of the relevant research has been brought together in Nisbett's 2003 book *The Geography of Thought*.[1] The central argument is that Westerners and East Asians have different cognitive styles. Westerners tend to cognize the world in a

more *analytic* fashion: for example, they are more likely to think in terms of categories and rules, and to attend more to the focal objects in a visual scene. East Asians, on the other hand, tend to cognize the world in a more *holistic* fashion: that is, they are more likely to think in terms of contextual relationships and family resemblance, and to attend more to backgrounds and the relations between objects.

In film studies, cognitive film theory arose in opposition to the "Grand Theories" of subject-positioning, based on Lacanian psychoanalysis, and semiotics, based on Saussurean structuralism.[2] To the extent that cognitive film theory is based on cognitive science—and to the extent that it wishes to distance itself from the social constructivist underpinnings of its predecessors—it has stressed the universal nature of film viewing. A key claim is that viewers all over the world, from post-industrial societies in North America to remote tribes in Papua New Guinea, process films with the same basic set of cognitive mechanisms.[3] The goal of this chapter is twofold: to assess the potential implications of the research on cultural-cognitive differences for the universalist account of the human mind/brain held by many cognitive scientists; and to assess the knock-on implications for the field of cognitive film theory.

three levels of cognition

One way of thinking about the universality of the human mind/brain is in terms of "modularity," an idea resurrected by the philosopher Jerry A. Fodor.[4] The *modularity hypothesis* (MH) allows us to distinguish three basic levels of cognition (see Figure 4.1).[5]

level one: modular perception

The primary candidates for mental modules are the five perceptual systems, corresponding to the classic five senses of sight, hearing, touch, taste, and smell. Take the visual system, for example. The domain of the visual system is to provide us with accurate representations of the objects in our environment.[6] If we are confronted by a man-eating tiger, then we need to recognize and localize that tiger immediately and without conscious effort. Mental modules can be described from two basic perspectives, hence the notion of the *mind/brain*. From a *functional* perspective, the visual system operates in a fast and automatic fashion. Crucially, it is "informationally encapsulated" and "cognitively impenetrable" with respect to our beliefs, expectations, and background knowledge.[7] From a *neurobiological* perspective, meanwhile, the visual system is associated with fixed, and psychophysically-detectable, neural architecture such as the occipital regions of the brain. This architecture is said to be innately specified or "hardwired," meaning that it only needs a few special environmental conditions to develop.

The implication of the modularity hypothesis is that visual perception is consistent across both individuals and cultures; that is, all human beings with a correctly functioning visual system will perceive a tiger if they are confronted with one.

level two: modular cognition

The modularity hypothesis has been also applied to certain cognitive domains, particularly within the field of *evolutionary psychology* (EP). Inspired by Charles Darwin, evolutionary psychologists argue that the mind/brain is composed of a large number of domain-specific computational systems which evolved by natural selection to solve the adaptive problems encountered by our ancestors.[8] Beyond the perceptual realm of objects, they propose that we come into the world equipped with a "folk understanding" of the physical, biological, psychological, and social reality in which we live. For example, it is plausible that there is a folk physics module which enables us to take a "physical stance" to moving objects, a folk biology module which enables us to take a "biological stance" to plants and animals, a folk psychology module which enables us to take an "intentional stance" to fellow human beings, and a variety of additional modules (for example, the "cheater detection module") which enable us to take some sort of "social stance" to significant exchanges with fellow human beings.[9] Functionally speaking, we can say that cognitive modules are fast and automatic, but only partially encapsulated in an informational sense. In neurobiological terms, meanwhile, we can say that cognitive modules are associated with fixed neural architecture, although this architecture is distributed and difficult to detect psychophysically. The implication of the extended modularity hypothesis is that objects and events are universally comprehended, up to a point, in physical, biological, psychological, and social terms.

level three: non-modular cognition

Above the level of modular perception and cognition, however, it is plausible that there is a level of *non*-modular cognitive processing that is more flexible and plastic, and more susceptible to cultural influences.[10] In other words, we need not accept the *massive modularity hypothesis* (MMH) that the mind/brain is entirely modular—a hypothesis criticized by many cognitive scientists.[11] Once again, this level of processing can be described from two basic perspectives. Functionally speaking the essence of non-modular cognitive systems lies in the property of global sensitivity (that is, sensitivity to the entire range of our beliefs, expectations, and background knowledge), while in neurobiological terms non-modular cognitive systems are associated with more distributed and "equipotential" neural architecture

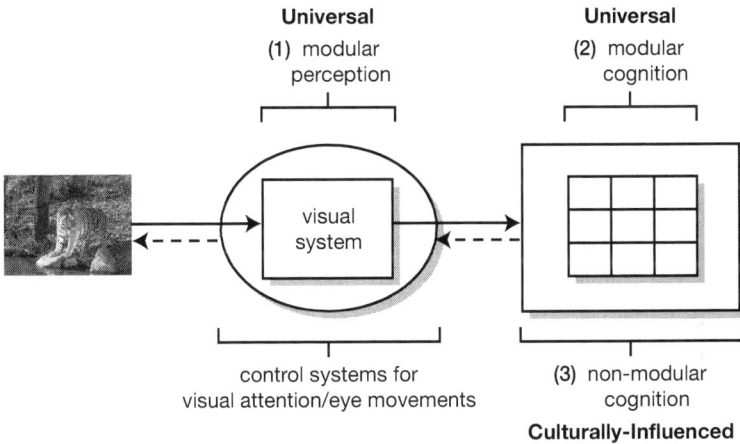

Universal
(1) modular
perception

Universal
(2) modular
cognition

visual
system

control systems for
visual attention/eye movements

(3) non-modular
cognition
Culturally-Influenced

Figure 4.1 Flow diagram illustrating the possible relationship between (universal) modular perception, (universal) modular cognition, and (culturally-influenced) non-modular cognition.

Source: Photograph of tiger from Chua, Boland, and Nisbett, "Cultural Variation in Eye Movements."

(possible candidates being the prefrontal and association cortices). I will argue that this is where the culturalist hypothesis potentially fits into the picture. In short, all of the examples of cognitive processing potentially susceptible to cultural influences can be regarded as instances of non-modular cognition.

cultural influences on cognition

So what exactly *is* the empirical evidence that cognitive differences exist between West and East? The existing empirical studies have employed a variety of experimental paradigms—both behavioral and neuroscientific—and tested a variety of cognitive processes. In this section, I will focus primarily on behavioral studies of the following cognitive domains: object categorizations and perceptual judgments; the perception of complex visual scenes; and logical, causal, and dialectical reasoning.[12]

opening examples: object categorizations and perceptual judgments

When considering the variety of cognitive processes potentially susceptible to cultural influences, a good place to start is the capacity to make object categorizations. According to the modularity hypothesis, the visual system can be said to deliver *basic categorizations*: that is, representations of three-dimensional and recognizable objects.[13] If, for example, we encounter either a real tiger or a *film* of a tiger, then our visual system will automatically

65

deliver the basic categorization "tiger" as opposed to, say, the basic categorization "tree." The non-modular cognitive systems, on the other hand, can be said to deliver more *abstract categorizations*. One example is the capacity to place the already identified target object into a group on the basis of some predefined criterion: for example, "This animal belongs to the genus *Panthera*," or "This animal is a sign in the Chinese zodiac." Another example is the capacity to distinguish the identified target object as either "reality" or a "(filmic) representation." Significantly, the research on object categorizations and cultural differences relates to the second case rather than the first, thus fitting into, rather than contradicting, the modularity hypothesis.

object categorizations

The first type of categorization task commonly cited in the literature was conducted by Chiu in 1972.[14] American and Chinese children were shown pictures of three target objects—for example, a cow, a chicken, and some grass—and asked, "Which two target objects go together?" (see Figure 4.2a). The modularity hypothesis predicts that both Westerners and East Asians should perceive these target objects in a similar way in terms of basic categorizations; that is, both American and Chinese children should perceive the cow, the chicken, and the grass immediately and without conscious effort. Instead, the cultural difference should operate at the more cognitive level of abstract categorizations. This is indeed what the study suggests. Chiu found that the American children tended to think in terms of categories: they were more likely to place the cow and the chicken together on the grounds that both the cow and chicken could be classified as animals. The Chinese children, on the other hand, tended to think in terms of relationships: they were more likely to place the cow and the grass together, on the grounds cows typically stand on and eat the grass.

A second type of categorization task was conducted by Norenzayan and colleagues in 2002.[15] European American, Asian American, and East Asian students were shown pictures of two groups of objects and one target object, and asked, "Which group of objects does the target object belong to?" (see Figure 4.2b). In one group of objects, for example, four flowers had a curved stem and three out of those four had oval-shaped petals. In a second group, all four flowers had a straight stem and three out of the four had triangular-shaped petals. Once again, the prediction of the modularity hypothesis—that the cultural difference should operate at a more cognitive and abstract level—was supported. The Western participants tended to think in terms of rules: they were more likely to place the target flower in the second group on the grounds that the target flower had a straight stem. The East Asian participants, on the other hand, tended to think in terms of "family resemblance": they were more likely to place the target flower in the first group on the grounds that the target flower had oval-shaped petals.[16]

The second psychological faculty of interest is the capacity to make perceptual judgments about a basic feature of a focal object such as orientation or size. In the Rod-and-Frame Test (RFT)—designed by Witken and colleagues, and extended to culture by Ji, Peng, and Nisbett—the task is to judge the verticality of a rod and to ignore the orientation of a surrounding frame (see Figure 4.2c).[17] The main finding can be described in terms of "field dependence": in comparison with Western participants, East Asian participants are less accurate at the task because they are less able to separate the focal object (the rod) from its surrounding field (the frame). A similar task is the Framed-Line Test (FLT), designed by Kitayama and others, in which the stimulus is a picture of a square frame intersected by a vertical line (see Figure 4.2d).[18] In this case, the main finding has been that Western participants are more accurate at the absolute task (drawing a new line that is identical in length to the original line), while East Asian participants are more accurate at the relative task (drawing a new line that is the correct length in proportion to the surrounding frame).

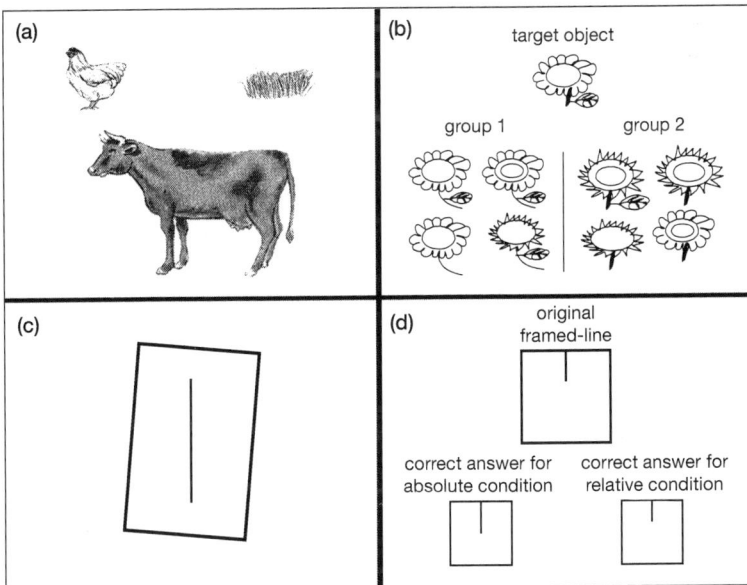

Figure 4.2 Examples of the experimental paradigms used for testing cultural differences in object categorizations and perceptual judgments: (a) object categorization task with three target objects (from Chiu, "A Cross-Cultural Comparison"); (b) object categorization task with one target object and two groups (from Norenzayan et al., "Cultural Preferences for Formal Versus Intuitive Reasoning"); (c) the Rod-and-Frame Test (RFT); and (d) the Framed-Line Test (FLT).

At first glance, the fact that Westerners and East Asians make different perceptual judgments looks like evidence against the modularity (and universality) of perception, because perceptual judgments appear to be internal to the perceptual systems. A closer examination, however, suggests that such perceptual judgments should be regarded more accurately as cognitive judgments *about* the outputs of perceptual systems (and/or top-down attentional modulations *of* such outputs). Support for this hypothesis comes from the fledgling field of *cultural neuroscience*. For example, Hedden and colleagues tested a modified version of the FLT paradigm using functional neuroimaging (fMRI).[19] Their results suggest that the cultural differences in operation involve the frontal-parietal regions of the brain associated with top-down attentional control, rather than the occipital regions associated with modular visual processing. More specifically, the authors found that the level of neural activity in frontal-parietal regions increased when the Western and East Asian participants were performing a version of the task that was incompatible with their (culturally-determined) cognitive style and thus required more conscious, effortful processing.

perception of complex visual scenes: verbal description, change detection, and eye tracking

The cultural differences in object categorizations and perceptual judgments (and a variety of other cognitive processes) can be explained by appealing to the Western tendency to attend more to objects and the East Asian tendency to attend more to context. A follow-up question is: Are these tendencies reflected in the way that Westerners and East Asians actually look at the visual world and in the way that Western and East Asian viewers actually look at films? Experimentally, this hypothesis has been investigated in a number of different ways, using (static) drawings, paintings, photographs, and (dynamic) cartoons and films as stimuli.

verbal description

A first method for investigating the perception of complex scenes has been straightforward observation followed by verbal description. In a 2001 study, Masuda and Nisbett conducted an experiment with American and Japanese students.[20] Each participant was shown ten twenty-second animated vignettes of underwater scenes. Each vignette contained both salient focal objects (for example, large and fast moving fish) and background elements (including the sea bed, marine plants, rocks, and slow-moving snails). After each vignette was presented twice, the participant was asked to verbally describe what they had seen for a period of up to two minutes. Each verbal description was recorded, transcribed, and coded. The main finding was that the American participants reported more

information about focal objects (and were more likely to mention the focal objects first), whereas the Japanese participants reported more information about the field and about the relations between objects.

change detection

A second method is the change detection (or "change blindness") paradigm. In a 2006 study, Masuda and Nisbett showed American and East Asian (Chinese, Japanese, and Korean) participants thirty pairs of still images of realistic industrial scenes (Exp. 1).[21] Following the flicker paradigm developed by Rensink, O'Regan, and Clark,[22] each pair of images was presented in a flicker sequence. For each pair of images, the task was to "spot the difference" between the two as quickly as possible by pressing a corresponding key on the keyboard, and to then verbally report the change for confirmation purposes. Here, the main finding was that the American participants were faster at detecting changes in focal object information, whereas the East Asian participants were faster at detecting changes in contextual information. In the interests of ecological validity, Masuda and Nisbett also tested dynamic scenes by showing American and East Asian participants five pairs of twenty-second animated vignettes (Exp. 2–3). The results were equivalent.

eye tracking

The most direct, "online" approach to investigating the visual system is provided by eye tracking, a method for recording eye movements in terms of fixations and saccades. In a founding investigation from 2005, Chua, Boland, and Nisbett tested both European American and Chinese graduate students all studying at an American university.[23] Each participant was shown thirty-six pictures of a foregrounded object (either an animal or a non-living entity) against a complex background. Each picture was shown for three seconds and the participants' task was to rate how much they liked the picture by using a seven-point scale. The main finding was that the Western participants fixated focal objects sooner (on average, by 118 milliseconds) and for longer durations, whereas the East Asian participants made more fixations on (and saccades to) the background. Interestingly, no culture differences were observed for the first 300 to 400 milliseconds of the picture presentation. The jury is still out, however, on whether or not cultural differences truly exist: in an eyetracking study from 2007, Rayner and colleagues only found evidence of cultural differences for a subset of their twenty-four stimuli, while in a 2009 study they failed to replicate the results using the original stimulus set.[24]

assessment

As in the case of perceptual judgments, at first glance the possibility that Westerners and East Asians may perceive the visual world differently looks

like evidence against the modularity (and universality) of perception. To recap, the modularity hypothesis stipulates that more cognitive, and culturally malleable, processing is not capable of influencing the operations of the visual system in a direct fashion: hence the notions of "informational encapsulation" and "cognitive impenetrability." One could argue, however, that such processing can have an indirect influence via the systems responsible for the top-down control of visual attention and eye movements; crucially, these systems can be thought of as involving frontal-parietal networks operating *outside* the occipital regions of the visual system. In other words, if we are confronted by the proverbial tiger and our eyes are wide open then we cannot help seeing that tiger, but we *can* choose where we point our eyes and where we place the focus of our attention.

cognition: logical, causal, and dialectical reasoning

So far, we have looked at cultural influences on cognitive processes that potentially manipulate the outputs of the modular visual system. How, though, does culture influence more archetypal examples of cognition such as the executive functions of thought and reasoning? In some modularity theories, thought and reasoning are described as non-modular processes.[25] If the essence of modularity lies in the property of informational encapsulation, then the essence of non-modularity lies in the property of global sensitivity: that is, sensitivity to the entire range of our beliefs, expectations, and background knowledge, all of which may be susceptible, in their own right, to cultural influence. At least three types of reasoning have been considered in the literature on cognition and cultural differences, at least two of which have direct implications for the film-viewing activities of narrative comprehension and character engagement.

logical reasoning

The first, and perhaps archetypal, example of reasoning is logical reasoning. In a 2002 study by Norenzayan and colleagues, European American, Asian American, and Korean participants were asked to rate formal arguments in terms of convincingness using a ten-point scale.[26] Two examples of the formal arguments used were: "All birds have ulnar arteries. Therefore, all eagles have ulnar arteries"; and "All birds have ulnar arteries. Therefore, all penguins have ulnar arteries." One way of reasoning about such arguments is based on formal logic: once a hidden premise for each argument has been inferred—namely, "All eagles are birds" and "All penguins are birds"—the validity of the conclusion can be evaluated by the process of deduction. Another way is based on typicality: an eagle is perceived to be a typical example of a bird, whereas a penguin (small wings, incapable of flight) is perceived to be an atypical example. The main finding of the study was that the Korean participants were more susceptible to the typicality

effect—that is, they were more affected by the typicality of the conclusions —than the American participants.

causal reasoning

A second, and more everyday, example of reasoning is causal reasoning. When we observe a given event taking place, we are capable of reasoning about the possible causes giving rise to that event. One of the main findings in the field of social cognition is the *fundamental attribution error* (FAE): we are more likely to attribute the causes of another person's behavior to internal dispositional factors such as personality traits and moral character than to external situational factors.[27] Originally, it was assumed that the FAE occurred universally across cultures. Recent research, however, suggests that Westerners are more likely to attribute the causes of events to dispositional factors than to situational ones, while the opposite is true for East Asians.[28] To cite an extreme example, Americans are more likely to attribute the causes of a murderer's actions to a dispositional factor such as mental instability, whereas the Chinese are more likely to attribute those causes to a situational factor such as societal pressure.

dialectical reasoning

The third example, dialectical reasoning, is concerned with how we deal with a contradiction between two pieces of information, or a conflict between two groups of people. The research on cultural differences suggests that Westerners tend to accept one side and reject the other, while East Asians tend to see the value in both points of view. In a 1999 study by Peng and Nisbett, the folk wisdom of Western and Eastern cultures was investigated by presenting American and Chinese participants with proverbs from their respective cultures (Exp. 1).[29] The main finding was that the Chinese participants preferred dialectical proverbs (for example, "too humble is half proud"), whereas the American participants preferred non-dialectical proverbs (such as "one against all is certain to fall"). This pattern of results also extended to the evaluation of social conflicts described in vignettes (Exp. 3; to be discussed in greater detail below).

assessment

Once again, how do these empirical results square with the modularity hypothesis? Although logical, causal, and dialectical reasoning can be conceived of as higher-level cognitive capacities, it is plausible that these capacities are applied to objects, people, and events that have already been universally recognized and localized, and that have already been universally comprehended, up to a point, in physical, biological, psychological, and social terms. This point can be illustrated by considering causal reasoning in particular. At one level, the perception of human behavior must be the same across cultures: fellow human beings must be perceived as intentional

agents with mental states such as beliefs and desires. The cultural variability only comes into play when the cause of the person's behavior is hidden from view. Similarly, at one level, the perception of physical movement is the same across cultures: when one billiard ball hits another, the motion of the first billiard ball is perceived as causing the motion of the second. The cultural variability only comes into play when the cause of the object's movement is ambiguous.

a note on causal explanations

Taken *en masse*, these various empirical studies suggest that some significant cognitive differences exist between Westerners and East Asians, with Westerners thinking more analytically and attending more to focal objects, and East Asians thinking more holistically and attending more to the relationships between objects. A natural follow-up question is: *Why?* That is, what are the causal explanations for such differences? To address this question, we can make a basic, and pragmatic, distinction between nature and nurture.

Starting with the *nature* side of the dichotomy, the field of evolutionary psychology assumes that the genetic basis for the human mind/brain is universal.[30] Evolutionary psychologists describe the set of selection pressures which shaped the mind/brain as the *environment of evolutionary adaptiveness* (EEA). The EEA is equated with the Pleistocene Epoch—around 1.8 million to 10,000 years ago—which saw the birth of the first type of human society on the African savannah, the "hunter-gatherers." In contrast, the Holocene Epoch—10,000 years ago to the post-industrial societies of the present day—is generally regarded as being too short a period of time for complex psychological adaptations to have evolved.

If the answer does not lie straightforwardly in nature, then it must lie somewhere in *nurture* instead. In *The Geography of Thought*, Nisbett traces the more analytical Western way of thinking to ancient Greece and the more holistic Eastern way of thinking to ancient China.[31] According to Nisbett's *socio-economic account* of cognition, the ecology of ancient Greece consisted primarily of mountains and sea which supported the economic activities of hunting, herding, fishing, and trading. These activities, in turn, could be successfully performed by a social structure based on small numbers of individuals. In contrast, the ecology of ancient China consisted primarily of fertile plains and accessible rivers which supported the economic activity of large-scale agriculture. This activity, in turn, required a more collectivist social structure based on cooperation between large numbers of people. Nisbett goes on to argue that these contrasting social structures may have had an influence on a variety of (internal) psychological factors including attention, folk metaphysics, tacit epistemology, and cognitive processes. While such an account is necessarily speculative and simplistic, it adds

cumulative weight to the idea that culture (broadly defined) may have some influence on cognition.[32]

implications for cognitive film theory

If there really *are* cognitive differences between West and East, then what are the implications for cognitive film theory? A good starting point for addressing this question is the *neoformalist* approach, advanced by David Bordwell and Kristin Thompson, on the grounds that it divides the study of film into three relatively tractable strands.[33] The first strand focuses on the formal structures of film, particularly its narrative and stylistic systems; the second strand focuses on the historical conditions in which those formal structures are produced; while the third strand focuses on how those formal structures are processed by an "active," rather than a "passive," viewer. One of the most fundamental distinctions in Bordwell and Thompson's work is between "classical Hollywood cinema" and "art cinema." Classical Hollywood cinema can be defined as a body of narrative and stylistic *norms*: for example, classical narratives obey cause–effect logic, follow goal-oriented characters, and are filmed using a system of continuity editing. Art cinema may be seen as a *deviation* from these norms. To this basic framework we can add Murray Smith's model of character engagement: to engage with a character, we must recognize him or her as "an individuated and continuous human agent"; we must be aligned with characters by means of the "interlocking functions" of spatio-temporal attachment and subjective access; and we must feel an allegiance to them by morally approving of their actions.[34]

How and why did these narrative and stylistic norms come into existence? Although such norms are constrained by a variety of historical conditions—economic, technological, social, and political—the most compelling answer, ultimately, is that they somehow "interface" with the viewer's natural perceptual and cognitive capacities. Analytical editing, for example, can be said to follow natural patterns of human attention: an establishing shot simulates our initial view of, say, a crowded room, while a "cut-in" to a medium shot or close-up simulates our attentional shift to a person or an object of interest. Similarly, eyeline match editing duplicates the human (and primate) tendency to follow the gaze of an intentional agent to its target, while match-action editing exploits the primacy of motion processing over form processing by cutting at "the point of greatest action."[35]

A complementary answer is that the evolutionary process operates on the medium of film itself.[36] While filmmakers have conscious goals and intentions, to the extent that human design is fallible the Darwinian mechanisms of "blind variation" and "selective retention" may come into play. In the way that the hunter-gatherer's world comprised part of the

EEA for the development of the human mind/brain, the human mind/brain may have comprised part of the EEA for the development of film form. In the early days of cinema, it is plausible that narrational and editing techniques evolved by a process of trial and error until they achieved a relatively stable fit with the human perceptual and cognitive systems.

In summary, while filmmaking norms are typically referred to using terms such as "Western," "classical," and "Hollywood," they should be more accurately described in the culturally-neutral terms of "universal" or "human." It may or may not be the case that Hollywood came first in the race to discover and articulate these norms, but, beyond this, it does not hold any official claim or patent over them. One of the central ideas in Bordwell's *Poetics of Cinema* is that Western (read: universal) norms provide the scaffolding for culture-specific deviations.[37] Bordwell argues, for example, that Japanese cinema from 1925 to 1945 followed Western norms of filmmaking in terms of narrational and editing techniques; however, these norms provided a framework in which more "Japanese" stylistic elements could be placed. Moving to Hong Kong and China, Bordwell argues that Hong Kong action films follow certain Western norms, but that a variety of stylistic techniques (clear shooting and staging, together with expressive amplification) are employed to maximize the impact of the action. Likewise, Bordwell argues that the Chinese director King Hu uses the Western techniques of one-by-one tracking and standard editing to establish the positions of the fighters in a martial arts scene, but employs a variety of "imperfect" stylistic techniques (for example, fast editing and whip pans) to generate excitement, speed, and power.

One strategy, then, for assessing the implications of cultural-cognitive differences for cognitive film theory is to look for general narrative and stylistic tendencies across Western and East Asian cinema, where the idiosyncrasies of individual filmmakers are effectively "averaged out." It should be stressed, however, that even if we do find that there are systematic differences between Western and East Asian films, this would not prove that Western and East Asian viewers actually perceive and cognize those films differently. There is nothing logically contradictory, for example, in saying that a "typical" Western (or East Asian) film is perceived and cognized in exactly the same way by both Western and East Asian viewers. With this caveat in mind, we can sketch at least two sets of research questions.

74

research questions one: perception and aesthetics

A first set of research questions concerns the domain of perception and aesthetics. As we have seen, evidence suggests that Westerners generally attend more to the focal objects in a complex visual scene, whereas East Asians attend more to the backgrounds and to the relations between

objects. The process of communication may be seen from at least two basic perspectives, that of the "sender" (or filmmaker) and that of the "receiver" (or film viewer).

film viewer

Until now, we have focused primarily on the perspective of the receiver (see Figure 4.3b). Most of the research on perception and cultural differences has been done using static photographs as visual stimuli. A possible avenue for future research, therefore, is to present participants with the types of dynamic scenes typically presented by film. Film brings a number of additional factors into the equation. One such factor is motion. Recent eye-tracking studies on dynamic scenes suggest that the addition of motion functions as a powerful attention cue, increasing the degree of attentional synchrony between viewers.[38] Another factor is Average Shot Length (ASL) or editing rate. The eyetracking study on cultural differences by Chua, Boland, and Nisbett suggests that, if there *are* any cultural differences, then they will appear after the first 300 to 400 microseconds: that is, after the basic gist of the scene has been extracted.[39] This implies that the longer a shot is held on the screen, the greater the likelihood for cultural (and individual) differences to emerge.

filmmaker

What if the sender or filmmaker is subject to the same constraints and influences as the receiver or film viewer (see Figure 4.3a)? This question brings us to the empirical studies of aesthetic preferences and cultural differences. In a 2008 study, Masuda and colleagues investigated aesthetic preferences with American students representing the West, and Chinese, Japanese, Korean, and Taiwanese students representing the East.[40] In a picture-drawing task (Study 2), the participants were asked to draw a picture of a landscape within a period of five minutes and to include at least five elements—a house, a tree, a river, a person, and a horizon. In an additional photograph-taking task, the participants were given a camera and asked to take portrait photographs of a model. In comparison with the American participants, the East Asian participants drew the horizon higher in the picture plane and included more additional objects; they also composed portrait photographs in which the model covered a proportionately smaller area and the background covered a proportionately larger area. A complementary, non-experimental study (Study 1) examined a sample of paintings from the history of Western and East Asian art and found an equivalent pattern of results.

A follow-up question, then, is whether such tendencies extend beyond the individual artist's creation of a landscape or portrait to the making of something as perceptually complex, and as collaborative, as a film. Do East Asian filmmakers, for example, tend to frame the action more widely than

Western filmmakers? Are focal character and events placed in non-central locations? Possible clues are provided by neoformalist analyses of certain types and periods of cinema. In *Poetics of Cinema*, for example, Bordwell examines the visual style of Japanese cinema in the period 1925 to 1945.[41] He describes how Japanese filmmakers such as Shimizu Hiroshi and Shimazu Yasujiro use wider framings, decentered compositions, and partial concealment, thus obliging the viewer to scan the frame more extensively in comparison with Western films. Interestingly, Bordwell considers the question of whether these stylistic tendencies can be traced, in a more or less linear fashion, to such pictorial traditions as "Japanese screen painting, *e-makimono* scrolls, and woodblock prints." He concludes that such a proposition is "untenable" and that "the situation is more complicated, and more interesting," but he does not go one step further by referring to the types of deep socio-economic (and psychological) causes cited above. Significantly, the research by Nisbett and colleagues suggests a complex triangulation of causal influences, with filmic styles influenced by pictorial traditions, filmic styles influenced by socio-economic factors, and, finally, pictorial traditions influenced by socio-economic factors.

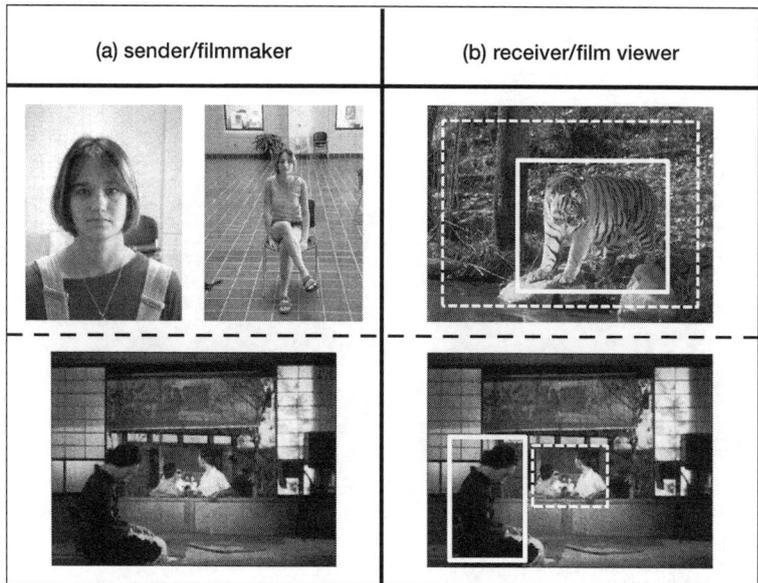

Figure 4.3 Potential ways in which culture may influence perception and aesthetics, in terms of framing and looking at scenes, from the perspective of (a) the sender/filmmaker and (b) the receiver/film viewer.

Notes: The upper examples are taken from existing studies on static pictures: Masuda et al., "Culture and Aesthetic Preference"; Chua, Boland, and Nisbett, "Cultural Variation in Eye Movements." The lower examples illustrate potential applications to film: frame still from Shimizu Hiroshi's *Children in the Wind* (1937). The bold lines represent the viewer's attention to focal objects, while the dashed lines represent the viewer's attention to background objects.

A second set of research questions deals with cognition. As we have seen, evidence suggests that there are cultural differences in certain executive functions: namely, logical, causal, and dialectical reasoning. While logical reasoning is perhaps *too* formal to be directly applied to the types of naturalistic structure presented by film, the other two cognitive capacities —namely, causal and dialectical reasoning—have potential implications for both narrative comprehension and character engagement.

causal reasoning

In film viewing, the cognitive capacity for causal reasoning manifests itself as reasoning about the causes that give rise to narrative events, especially the behavioral actions of characters. In a discussion of film and social cognition, Newman notes that the tendency of viewers to make the fundamental attribution error is "tailor-made" for the reception of classical (Western) narratives, in which the main characters are typically conceived of as causal agents.[42] In an action-adventure film, for example, the viewer reasons that the hero James Bond does behavioral action X *because* he is morally good, while the villain Ernst Stavro Blofeld does behavioral action Y *because* he is morally bad. Less mainstream films (for example, independent art-house films) may attempt to distance themselves from the classical template by placing more emphasis on situational factors. In Todd Solondz's film *Welcome to the Dollhouse*, Newman argues that, although the default stance of the viewer is to attribute a character's behavior to his or her disposition, the unfortunate fate of the main character Dawn (a socially awkward teenage school girl) can be attributed to a complex interaction of both the dispositional and the situational.[43]

When it comes to the difference between East and West, research suggests that East Asians pay more attention to situational factors than Westerners, and are thus *less* likely to make the fundamental attribution error. From a filmic point of view, this leads to the following two research questions, one from the perspective of the viewer and one from the perspective of the maker. *Film viewer:* Does this psychological tendency cross over to the East Asian viewer's interpretation of narrative film and his or her moral evaluation of characters? This question relates to Smith's notion of "allegiance": attributing a so-called villain's actions to, say, societal pressures rather than mental instability may result in a more favorable moral evaluation and a deeper level of engagement.[44] *Filmmaker:* Is it the case that East Asian filmmakers place more emphasis on the situational factors that potentially influence a character's behavior? This question raises the intriguing possibility that, what is considered "art house" in Western cinema is more of a standard deviation from the (universal) norm in Eastern cinema.

dialectical reasoning

The cognitive capacity for dialectical reasoning raises equivalent issues. The 1999 study by Peng and Nisbett (Exp. 3) is of particular relevance for our purposes, as it used two narratives (vignettes) as test materials: a "mother–daughter conflict" in which the values of three mothers are rejected by their grownup daughters, and a "school-fun conflict" in which three students complain that school has taken the fun out of learning.[45] The American participants were more likely to take one side rather than the other, whereas the Chinese participants were more likely to take a "middle-ground" position.

Once again, we can consider two types of research question in terms of film. *Film viewer:* Does the East Asian's interpretation of vignettes (written texts of around fifty words) extend to their interpretation of audiovisual narratives with an average duration of around two hours? There are no *a priori* reasons to believe that it should not, especially given that an audiovisual narrative is potentially capable of presenting the two sides of an argument (for example, the mother's perspective and the daughter's perspective) in a more perceptually vivid and emotionally forceful way. *Filmmaker:* If it is the case that East Asian filmmakers focus more on situational factors, is it also the case that East Asian filmmakers align the viewer more equally with the two sides of a social conflict? This question relates to Smith's notion of "alignment": the two principal methods for aligning the viewer with a character or a social group are through spatiotemporal attachment and subjective access.[46]

conclusion

It remains to be seen whether the recent research on cultural-cognitive differences will mark a kind of paradigm shift in film studies or merely a modification of an existing paradigm. As in many academic debates, the pattern seems to be that a first generation of researchers stresses one position (for example, the socially constructed nature of film viewing) and then a second generation makes its mark by stressing the opposite (for example, the universal nature of film viewing). Finally, a third generation comes along, acting as a kind of moderator and peacemaker, and argues that the truth lies somewhere between the two. As a universalist by training, I am still tempted to say that the pointer should be placed much closer to the universalist end of the spectrum than the culturalist end. But even a short distance along the spectrum is enough to take the notion of cultural differences seriously. A central theme in this chapter has been that universal frameworks provide the scaffolding for culture-specific deviations. The universal structure of the human mind/brain provides the scaffolding for more analytical and holistic ways of thinking, while the

universal norms of film form provide the scaffolding for more culturally-specific uses of film style.

In summary, the modularity hypothesis suggests that our perceptual systems are largely modular and universal in nature, while evolutionary psychology suggests that this hypothesis can be extended to the cognitive faculties that underlie our "folk understanding" of the physical, biological, psychological, and social reality in which we live. The implication for film is that characters and events are universally recognized in perceptual terms and universally comprehended, up to a point, in cognitive terms. Above the level of modular perception and cognition, however, it is plausible that there is a level of non-modular cognitive processing that is potentially influenced by culture: examples of such processes include the top-down control of visual attention and eye movements, and the executive functions of causal and dialectical reasoning. These processes have potential implications for such film-viewing activities as perception and aesthetic appreciation, and narrative comprehension and character engagement. One of the challenges for the future will be to investigate these activities more precisely by marrying neoformalist studies of film form with empirical studies of the film viewer.[47]

notes

1. Richard E. Nisbett, *The Geography of Thought: How Asians and Westerners Think Differently . . . and Why* (London: Nicholas Brealey Publishing, 2003). Also see Richard E. Nisbett, Kaiping Peng, Incheol Choi, and Ara Norenzayan, "Culture and Systems of Thought: Holistic Versus Analytic Cognition," *Psychological Review* 108, no. 2 (2001): 291–310.

2. See David Bordwell, *Narration in the Fiction Film* (Madison: University of Wisconsin Press, 1985); Noël Carroll, *Mystifying Movies: Fads and Fallacies in Contemporary Film Theory* (New York: Columbia University Press, 1988); David Bordwell and Noël Carroll, ed., *Post-Theory: Reconstructing Film Studies* (Madison: University of Wisconsin Press, 1996).

3. See Paul Messaris, *Visual Literacy: Image, Mind, and Reality* (Boulder, CO: Westview Press, 1994); Joseph D. Anderson, *The Reality of Illusion: An Ecological Approach to Cognitive Film Theory* (Carbondale: Southern Illinois University Press, 1996).

4. See Jerry A. Fodor, *The Modularity of Mind: An Essay on Faculty Psychology* (Cambridge, MA: MIT Press, 1983); and Jerry A. Fodor, *The Mind Doesn't Work That Way: The Scope and Limits of Computational Psychology*, Representation and Mind (Cambridge, MA: MIT Press, 2000).

5. For a more detailed discussion in relation to cognitive film theory, see Daniel Barratt, "The Paradox of Fiction Revisited: A Cognitive Approach to Understanding (Cinematic) Emotion," Ph.D. thesis, University of Kent, UK, 2004.

6. See David Marr, *Vision: A Computational Investigation into the Human Representation and Processing of Visual Information* (San Francisco: W. H. Freeman, 1982).

7. The notion of "informational encapsulation" is used by Fodor, *The Modularity of Mind*, while the notion of "cognitive impenetrability" is used by

Zenon W. Pylyshyn, "Computation and Cognition: Issues in the Foundations of Cognitive Science," *Behavioral and Brain Sciences* 3, no. 1 (1980): 111–132.

8. See Charles Darwin, *On the Origin of Species* (Cambridge, MA: Harvard University Press, 1964); *The Adapted Mind: Evolutionary Psychology and the Generation of Culture*, ed. Jerome H. Barkow, Leda Cosmides, and John Tooby (New York: Oxford University Press, 1992).

9. For a discussion of such cognitive domains as folk physics and folk biology, see, for example, *Mapping the Mind: Domain Specificity in Cognition and Culture*, ed. Lawrence A. Hirschfeld and Susan A. Gelman (Cambridge: Cambridge University Press, 1994). For folk psychology in particular, see Daniel C. Dennett, *The Intentional Stance* (Cambridge, MA: MIT Press, 1987); and Simon Baron-Cohen, *Mindblindness: An Essay on Autism and Theory of Mind* (Cambridge, MA: MIT Press, 1995). For an account of the "cheater detection module," see Leda Cosmides and John Tooby, "Cognitive Adaptations for Social Exchange," in Barkow, Cosmides, and Tooby, 163–228.

10. See Fodor, *The Modularity of Mind* and *The Mind Doesn't Work That Way*.

11. For example, see Richard Samuels, "Massively Modular Minds: Evolutionary Psychology and Cognitive Architecture," in *Evolution and the Human Mind: Modularity, Language and Meta-Cognition*, ed. Peter Carruthers and Andrew Chamberlain (Cambridge: Cambridge University Press), 13–46.

12. There is also significant research on cultural influences on emotion, not considered here for reasons of space. For example, "primary" or "basic" emotions are thought to occur universally and are associated with specific facial expressions and appraisal patterns—the list includes fear, anger, disgust, sadness, and happiness. "Secondary" emotions, on the other hand, are considered to be more complex, more cognitive, and more culturally variable.

13. See Fodor, *The Modularity of Mind*; Marr, *Vision*.

14. Lian-Hwang Chiu, "A Cross-Cultural Comparison of Cognitive Styles in Chinese and American Children," *International Journal of Psychology* 7, no. 4 (1972): 235–242.

15. Ara Norenzayan, Edward E. Smith, Beom Jun Kim, and Richard E. Nisbett, "Cultural Preferences for Formal Versus Intuitive Reasoning," *Cognitive Science* 26, no. 5 (2002): 653–684.

16. The notion of "family resemblance" was introduced by Ludwig Wittgenstein, *Philosophical Investigations*, 2nd ed., trans. G. E. Anscombe (Oxford: Blackwell, 1958).

17. See Herman A. Witkin, "A Cognitive-Style Approach to Cross-Cultural Research," *International Journal of Psychology* 2, no. 4 (1967): 233–250; Li-Jun Ji, Kaiping Peng, and Richard E. Nisbett, "Culture, Control, and Perception of Relationships in the Environment," *Journal of Personality and Social Psychology* 78, no. 5 (2000): 943–955.

18. See Shinobu Kitayama, Sean Duffy, Tadashi Kawamura, and Jeff T. Larsen, "Perceiving an Object and its Context in Different Cultures: A Cultural Look at New Look," *Psychological Science* 14, no. 3 (2003): 201–206.

19. Trey Hedden, Sarah Ketay, Arthur Aron, Hazel Rose Markus, and John D. E. Gabrieli, "Cultural Influences on Neural Substrates of Attentional Control," *Psychological Science* 19, no. 1 (2008): 12–17.

20. Takahiko Masuda and Richard E. Nisbett, "Attending Holistically Versus Analytically: Comparing the Context Sensitivity of Japanese and Americans," *Journal of Personality and Social Psychology* 81, no. 5 (2001): 922–934.

21. Takahiko Masuda and Richard E. Nisbett, "Culture and Change Blindness," *Cognitive Science* 30, no. 2 (2006): 381–399.

22. Ronald A. Rensink, J. Kevin O'Regan, and James J. Clark, "To See or Not to See: The Need for Attention to Perceive Changes in Scenes," *Psychological Science* 8, no. 5 (1997): 368–373.

23. Hannah Faye Chua, Julie E. Boland, and Richard E. Nisbett, "Cultural Variation in Eye Movements During Scene Perception," *Proceedings of the National Academy of Sciences of the United States of America* 102, no. 35 (2005): 12629–12633.

24. See Keith Rayner, Xingshan Li, Carrick C. Williams, Kyle R. Cave, and Arnold D. Well, "Eye Movements During Information Processing Tasks: Individual Differences and Cultural Effects," *Vision Research* 47, no. 21 (2007): 2714–2726; Kris Evans, Caren M. Rotello, Xingshan Li, and Keith Rayner, "Scene Perception and Memory Revealed by Eye Movements and Receiver-Operating Characteristic Analyses: Does a Cultural Difference Truly Exist?," *Quarterly Journal of Experimental Psychology* 62, no. 2 (2009): 276–285.

25. See Fodor, *The Modularity of Mind* and *The Mind Doesn't Work That Way.*

26. Norenzayan et al., "Cultural Preferences."

27. See Lee Ross, "The Intuitive Psychologist and His Shortcomings: Distortions in the Attribution Process," in *Advances in Experimental Social Psychology, Vol. 10*, ed. Leonard Berkowitz (New York: Academic Press, 1977), 173–220.

28. For example, see Incheol Choi, Richard E. Nisbett, and Ara Norenzayan, "Causal Attribution Across Cultures: Variation and Universality," *Psychological Bulletin* 125, no. 1 (1999): 47–63.

29. Kaiping Peng and Richard E. Nisbett, "Culture, Dialectics, and Reasoning About Contradiction," *American Psychologist* 54, no. 9 (1999): 741–754.

30. See Barkow, Cosmides, and Tooby, *The Adapted Mind.* The dates for the Pleistocene Epoch are taken from this source.

31. See Nisbett, *The Geography of Thought*, Chapters 1–2.

32. For an intermediate perspective, see Robert Boyd and Peter J. Richerson's culture-gene coevolutionary theory, in *Culture and the Evolutionary Process* (Chicago: University of Chicago Press, 1985). For an argument on the potential capacity of native languages to shape thought, see Per Durst-Andersen, "What Languages Tell Us About the Structure of the Human Mind," *Cognitive Computation* 4, no. 1 (2012): 82–97.

33. See Bordwell, *Narration in the Fiction Film*; Kristin Thompson, *Breaking the Glass Armor: Neoformalist Film Analysis* (Princeton, NJ: Princeton University Press, 1988); David Bordwell, Janet Staiger, and Kristin Thompson, *The Classical Hollywood Cinema: Film Style and Mode of Production to 1960* (New York: Columbia University Press, 1985). For a more quantified approach, see the work on *cinemetrics* by Yuri Tsivian and Gunars Civjans (www.cinemetrics.lv), inspired by, for example, Barry Salt's work on Average Shot Length (ASL), "Statistical Style Analysis of Motion Pictures," *Film Quarterly* 28, no. 1 (1974): 13–22.

34. Murray Smith, *Engaging Characters: Fiction, Emotion, and the Cinema* (Oxford: Clarendon, 1995). Subsequent quotes, ibid., 82, 83.

35. For an explanatory account of eyeline match editing, see Noël Carroll, "Toward a Theory of Point-of-View Editing: Communication, Emotion, and the Movies," in *Theorizing the Moving Image*, ed. Noël Carroll, Cambridge Studies in Film (Cambridge: Cambridge University Press, 1996), 125–138.

81

For an account of match-action editing, see Anderson, *Reality of Illusion*, 99–103.

36. See Dirk Eitzen, "Evolution, Functionalism, and the Study of American Cinema," *The Velvet Light Trap* 28 (1991): 73–85.

37. David Bordwell, *Poetics of Cinema* (New York: Routledge, 2008), Ch. 12–15. For a review, see Daniel Barratt, "Understanding Cinema: Poetic Films and Embodied Viewers," *The Evolutionary Review: Art, Culture, Science* 1, no. 1 (2010): 84–87.

38. See Parag K. Mital, Tim J. Smith, Robin L. Hill, and John M. Henderson, "Clustering of Gaze During Dynamic Scene Viewing is Predicted by Motion," *Cognitive Computation* 3, no. 1 (2011): 5–24.

39. Chua, Boland, and Nisbett, "Cultural Variation."

40. Takahiko Masuda, Richard Gonzalez, Letty Kwan, and Richard E. Nisbett, "Culture and Aesthetic Preference: Comparing the Attention to Context of East Asians and Americans," *Personality and Social Psychology Bulletin* 34, no. 9 (2008): 1260–1275.

41. Bordwell, *Poetics of Cinema*, Chapter 12. Subsequent quotes, ibid., 351.

42. Michael Z. Newman, "Characterization as Social Cognition in *Welcome to the Dollhouse*," *Film Studies: An International Review* 8 (2006): 53–67.

43. *Welcome to the Dollhouse*, director Todd Solondz (Argentina: Lider Films, 1995).

44. See Smith, *Engaging Characters*, Chapter 6.

45. Peng and Nisbett, "Culture, Dialectics and Reasoning."

46. See Smith, *Engaging Characters*, Chapter 5.

47. Thanks to Per Durst-Andersen for introducing me to the research on cultural-cognitive differences.

part two

psychological

research and

media theory

audiovisual correspondences in sergei eisenstein's *alexander nevsky*

five

a case study in viewer

attention

tim j. smith

Cognitive film theory is an approach to analyzing film that bridges the traditionally segregated disciplines of film theory, philosophy, psychology, and neuroscience. Considerable work has already been presented from the perspective of film theory that utilizes existing empirical evidence of psychological phenomena to inform our understanding of film viewers and the form of film itself.[1] But can empirical psychology also provide ways to directly test the insights generated by the theoretical study of film? In this chapter I will present a case study in which eye tracking is used to validate Russian film director Sergei Eisenstein's intuitions about viewer attention during a sequence from *Alexander Nevsky* (1938).[2]

knowing where you are looking

One aspect of viewer cognition a filmmaker can influence in order to shape viewer experience is attention. Attention is the allocation of processing resources to a point in space, an object or visual feature, resulting in an increase in information gathered by the senses.[3] Attention operates in all

sensory modalities but the modalities most relevant to film are audio and visual. A filmmaker can direct visual attention to a specific element within a scene by cutting to a close-up; to an object within a shot by presenting it in sharp focus; or by directing audio attention to objects out of shot using off-screen sounds. By controlling what the viewer sees and what they do not see the filmmaker directs viewer comprehension and creates drama from a scene that might be rendered ambiguous if presented theatrically as a single unedited long shot.

The composition of a shot—deciding what to include or exclude—is the clearest example of the way in which a director can manipulate viewer attention; but controlling where viewers look within a frame is also important, due to the limited visual acuity of the human eye. The non-uniform distribution of photosensitive receptors in the human retina means that we cannot see the whole visual scene in detail at the same time and must move our eyes to sequentially process the parts of the scene in which we are interested. Detailed color processing happens in a small region (two degrees of visual angle) near the optical axis known as the *fovea* and image resolution drops rapidly as the distance from the fovea increases.[4]

Most encoding of visual information occurs when our eyes stabilize on a point in space (that is, fixate) and prioritizes the parts of the image projected near to the fovea.[5] To process a new part of the scene, the eyes must rotate so that the new target is projected onto the fovea: that is, to perform a *saccadic eye movement*. Visual sensitivity effectively shuts down during a saccade via a process known as saccadic suppression, in order to ensure that the rapid movement of light across the retina is not perceived as motion blur.[6]

Given that a cinema screen often subtends more than 35 degrees of visual angle,[7] viewer attention can only cover a small proportion of the screen at any one time. Therefore, if a filmmaker wishes to control what a viewer is perceiving at any moment during a film it is imperative that they are able to predict where a viewer will attend.

In "The Attentional Theory of Cinematic Continuity,"[8] I argue that careful manipulation of viewer attention within shots and across cuts is necessary to create the impression of a smooth flow of action across an edited sequence. I show how cinematographic and editing conventions, such as match-on-action editing (cutting between two views of an action just after the action begins), use natural attentional cues (for example, sudden onsets of motion) to attract and cue attention across cuts, creating minimal expectations about scene content that can be satisfied by shifts in viewpoint. Demonstrations of how viewer eye movements respond to natural attentional cues within film sequences and across continuity cuts support the attentional theory. However, such analyses are observational and based on hypotheses about how viewers may watch these sequences derived from post-hoc analysis of film sequences.[9] A stronger test of the attentional

theory would be to demonstrate that a filmmaker's own intuitions about viewer attention may be validated through empirical investigation.

audiovisual correspondences

Filmmakers often abstractly discuss how they intended to manipulate viewer attention. Edward Dmytryck discusses the timing and movement of the viewer's eye following a character's exit from the screen,[10] while Walter Murch considers a viewer's "eyetrace"—"the location and movement of the audience's focus of interest within the frame"[11]—as one of the six criteria important for choosing the right cut.[12]

Unfortunately, descriptions of how filmmakers have manipulated viewer attention are often too abstract to facilitate empirical testing. The exception to this is Sergei Eisenstein's description of a sequence from *Alexander Nevsky*. In his book *The Film Sense*,[13] Eisenstein presents a detailed analysis of the famous "Battle on Ice" sequence from the film. In this sequence, the people's hero, Alexander Nevsky, leads a Russian army against the invading German knights across a frozen lake. The scene ends with Nevsky's soldiers victorious and the German invaders swallowed by the freezing water as the ice cracks. The sequence of shots Eisenstein analyzes precedes the conflict and represents the anticipation of the soldiers as they stare off into the distance at the enemy. Whilst mostly devoid of action, this sequence creates tension through what Eisenstein refers to as *audiovisual correspondences*; these "relate the music to the shots *through identical motion* that lies at the base of the musical as well as the pictorial movement."[14] Rising musical notes in the accompanying score by Sergei Prokofiev are said to correspond to rising "lines" in the pictorial composition. These pictorial lines can take various forms—including the arrangement of people, faces, objects, or actions—but

> the most striking and immediate impression [of correspondence with the audio] will be gained, of course, from *a congruence of the movement of the music with the movement of the visual contour*—with the graphic composition of the frame; for this contour or this outline, or this line is the most vivid 'emphasizer' of the very idea of the movement.[15]

To demonstrate the relationship between movement in the music and image Eisenstein presents a fold-out diagram at the end of the book (reproduced as Figure 5.1). This diagram represents the temporal alignment of the movie frames to the musical phrases, the score, a diagram of the pictorial composition, and—most critically for the topic of this chapter—a "*graph of the eye's movement* over the main lines ... [of a shot] which 'correspond' to this music."[16] Eisenstein believes that to fully appreciate the film experience we must examine the combined impression the audio and

visuals make on the mind of a viewer in the auditorium. The index of viewer cognition Eisenstein uses to gain this insight is eye movements. His graph of the eye's movement over the image is meant to represent the elements of the audiovisual continuity that exert the greatest pull on our attention. In effect, the graph is an idealized scanpath of the viewer's eye movements over the 2D surface of the image and over time.

The line of eye movements is presented continuously (except for a brief break in shot V) over the twelve shots, as if the shots were aligned side by side in a space in front of the viewer and their eyes entered a new shot in exactly the same position it left the previous shot. Of course, practically each shot replaces the previous shot on the screen via a cut, meaning that the horizontal progression of this line cannot be interpreted literally. However, Eisenstein's explanation of the diagram suggests that he intends the vertical movement of the graph to be interpreted as a direct representation of the vertical eye movements.

Eisenstein's belief in his ability to predict the collective viewing behavior of his audience is staggering. At the time he was making *Alexander Nevsky* the scientific investigation of eye movements was still very much in its infancy. In Chicago in the 1920s Guy Buswell developed an optical method for recording eye movements and used it to investigate reading and picture viewing, producing scanpaths of people viewing classic works of art such as Hokusai's *The Wave*.[17] Similar eye-movement research did not occur in the USSR until after Eisenstein's death in 1948. During the 1950s, Alfred L. Yarbus, a biophysicist and professor in experimental psychology at the USSR Academy of Sciences in Moscow, pioneered several devices for recording eye movements and stabilizing visual stimuli on the retina.[18] This research was published widely in Russian during the 1950s but did not gain international exposure until an English-language translation of his monograph, *Eye Movements and Vision*, was published in 1967. Yarbus and Eisenstein were both very well connected within the Moscow scientific community, but it is unlikely that they ever met due to Eisenstein's untimely death before Yarbus began his eye-movement research.[19]

The rich mixture of scientific, artistic, and political influences on Eisenstein's films and theories raises his work up above mere cinematic entertainments. His work may be understood as a synthesis of psychology, aesthetics, and visual art,[20] and numerous pseudo-experiments can be found within his films. In *The Film Sense*, Eisenstein makes strong claims about how viewers should attend to the sequence from *Alexander Nevsky*, and these claims can be operationalized as testable hypotheses. To do this we first need to identify an appropriate measure of viewer attention and establish whether Eisenstein's claims are already supported by the existing psychological literature on film perception.

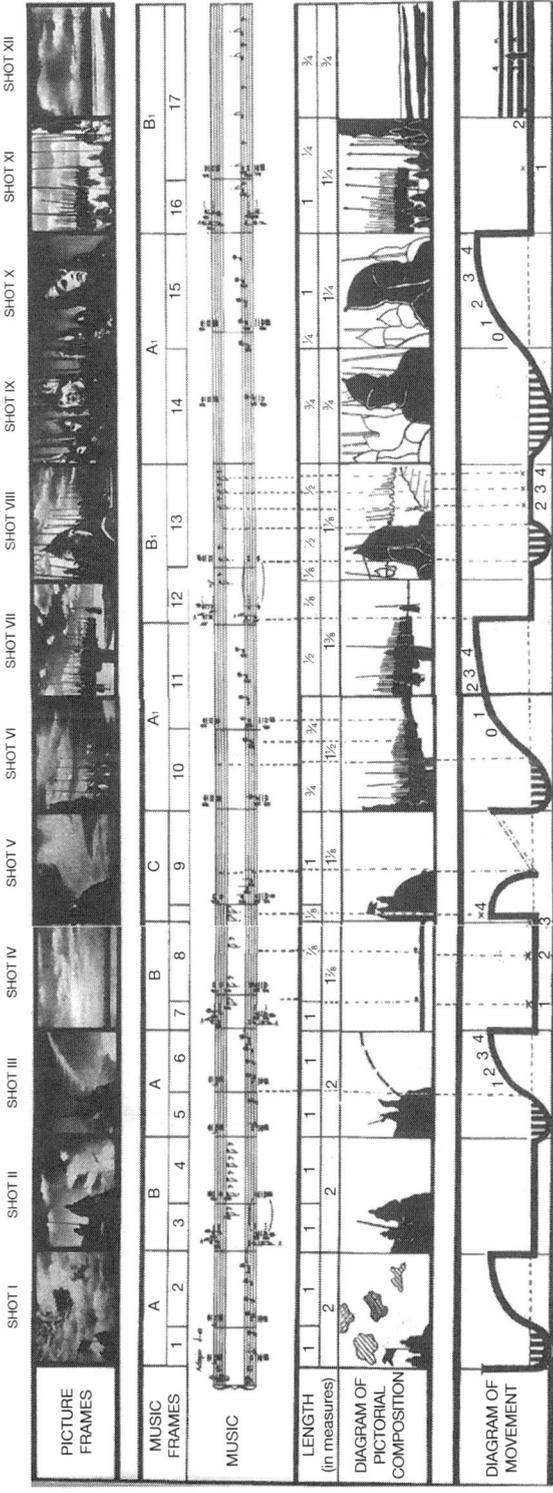

Figure 5.1 From *The Film Sense* by Sergei Eisenstein, translated by Jay Leyda.

attentional synchrony vs. idiosyncratic gaze

One of the key assumptions of Eisenstein's analysis of the audiovisual correspondences in the "Battle on Ice" sequence is that all viewers will attend to the sequence in the same way: "The art of plastic composition consists in leading the spectator's attention through the exact path and with the exact sequence prescribed by the author of the composition."[21] The "spectator" here can be assumed to be all spectators. Is there evidence that viewers all attend to a movie in the same way?

In 1980, Barbara Anderson questioned the assumption of universal viewing behavior in an article entitled "Eye Movement and Cinematic Perception."[22] She referenced Alfred Yarbus's[23] demonstration of the influence of task on eye movements during static image viewing, and David Noton and Lawrence Stark's investigations into eye-movement scanpaths.[24] These studies revealed the close ties between fixation location and perception in static scenes but also the large variation in scanpaths between participants. Viewers may prioritize the same features of a scene, such as faces and points of high visual salience, but they do not necessarily attend to these features at the same time or in the same order. If the same behavior was observed during film viewing, such idiosyncrasies in attention would make it impossible for a film director to predict where their viewers would look. However, Anderson admitted that, "little experimentation [had] been done in this area with motion picture images" at the time she was writing.[25]

Since the 1980s, technological advances have made eye tracking cheaper and more accessible but eye tracking has rarely been used to investigate film viewing. Stelmach and colleagues were the first to record eye movements during film viewing.[26] When they collated the fixation points across all viewers they noticed something striking: the gaze of all viewers was tightly clustered within a very small portion of the screen area. This spontaneous clustering of gaze during film viewing has subsequently been replicated by numerous studies,[27] and has been named *attentional synchrony*.[28] The degree of attentional synchrony observed for a particular movie frame will vary depending on whether it is from a Hollywood feature film or from unedited real world footage, the time since a cut, and compositional details such as focus or lighting,[29] but attentional synchrony will always be greater in moving images than static images.[30]

The key difference between a static image and a moving image is the inclusion of motion. In typical laboratory investigations of visual attention, sudden onset of motion has been identified as one of the most reliable ways to capture visual attention.[31] In a computational analysis of the predictability of gaze by low-level visual features in movies—such as luminance, edges, and motion—my colleagues and I found that by identifying points of high motion in a shot we could predict with reasonable reliability where viewers would fixate and when we would observe moments of attentional

synchrony.[32] Points of high motion are said to be highly visually *salient* and involuntarily attract visual attention.[33] The reliability of viewing behavior during free viewing of professionally produced moving images allows film directors to predict, with reasonable certainty, where their spectators will be fixating during most scenes.[34]

The "Battle on Ice" sequence chosen by Eisenstein to exemplify his use of audiovisual correspondences is problematic. We would predict that viewer gaze should exhibit attentional synchrony during this sequence, allowing Eisenstein to predict where viewers would fixate and whether their gaze followed the patterns transcribed in his diagram. However, Barbara Anderson's prediction that idiosyncrasies in gaze may render such predictions impossible may be valid, as Eisenstein chose this specific sequence because its mostly stationary nature allowed him to render it accurately on the printed page. In doing so, he may have omitted the motion critical for the creation of his intended correspondences between the film and viewer attention.

cross-modal influences of audio on visual attention

Eisenstein's predictions about how viewers will move their eyes during the "Battle on Ice" sequence in *Alexander Nevsky* differ to most previous investigations of viewer attention over static and dynamic scenes, in that he emphasizes the role played by audio in guiding visual attention. Most studies of attention to film treat hearing and vision in isolation,[35] but since the introduction of synchronized sound in the 1920s the film image has rarely been presented to the audience in isolation. Eisenstein's predictions may be invalid for silent film, but what about when accompanied by a soundtrack?

Investigations of visual and auditory attention traditionally occur in distinct and non-overlapping research fields. However, several key demonstrations of cross-modal effects exist. For example, the McGurk effect is a classic demonstration of how audio and visual perception is distorted by the presence of both sensory channels simultaneously.[36] The auditory presentation of the syllable /ba/, combined with the visual presentation of a face mouthing /ga/, will be perceived by an observer as mid-way between the two, /da/. The two channels combine to reconcile ambiguity in both channels, and create an integrated percept. Similar non-veridical audiovisual percepts are achieved by foley artists, who create sound effects—such as the sound of a body being stabbed or footsteps in snow—by using perceptually believable but mismatching objects to produce the sounds, such as stabbing a watermelon or walking on cornstarch.[37] Such audiovisual integration occurs automatically and very early in the perceptual processing of each sensory channel.[38]

In order to understand the influence audio may have on visual attention, we first need to establish the ways in which audio and vision can interact in film. "Sound may be diegetic (in the story space) or nondiegetic (outside of the story space). If it is diegetic, it may be on-screen or off-screen, and internal ('subjective') or external ('objective')."[39] If a sound object corresponds to a visual object on the screen, such as a barking dog (that is, a *diegetic on-screen external* source), the viewer will be able to shift their gaze to the source of the sound. If the barking was heard off-screen the viewer cannot overtly shift their attention to the sound source, but if the audio source is spatialized (through stereo or surround sound presentation) the viewer may covertly shift attention to the screen edge, cued by the audio to anticipate the appearance of the dog. Similarly, internal diegetic audio, such as a voiceover or access to a character's thoughts, may draw gaze to the associated character—if they are present on the screen—or covertly to the associated off-screen space.

These predictions of audio-cuing are supported by recent empirical evidence from various studies. The audio-cuing of off-screen space and its influence on viewer gaze has been demonstrated by Quigley and colleagues.[40] They recorded the eye movements of participants who were presented with static photographs of natural scenes, whilst a single ambiguous sound, such as folding a piece of aluminum foil, was played in one of the four screen corners. Quigley and colleagues found that viewer gaze was biased towards the corner corresponding to the audio, even though there was no corresponding visual referent present in the image.

When the visual referent is present on the screen, such as the face of a speaker (that is, a *diegetic on-screen external sound* source), gaze will be biased towards the sound source,[41] and towards the lips if the audio is difficult to interpret.[42] Both the image and audio have independent influences on attention, but their combination has been shown to result in increased processing of both channels. The co-occurrence of a visual and sound onset will quicken detection of both relative to either presented in isolation and make the visual stimuli more perceivable.[43] Even spatially uninformative sounds such as a simple "pip" can increase detection of a visual search target when it co-occurs with the onset of the target.[44]

Evidence for the increased activity of visual attention in the presence of audio has been demonstrated by eyetracking experiments. Film clips presented with their original audio resulted in significantly greater attentional synchrony, larger saccade amplitudes, and longer fixation durations, than when the same clips were presented without audio.[45] This suggests that the audio was assisting all viewers in locating the most important area of the visual scene and maintaining fixation on it. Similar impact of the presence of audio on eye movements has been observed for close-up videos of people in conversation,[46] and a short film presented with four different versions of the soundtrack.[47]

But what about non-diegetic sounds? So far, I have reviewed empirical evidence indicating that sounds can direct our attention to, and increase our perception of, on-screen and off-screen visual objects. However, the audiovisual effect intended by Eisenstein in the "Battle on Ice" relies entirely on non-diegetic music to spatially cue visual attention. The literature on how music or auditory rhythm influences visual attention is very sparse. In a study by Vroomen and de Gelder,[48] participants listened to four tone sequences whilst they searched for a particular pattern of dots in a sequence of distractor patterns presented serially at fixation. The tones co-occurred with the onset of each pattern and were either four low-frequency tones, or three low-frequency tones with one high-frequency tone co-occurring with the target pattern. When the onset of the target was cued by the change in pitch, participants were significantly better at perceiving the target. Phenomenally, the sequence of patterns appears to momentarily pause, allowing greater detection. Vroomen and Gelder referred to the effect as the *freezing phenomenon*.

The rhythmical presentation of a series of pure tones has also been shown to entrain visual attention and quicken visual orienting and perception. Miller, Carlson, and McAuley[49] presented participants with a series of simple tones. When one of these tones coincided with the onset of a visual target, saccadic latencies to the target were significantly quicker than if the target appeared just before or after the tone ($+/-21ms$). The rhythmical sequence also increased participants' ability to discriminate a target at fixation. These results, in combination with those of Vroomen and de Gelder,[50] suggest that covert visual attention can be entrained to an auditory rhythm, increasing perception at fixation and quickening responses to peripheral events. However, there is no evidence in the literature to support Eisenstein's more specific predictions about the influence of soundtrack on viewer gaze. His "diagram of movement" makes specific predictions about the vertical movement of gaze corresponding to increases and decreases of musical pitch. To the best of my knowledge, no empirical evidence for such directional effects of music on gaze exists in the literature.

testing eisenstein's predictions

The lack of empirical evidence of non-diegetic, non-spatialized audiovisual effects on the direction of visual attention means that the only way to test Eisenstein's hypothesis is to directly record viewer eye movements during the "Battle on Ice" sequence. This approach could then be followed by more controlled studies that strip away features of the film in order to see which are critical for creating the intended effect.

Eisenstein states that, "The strongest impression . . . does not come from the photographed shots alone, but is an *audio-visual impression* which is created by the combination of [the] . . . [s]hots together with the corresponding

music."[51] Therefore, we can formulate three hypotheses about viewer gaze during this sequence: (1) that all viewers will attend to the sequence in the same way; (2) that viewer gaze will follow the path described in the "diagram of movement" (Figure 5.1); and (3) that the presence of the audio is essential for creating the gaze behavior. In order to test these hypotheses, we presented two separate sets of participants with the sequence with or without accompanying audio, whilst their eye movements were recorded with an eye tracker.[52]

In order to test the three hypotheses stated above, gaze behavior in the original audio condition was compared to the silent condition. An initial method for comparing global eye movement behavior across the two conditions is to examine standard eye-movement measures such as fixation durations and saccade amplitudes. If the audio was guiding eye movements to parts of the image, we might expect to observe larger mean saccade amplitudes and longer fixation durations, as was previously found by Antoine Coutrot and colleagues.[53] The mean fixation duration was numerically smaller in the audio condition (mean = 437.14ms, standard deviation, sd = 121.98ms) than the silent condition (mean = 445.81ms, sd = 172.96ms) but this difference was not significant ($t(24) = -.148$, $p = .884$, not sig.). Average saccade amplitudes also failed to differ between the audio conditions (audio: mean = 4.92 degs, sd = 1.13; silent: mean = 4.68 degs, sd = 1.255; $t(24) = .509$, $p = .615$, not sig.). This suggests that there were no global differences in how the two sets of participants controlled their attention whilst watching the sequence, and possibly suggests the primacy of the image in guiding visual attention.

The similarity of gaze in the two audio conditions becomes clear when visualized as dynamic heat-maps. A video of the gaze for both conditions (left = audio, right = silent) may be viewed online.[54] What is immediately striking when watching the synchronized audio and silent dynamic heat-maps is their similarity. Following cuts, both gaze groups snap to the same parts of the image and linger on similar regions during each shot's presentation. For example, in shot I of the sequence (Figure 5.1), both sets of viewers initially fixate the dark cloud at the screen's center, then saccade down to the figures in the bottom left as the fade-in gradually reveals them. What is also evident from the dynamic heat-maps is the frequency of saccades (2.27 per second on average) and the rapid way in which viewers explore the image over the long duration of each shot (mean shot duration = 7107ms), increasing the variance between individual gaze position as the shot continues. This pattern is characteristic of gaze during movie viewing.[55]

In order to facilitate comparison of gaze in the audio and silent conditions, each shot from the sequence was converted into a peak-through heat-map (Figures 5.2 and 5.3). These static heat-maps represent the distribution of fixations during each shot's duration. Using these static

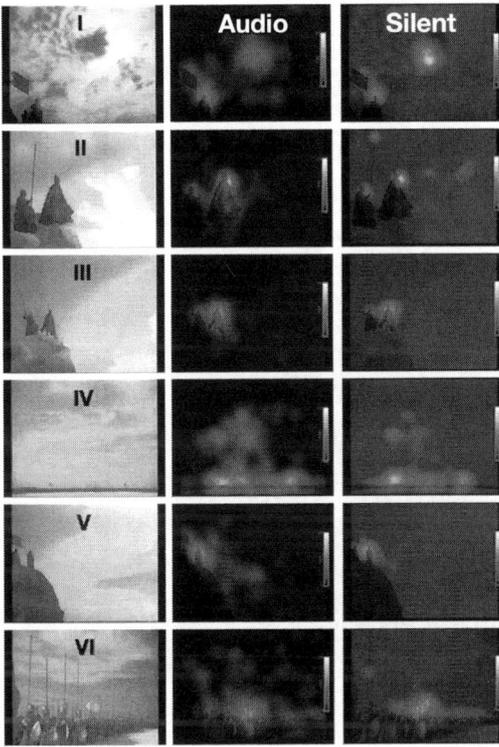

Figure 5.2 "Battle on Ice" sequence I–VI of *Alexander Nevsky* (1938). Left column = shot sequence I to VI; middle column = peak-through heat-map of fixations for the corresponding frame with original audio (audio condition); right column = peak-through heat-map of fixations for the corresponding frame without audio (silent condition).

Note: Brightness of image indicates number of fixations.

heat-maps we can begin to look for qualitative differences between the audio conditions and look for signs of the movement patterns described by Eisenstein (Figure 5.1). Firstly, the distributions of fixations in the two audio conditions are very similar. The centers of interest (the brightest parts of the heat-map) match in both conditions and mostly correspond to the key features of pictorial composition identified by Eisenstein (Figure 5.1, row 3). For example, centers of interest in shot I are the central cloud, then the figures on the rock, in shot II they are the heads of the two figures in the bottom left; shot III are the same figures as in II; shot IV is the line of soldiers at the bottom of the screen, with particular interest in the two tall flags; and shot V returns interest to the two figures on the rock. Later shots (VIII, IX, and X) all demonstrate a gaze bias towards the faces of the characters shown in close-up. Our gaze initially snaps to their noses,[56] and then explores the eyes and mouth before shifting to other faces and figures. These centers of interest are very similar across both audio conditions.

95

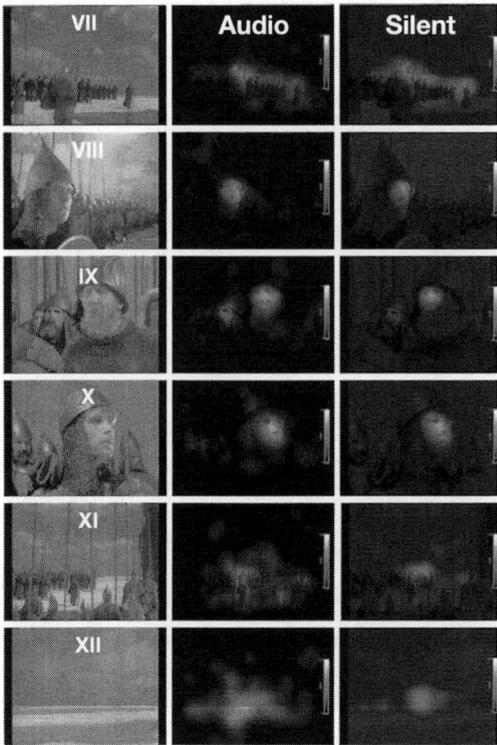

Figure 5.3 "Battle on Ice" sequence VII–XII of *Alexander Nevsky* (1938). Left column = shot sequence VII to XII; middle column = peak-through heat-map of fixations for the corresponding frame with original audio (audio condition); right column = peak-through heat-map of fixations for the corresponding frame without audio (silent condition).

Note: Brightness of image indicates number of fixations.

Static analysis of the distribution of fixations for each shot appears to mostly support Eisenstein's predictions about which features of the pictorial composition will capture viewer attention. However, Eisenstein's predictions are mostly concerned with the correspondence between the audio and the movement of attention between these centers of interest. This correspondence is most evident in the rising and falling pitch of the music, as demonstrated in this description of shots III and IV:

> The first chord can be visualised as a 'starting platform'. The following five quarter-notes, proceeding in a scale upwards, would find a natural gesture-visualization in a *tensely rising* line . . . [t]he next chord (at the beginning of measure 7), preceded by a sharply accented sixteenth, will in these circumstances create an impression of an abrupt fall.[57]

Eisenstein claims that this rise and fall of the music matches the vertical movement of gaze across the image. To examine whether such a correspondence between music and vertical eye movements is observed in this sequence, the average vertical gaze location (Y-coordinate) of all viewers over time was calculated and mapped against Eisenstein's diagram of movement (Figure 5.4).

The vertical position of gaze in Figure 5.1 represents the mean across all participants within one-second time-bins throughout the sequence. If viewer gaze was distributed evenly across the image, the average would remain at the screen mid-line (Y-coordinate = 400 pixels). Any deviation from this mid-line indicates a collective rise or fall of gaze and can be matched directly to Eisenstein's predictions via the aligned "diagram of movement."

An examination of the gaze for shots III and IV—which Eisenstein claimed was the most impressive audiovisual group—indicates a constant high level of gaze in shot III, followed by a rapid drop to the screen bottom at the onset of shot IV. This drop directly mirrors the vertical movement predicted by Eisenstein in his "diagram of movement," and coincides with the musical drop in pitch from a B to a G sharp. The accompanying waveform shows how the eyes move during the silence between notes, and land in shot IV just as the isolated G sharp sounds (Figure 5.4; bottom row). The "tensely rising line" is absent from shot III prior to the cut, but this is probably due to the poor image transfer in the DVD copy used for this experiment. The arc of cloud Eisenstein expected to draw gaze up to top right of the screen is hard to discern in the digital version presented to participants (compare shot III in Figure 5.2 to shot III of the "picture frames" in Figure 5.1). However, even if this arc of cloud was visible in the image, such a static visual feature is unlikely to guide the gaze of all viewers at the same time.[58]

In a continuation of our examination of vertical gaze shifts, we see a sharp rise in gaze at the onset of shot V. This vertical movement coincides with the fifth repeated note from shot IV, and therefore does not create as clear an audiovisual correspondence as the fall from shot III to IV. Shot V is accompanied by a falling series of notes played on an oboe, followed by a silence and then a sharply accented rising note accompanied by piccolo. This accented note coincides with the first clear presentation of the massed troops and a sharp fall of gaze from the figures on the rock in shot V to the center of the troops in shot VI, creating a correspondence between gaze and audio.

The next sharp fall in Eisenstein's "diagram of movement" comes near the end of shot VII. Shots VI and VII depict the massed troops on the left of the screen, peering into the distance at the German troops. The musical sequence is identical to the sequence used in shots III and IV to denote a rise and then a sharp fall at the onset of IV. However, because the troops

in shots VI and VII are aligned horizontally rather than vertically, Eisenstein claims that the accented sixteenth will create a "jolt" perspectively inwards, towards the horizon. Examination of the vertical gaze positions shows no change in gaze height, but watching these shots in the dynamic heat-map (link provided to video in note 52) also shows no tendency to shift gaze towards the horizon coinciding with the sharp musical fall. We cannot rule out the possibility that the musical sequence creates the perception of a movement in depth, but this is not evident in the gaze.

Shots VIII and IX are represented as mostly stationary by Eisenstein but culminating in a rise in shot X, followed by a sharp fall to shot XI as the images are accompanied by the same musical sequence as in shots III and IV. The corresponding vertical gaze position rises gradually from shot VIII to X, mirroring the rising notes in shot X, and then falls sharply at the onset of shot XI as the accompanying music also falls. This repetition of shots III and IV's audiovisual correspondences and gaze pattern ends the narrative unit depicting the soldiers waiting, and anticipates the dramatic and musical change about to occur after the mute images and audio of shot XII.

This analysis of the audiovisual correspondences and their manifestation in viewer gaze has confirmed several of Eisenstein's predicted rises and falls in gaze between shots (as in shots III–IV and X–XI), but also failed to support some of his more fanciful predictions about movements within shots (such as in shots VI–VIII). Due to the absence of image motion in this sequence, the only point at which Eisenstein could reliably predict where viewers would look was across cuts. Immediately following a cut, our attention is predominantly driven by low-level visual features,[59] by biases towards the screen center, and by social features such as faces and bodies.[60] By positioning such features at different heights before and after the cut, Eisenstein was able to create a reliable vertical shift in collective viewer attention. This movement may have been noted by Prokofiev when composing the score for the fully edited image sequence, and mirrored in the note transitions to create musical accents corresponding to the visual.

There is also an important question about the causal direction of the correspondences. Does the audio cause the corresponding gaze pattern or is the gaze caused by the pictorial composition and simply mirrored by the audio? Qualitative comparison of the dynamic heat-maps (link provided to video in note 52), the static peak-through maps (Figures 5.2 and 5.3), and the vertical gaze coordinates (Figure 5.4) shows no clear differences between the audio and silent conditions, suggesting the primacy of the image in guiding viewer gaze. Quantitative analysis of the vertical gaze coordinates in the audio and silent groups reveals a marginally significant difference in the overall vertical coordinates of gaze in the audio and silent conditions ($F(1,24) = 3.291$, $p = .082$, marginal), with the silent condition often having higher gaze coordinates than the audio (see Figure 5.4). Both audio conditions show

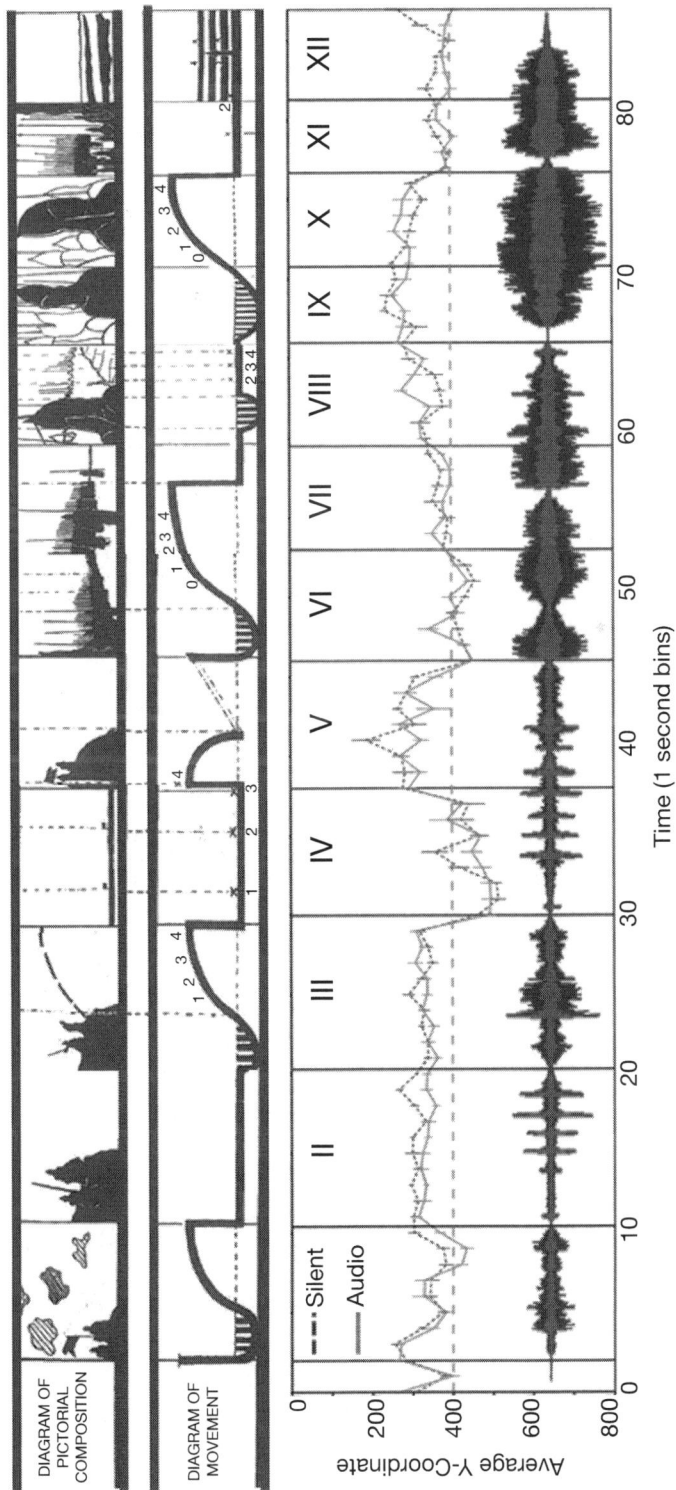

Figure 5.4 "Battle on Ice" sequence I–XII of *Alexander Nevsky* (1938). Top row of chart: Eisenstein's diagram of pictorial composition. Second row = Eisenstein's diagram of "movement" in each shot. Third row = chart of average Y-coordinate of viewer gaze whilst viewing the sequence (0 coordinate = top of screen). Audio condition = green solid line, silent condition = blue dotted line. Bottom row = audio waveform representing the soundtrack accompanying the sequence (amplitude of waves = loudness).

a significant effect of time ($F(87,2088) = 14.204$, $p < .001$) but the difference between audio conditions does not change with time (that is, there is no interaction; $F(12,294) = 1.263$, $p = .239$, not sig.). In general, the pattern of gaze is very similar across audio conditions and especially at the time points previously identified as moments of strong audiovisual correspondence (for example, transitions III–IV, V–VI, and X–XI). Differences in gaze position across the audio conditions appear to mostly occur within shots, but whether this is caused by the non-diegetic audio will have to be investigated in further studies.

conclusion

This analysis of eye-movement behavior during the sequence from Eisenstein's *Alexander Nevsky* has confirmed some of Eisenstein's predicted correspondences between movement of the musical score and movement of viewer gaze across the image. By formalizing Eisenstein's predictions made over sixty years ago as hypotheses testable using modern empirical methods (for example, eye tracking), we have finally been able to confirm some of Eisenstein's intuitions and to provide empirical evidence that some filmmakers do indeed have the "uncanny facility to have your brain 'watch and note' your [own] eyes' automatic responses."[61] The greatest moments of attentional synchrony occurred immediately following cuts and were only preserved in shots with minimal pictorial details or clear faces or figures (for example, in shots I, II, III, V, VIII, IX, and X), whereas more complex shots (VI, VII, and XI) lead to less attentional synchrony. However, even in these complex shots the systematic gaze shifts across cuts were present. The lack of a significant change in gaze behavior when audio was removed suggests that in this instance the visuals had primacy in the creation of audiovisual correspondences. However, we cannot rule out the possibility that, by adding complementary musical transitions, Prokofiev has vertically cued visual attention to covertly shift away from fixation, thereby influencing the perception of each shot. Such covert shifts are not measurable by eye tracking and would require follow-on behavioral measures.

This study provides a template for future investigations into audiovisual correspondences in film, as well as related phenomena in cross-modal attention and perception. For instance, the primacy of the image in the sequence examined here may not be present in other film sequences or in other styles of audiovisual material. For example, montage sequences are a common technique in Hollywood cinema and TV for portraying the passage of time or the completion of a task.[62] Montage sequences are structured by the accompanying music. The pacing of cuts and movement within each shot closely relates to the music, often at the expense of

narrative or spatiotemporal continuity. As such, montage sequences may be expected to have primacy of the audio in guiding attention within a shot or guiding the choice and timing of a shot. The same audio primacy is clear in music videos. Here the choice of imagery and editing structure is generally subservient to the audio. Music videos are likely to demonstrate strong audiovisual correspondences and it would be interesting to see if these correspondences are reflected in viewer gaze as in *Alexander Nevsky*.

Finally, this study has also revealed the surprising dearth of research into cross-modal influences on attention using naturalistic dynamic scenes. A handful of recent eyetracking studies have begun investigating the influence of diegetic sounds on overt visual attention,[63] but these fall far short of the level of insight into cross-modal effects claimed by sound designers and film theorists.[64] Future empirical investigations of the influence of diegetic and non-diegetic audio on visual attention and the cognitive and emotional responses to film would further our understanding of cinematic experiences, and support Eisenstein's claim that audiovisual correspondences are more than the sum of their parts.

notes

1. Joseph D. Anderson, *The Reality of Illusion: An Ecological Approach to Cognitive Film Theory* (Carbondale: Southern Illinois University Press, 1996); David Bordwell and Noël Carroll, eds., *Post-Theory: Reconstructing Film Studies*, Wisconsin Studies in Film (Madison: University of Wisconsin Press, 1996).
2. *Alexander Nevsky*, directors Sergei Eisenstein and Dmitri Vasilyev (Moscow: Mosfilm, 1938).
3. Harold Pashler, ed., *Attention*, Studies in Cognition (Hove, UK: Psychology Press, 1998).
4. John M. Findlay and Iain D. Gilchrist, *Active Vision: The Psychology of Looking and Seeing*, Oxford Psychology Series (Oxford: Oxford University Press, 2003).
5. John M. Henderson and Andrew Hollingworth, "High-Level Scene Perception," *Annual Review of Psychology* 50 (1999): 243–271.
6. Ethel Matin, "Saccadic Suppression: A Review and an Analysis," *Psychological Bulletin* 81, no. 12 (1974): 899–917.
7. THX. *THX tech pages*. 2012. Viewing Distance Requirements. http://www.cinemaequipmentsales.com/athx2.html (accessed February 13, 2012).
8. Tim J. Smith, "The Attentional Theory of Cinematic Continuity," *Projections: The Journal for Movies and the Mind* 6, no. 1 (2012): 1–27.
9. David Bordwell, *Observations on Film Art*, 2008. http://www.davidbordwell.net/blog/2008/02/13/hands-and-faces-across-the-table/ (accessed February 4, 2013).
10. Edward Dmytryk, *On Filmmaking* (London: Focal Press, 1986), 27–33.
11. Walter Murch, *In the Blink of an Eye: A Perspective on Film Editing*, 2nd ed. (Los Angeles: Silman-James Press, 2001), 18.
12. Bruce Block, *The Visual Story: Seeing the Structure of Film, TV, and New Media* (Woburn, MA: Focal Press, 2001).

13. Sergei M. Eisenstein, *The Film Sense*, trans. and ed. Jay Leyda (London: Faber and Faber, 1943).

14. Eisenstein, *The Film Sense*, 136.

15. Ibid., 135.

16. Ibid., 138.

17. Guy Thomas Buswell, *How People Look at Pictures: A Study of the Psychology of Perception in Art* (Chicago: University of Chicago Press, 1935), xv, 198; including illustrations, plates, and diagrams.

18. Benjamin W. Tatler, Nicholas J. Wade, Hoi Kwan, John M. Findlay, and Boris M. Velichkovsky, "Yarbus, Eye Movements, and Vision," *i-Perception* 1, no. 1 (2010): 7–27.

19. Eisenstein's theories of montage were heavily influenced by contemporary work on neuroscience and psychology and he even states in retrospect, "Had I been more familiar with Ivan Pavlov's teaching, I would have called the 'theory of the montage of attractions' the 'theory of artistic stimulants.'" In Sergei M. Eisenstein, *Notes of a Film Director*, trans. X. Danko (New York: Dover, 1970), 17.

20. Oksana Bulgakowa, *Herausforderung Eisenstein* [*Challenge Eisenstein*] (Berlin: Akademie der Künste der DDR, 1988).

21. Eisenstein, *The Film Sense*, 148.

22. Barbara Anderson, "Eye Movement and Cinematic Perception," *Journal of the University Film Association* 32, nos. 1 and 2 (1980): 23–26.

23. Alfred L. Yarbus, *Eye Movements and Vision*, trans. Basil Haigh (New York: Plenum Press, 1967).

24. David Noton and Lawrence Stark, "Scanpaths in Eye Movements During Pattern Perception," *Science* 171, no. 3968 (1971): 308–311.

25. Barbara Anderson, 25.

26. Lew B. Stelmach, Wa James Tam, and Paul J. Hearty, "Static and Dynamic Spatial Resolution in Image Coding: An Investigation of Eye Movements," in *Human Vision, Visual Processing, and Digital Display II* (Proceedings of SPIE), ed. Bernice E. Rogowitz, Michael H. Brill, and Jan P. Allebach (San Jose, 1991), 147–152.

27. Robert B. Goldstein, Russell L. Woods, and Eli Peli, "Where People Look When Watching Movies: Do All Viewers Look at the Same Place?," *Computers in Biology and Medicine* 37, no. 7 (2007): 957–964; Uri Hasson, Ohad Landesman, Barbara Knappmeyer, Ignacio Vallines, Nava Rubin, and David J. Heeger, "Neurocinematics: The Neuroscience of Film," *Projections: The Journal of Movies and Mind* 2, no. 1 (2008): 1–26; Tim J. Smith, "An Attentional Theory of Continuity Editing,", unpublished thesis (Edinburgh: University of Edinburgh, 2006), 400; Virgilio Tosi, Luciano Mecacci, and Elio Pasquali, "Scanning Eye Movements Made When Viewing Film: Preliminary Observations," *International Journal of Neuroscience* 92, nos. 1–2 (1997): 47–52; Ran Carmi and Laurent Itti, "Visual Causes Versus Correlates of Attention Selection in Dynamic Scenes," *Vision Research* 46, no. 26 (2006): 4333–4345.

28. Tim Smith and John Henderson, "Attentional Synchrony in Static and Dynamic Scenes," *Journal of Vision* 8, no. 6 (2008): 773.

29. For review, see Tim J. Smith, "Watching You Watch Movies: Using Eye Tracking to Inform Cognitive Film Theory," in *Psychocinematics: Exploring Cognition at the Movies*, ed. Arthur P. Shimamura (New York: Oxford University Press, 2013), 165–191.

30. Tim J. Smith and Parag. K. Mital, "Attentional Synchrony and the Influence of Viewing Task on Gaze Behaviour in Static and Dynamic Scenes," *Journal of Vision* 13, no. 8 (2013): 16.

31. Jeremy M. Wolfe and Todd S. Horowitz, "What Attributes Guide the Deployment of Visual Attention and How Do They Do It?" *Nature Reviews Neuroscience* 5 (2004): 1–7.

32. Parag K. Mital, Tim J. Smith, Robin L. Hill, and John M. Henderson, "Clustering of Gaze During Dynamic Scene Viewing is Predicted by Motion," *Cognitive Computation* 3, no. 1 (2011): 5–24.

33. Laurent Itti, "Quantifying the Contribution of Low-Level Saliency to Human Eye Movements in Dynamic Scenes," *Visual Cognition* 12, no. 6 (2005): 1093–1123.

34. Smith, "Watching You."

35. For review of empirical studies of film cognition, see Tim J. Smith, Daniel Levin, and James E. Cutting, "A Window on Reality: Perceiving Edited Moving Images," *Current Directions in Psychological Science* 21, no. 2 (2012): 107–113.

36. Harry McGurk and John MacDonald, "Hearing Lips and Seeing Voices," *Nature* 264, no. 5588 (1976): 746–748.

37. Michel Chion, *Audio-Vision: Sound on Screen*, ed. and trans. Claudia Gorbman (New York: Columbia University Press, 1990).

38. M. H. Giard and F. Peronnet, "Auditory-Visual Integration During Multi-modal Object Recognition in Humans: A Behavioral and Electrophysical Study," *Journal of Cognitive Neuroscience* 11, no. 5 (1999): 473–490.

39. David Bordwell and Kristin Thompson, *Film Art: An Introduction*, 6th ed. (New York: McGraw Hill, 2001), 333.

40. Cliodhna Quigley, Selim Onat, Sue Harding, Martin Cooke, and Peter König, "Audio-Visual Integration During Overt Visual Attention," *Journal of Eye Movement Research* 1, no. 2 (2008): 1–17.

41. Melissa L.-H. Võ, Tim J. Smith, Parag K. Mital, and John M. Henderson, "Do the Eyes Really Have it? Dynamic Allocation of Attention When Viewing Moving Faces," *Journal of Vision* 12, no. 13 (2012): 1–14.

42. Eric Vatikiotis-Bateson, Inge-Marie Eigsti, Sumio Yano, and Kevin G. Munhall, "Eye Movement of Perceivers During Audiovisual Speech Perception," *Perception and Psychophysics* 60, no. 6 (1998): 926–940.

43. Charles Spence and Jon Driver, "Audiovisual Links in Exogenous Covert Spatial Orienting," *Perception and Psychophysics* 59, no. 1 (1997): 1–22; John J. McDonald, Wolfgang A. Teder-Sälejärvi, and Steven A. Hillyard, "Involuntary Orienting to Sound Improves Visual Perception," *Nature* 407 (2000): 906–908.

44. Erik Van der Burg, Christian N. L. Olivers, Adelbert W. Bronkhorst, and Jan Theeuwes, "Pip and Pop: Nonspatial Auditory Signals Improve Spatial Visual Search," *Journal of Experimental Psychology: Human Perception and Performance* 34, no. 5 (2008): 1053–1065.

45. Antoine Coutrot, Nathalie Guyader, Gelu Ionescu, and Alice Caplier, "Influence of Soundtrack on Eye Movements During Video Exploration," *Journal of Eye Movement Research* 5, no. 4 (2012): 1–10.

46. Võ et al.

47. Anna Vilaró, Andrew T. Duchowski, Pilar Orero, Tom Grindinger, Stephen Tetreault, and Elena di Giovanni, "How Sound is the Pear Tree Story?

Testing the Effect of Varying Audio Stimuli on Visual Attention Distribution," *Perspectives: Studies in Translatology* 20, no. 1 (2012): 55–65.

48. J. Vroomen and B. de Gelder, "Sound Enhances Visual Perception: Cross-Modal Effects of Auditory Organization on Vision," *Journal of Experimental Psychology: Human Perception and Performance* 26, no. 5 (2000): 1583–1590.

49. Jared E. Miller, Laura A. Carlson, and J. Devin McAuley, "When What You Hear Influences When You See: Listening to an Auditory Rhythm Influences the Temporal Allocation of Visual Attention," *Psychological Science* 24, no. 1 (2013): 11–18.

50. Vroomen and de Gelder.

51. Eisenstein, *Film Sense*, 137.

52. Twenty-six participants were presented the "Battle on Ice" sequence (Chapter 10, 52:06–55:17; ripped from DVD as XVID format). Participants were instructed to simply "watch the film clip" whilst their eye movements were recorded using an Eyelink 1000 desk-mounted eyetracker (SR Research). The film was presented on a 21-inch CRT monitor (720 x 576 pixel resolution DVD quality; viewing angle = 36.44 degrees) at a distance of 60 cm with participant head stabilized on a chinrest. Audio was presented on Sennheiser stereo headphones converted from original mono audio recording (i.e., left/right audio channels were identical). Participants were randomly allocated to one of two groups: with original audio (13 participants) and without audio (13 participants). Gaze data was analyzed using Data Viewer (SR Research) to generate peak-through heat-maps of fixation distributions for each shot (Figures 5.2 and 5.3) and parsed into fixations and saccades using standard filters (Dave Stampe, "Heuristic Filtering and Reliable Calibration Methods for Video-Based Pupil-Tracking Systems," *Behaviour Research Methods, Instruments, and Computers* 25, no. 2 (1993): 137–142). Note we do not have to be concerned about smooth pursuit eye movements in this sequence as objects are mostly stationary. Raw gaze data was also parsed into frame-based coordinates for each participant and mapped back on to the original sequence using CARPE (Mital et al.).

53. Coutrot et al.

54. DVClab account on Youtube. Video entitled "Audiovisual correspondences in Alexander Nevsky": http://www.youtube.com/watch?v=KBKR SFP9KUM. The center of each viewer's gaze is represented by a small green eye and surrounded by a small Gaussian blob (4 degrees in diameter; roughly the size of the foveal region). The more concentrated the gaze is on one part of the image the hotter the gaussians appear (hence this is referred to as a gaze "heat-map"). This visualization allows us to gain a qualitative insight into the distribution of gaze throughout the sequence and identify centers of interest (that is, where gaze is most clustered).

55. Michael Dorr, Thomas Martinetz, Karl R. Gegenfurtner, and Erhardt Barth, "Variability of Eye Movements When Viewing Dynamic Natural Scenes," *Journal of Vision* 10, no. 10 (2010): 1–17; Mital et al.

56. The center of the face; Võ et al.

57. Eisenstein, *Film Sense*, 138.

58. Mital et al.

59. Carmi and Itti.

60. Wolfe and Horowitz.

61. Richard D. Pepperman, *The Eye is Quicker: Film Editing: Making a Good Film Better* (Studio City: Michael Wiese Productions, 2004), 11.

62. Bordwell and Thompson.

63. Võ et al.; Coutrot et al.; Vilaró et al.

64. Chion; Murch, *In the Blink of an Eye*.

audiovisual correspondences

engaged and

detached film

viewing

exploring film viewers'

emotional action readiness

ed s. tan

emotional action readiness

Emotions are often regarded as disturbances of people's regular psycho-logical life, where normally all is quiet. Popular cinema is one of the places where such disturbances are being routinely provided, and in line with this, stereotypical pictures of audience members show their wild gesticulations, grotesque facial expressions, and loud cursing. Actual habitual patrons know that, in contrast to the stereotype, their fellow cinema-goers and they themselves usually remain quiet, while it is true that they can go through intense emotions.[1] Maybe we can say that cinema "refines" emotions, compared to ones we have in response to exciting real-life events. Accord-ing to psychologists Nico H. Frijda and Louise Sundararajan, *refined emotion* is characterized by an attitude of detachment and a reflexive awareness of one's emotional experiences; aesthetic emotions, such as ones experienced when one reads poetry, are an example. Time is taken to forestall impulsive responses, giving the opportunity to savor a rich set of features of the event. Extensive reflection on emotional events carries their meaning beyond how

they are immediately perceived. More remote meanings, such as insights about life in general, oneself, and one's acts become accessible.[2]

The stereotypical picture of the film audience's excited expressions does seem correct, in that it illustrates the idea that emotions instigate behavioral activity. In the past decades, a great deal of research has supported the functional view of the emotions as a biological system predisposing the individual to proper action.[3] The emotion process starts with appraising what a situation or event means for the individual. For example, fear sets in when a threat is identified. Appraisal links the situation to the individual's concerns—that is, goals that really and ultimately matter to her or his well-being. When a threat is identified, the concern is for safety. Appraisal results in an emotional drive to act upon the situation in correspondence with concerns: in the example, this is the tendency to flee. Emotions then entail states of *action readiness*, motive states that prompt behavioral responses, thoughts, or attention.

According to the functional perspective, action readiness is a *sine qua non* for emotion. What distinguishes emotion from other states of mind is readiness for action. If the experiencer does not exhibit or feel a readiness to do something, then she cannot have a genuine emotion. Only feeling states comprising an inclination to act in one way or another can be called emotions. Action readiness is an essential part of emotion.[4] If we assume that film does provoke real emotions—and there is every reason to believe it does—then the issue raised is what action readiness means in the cinema. It is certain that many action film viewers experience intense anger towards a bully antagonist, but it is extremely rare that somebody stands up shouting names, or that horror-film patrons run away in panic. Is it common in the cinema to have an urge to do things, but to suppress action readiness? And readiness to what kind of action is invoked in the cinema? The study presented in this chapter attempts to identify forms of action readiness in response to film.

Frijda's inventory of forms of action readiness is the basis for the study presented here.[5] The idea behind the general inventory is that although the number of different forms of action readiness may be very high—as there is a virtually unlimited variety of emotions—a much more limited number of dimensions underlying forms of action readiness may be distinguished. Examples include approach versus avoidance, and high versus low energy. As another dimension, we may think of engagement versus detachment, to which we will return in a moment. Every emotion may involve one or more of the forms of action readiness, or variants of these, that are part of the inventory. For example, anger may incite an urge to approach and attack, while fear may instigate inclinations to flee or freeze. Except for the so-called basic emotions (such as anger, fear, joy, surprise, and disgust), emotions are not associated with a fixed set of action readiness forms.

Two particular types of action readiness cut across Frijda's inventory: action tendencies and activation modes.[6] Action tendencies have a distinct aim; an example is an inclination to hurt another person when one is angry. Action tendencies include *attend; interest (that is, to inspect or investigate with interest); shut off; approach; withdraw; reject; oppose; disappear from view; be with; fuse with; dominate; submit; possess; care for; amend; undo; hurt; broaden and build; disinterest (that is, to avoid inspection or investigation); rest; depend;* and *action suspension.* Activation modes are more general states of action readiness which lack specific aims. For example, sadness makes a person apathetic, which means that they feel like doing nothing, but there is no particular activity they wish to avoid. Activation modes in Frijda's inventory include *relaxed; tense; apathetic; inhibited; reactant;* and *helpless.*[7] The aims of action tendencies are specified at various levels.[8] For instance, the class of action tendencies with a defensive aim include *shut-off; withdraw; eject; go against; detach;* and *submit.* Depending on the particular emotional situation, "going against" can take the more specific shape of a physical or a verbal attack; a verbal attack may be manifested as an insult or a sarcastic remark. Action readiness is experienced consciously and it contributes a great deal to the specifically dynamic nature of emotion experience, which underlies emotions as "passions."[9]

"refined" emotion and detached vs. engaged action readiness in the cinema

One answer to the question of what constitutes action readiness in film viewing has its starting point in the cinematic experience that positions the viewer in the role of passive onlooker of emotion-provoking situations. In the cinema we cannot act. To be sure, in real life too there are situations in which we experience emotion-provoking events as witnesses who are unable to act. An example would be seeing an accident happening on the other side of a busy street. According to Frijda, action readiness in response to similar situations in real life may be *virtual.*[10] In all emotions, part of the appraisal of a situation in relation to the individual's concerns involves a perception of what possibilities for action it affords. In some emotional situations, the person appraises these possibilities as nil. Action readiness in such cases is felt nonetheless. Virtual action readiness consists of an imagined representation of the action or an imagined desired end state. In the cinema, the spectator's role in events is structurally that of a witness and therefore most forms of action readiness are virtual.[11] We cannot hurt the antagonist bully, but our anger will often result in a desire that he be hurt one way or another, and we then entertain a virtual readiness to hurt. We cannot persuade the protagonist to do it, but we can wish that he will— a virtual "amending" of the situation.

The witness position renders emotions more refined than those we would have if we were able to act. More specifically, it casts action readiness

into virtual forms—an imagination or other mental representation of what one would want to do, which is contemplated rather than executed. However, there is an exception to the rule of non-action: in the cinema we want to watch, and this is what we do. We watch with attention and interest, which also implies other activities such as making inferences and imagining things. This tendency to actively follow the narration is emotional, as I will argue in a moment. Although we usually do not experience it consciously, a decision to see or not to see an event in the ongoing film is an action on the part of the viewer. There is effort in attending to and following a film, and watching events must therefore be motivated: that is, emotionally driven. In earlier work I have proposed that the driving emotion is interest. The core of interest is the appraisal of a stimulus that holds a promise, or posing a challenge that can be met.[12]

engaged and detached interest and action readiness

Interest is an action tendency, as we have seen. But it is also the name of the emotion that has interest as an action tendency. Interest as an emotion underlies the emotional experience of narrative film as a whole.[13] Interest, both as an emotion and as an action tendency, represents the viewer's natural response to having witnessed a series of events controlled by a narrating instance that determines what the viewer sees, as well as how and ultimately why. If the narration is sufficiently challenging, viewers experience interest. Higher intensities of interest can be called engaged interest or, more briefly, *engagement*. In the engaged interest mode, one is involved in events and focused on certain aspects of them. Action readiness in this context is an eager desire to see and know more. With detached interest, the attitude to events is more reserved or aloof, attention is less focused, and the impulse to see or know more is restrained.

The object of interest in film viewing determines refinement of the emotion. In the cinema we can watch (1) events in the world portrayed by the film; and (2) events of filmic narration or presentation. Events happening in the represented world—*story events*—include actions taken by characters, the places where they happen, and so forth. Events of filmic narration, or *filmic events,* refer to units of filmic narration, or "utterances": in other words, *parts or aspects of film as an artifact instead of an imagined world.* Examples include a dialog sequence or action sequence filmed in a particular way; an action scene exhibiting a certain style; an acting performance; or a pattern of framings that stands out for one reason or another. In contrast to story events, filmic events can be attributed to a filmmaker with specific intentions and can be emotionally appraised as such. Both types of events can and do raise interest, as viewers can attend both story and filmic events; but it may be argued that they result in emotional experiences that differ in terms of refinement. Interest in story events is typically engaged,

whereas interest in filmic events is detached. This is because traditional narrative film, at least, conveys story events using filmic style as means to an end. Interest in story events and characters, following the vicissitudes of the life of a protagonist, is dominant.[14] However, film events may also foster engaged interest, and story events may engender detached interest. For instance, strong likes or dislikes for a filmic event may incite engaged readiness to share one's admiration or dejection with the filmmaker or with fellow members of the audience. As another example, highly interesting story events may stimulate detached reflection on story themes and their meaning.

Several *film factors* may add to or detract from detachment of action readiness in film-provoked interest; one is narration.[15] Films can select events and show them in ways that promote either engagement or detachment. For instance, high depth of information—the degree to which a viewer is granted access to a protagonist's inner life (for example, through dialog or close-ups)—makes for empathic engagement, whereas low depth of information results in a more detached attitude.[16] Genre, too, modulates detachment. Fiction generally introduces psychological distance to events and characters, and comedy more so. But other fiction genres, such as drama, compare favorably with real-life situations when it comes to giving access to what is felt by participants in conflict-laden situations. On the basis of such film factors it is possible to classify any film as giving rise to more or less detached viewing attitudes. In summary, we conclude that while it is a given that the film viewer's attitude to emotion-provoking events is generally detached in comparison to that of the witness of events in real life, films vary in the degree of engagement or detachment that they afford.

To my knowledge, no empirical explorations of action readiness in film spectators have been published so far. In this study we embark on such an exploration, aiming to capture engaged and detached forms of action readiness associated with interest, the leading emotion in the cinema. The methods of data collection are introspection, followed by focus groups and self-report measures. The research questions are:

1. Can engaged and detached forms of interest-related action readiness be distinguished?
2. Can profiles of engaged and detached action readiness meaningful for different genres be identified?

construction of self-report measures of action readiness in the cinema

As a first step towards creating measures of action readiness, activation modes and action tendencies were formulated that seemed appropriate

Table 6.1 Forms of interest-related action readiness in the cinema

Object of Action Readiness			
Form of A R	Story Events	Characters/Figures	Filmic Events
Engaged	attend; know/see more; infer; imagine; be in; be with; identify	[eagerly] attend; know/see more; fuse with; empathize; sympathize; want the best for	share positive or negative feeling with others
Detached	watch; reflect	[critically] watch; attend; know/see more details disregarding/ objectifying person; reflect	watch; [critically] attend; know/see more; reflect

for interest as the major emotion in film viewing across all genres.[17] Forms of action readiness could have as their object either (a) story events; (b) story characters or figures; or (c) filmic events. We attempted to devise engaged or detached interest forms of action readiness. The schema for the action tendencies at a general level of aim specification is presented in Table 6.1.

These forms of action readiness are far too abstract to serve as valid self-report statements. An attempt was made to categorize them into statements viewers can recognize when they experience events and characters/persons in specific films. The aim of this part of the study, then, was to see whether we could devise meaningful action readiness self-report statements for four tested genres, and the particular events, characters, or figures featuring in the tested film clips.

Four ten-minute film clips from distinct genres were selected:

1. *The Notebook* (N. Cassavetes, 2004)—(Drama) Romance[18]
2. *Lost in Translation* (S. Coppola, 2003)—(Drama Romance) Art House[19]
3. *Planet Earth* (Attenborough and Fothergill, 2006)—(Nature) Documentary Series[20]
4. *Armani Fashion Show Spring–Summer 2010* (E. Armani and Milano Moda Donna, 2009)—(Show) Reportage[21]

Selection was made with the distinction in mind between engaged and detached interest and forms of action readiness. Table 6.2 presents descriptions of the test clips. *The Notebook* was selected for its high potential for engagement. As a romance drama it affords the target female audience a maximum of empathy and sympathy. *Armani Fashion Show* was picked for its high detachment potential. This genre invites viewers to contemplate fashion models as human figures lacking narrative meaning. We expected

Table 6.2 Abbreviated introductions to clips presented to test participants

Documentary	Reportage	Art House	Romance
Planet Earth . . . aims to give audiences a definitive look at the diversity of the planet. It was one of the most expensive nature documentaries ever made and took four years to complete. The series consists of eleven episodes, each of which presents an overview of a different habitat on Earth. The present clip is an excerpt from the "Fresh Water" episode. This episode identifies the course taken by rivers and some of the species which live in fresh water habitats, such as fresh water Boto dolphins.	The theme of liberty that prevails throughout this collection . . . contemporary and metropolitan, leads to a very original treatment of prints: multi-colored graphic patterns and stylized flowers in shades of fuchsia, red, coral, and orange from an Italian garden, seen on walks along the southern coast . . . short silk dresses, wide pants made of light fabrics, and bright accessories are the right choice this season. Clutches and belts from the new collection are decorated by crystals.	Bob Harris (Bill Murray) is an aging movie star arriving in Tokyo to film an advertisement. Charlotte (Scarlett Johansson) is the young wife of a celebrity photographer working in Tokyo. She is left alone living in a hotel while her husband is off on a business trip. Bob's 25-year marriage is tired and lacking in romance as he goes through a mid-life crisis. Bob and Charlotte meet in the bar of the hotel where they are both staying and strike up a friendship. The two bond through their adventures in Tokyo together, experiencing the differences between Japanese and American culture, and between their own generations.	The Notebook is an epic love story . . . two young lovers, Allie Hamilton (Rachel McAdams) and Noah Calhoun (Ryan Gosling) . . . meet one evening in the 1940s at a carnival and develop a passionate summer romance. At the end of the summer, they are tragically separated by Allie's upper-class parents . . . Allie meets and becomes engaged to a handsome young soldier named Lon . . . as Allie is preparing for her wedding she discovers that Noah has fulfilled his promise to her of restoring the . . . mansion they had dreamed of living in together the summer they fell in love. Allie returns to Noah and rekindles their love.

Table 6.3 Examples of action readiness form items

		Engagement (Scale 1–5)	Events	Characters/Persons	Filmic Events
Romance Drama *The Notebook*	Engaged	4.37 (.84)	I wished Lon hadn't called Allie in her hotel (Undo)	I could sense Allie's happiness in the scene where she feeds the geese (Be with/fuse)	I would like to compliment the filmmakers for the camera stressing the distance between Allie and Noah (Share)
	Detached		The boat scene could have done without a flock of geese (Amend)	I wanted to touch Allie's curly bangs (Attend; Approach contact)	The way Allie and Noah were dressed reflects the time the movie is set in (Reflect)
Art House Romance *Lost in Translation*	Engaged	3.62 (1.26)	I didn't want Bob to leave Charlotte after he had tucked her in (Be with/Fuse)	When Charlotte wiggles her shoulders as she sings karaoke, I wanted to wiggle my shoulders with her (Be with/Fuse)	I would like other people to know Sofia Coppola proves to be a master of understatement in this film (Share; Submit)
	Detached		I really liked seeing Charlotte wearing her pink wig (Attend; Interest)	I want to contemplate the complexity of feelings Charlotte and Bob have (Reflect)	I would like to see more movies with such an authentic atmosphere created by skilful use of lighting, sound, and motion (Broaden and build)
Nature Documentary *Planet Earth*	Engaged	4.07 (.95)	I wanted to protect the [prey] fish as they attempted to escape from the dolphins (Care)	I imagined how wonderful it would be to swim with the dolphins (Be with; Interact)	I wanted to see more underwater shots of the Boto dolphins (Interest; Approach)
	Detached		I felt like sitting back while watching the documentary (Relax)	XXXXXX	The slow movement of the camera made me relax (Attend; Relax)
Fashion Show Reportage *Armani 2010*	Engaged	2.98 (1.19)	I wanted to tell the models they were doing well (Sympathize)	I imagine I could feel the audience's critical gaze (Be with/Fuse)	I wanted to compliment Armani for the show's simplicity (Share; Submit)
	Detached		I wanted to try the dresses on (Interest; Possess)	I stopped paying attention because the models all looked the same (Shut-off)	I paid attention to details like the materials the clothes were made of and the accessories (Attend)

Note: Engagement scores represent means per clip, N = 61. Standard deviations appear in parentheses.

that the engagement potential of *Lost in Translation* and *Planet Earth* would be in between the two extremes. As an art-house romance of sorts, *Lost in Translation* offers viewers material for contemplation and seems less engaging than *The Notebook*. As a documentary, *Planet Earth* offers viewers more engaging events than does *Armani Fashion Show*, in which the series of catwalk performances are repetitious.

The researchers attempted to list their emotions, (virtual) action tendencies, and activation modes in response to major events, characters, and filmic events while watching each clip. Subsequently, two all-female participant focus groups discussed the appropriateness of the proposed forms of action readiness—selecting, complementing, and improving on these—while the test films were shown and halted from time to time.

Action tendencies were often not formulated directly but as consequences of the tendency. This was done to reduce respondent tendencies to subscribe to suggested theoretical concepts, or a reverse tendency to shy away from these.[22]

validation of action readiness questionnaire: method

In order to assess whether the action readiness forms identified in the construction phase were meaningful and recognizable to other film viewers, a questionnaire validation study was carried out.[23]

Of sixty-one women who participated in the test, about half were university students while the other half were somewhat older and were professionals in various fields. Participants watched the four clips, in groups of six to fifteen, in a fixed order—namely, documentary, art house, reportage, and romance—and rated action readiness statements on a five-point scale, in which 1 stands for the respondent's minimal agreement and 5 for maximal agreement. Engagement experienced in response to each clip was also measured using a similar scale. Each clip was preceded by a slide which offered a brief introduction, as shown in Table 6.2.

results of action readiness questionnaire test[24]

The four film clips were engaging for the test participants, with mean scores of 3 or higher on a five-point scale (see Table 6.3). Significance tests yielded expected differences, with the romance evoking the highest degree of engagement, followed by the documentary, then the art-house film, and finally the reportage. In order to draw conclusions only for the most valid items, all action statements which received a mean score of less than 2 on the five-point scale were removed from the analyses.

Hierarchical cluster analyses were performed on the remaining items. This algorithmic technique groups together test items where the scores tend to co-vary.[25] Researchers who use cluster analysis need to interpret

clusters by assigning labels reflecting the common meaning of items. Action readiness clusters are presented in italics for each clip below, with a brief interpretation. The interpretation motivates the tentative label given to the cluster.[26] Numbers refer to complete statements on the original questionnaire.

romantic drama (The Notebook)

1. *Tender Identification:* 46. I could sense Allie's happiness when she is feeding the geese; 47. I could have smiled with happiness then; 35. I felt touched when Allie says, "We were kids but really loved each other." This cluster seems to reflect engaged tendencies to be with and fuse with characters; being touched is a more diffuse activation state, rendering the cluster even more engaged.
2. *Sympathetic Identification:* 43. I wish Lon hadn't called Allie; 48. I wish I were Allie when she feeds the geese; 44. I hated seeing Allie's fiancé. The cluster represents engaged tendencies to side with and identify with the protagonist.
3. *Savor Romance:* 56. I wish I could tell Allie to pick Noah; 58. I'd love to see this romance again; 53. When Allie got angry at Noah I wanted to defend him; 63. I'd like to replay Noah's reading for the atmosphere; 66. Seeing Noah and Allie in the rain made me want to play in the rain. The majority of statements were detached items. Taken together they suggest test viewers' detached conscious awareness and appreciation of their own feeling and their recognition of the film's contribution to it.

art house romance (Lost in Translation)

1. *Be with:* 13. I felt touched when Bob carries Charlotte to her room; 61. I wanted to compliment Bob for caring so kindly. The cluster reflects engaged tendencies to be or fuse with characters. In addition, a larger detached cluster was formed with three sub-clusters:
2. *Watch/Take in:* 69. I loved watching Charlotte and Bob sing karaoke; 71. I had to laugh about Bob communicating with Japanese.
3. *Share Contentment with Film:* 89. I would have used the same music; 90. I want to recommend the film for its script, acting, etc. fitting together; 79. I fondly remember Charlotte's faint smile.
4. *Reflect:* 84. I noted Bob and Charlotte were very different but could get along very well; 88. I was made to reflect on the difference between love and friendship; 74. I liked seeing Charlotte's pink wig; 81. I noticed Bob and Charlotte share mutual understanding; 82. I loved that all others were strangers, emphasizing Bob and Charlotte's friendship; 80. Bob acted like a fatherly figure.

nature documentary (Planet Earth)

One detached cluster obtained with three sub-clusters:

1. *Relax*: 46. Vast bodies of water made me relax; 47. Slow camera movement made me relax. Detachment here is in reflection on the source of the inclination to relax as well as in letting go and allowing oneself to be carried away.

2. *Lean Forward Interest*: 41. I wanted to see more underwater shots of dolphins; 45. I was impressed by dolphins lifting rocks; 44. I wanted to see the dolphins' faces in more detail. The cluster seems to reflect a desire to watch up close.

3. *Lean Back*: 5. I loved seeing the dolphins interact; 36. I felt like sitting back.

4. Apart from the two sub-clusters, the single item 31 ("I wanted to visit Amazonia") was also part of the larger cluster that, on the whole, may represent an enjoyable activation state of detached interest and readiness to watch in a leisurely manner.

fashion show reportage (Armani Fashion Show)

One minimal cluster could be interpreted as representing an engaged or, in this case, empathic action readiness:

1. *Be/Fuse with*: 51. I wanted to compare myself with the models; 60. I felt an urge to adjust my posture. The remaining two clusters are detached:

2. *Appetitive Approach*: 35. I imagined wearing the clothes; 44. I wanted to have the clothes; 64. I wanted to try the dresses on; 45. I wanted to see more of the designer's collection; 67. I appreciated Armani's clothes more after show; 62. I wanted to change my style of clothing; 43. I paid attention to details; 56. I indulged in the loungy music. This larger cluster had detached desires to inspect, handle, possess, and use dresses and attributes, as if participants were customers attending a fashion show.

3. *Shut-off/Reject*: 34. I wanted to make negative comments; 50. I hated to see the skinny models; 47. I disliked the necklaces; 49. I stopped watching because all models looked the same.

conclusions

The identification of clusters enabled us to more closely analyze detachment versus engagement in genre-related forms of emotional action readiness. The top-engaging film, *The Notebook*, afforded the most engaged

action tendencies—more specifically, tender identification-like tendencies. "Tender and Sympathetic Identification" had very high scores (for example, 46: "I could sense Allie's happiness" measured 4.3 on a five-point scale; 49: "I wished I were Allie" measured 4.5 on a five-point scale). This illustrates how narrative film offers the viewer an ideal space for imaginary participation.[27] Imaginary participation fosters virtual action tendencies, as demonstrated by the score for "Sympathetic Identification." Taking a distanced attitude to story-world events seems to be very hard, as we learned when introspectively constructing detached statements. In the focus group, too, it was found awkward to attend to filmic rather than story events. In particular, focusing on actors and acting rather than characters seemed unnatural when viewing this film. Observation of details, as in the documentary or the fashion show, is emphatically not part of engaged interest, as in *The Notebook*. Instead, another form of detachment emerged here, as viewers showed reflective awareness of their engaged feelings: they seemed to "Savor the Romance." However, this variant of detachment can also be argued to be engaged, since "indulging" may be as proper a label as "savoring."

The Art House Romance provoked clear engaged desires to be intimate with the characters, just as the romance did, but in contrast, it also involved more clearly detached tendencies to watch for the sake of enjoying a particular view of people—as beautiful or funny. Detached inclinations to reflect were found, possibly because the romance of sorts in this film was more remarkable than intense. Hence interest in it was associated with investing what was shown with deeper meaning. Refinement of emotion seemed also higher than in the romantic drama because filmic events (overall composition; use of music) were appreciated by viewers and they wanted to share their appreciation of the artifact.[28]

No engaged action readiness cluster emerged in the analysis of the nature documentary action readiness statements. Identification-like items such as "I felt an inclination to imagine I were a dolphin" failed to survive the focus groups. The spectacular nature of "story" events seems the source of interest here, which fostered detached action tendencies such as close-up watching. The vast waters and wide panoramas seemed to inspire awe and allow surrender into relaxation ("Relax"). Detachment in this particular documentary may be qualified by labeling the role of the viewer vis-à-vis the represented world: as a tourist ("Relax" and "Lean Backward Interest") or as an amateur naturalist ("Lean Forward Interest") wanting to studiously watch wildlife.

Finally, the fashion show had the lowest engagement scores of all four genres. In the responses to it, detached action readiness tended to prevail as well. Engagement with the models in the fashion show seemed to hit on similar obstacles as empathic virtual action towards animals and nature did.

The fashion show is for exhibiting attire and attributes using human bodies (rather than persons) to get the objects of interest across. The viewer's imaginary role in the show may be that of a customer wanting to critically inspect the goods with a view to deciding to purchase—whether to possess, or not. The critical attitude tended to result in opposing the seller's presentation and goods (Shut-off/Reject) but this opposition seemed collaterally related to a much less objectifying sympathetic engagement with the models (Be/Fuse with).

general discussion

The study shows that it appears feasible to identify specific forms of emotional action readiness in response to events in film with the general schema in mind with which we started. The general schema connects the forms of readiness found in film viewers with forms of action readiness in emotions we have outside the cinema in the reality of everyday life. The work of finding which forms of action readiness apply to the situation of film viewing has only just begun. During the current exploration many candidate action readiness statements were discarded. These concerned some virtual tendencies to act on events in the story-world, as well as the most sophisticated observation of filmic events—that is, the filmmaker's use of style and technology.

The results of the present study throw light on the distinction between engaged and detached modes of interest and action readiness. The majority of action readiness items that passed selections were detached. Two caveats must be raised against generalizing these findings to the cinematic experience at large. First, the formal self-report method may have prevented engaged action readiness from showing. It seems rather silly to subscribe to statements expressing a desire to be intimate with characters or to trade places with them. Second, and more importantly, there is a detachment bias in the selection of tested clips. The romantic drama is the only genre in our test set characterized by a narrative that centers almost exclusively on psychologically-motivated characters driving the action. The narration invites the viewer to imagine himself or herself as a witness in the midst of story events, and from this position to identify and sympathize with characters as persons. There are other genres at least as popular as romance which are not included in this study and which are equally engaging, such as action, thriller, social realist, and psychological drama. These genres may also invite viewers to respond with virtual forms of readiness such as *be with*; *fuse*; *sympathize*; *care for*; *support*; *encourage*; *trust*; and so on. We hope that the present study will be replicated using such genres and we expect that many more instances of engaged action readiness will be identified (for instance, it does not seem far-fetched to expect that the virtual tendency

to warn a protagonist about a threatening crook behind his back will soon be demonstrated). But the other two titles had been selected with their detachment potential in mind. The art house romance seemed, pre-theoretically, capable of adding reflection and aesthetic appreciation to engagement, and it was indeed found to incite inclinations to search for and savor meaning and beauty. The documentary and reportage clips were expected to foster increasingly detached action readiness because, as non-narrative film forms, they do not rely on suspension of disbelief and empathy with characters or persons.

We set out to introduce the notion that film-provoked emotions are refined relative to real world provoked ones. The idea was that possibilities for action in the cinema are extremely restrained. In accordance with the refinement notion we found that action readiness is sometimes virtual and often detached. We previously mentioned a film selection bias that explains the refinement of observed action readiness. However, even enjoying the romance was found to have a detached activation mode to it, so refinement appears to almost reign supreme in cinematic emotion. Moreover, there were various findings that brought the appropriateness of the label "refinement" into question. First, the two detached clips were not experienced by test participants as detached: *Armani Fashion Show* had the lowest engagement score but that was still at the mid-point of the scale. Second, an unexpected finding was that *Planet Earth*, a non-narrative minimal empathy film form, did not score significantly lower on engagement than *Lost in Translation*. This suggests that interested but relaxed viewing is not completely distant. Third, we observed that self-aware action tendencies in viewing *The Notebook* might also have been labeled "indulged." This is because they express a desire to participate in story events. Fourth, action tendencies towards filmic events surviving selections were almost invariably of the enthusiastic sharing kind, whereas statements expressing desires to view films more analytically did not survive selections. These findings collectively suggest a kind of eagerness in action readiness, opposite to the attitudes of distanced observation. The interpretation of detached action readiness items adds more weight to objections one might have against the label of detachment as appropriate. We found that detached items seem to invite viewers to watch *for the sake of what is in the filmic events for them*: an enjoyable view, lovely imagery, a valuable theme, and so on. Somewhat paradoxically, then, that which has been called detached interest involves eagerness too. There is a great deal at stake in detached viewing; it is not disinterested. It therefore seems worthwhile to reconsider the use of this label for the non-narrative genres we have studied. It implies a coldness of viewing attitude that is not entirely covered by the contents of action readiness statements. For instance, action tendencies towards filmic events reflected enthusiasm, as did "Lean Forward Interest" ones in response to *Planet Earth*. Want-to-have

items in viewing *Armani Fashion Show* betrayed eagerness, and some "Reject" tendencies expressed anger of some intensity. It would seem that whereas the term "engagement" fell into place by the end of this study's day, "detachment" did not cover the experience to full satisfaction. Should it be replaced by something like "fascination," for want of a less historically charged term? All in all, action readiness in the cinema seems to be refined because viewers recognize their tendencies to act onto story-world events as impossible to implement and hence virtual. Action readiness in the cinema seems less refined, as it also induces eager desires to watch and consume images and filmic events.

In closing, we express a hope that this first qualitative study will invite other researchers to develop more general measures of action readiness, and so to contribute to accounts of emotional experiences in the cinema. More specifically, studying action readiness may lead to a greater understanding of the state of immersion or absorption that is character-istic of interested film viewing.[29] This study has illustrated that action readiness as it is consciously felt by the audience adds a lot to the cinematic experience.[30]

notes

1. Registrations of facial behavior under normal viewing conditions confirm the notion that film viewers mostly do not show emotional expression. See, for example, José-Miguel Fernández-Dols, Flor Sánchez, Pilar Carrera, and Maria-Angeles Ruiz-Belda, "Are Spontaneous Expressions and Emotions Linked? An Experimental Test of Coherence," *Journal of Nonverbal Behavior* 21, no. 3 (1997): 163–177.

2. Refined emotion, according to Frijda and Sundarajan, is a mode of emotional responding rather than a subset of particular emotions; that is, very different emotions such as fear and mirth can be experienced. Nico H. Frijda and Louise Sundararajan, "Emotion Refinement: A Theory Inspired by Chinese Poetics," *Perspectives on Psychological Science* 2, no. 3 (2007): 227–241.

3. See Nico H. Frijda, *The Emotions*, Studies in Emotion and Social Interaction (Cambridge: Cambridge University Press, 1986), and *The Laws of Emotion* (Mahwah, NJ: Lawrence Erlbaum Associates, 2007); see also Klaus R. Scherer, "What are Emotions? And How Can They Be Measured?," *Social Science Information* 44, no. 4 (2005): 695–729.

4. Frijda, *The Laws of Emotion*.

5. Ibid.

6. Ibid.

7. Ibid.

8. Nico H. Frijda, "Impulsive Action and Motivation," *Biological Psychology* 84, no. 3 (2010): 570–579.

9. Nico H. Frijda, "Emotion Experience and its Varieties," *Emotion Review* 1, no. 3 (2009): 264–271.

10. Frijda, *The Laws of Emotion*.

11. Ed S. Tan, "Film Induced Affect as a Witness Emotion," *Poetics* 23 (1995): 7–32.

12. Paul J. Silvia, "What is Interesting? Exploring the Appraisal Structure of Interest," *Emotion* 5, no. 1 (2005): 89–102.

13. Ed S. Tan, *Emotion and the Structure of Narrative Film: Film as an Emotion Machine* (Mahwah, NJ: Lawrence Erlbaum Associates, 1996); "Entertainment is Emotion: The Functional Architecture of the Entertainment Experience," *Media Psychology* 8, no. 1 (2008): 28–51.

14. Characteristic states of action readiness include: first, the tendency to attend with eagerness to mobilize and spend one's resources in order to fully grasp and view the story events, and to explore their possible causes and implications. Second, there is an eager desire to know more about characters and invest sympathy, hopes, and fears in their fates.

15. See, for example, David Bordwell, *Narration in the Fiction Film* (Madison: University of Wisconsin Press, 1985).

16. Ed Tan, "The Empathetic Animal Meets the Inquisitive Animal in the Cinema: Notes on a Psychocinematics of Mind Reading," in *Psychocinematics: Exploring Cognition at the Movies*, ed. Arthur P. Shimamura (New York: Oxford University Press, 2013), 337–367.

17. It should be noted that Frijda's inventory was used in a most liberal manner; more general descriptions—for example, appetitive or defensive states of action readiness—were also taken as points of departure, as in Frijda's "Impulsive Action and Motivation."

18. *The Notebook*, director Nick Cassavetes (Los Angeles: New Line Cinema, 2004).

19. *Lost in Translation*, director Sofia Coppola (Universal City: Focus Features, 2003).

20. *Planet Earth*, director Alastair Fothergill, featuring David Attenborough (London: BBC, 2006).

21. Emporio Armani—Spring–Summer 2010 Fashion Show, produced by Milano Moda Donna, 2009, The Ultimate Fashion Channel, http://www.youtube.com/watch?v=ui0FvW68cSg (accessed August 18, 2013).

22. For example, it was assumed that a detached action tendency like *reflect* could be properly established by asking about the appropriateness of an actual reflection ("The way Allie and Noah were dressed," and so on), rather than by mentioning the tendency itself (for example, "The dresses made me reflect"). Other items de-emphasized the action inclination while just mentioning the result: "I imagined falling while on the catwalk," rather than, "I couldn't help imagining . . ."

23. The full questionnaire can be obtained from the author. Please check his website for an e-mail address.

24. The report on the questionnaire data and their analysis is incomplete due to space limitations. A fuller report is forthcoming.

25. Scores on two items A and B co-vary if either (1) participants who score above average on A also score above average on B; or (2) participants who score below average on A also score below average on B; or (3) participants who score above average on A score below average on B; or participants who score below average on A also score above average on B. The algorithm first clusters items that show highest correlations, and then it unites clusters into larger units in subsequent steps. Clusters formed at a distance of 1.5 or larger from the origin were discarded. In our case they were item

pairs that did not seem to make much sense and were therefore regarded as unreliable measures.

26. The validity of action readiness cluster labels is illustrated by their significant correlation with a relevant emotion item. Item numbers starting with E refer to engaged emotions, and those starting with D to detached emotions:

> *The Notebook: Tender Identification* (m = 4.28, sd = .64). E1. I felt moved by Noah's defeated look; *Sympathetic Identification* (m = 2.89, sd = .76). E11. I wish I could tell Allie to pick Noah instead of her fiancé; *Savor Romance* (m = 3.19, sd = .86). D17. This movie is a great romantic film.
>
> *Lost in Translation: Be with* (m = 3.32, sd = .99). E15. I was moved by Bob carrying Charlotte to her room; *Watch/Take in* (m = 3, sd = 1.13). D18. I find Bob's attempts to communicate with Japanese funny); *Share Contentment w. Film* (m = 3.50, sd = .99). D27. This is a great film, etc.; *Reflect* (m = 3.26, sd = .80). D16. I liked Bob and Charlotte's natural understanding without making things explicit.
>
> *Planet Earth: Relax* (m = 4.04, sd = .78). D18. I felt increasingly relaxed; *Lean Forward Interest* (m = 3.10, sd = .78). E7. I was fascinated by how male dolphins impressed mating partners; *Lean Back Interest* (m = 4.23, sd = .65). D7. The underwater shots of the dolphins were lovely.
>
> *Armani Fashion Show: Be/Fuse with* (m = 2.28, sd = .94). E12. I felt dissatisfied with my body watching models; *Appetitive Approach* (2.96, sd = .97). D1. I liked the clothes the models wore; *Shut-off/Reject* (m = 2.55, sd = .96). D11. I disliked how skinny the models were.

27. Alternative narrative forms to film, such as written stories, can also present a space for participation. The studies by Richard Gerrig demonstrate they do, and also call forth virtual action tendencies. See Richard J. Gerrig and Matthew E. Jacovina, "Reader Participation in the Experience of Narrative," in *The Psychology of Learning and Motivation Vol. 51: Advances in Research and Theory*, ed. Brian H. Ross (Burlington, MA: Academic Press, 2009), 223–254.

28. Action readiness towards filmic events in the romantic drama did not pass the selections (focus group, average score 2 or higher on five-point scale, clustering with at least one other item).

29. See, for example, Melanie C. Green and Timothy C. Brock, "In the Mind's Eye: Transportation-Imagery Model of Narrative Persuasion," in *Narrative Impact: Social and Cognitive Foundations,* ed. Melanie C. Green, Jeffrey J. Strange, and Timothy C. Brock (Mahwah, NJ: Lawrence Erlbaum Associates, 2002), 315–341; Keith Oatley, *Such Stuff as Dreams: The Psychology of Fiction* (Chichester: Wiley-Blackwell, 2011); Mel Slater and Sylvia Wilbur, "A Framework for Immersive Virtual Environments (FIVE): Speculations on the Role of Presence in Virtual Environments," *Presence: Teleoperators and Virtual Environments* 6 (1997): 603–616; and Ed S. Tan, *Emotion and the Structure of Narrative Film: Film as an Emotion Machine* (Mahwah, NJ: Lawrence Erlbaum Associates, 1996).

30. A preliminary version of this chapter was presented at the conference "24 Hours of Communication Science" held at Leuven University, Leuven, Belgium, February 9–10, 2012; see Ed S. Tan, Elena Skoutaki, and Floor K. Beemsterboer, "An Empirical Study of Virtual Action Tendencies in Response to Narrative Film: Film Viewers Act in Response to Narration."

The research reported here was supported by a grant from the Netherlands Organisation for Scientific Research NWO to Ed S. Tan and Nico H. Frijda, and part of the ESF EUROCORES Programme, Consciousness in a Natural and Cultural Context (CONTACT). The author is indebted to Elena Skoutaki and Floor K. Beemsterboer, who were most helpful in constructing questionnaires and gathering the data, and to Nadine Kuijper for assistance in the analyses.

123

coloring the animated world

exploring human color perception and preference through the animated film

kaitlin l. brunick and
james e. cutting

Animated films present a unique set of challenges and questions to scholars examining films from a cognitive perspective. When the confines of the real world do not exist as they do in live action films, the filmmaker is confronted with creating the entire narrative space from scratch.[1] How do animators manage this seemingly enormous task? This question certainly predates film; creating space and life in visual art has been a subject of intense study by artists, historians, photographers, and psychologists alike. While the goal may be to create an extremely realistic visual space, the option given to visual artists and animators alike is to abandon tenets of realism in favor of an alternative perspective on the visual world. Animation alone can bring life to inanimate objects, defy laws of physics, and create visual effects impossible in live action film.[2]

Animation and color have coevolved since their respective inceptions. Color has been both a distinct challenge as well as a space for exploration for animators throughout animation's history. Scientific discoveries regard-

ing the perception of color also influenced its use in art and animation, making color an ideal target for further exploration in a cognitive context.

This chapter will pose and answer three questions. First, what exactly is color and how is it defined? Second, how has color been used by animators throughout the history of animated film? Finally, how does our cognitive experience of color shape viewers' cognitive experience of a film? The final question will address a specific population of animated films (those geared for children), and how the use of color in these films strategically differs from other types of films.

what is color?

Color is a concept that philosophers, artists, and scientists have historically spent a great deal of time exploring and quantifying. Physiologically, our perception of color results from varying wavelengths of light being reflected onto the retina, which in turn are processed by cells called photoreceptors. The relative responses to light spectra by these cells are what generates our ability to see and distinguish between colors. Anomalies in photoreceptor cells can cause deficits in the ability of an individual to see color, though in some unique circumstances these anomalies allow individuals to more finely discriminate between colors.[3]

quantifying color

Attempts to categorize color significantly predate our understanding of the physiology of the eye, but Sir Isaac Newton's 1704 *Opticks* is pivotal in its introduction of his color wheel for understanding color theory.[4] The ordering of the colors around his color circle (and in subsequent iterations by other color theorists) is based on the order in which the colors are refracted out from the prism, uniting violet and red to close the radial axis. Thus the ordering of the colors on the color wheel is not arbitrary, but based in the physics of light. Newton also introduced the notions of primary and secondary colors, and noted that opponent colors on the color wheel combine to create a neutral light color.[5]

Despite its evolution over time and its various forms, the color wheel continues to play an important part in both the artistic and psychological understanding of color. Notably, it is useful for defining several metrics of color, namely *hue* and *saturation*. Hue refers generally to named colors, and corresponds to the sectors of color into which color wheels are typically divided. Examples of hue-based descriptions include "blue-green," "red," and "pink." *Saturation* is another important color variable, and generally refers to how bright or potent a color is. Pastel colors (which are closer to the center of the color circle) are relatively unsaturated. Very saturated colors (which are referred to as "bright red" or "bold blue," for example) lie along

the outer edges of the color circle. *Luminance* is another variable important for discussing color. Luminance refers to how light or dark something is; when discussing color in particular, it refers to how much black is contained within a particular color. Unlike hue and saturation, luminance can be independent of color; in other words, black-and-white images contain no hue or saturation information but do contain luminance information. Because luminance is not a variable unique to color stimuli, it is not represented on the color wheel,[6] but nonetheless it is an important variable when discussing color. These terms, including the way in which they are mathematically quantified, will be revisited later with data.

The color wheel is not the only color quantification system to define colors using the metrics of hue, saturation, and luminance. One of the most noted color classification systems, and the one still most reliably used in psychophysiological testing, was originally developed by Albert Munsell, and also uses these color parameters.[7] Munsell compiled and organized a tremendous set of finely-grained discrete colors now known as Munsell colors or Munsell chips.[8] The Munsell color system emphasizes that color perception is dependent on the physiology of the human eye. For example, humans can identify many more discrete levels of yellow than blue at high values, whereas the reverse is true at low values. In other words, one can argue that more light yellows exist than dark yellows, whereas color wheel representations suggest that all color values exist equally in our visual environment.

While the study of how we physiologically perceive color is important, perhaps more critical in studying art and film from a cognitive perspective is the question of how we psychologically respond to color. Our preferences for, and biases toward, particular colors have the potential to influence how we respond cognitively and emotionally to art.

color preferences

Artists across visual domains recognize how the use of color affects viewers' perception of their work. Deliberate and comprehensive choices regarding the use of color permeate all types of visual art, including intentional choices to omit color from artwork.[9] Unsurprisingly, people tend to have strong predilections for particular colors. While it might intuitively seem that each individual has unique color preferences, psychological research reveals a surprising amount of concordance across people in terms of color preferences.

In terms of specific colors, research has consistently demonstrated a cross-gender and cross-cultural preference for blue hues above other hues.[10] People also tend to consistently rate yellow and brown hues as being least pleasant, especially in their darker forms.[11] Biases across populations are not limited to hue; people consistently tend to favor colors in more

saturated forms, as opposed to more washed-out or pastel counterparts of the same hue.[12]

Naturally, these consistent results drove psychologists to posit theories on the development of color preference. Some have proposed that color preference is an innate artifact of human evolutionary history, which developed to facilitate our early survival in hunter-gatherer societies.[13] Some biological evidence supports this idea; however, if color preferences are present at birth, infants and adults should show similar color preferences, when in fact they do not. Data collected from infants and young children suggest that color preferences change over time, and that while children eventually match adults on their color preferences later, they are not born with those preferences. Infants tend to prefer colors that adults classify as unpleasant, namely dark yellows, yellow-greens, and reds.[14] Children also have a preference for very high saturation that gradually diminishes to match the adult preference level for saturation.[15]

Since preferences for color dimensions seem to be dynamic over the lifespan, it is unlikely that color preferences are built in. This is not to say that color preference is purely non-functional; in fact, the ecological valence theory of color preference suggests that the early associations humans build with colored objects facilitate their color preferences.[16] For example, our early preference for dark yellows in infancy may come from consistent positive exposure to caregiver skin tones and hair color; it is only later that we learn the association between dark yellows and rotten food or excrement, at which point this preference changes direction. Conversely, as we increase our exposure to stimuli like clean water and fresh food, our preference for blues and slightly-saturated hues begins to dominate color preferences.

Yet another theory, which is particularly relevant for the use of color in an art space, is that we learn strong associations between emotion and color, and color can consequently be used to evoke particular states of emotion. Specific colors have been shown to correlate with arousal[17] and scales of emotional valence.[18] This theory is not necessarily at odds with other theories on color preference; in fact, it may simply supplement the idea that gaining positive associations with a color increases our preference for that color, which is an assumption that guides most current theories on color preference.

The question that remains from our understanding of color preference is whether or not art mimics life; in other words, how do animated filmmakers instill color in an artificial world, and do filmmakers exploit our color preferences in order to make their films more engaging?

how is color used in animation?

Color is arguably one of the most salient features of even the earliest animated films. This is not to imply, however, that the technique involved

in creating an animated space with dynamic color is a simple process. In fact, some of the biggest obstacles in moving animation forward as an art form arose from the complications of colorization.

cel animation

Often referred to as "traditional animation," the cel animation approach dominated the animated film landscape from very early in film history to the relatively recent advent of computer animation. Cel animated films composite a meticulously painted background layer, with a transparent celluloid (or "cel") layer containing foreground information. Each layer carries with it important implications for how color is ultimately represented and rendered in the final film.

The background layer, while usually created first, must work reciprocally with the cel layers in order for the colors to appear natural together and for the layers to appear integrated. The overuse of color, in particular colors that are heavily saturated, tends to overwhelm cel forms placed overtop the background; instead, the background ideally consists of more muted colors to complement the component cel forms. This led to the Disney animated film signature "watercolor effect" of its background layers.[19]

The cel layer presents significantly more challenges where color is involved, and these challenges were originally addressed by Disney's larger-budget animation studios. The physical properties of celluloid itself have implications for color: the thicker the cel, the darker the resulting colors layered onto the cel layer.[20] Thus, paint color had to be balanced in such a way that the resulting cel painting did not clash with the watercolor appearance of the background layer. Colors high in saturation were often difficult to achieve because they ultimately darkened when photographed from the cel. Disney's animators found that muted colors in the cel layer were often the best complement for a variety of background layers. When designing a character or a cel-layer object, animators were often limited by the expense of cel paint colors, and thus character design was, in a sense, limited by color. Adding to this complication, cel artists and color keys also had to adjust the color palettes of characters depending on the implied lighting of a background, to avoid a character looking overly red or overly saturated in a nighttime scene, for example.[21] Color in the cel layer also contained some complications for maintaining realism in the animated scene. For example, outlining characters in black often made their appearance visually heavier and detracted from their integration with the background layer. Disney first introduced colored inking to replace universal black inking, and colored inking was also integrated with the emerging cel Xeroxing technology.[22]

Another color problem dealt with creating depth in the cel layer: textures in hair and fur could be created via airbrushing and drybrushing, but this created a flicker effect when the individual cels were captured in sequence. Animators ultimately decided this depth was worth a certain small-scale amount of flicker tradeoff.[23]

computer animation

The cel approach dominated animated films for decades, and the interest in streamlining the cel animation process led to the initial involvement of computers in animation. The first film to be digitally composited was Disney's 1990 film *The Rescuers Down Under*.[24] Computer involvement in animation was also prioritized as a means of film restoration and improving film resolution; that same year, digital paint techniques allowed Disney to fix flaws in the original print of *Fantasia* for reissue, and in 1993, *Snow White and the Seven Dwarfs*[25] was completely "restored" to create a higher-resolution version of the film.[26] Computer-based coloring was particularly valuable because it generated more freedom to alter independent components of an image. Prior to computer involvement, color correction had to be done on a whole-frame basis; the process of digitally compositing and altering films meant that color-correction could be done on an individual object or character without the need to alter the entire frame image.[27]

The involvement of computers in animation continued to grow as the technology became more inexpensive and accessible, and animators experimented with new computer-based techniques for animating (such as crowd-generation in *Mulan*).[28] By the mid-1990s, the vast majority of cel animated films employed computers to streamline the once arduous tasks involved in hand-animating films, including colorization. Because animators no longer had to rely on physical paint or hand-calibrated background and cel layers, the colorization and texturization processes became much easier, and artists in turn were able to work with more degrees of freedom in their animating.

The revolution in computer animation began in 1995 with the first fully computer-based animated film, *Toy Story*.[29] Moving from a two-dimensional animation space into a three-dimensional, digitally-constructed environment had a huge initial investment cost (both in labor and finance), but ultimately gave the animated filmmaker a great deal of flexibility in constructing visual narratives.[30] The construction and coloring of a 3D environment and set of characters involves a great deal of initial time and planning, but the ultimate outcome is a greater degree of control in colorization, in which every individual element in the digital landscape can be fine-tuned in color space.

129

One important caveat worth noting when discussing animation is that the color of the final product is always affected by the film stock. Even in contemporary computer animation, in which color design can be done on a very fine-grained scale, the final film is ultimately rendered onto film stock. The choice of film stock, as evidenced especially by the changes in stock availability and popularity over time, as well as advances in stock quality, renders color variably.[31] Technicolor film stock was popular with early Disney animated films, which exacerbated complications with cel painting by rendering colors heavy in midtones. This forced animators and color keys[32] into a particular spectrum of colors when painting in order to achieve the desired final look on the Technicolor film stock.[33] Even in modern animated films, the change between the cel or computer and the film stock accounts for some variability in the coloring of the final product. Indeed, this is not even the last step in color variance: the original camera negative is almost always different from the colors displayed in theaters, on home televisions, or on computer screens.[34] Some of this variance can potentially be put to rest with the increasing number of films being distributed as Digital Cinema Packages (rather than in 35mm form), but it persists as a problem for those interested in the scientific study of pinpointing color in film.[35]

It is clear that artists have more freedom with color in animated films. Before digital technology, live action films were confined by the natural color of objects in a scene as well as by the limited amount of post-production work available to alter color.[36] However, from animation's inception, animators have been able to select a wide range of colors to best suit their needs, despite some of the early cost and technical constraints. The introduction of computer animation allows for the greatest amount of freedom in color control, putting the entire digital color environment under the direction of the artistic team.

The precise control of color in this setting not only has artistic consequences, but also important implications for how films can evoke particular psychological responses in their viewers. The rest of this chapter will examine the work revolving around the use of color for a particular audience of animated viewers: specifically, how filmmakers use color in animated films intended for children.

children's animated films: are there differences in color use?

In the introduction to her book *A Reader in Animation Studies*, Jayne Pilling discusses how the Disney corporation—as the first company to invest heavily in animated features—eventually became the model for animated

films, and subsequently marginalized animation into an art form "somehow intrinsically only appropriate for entertaining children."[37] Indeed, it appears that the Disney model caused an aggressive bifurcation in the animated feature world, with heavy emphasis being placed on the creation of child-oriented animated films, and a smaller contingent of artists attempting to legitimize animation as an art form appealing to adults. While Pilling is correct in that the latter set of films is certainly underrepresented in film studies literature, child-oriented animated features have a particular appeal from a cognitive perspective. Filmmakers in this animation subset face a specific challenge in trying to engage children in their visual narrative; there is ample evidence that the cognitive and attentional capacities of children differ considerably from those of adults, so what changes must the director of a children's animated film make in order to captivate this unique audience? One potential shift to accommodate this audience appears to take place in the colorization of these films.

In order to study the physical properties (including color) of children's films, we assembled a sample of G-rated children's films made between 1985 and 2008.[38] Films in the sample were the highest-grossing G-rated theatrical films from each year in the range and also included some direct-to-video films; the sample included live-action, cel animated, and computer animated films geared to a variety of ages.[39] We considered our entire sample of children's films for our original analyses; for the purposes of this chapter, only the animated films (both cel and computer) will be discussed. This sample is contrasted with a subsample of adult-geared, non-animated films from the same time period.[40] The following sections will (1) discuss how the color parameter in question was mathematically quantified, and (2) discuss the trends in the color parameter for the child- and adult-directed samples.

saturation

As discussed earlier, saturation refers to the "brightness" or "boldness" of a color. Saturation radiates outward from the center of the color circle: the center of the circle is white, with no saturation, while the edges of the circle represent fully saturated forms of a particular hue. However, when analyzing color digitally, saturation is typically not discussed in terms of a color wheel, but instead in terms of a digital color space known as the HSV cone. This space is named for its dimensions: hue, saturation, and value. Value is roughly equivalent to luminance, and this space is essentially constructed by adding this variable to the color wheel. The base of the HSV cone is a color wheel, and the height of the cone represents value. As value decreases (as the colors become darker), colors are limited in their saturation. Saturation is generally quantified on a scale from 0 (white, no saturation) to 1 (fully saturated).

Saturation levels for each pixel in a frame were digitally computed. The median saturation level for all the pixels in each frame was computed, and an average of the frames was obtained for the entire film. Within the children's film sample, we found that cel animated films use significantly more saturated colors than computer-generated animated films, independent of the year that the films were made. Both live-action children's films and the matched sample of adult-geared films have been increasing in saturation over time; in other words, newer films are prone to be more saturated than older films. However, even with this trend, the live-action children's films and adult-directed films are dramatically less saturated than their animated counterparts. This finding is both interesting and unsurprising for the same reason: the saturation levels in children's films likely reflect young children's preference for bright colors. However, it is unlikely that filmmakers are consciously making these choices based on the psychological literature; filmmakers instead are likely intuiting this preference, perhaps based on their own conceptions of how children respond to film or other parts of their visual environment. Regardless of the basis of this intuition, it is important to note that the saturation trends in the films appear to match the scientifically-established preferences of the target audience.

luminance

Though it can be measured independently of color, luminance plays an important part in color space and in how a color is ultimately perceived on screen. To assess luminance, color was digitally removed from the film using a standard digital grayscale conversion. Each pixel's luminance value is computed, with values ranging from 0 (pure black) to 255 (pure white). The mean of the pixels in a frame was averaged to create the mean luminance for that frame, and the frames were subsequently averaged to create whole-film luminance.

The trend in Hollywood films for adult audiences is a decrease in luminance; in other words, films have steadily been getting darker throughout the studied period, which has implications for directing eye gaze and attention of the viewer during the film.[41] Animated films for children, conversely, maintain a steady level of brightness independent of the year, the target age of the film, or the type of animation (cel or computer) used. While one could argue that consistent brightness is a possible artifact of representing particular colors in animation, children's live-action films increase in brightness over this period; this evidence instead supports an interpretation that the intended audience is driving the brightness level, not simply that animated films are generally brighter.

Another question posed by these findings pertains to the potential interaction between saturation and luminance. As demonstrated by the HSV

cone, colors with lower values are limited in their saturation. Is it then possible that children's films are more saturated only because they are brighter? Or, perhaps, does the inclination of filmmakers to use saturated colors in children's films necessitate a certain luminance level? While this is certainly possible, it is unlikely that the luminance findings are purely an artifact of the saturation levels, or vice versa. If this were the case, one would expect the trends in both the children's films and adult-directed films to be complementary; in other words, both luminance and saturation should increase or decrease together in the samples. This is not what we find. In the children's sample, saturation levels hold steadily across time, while these films have increased in brightness over the same period. Even more importantly, adult-geared films have become considerably darker, but have also become steadily *more* saturated, not less. This evidence suggests that while luminance and saturation have a reciprocal relationship, and while some of the variance in one accounts for variance in the other, the findings reported here on the two metrics are largely independent.

hue

As discussed earlier, hue generally refers to named colors. In both the color wheel and in the HSV cone, hue is represented around the radial edge. One major problem with this representation of hue is that it is based in circular geometry, which makes the mathematical quantification and comparison of hues difficult and unintuitive. Fully isolating luminance from hue in the HSV color space is also problematic; an ideal space for considering hue would allow for a full spectrum of colors to be represented (1) in a more convenient mathematical space, and (2) independent of luminance.

Accordingly, we considered hue using the YCbCr color space, which meets these important criteria. This color space takes the form of a rectangular prism on a diagonal axis. This color space is also named for its axes in the space: Y (on the vertical axis) refers to luminance, while Cb and Cr refer respectively to chrominance-red and chrominance-blue. The chrominance axes plot complementary colors from the color wheel (red-green and blue-yellow, respectively) on opposite rectangular planes of the prism. The distinct advantage of YCbCr is having luminance on its own axis; in this way, one could take a square slice through the prism to get a square containing all colors at an isoluminant level.

Rather than examining whole-film hue, which is nearly impossible without reducing hue on arbitrary dimensions, our research has examined the hue of particular characters in children's films. We asked independent coders to view children's animated films in grayscale, and to identify unambiguous protagonists and antagonists in the film. Frames containing these characters were selected, and the characters themselves were extracted from their background. The dominant hues of the protagonists

and antagonists were plotted on an isoluminant slice of YCbCr color space. The analyses showed that protagonists, defined as unquestionably positive and morally-right characters, contained more blue and green hues. Antagonists, conversely, contained more red and yellow hues.[42] Unlike saturation, where films mimic the preferences found in children, this analysis shows that the use of hue in children's films coincides with adult hue preferences. If children's preferences were being exploited, "good" characters would be likely to contain more child-preferred hues, such as red and yellow, whereas in reality precisely the opposite occurs. The reason for this trend is unclear, and certainly merits further analysis. One possible explanation is that the shift in hue preferences supposedly occurs earlier than the shift in saturation preferences; adults may be less aware of the hue preference in children because it shifts earlier, and thus adults and filmmakers have less exposure to this cognitive facet of child color preference.

The implications for studying children's animated films, and children's films in general, are vast. Researchers not only are able to gain insight into children's cognitive capacities and preferences, but they can also observe the early reciprocal relationship between filmmaker and viewer. While films for adults are mostly classified as art or entertainment, film in a child's world also serves as an important tool for learning. The facilitation of early learning from visual stimuli is a major goal of both psychology and education researchers, and children's films may serve as an important medium for conveying both artistic and educational information to a young population.

final thoughts

Not only is it important to note that color in film is quantifiable along several dimensions, but we must also recognize that these cinemetric data are accessible and worthy of further study. Animation in particular presents a unique opportunity for quantifying and studying color; animators have always had greater control of the colors used in their filmic world than directors of live-action films, and technology has only improved the level of detail and the deliberateness with which the animator can control the color space. This is not to suggest that instantiating color in an animated film is an easy task; whether through meticulous color selection and hand-painting, or through the arduous development of software for digital colorization, the creation of the brilliant colors typical of animated films carries with it a high investment of both time and resources.

The commonalities and differences in perception across people has always been a topic of interest for psychologists, and a cognitive approach to film is yet another way to access and interpret facets of this topic. The preponderance of films for children among animated films is in a sense very

kaitlin l. brunick and james e. cutting

134

convenient because it allows research to observe the reciprocal relationship between children's perceptual biases and how filmmakers create art and media for this audience. The developmental perspective affords us insight into the origins of our perceptions and preferences, which will likely prove to be an important pillar in cognitive perspectives to film.

notes

1. See *Animated 'Worlds'*, ed. Suzanne Buchan (Eastleigh, UK: John Libbey, 2006); and Suzanne Buchan, "Ghosts in the Machine: Experiencing Animation," in *Watch Me Move: The Animation Show*, ed. Greg Hilty and Alona Pardo (London and New York: Merrell, 2011), 28–38.
2. The introduction of computer-generated imagery (CGI) in live-action films has undoubtedly revolutionized what is possible to portray on screen in live-action films. Recent films, namely *Avatar*, blur the distinction between the once obvious classifications of films as live-action or computer-animated. For the purposes of this chapter, we will focus on more conventional styles of animation: cel animation and computer animation done independent of live-action elements such as motion capture. *Avatar*, director James Cameron (Los Angeles: Twentieth Century Fox, 2009).
3. See Maureen Neitz, Timothy W. Kraft, and Jay Neitz, "Expression of L Cone Pigment Gene Subtypes in Females," *Vision Research* 38, no. 21 (1998): 3221–3225; G. Jordan and J. D. Mollon, "A Study of Women Heterozygous for Colour Deficiencies," *Vision Research* 33, no. 11 (1993): 1495–1508; and Allen L. Nagy, Donald I. A. MacLeod, Nicholas E. Heyneman, and Alvin Eisner, "Four Cone Pigments in Women Heterozygous for Color Deficiency," *Journal of the Optical Society of America* 71, no. 6 (1981): 719–722.
4. Newton's discussion of color in *Opticks* is arguably the first work to unify the physics of color with how humans perceive it, though it is certainly not the first major work on color perception. Philosophical and artistic discussions date back to Renaissance scholars including Leone Battista Alberti, Cennino Cennini, and Leonardo da Vinci.
5. Newton defines the colors within the color circle as consecutive arcs, such that the terminal points of any diameter line would correspond to opponent colors. Despite that, mathematically, these terminal points should combine at the center of the circle (which Newton defines as white), he also notes that his experiments with combining opponent colors of light do not produce "perfect white," but instead a "faint anonymous colour." See Sir Isaac Newton, *Opticks: Or, a Treatise of the Reflections, Refractions, Inflection and Colours of Light*, 1704, 4th ed., http://www.gutenberg.org/files/33504/33504-h/33504-h.htm, 157 (accessed July 15, 2013).
6. Luminance is not represented in most color wheels, but is often represented in three-dimensional color spaces. In these representations, luminance is related to (but not identical to) the variable "value." This is discussed more extensively later in this chapter.
7. The color parameters as described by Munsell were named chroma (equivalent to saturation), hue, and value (equivalent to luminance).
8. A. H. Munsell, "A Pigment Color System and Notation," *American Journal of Psychology* 23, no. 2 (1912): 236–244; and A. H. Munsell, *A Color Notation*, 5th ed. (New York: Munsell Color Company, 1919).

9. In modern film, the choice to make a fully black-and-white film or to use limited color has served multiple artistic purposes. Recent examples of limited color include *Schindler's List*, in which color is used for highlighting symbolic content, and *Memento*, where the alternation between color and black-and-white clarifies the unusual narrative structure. *The Artist* was rendered fully in black-and-white (despite being shot on color film stock) to evoke the historical context of the film. Other modern black-and-white films, such as *Much Ado About Nothing* (2012), avoid color as a means of emphasizing the narrative and the characters over the visual aspects of the film; this use of black-and-white, as well as its consequences for the "realism" of the visual space, is hotly contested (Bordwell, 2004). *Schindler's List*, director Steven Spielberg (Universal City: Universal Pictures, 1993); *Memento*, director Christopher Nolan (Los Angeles: Newmarket Films, 2000); *The Artist*, director Michel Hazanavicius (Paris: Studio 37/Orange Studio, 2011); *Much Ado About Nothing*, director Joss Whedon (New York: Bellwether Pictures, 2012).

10. See H. J. Eysenck, "A Critical and Experimental Study of Colour Preferences," *American Journal of Psychology* 54, no. 3 (1941): 385–394; G. W. Granger, "Objectivity of Colour Preferences," *Nature* 170 (1952): 178–180; I. C. McManus, Amanda L. Jones, and Jill Cottrell, "The Aesthetics of Colour," *Perception* 10, no. 6 (1981): 651–666; and JoAnn Wypijewski, *Painting By Numbers: Komar and Melamid's Scientific Guide to Art* (Berkeley: University of California Press, 1997).

11. Stephen E. Palmer and Karen B. Schloss, "An Ecological Valence Theory of Human Color Preference," *Proceedings of the National Academy of Sciences of the United States of America* 107, no. 19 (2010): 8877–8882.

12. Granger.

13. Anya C. Hurlbert and Yazhu Ling, "Biological Components of Sex Differences in Color Preference," *Current Biology* 17, no. 16 (2007): R623–R625.

14. See Marc H. Bornstein, "Qualities of Color Vision in Infancy," *Journal of Experimental Child Psychology* 19, no. 3 (1975): 401–419; and Russell J. Adams, "An Evaluation of Color Preference in Early Infancy," *Infant Behavior and Development* 10, no. 2 (1987): 143–150.

15. Irvin L. Child, Jens A. Hansen, and Frederick W. Hornbeck, "Age and Sex Differences in Children's Color Preferences," *Child Development* 39, no. 1 (1968): 237–247.

16. Palmer and Schloss.

17. Patricia Valdez and Albert Mehrabian, "Effects of Color on Emotions," *Journal of Experimental Psychology: General* 123, no. 4 (1994): 394–409.

18. Naz Kaya and Helen H. Epps, "Color-Emotion Associations: Past Experience and Personal Preference," in *AIC 2004 Color and Paints, Interim Meeting of the International Color Association, Proceedings* 5 (2004): 31–34. For a detailed review of color-emotion literature, see also Anders Steinvall, "Colors and Emotions in English," in *Anthropology of Color: Interdisciplinary Multilevel Modeling*, ed. Robert E. MacLaury, Galina V. Paramei, and Don Dedrick (Amsterdam and Philadelphia: John Benjamins, 2007), 347–362.

19. Frank Thomas and Ollie Johnston, *The Illusion of Life: Disney Animation* (New York: Hyperion, 1995).

20. Thomas and Johnston.

21. Ibid.

22. Ibid.
23. Ibid.
24. Stephen Prince, *Digital Visual Effects in Cinema: The Seduction of Reality* (Piscataway, NJ: Rutgers University Press, 2012); *The Rescuers Down Under*, directors Hendel Butoy and Mike Gabriel (Burbank: Walt Disney Company, 1990).
25. *Fantasia*, directors James Algar, Samuel Armstrong, Ford Beebe Jr., Norman Ferguson, Jim Handley, T. Hee, Wilfred Jackson, Hamilton Luske, Bill Roberts, Paul Satterfield, and Ben Sharpsteen (Burbank: Walt Disney Company, 1940); *Snow White and the Seven Dwarfs*, directors William Cottrell, David Hand, Wilfred Jackson, Larry Morey, Perce Pearce, and Ben Sharpsteen (Burbank: Walt Disney Company, 1937).
26. David Bordwell, "Pandora's Digital Box: Pix and Pixels," blog post, http://www.davidbordwell.net/blog/2012/02/13/pandoras-digital-box-pix-and-pixels (accessed February 13, 2012).
27. Prince, *Digital Visual Effects*.
28. Two scenes in *Mulan* (the Hun attack and the final celebration scene) required the depiction of large crowds of people. Creating, painting, and animating hundreds to thousands of individual characters in these scenes would have been nearly impossible; computer animators for the film were able to more efficiently and effectively portray the very large crowds of individuals in these scenes using crowd-generating algorithms and software, including Attila (developed for *Mulan* specifically) and an early version of Pixar's RenderMan. *Mulan*, directors Tony Bancroft and Barry Cook (Burbank: Walt Disney Company, 1998).
29. *Toy Story*, director John Lasseter (Emeryville, CA: Pixar, 1995).
30. For a review, see John Lasseter, "Principles of Traditional Animation Applied to 3D Computer Animation," *ACM Siggraph Computer Graphics* 21, no. 4 (1987): 35–44.
31. David Bordwell and Kristin Thompson, *Film Art: An Introduction*, 7th edn. (New York: McGraw Hill, 2004).
32. The term "color key" refers to a subset of animation artists responsible for selecting and coordinating colors on cels and in background layers.
33. Thomas and Johnston.
34. Prince.
35. Bordwell, "Pandora's Digital Box."
36. Prince.
37. Jayne Pilling, "Introduction," in *A Reader in Animation Studies*, ed. Jayne Pilling (Sydney: John Libbey, 1997), xi.
38. See Kaitlin L. Brunick, Jordan E. DeLong, and James E. Cutting, "The Use of Hue and Saturation in Children's Film," 10th International Conference of the Society for the Cognitive Studies of the Moving Image, June 2012, Sarah Lawrence College, Bronxville, New York. For the complete list of films included in the sample, see Kaitlin L. Brunick and James E. Cutting, "The Physical Features of Children's Films" (forthcoming).
39. The direct-to-video films were selected by identifying the Internet Movie Database (IMDB; http://us.imdb.com) highest-rated direct-to-video films for binned five-year periods within the range; thus, five direct-to-video films were included in the sample. As it is almost exclusively a child-geared phenomenon, we felt that this niche of films merited inclusion alongside

137

theatrical films. The target age range of each film in the sample was obtained from age recommendation ratings from the non-profit organization Common Sense Media (http://commonsensemedia.org).

40. For films from 1985 through to 2005, see James E. Cutting, Jordan E. DeLong, and Christine E. Nothelfer, "Attention and the Evolution of Hollywood Film," *Psychological Science* 21, no. 3 (2010): 440–447.

41. See James E. Cutting, Kaitlin L. Brunick, Jordan E. DeLong, Catalina Iricinschi, and Ayse Candan, "Quicker, Faster, Darker: Changes in Hollywood Film Over 75 Years," *i-Perception* 2, no. 6 (2011): 569–576; see also Tim J. Smith, "The Attentional Theory of Cinematic Continuity," *Projections: The Journal for Movies and the Mind* 6, no. 1 (2012): 1–27.

42. Brunick, DeLong, and Cutting.

cognitive theory

and media

content

mood and ethics

in narrative film

e i g h t

c a r l p l a n t i n g a

The affective power of narrative film strongly plays into ethical criticism.[1] For example, if films can elicit moral emotions—sociomoral disgust or admiration, for example—this can confirm, enliven, or alter the perspectives of viewers on the film's subjects and on actual persons or events to which the fiction is thought to refer.[2] Thus *Blood Diamond* (2006), a film about "conflict diamonds" and the fighting that occurs in Sierra Leone over the valuable diamond fields, may elicit anger about the cruel tactics and practices of the rebel forces (the R.U.F.) in Sierra Leone, and also about the consumer market (primarily in the United States) that not only ignores but profits from the worst effects of the diamond trade on Africa.[3]

The ethical implications of engagement with fictional characters have also generated a good deal of attention. Thus Murray Smith, for example, has examined the role of moral judgment in the viewer's allegiance toward characters in film, and has examined what occurs when viewers have allegiance with characters who are apparently immoral.[4] We have also seen investigations of the role of desires in narrative fiction: for example, Gregory Currie's suggestion that "desiring things in the imagination . . .

has connections with one's tendency actually to desire them."[5] Critics and philosophers have been discussing the moral psychology of fiction for thousands of years, dating back at least to Plato and Aristotle. How do fictions engage the moral judgment of readers, listeners, or viewers? Do fictions confirm and/or alter the viewer's moral and political beliefs and values, and if so, how?

Despite this work, our understanding of the moral psychology of narrative cinema is incomplete and underdeveloped. In this chapter I hope to make a contribution to that understanding by examining the role of moods in cinematic narratives. More specifically, I will show how moods figure into the moral implications of cinematic fiction. The importance of mood in the cinema, in my opinion, is underestimated and the nature of cinematic moods has only been tentatively examined.[6] We often think of moods as the atmosphere or tenor or tone of a film or film scene, and thus we associate moods with the "feel" of a scene. We might suppose that moods are purely an aesthetic element used to suffuse the film-viewing experience with affect, to make film-viewing thrilling or nostalgic or suspenseful. And of course, it *is* true that mood figures importantly into aesthetics. But moods are also firmly implicated in the moral psychology of film viewing and figure strongly into the ethics of narrative film. It is the purpose of this chapter to demonstrate how this might be so.

moods that people have

When we speak of moods in film, what do we mean? To answer this question, we should first distinguish human moods from moods in narrative film and television. A human mood is an affective state. Other sorts of affect include reflex responses, felt bodily states (such as hunger, sexual attraction, or indigestion), desires, and emotions. I conceive of emotions, after philosopher Robert C. Roberts, as concern-based construals.[7] To take the emotion of jealousy as an example, I may become jealous when I *construe* that my romantic partner is interested in someone else, and in relation to my *concern* that I maintain an exclusive romantic relationship with her. Thus my jealousy is a construal (or perception or appraisal) based on a strong concern. Emotions are thus intentional mental states that are accompanied by a physiological disturbance, feelings, and action tendencies. There is much more to say about the nature of emotion, of course, and there are many contentious debates about emotion, but this brief definition will have to suffice for the moment.

Moods are affects in that they are felt bodily and mental perturbations. They differ from emotions in various regards. It is often said that moods have causes but not reasons. I may be in a sad or depressed mood for no identifiable reason, even though my sadness and depression have a cause. In contrast, my experience of the emotion of joy in relation to a friend's

Table 8.1 Emotions distinguished from moods

Emotions	Moods
Intentional State (relationship of subject to object)	Non-intentional State
Nameable cause (usually)	Diffuse causality (usually)
Have objects	Objectless (or only a diffuse object, i.e., the "world as a whole")
Relatively brief in duration	Longer in duration
Distinctive facial expressions	Lack of distinctive facial expressions
Modulates or biases action	Modulates or biases cognition

good fortune has a clear reason. Moods are also thought to be objectless. While my friend's good fortune is the object of my joy, my good mood (on another occasion) may have no apparent object: I just find myself contented and happy. Table 8.1 illustrates typical ways in which scholars differentiate emotions and moods.[8]

moods that films have

The mood of a film is also sometimes called its *tone* or *atmosphere*. The first thing to note is that, literally speaking, films have no moods, at least in the sense that human beings do. As audiovisual displays, narrative films cannot have mental states accompanied by bodily perturbations. When we use the word *mood* in relation to a narrative film, we either use the word metaphorically or we use it in some sense other than that we use to refer to human moods. I make this rather obvious point for the reason that we tend to run the two senses of "mood" together in our thinking, and it would clarify the issue to keep them separate. This is all the more true because the two senses are sometimes closely related, as I will show below.

What do we mean then when we say that *Singin' in the Rain* (1952) has an upbeat and joyful mood, or that Hitchcock's *Strangers on a Train* (1951) has a macabre mood of anxiousness and suspense?[9] I will argue that when we say that a film or scene has a certain mood—sadness, for example—we are making two conjoined claims: that the film or scene (1) has a strong affective character of sadness that (2) is an expression of the perspective of the film's narration, a narrator, and/or a character. In other words, a sad film has an affective character generally associated with sadness. But not only that, a sad film expresses the notion that what it shows is sad.

We sometimes describe a film as having an overall mood, such as the *joie de vivre* of 1950s American musicals such as *Singin' in the Rain* and *Oklahoma!* (1955), the bleak cynicism of *films noirs* like *Double Indemnity* (1944) or *Murder,*

143

My Sweet (1944), or insouciant, carefree confidence in caper films such as *The Sting* (1973) and *Ocean's Twelve* (2004).[10] But most films do not feature a single mood. We also describe scenes *within* films as having a mood. In Kenji Mizoguchi's *Ugetsu Monogatari* (1953), for example, five farmers are fleeing strife in their village, and set off in a boat across Lake Biwa.[11] The lake is calm on this moonlit night, and the boat floats in and out of thick wafts of fog. One of the women stands at the stern, rowing rhythmically and singing a melancholy song about the woes of humankind. All sounds are muffled in this fog, and we hear the beating of distant drums. Before the group comes upon a "ghost ship" and the bad omen waiting for them, the audience has been well prepared by the scene's mood to fully understand, both cognitively and affectively, the fear of the four villagers. In Stanley Kubrick's *2001: A Space Odyssey* (1968), to take another example, Kubrick's decision to respect the deep silence of space on the film's soundtrack lends an air of emptiness and extreme loneliness to some of the scenes.[12] In the *Star Wars* films, on the other hand, in which sound designer Ben Burtt decided to forsake realism, the whooshing and deep bass rumbling of the spaceships, together with other exuberant and humorous sounds never actually heard in space, make the space scenes emotionally warmer and more dramatic.[13]

I take it for granted that most, if not all, films, film scenes, shots, and sounds have an affective character. Even mere objects within shots or discrete sounds on the soundtrack have an affective character. We might *not* normally say that a shot of a gurgling brook and the sound of a blood-curdling scream, for example, have moods, but this is only because in talking about films we tend to reserve the word *mood* for the affective character of the film as it is extended in time. When it is extended in time, we call this affective character a mood, be it sad, happy, suspenseful, vibrant, boring, horrifying, anxious, calm, and so on.

Of course, none of this is surprising. Expression theorists such as R. G. Collingwood and Leo Tolstoy have long held that what is essential to the arts is the expression of emotion or feeling, these words typically used in a broad way that would include what I call mood.[14] Such theories have a long and illustrious history, and are still powerful and convincing today in some respects. That mood has an important role to play in film and the other arts fits with Georg Wilhelm Friedrich Hegel's contention that in the arts ideas are presented in sensuous form rather than through the conceptual thought of philosophy.[15] Richard Wollheim, in writing about painting, has claimed that human beings have a capacity rooted deep within our psychology to "project" our internal states onto natural objects.[16] The idea seems to be, in part, that we characterize inanimate objects in affective terms in response to how such objects affect us.

I am not certain that our association of light, colors, compositions, objects, symbols, and ideas with affective qualities is merely a matter of projection, however. If we were to ask the question, why do human beings

attribute affective or other psychological qualities to inanimate entities, we might have to admit that the reasons are various and perhaps not subsumable under a simple and unified theory.[17] To gauge the affective impact of film elements, filmmakers draw from a web of cultural associations deeply embedded in religious, political, and ethical standpoints. Think of the affective associations of the swastika, the Christian cross, or any recognized national flag. But the affective qualities of other objects come not from cultural association but from physical resemblances or fittingness between artistic qualities and the natural expression of human emotion.[18] Thus a softly curving line is much more likely to be associated with calm music than a jagged line, and a scene featuring frenzied editing and lively camera movement is expressive of energy and vitality rather than calm repose.[19] In addition to cultural association and fittingness, the evocation of affect is another cause of our association of an entity with a particular affective character. A scene might be sad because it evokes a feeling state associated with sadness, or happy because its affective qualities—humor, energy, and smiles, for example—are associated with happiness. Whether the association of films with affective qualities comes about through cultural association, fittingness, and/or the tendency to evoke associated mental and feeling states, it is clear that audiences experience films in relation to mood and/or affective character.

I would add here that the mood of a scene or film is experienced as a gestalt, that is, as an overarching way of experiencing a particular scene or film. Thus the Lake Biwa scene in *Ugetsu* uses mood to represent the journey across the lake as frightening, mysterious, even supernatural, while Kubrick's representation of deep space shows it to be lonely and inhospitable. The mood of a scene or a film is a *way of seeing* or *experiencing* the fictional world of the film.

My first claim about mood, then, is that the mood of a scene or film is its overall affective charge, considered as a gestalt. My second claim is that in the viewer's experience of a film, mood is a fundamental means by which the narration communicates attitude, perspective, or point of view. A mood in narrative film is not merely the film's affective character. Natural landscapes have an affective character; each day that we live has an affective character: it feels a certain way. What separates art moods from the mood of a day or a landscape is that we take the art mood to express a perspective or point of view. A natural landscape does not express a perspective: it simply is. The mood of *Singin' in the Rain* or *Oklahoma!*, on the other hand, expresses something about the joyful and colorful worlds of those films. This is so because a narrative film, unlike a landscape, is a human artifact designed to communicate with its audiences, and the mood of a film is an important tool used to communicate perspective.

It is important here to note what I do not mean. I do not mean that the mood is necessarily an expression of a mood that the filmmakers actually

had. I suppose that a work of art *could* express the mood of one or more of its makers. But it could also be an expression of a mood that *none* of the filmmakers actually had, that is unique to the experience of the work of art and that emerged only through the making of the film. Perhaps it was a surprise to the audience and filmmakers alike. Neither do I think that the mood of a scene or film is necessarily the expression of a point of view we attribute to any particular persona, whether an implied filmmaker or a character within the diegesis. It *can* be so attributed, of course, but we often experience mood as the perspective of the narration, and the narration is not necessarily experienced as deriving from a person or as a persona. We sometimes accept the narrational perspective of a narrative film without inquiring or caring much about whose perspective it is. After viewing the film, we might think that the perspective embodied in the film is equivalent to that of the director, screenwriter, one of the actors, or the composer. But we cannot assume that. What we *can* know is that the film—this constructed artifact that we have just experienced—takes such and such a perspective, or embodies a particular way of seeing or experiencing war or outer space or romantic love or whatever. This is the perspective or point of view of the narration.

In a recent essay, Robert Sinnerbrink argues that mood in narrative cinema works to disclose "cinematic worlds." Our response to a film character, for example, "depends on the sensuous-affective background or encompassing 'mood' against which our complex flow of emotional responsiveness becomes manifest."[20] I would add that the mood of a scene or of an entire film can be presented as an expression of narrative point of view generally, or it may be developed as a character's perspective. Often, narrational and character point of view are united, as the film's narration will express an overarching mood to give us a sense of the protagonist's experience, as in Hitchcock's *Rebecca* (1940).[21] Of course, mood in the latter case, ultimately, is also a function of the film's narration, even if the mood is associated with a character's subjective experience.

the functions of cinematic moods

What roles do moods have in our experience of narrative cinema? Mood clearly has a central place in the *aesthetics* of film. Audiences delight in the sensual qualities of mood, of course, but moods also embody a perspective on the world of the film and figure prominently into the creation of fictional worlds.[22] In relation to the aesthetics of mood, Sinnerbrink lists four types of moods: disclosive (encompassing or characteristic of the entire film); episodic (confined to an episode or sequence); transitional (assisting in the move from one scene to another); and autonomous (where moods take on "a primary rather than a supporting role in the composition of the fictional world").[23] We could establish other important categories of mood

as well, based, for example, on whether or not an expressed mood is *focalized*, that is, established as that of one or more characters, or *world-based*, the mood of the fictional world generally (as established through the narration). For example, the brooding and nostalgic mood of Alfred Hitchcock's film *Rebecca* is focalized, wholly an expression of the mood of the protagonist, while the moods of other Hitchcock films such as *Strangers on a Train* and *North by Northwest* (1959) are sometimes focalized and sometimes world-based.[24]

Beyond aesthetics, however, ethical criticism will be interested in the ways in which filmic moods relate to the spectator's experience of the film, to viewer affect and cognition. Greg M. Smith claims that the evocation of mood is central to narrative cinema, and that its central function is to prepare the way for particular sorts of emotions.[25] If the film provides an upbeat mood, it is easier for filmmakers to elicit emotions associated with good moods, such as laughter, happiness, and elation. This makes sense given that certain moods and emotions share what psychologists call a "valence." Negative emotions such as distress, annoyance, and sadness share a valence with various "bad" moods, as do positive emotions such as gladness, delight, and astonishment with "good" moods.

But let us back up one step. Smith's theory tends to conflate art moods and human moods, at least insofar as the theory does not explicitly distinguish between them. But does a sad film make viewers sad, or an anxious film make them anxious? And if this is so, how might this process occur? The causes of human moods are diverse and somewhat mysterious; moods can be caused by factors internal to the person or by characteristics of the environment. We have long known that various perceptual experiences can influence our moods. We also have a degree of control over our own moods and those of others. Listeners manage their moods through their choice of music, and commercial enterprises have spent fortunes attempting to manage the moods of consumers through background music.

If music by itself can influence mood, then it seems clear that narrative cinema, which typically employs music as one instrument among many in its expressive toolkit, can do so as well. Narrative films induce human moods in at least three ways: (1) by eliciting emotions (which can lead to changes in mood);[26] (2) by highlighting "qualities" of form and content associated with particular moods; and (3) by encouraging cognition or "cognitive styles" associated with moods. All of this requires some un-packing, and elsewhere I have argued in more detail for these claims; for now, suffice it to say that the moods of a film can influence the viewer's actual mood in at least these three ways.[27]

Filmic moods also bear on human thought. The human emotions have what Noël Carroll has called a "searchlight" function, in that when they are experienced, they direct attention to salient elements of an

147

environment.[28] When in a state of fear, for example, a person will give rapt attention to anything that might cause harm, while a jealous lover will ardently search for any sign that a favored one is directing amorous thoughts to another. In human evolutionary history, the emotions had the adaptive advantage of quickly focusing the person on salient aspects of the environment. Human moods, like emotions, also have effects on thinking and perceiving. Inducing moods in narrative is a means of directing thought and perception, and mood evocation becomes another device in the writers' and filmmakers' toolkits.

The cognitive effects of moods have been well established. While emotion researchers tend to focus on the causality of emotions, researchers focused on mood pay more attention to the effects of mood on memory, social judgment, thinking, and perceiving. Carroll describes the cognitive import of emotions and moods as follows. Emotions are directed at specific objects, while moods are diffuse. Emotions are selective and exclusive, while moods are incorporative and inclusive. Moods pervade perception rather than focus it. Moods bias the subject toward making certain kinds of judgments over others, but are linked to cognition indirectly rather than directly. Moods are like frames of mind, setting a broad agenda.[29]

The social science literature on the influence of mood on perception and cognition is vast, offering theories of how good and bad moods influence perception and styles of cognitive processing. For example, moods influence memory, and persons in a bad mood more frequently and regularly recall negative memories.[30] Moods are associated with biases in attention and "processing styles." Negative moods, for example, may lead to a relatively narrow focus of attention, analytic thinking, and a focus on details.[31] The most general function of moods, psychologist Richard J. Davidson writes, is to bias cognition in a general sense, not toward a particular object but toward "life" or "things in general."[32] For our purposes, psychologist Joseph P. Forgas's summary of the findings will more than suffice:

> . . . affect and cognition are integrally linked within an associative network of cognitive representations . . . Thus, material that is associatively linked to the current mood is more likely to be activated, preferentially recalled, and used in various constructive cognitive tasks, leading to a potential mood congruency in attention, learning, memory, associations, evaluations, and judgments. In other words, affect is not an incidental, but an inseparable, part of how we see and represent the world around us; how we select, store, and retrieve information; and how we use stored knowledge structures in the performance of cognitive tasks.[33]

In other words, moods do not merely affect discrete elements of our conscious experience, although they can do that. Moods also have the tendency to draw together cognition, judgment, memory, and associations based on prior experience. This understanding of mood lends credence to Martin Heidegger's claim that mood is one of the existential categories through which we understand our "being in the world."[34] We need not accept his overall metaphysics to see merit in the idea that a mood is not merely a feeling, but a gestalt or schema through which we experience the actual world or, more to the point here, the fictional world of a work of art. Knowing that moods in film strongly influence the spectator's affective *and* cognitive experience lends support to my argument that filmic mood plays a central role in the ethics of narrative film.

mood and ethics one: mood as perspective

There are many ways in which narrative films are subject to ethical concerns and ethical criticism. Here I will be concerned with three of these. First, films can express claims or perspectives or can embody a worldview that can be evaluated on ethical grounds. Second, films may be thought to affect moral understanding. Third, films may have various effects that are subject to moral evaluation: for example, films may alter or else confirm the viewer's sympathies or moral intuitions. I will argue that mood in film plays a role in all three of these, and that mood is therefore of central concern for an ethics of narrative cinema.

Let us begin with the claims or perspectives or worldviews propounded by narrative films. In this regard, a filmic mood can be considered as a perspective on the fictional world presented in the work. Yet both the source and the target of a film's mood are sometimes difficult to identify. Thus if mood is a central means by which the attitude or perspective of the narration is established, it is also important to understand the source and target of the mood. Some cases are relatively easy. For example, consider the target of *Blood Diamond*, mentioned above, which tells of individuals caught up in the civil wars in Sierra Leone. The film shows torture, killing, kidnapping, and the despicable training of child soldiers to do the bidding of their violent captors. The major characters are fictional, but representative of real people in similar circumstances. How is the mood established for this film? The first image we see is a featureless map of Africa, marking the location of Sierra Leone. Then we see graphics that establish the setting, Sierra Leone in 1999, and state: "Civil war rages for control of the diamond fields. Thousands have died and millions have become refugees." This beginning clearly establishes close connections between the story of the film and historical reality, and thus the target of any mood will likely be not only the film's depicted events and persons, but also by analogy all similar events and situations in Africa.

The mood of *Blood Diamond* might be described as one of sympathetic and anxious concern. This is established at the story's beginning, as we are introduced to Solomon (Djimon Hounsou) and his warm relationship with his son, followed closely by the arrival of trucks with violent warriors who ravage the village and cause Solomon and his family to flee. The mood of anxious concern is established not only by the terrible events we are shown, but by the music; close-ups of frowning and crying faces; the sounds of screams, yelling, gunfire, and deep bass rumblings; chaotic editing and camera movements; and many expressions of strong and sincere emotions by the characters, such as anger, compassion, sadness, and terror. This sympathetic and anxious concern is carried through much of the narrative: clearly, it is the world-based expression of the film's narration toward the events shown and toward the reality beyond which the narrative points. The mood implies that viewers should be sympathetic and concerned about Solomon and his family, and, by extension, about the thousands of people in Africa who are in situations similar to that of Solomon.

Both the source and target of the mood of *Blood Diamond* are easy enough to discern. This is not true for all films, however. Consider Stanley Kubrick's *A Clockwork Orange* (1971), in which Alex and his droogs joyfully maim, kill, rape, and otherwise terrorize others on their rampages of destruction.[35] Near the beginning of the film we see a rival gang—Billy Boy and his four "droogs"—on the stage of an abandoned theater, assaulting a woman, stripping off her clothes, and preparing to rape her. Alex and his droogs show up, interrupting their attempted rape, and they begin to taunt the rival gang. Alex calls Billy Boy "thou globby bottle of cheap, stinking chip oil," and initiates a fight between the two gangs that ends with Alex and his men beating their rivals to a pulp.

The mood of the scene is seemingly inappropriate. On the soundtrack plays the overture to Rossini's *The Thieving Magpie*—music that is both majestic and florid, dramatic and ironic—lending the scene an ambiguous quality. Both the attempted rape and the violent fight are treated more or less as farces. The attempted rape occurs on a stage. The shot begins with the camera slowly craning downward from the top of the proscenium arch, with its ornate statuary, to the action on stage below. The music is anempathetic in relation to the attempted rape: that is, it is inappropriate

to the weightiness of the crime being committed. It renders the woman's screams as faintly ridiculous, or "weepy" as Alex puts it. When Alex arrives on the scene, Billy Boy and his gang release the now-naked woman, and she escapes and runs away, the camera voyeuristically following her as she flees. The fight that ensues between the two gangs is comic, using almost every cliché of fight choreography. The droogs smash each other with chairs, windows, and beer bottles; they jump and dive onto various surfaces and through windows; one droog holds two others in a headlock; another

trips someone with a billy club, using the momentum of an attacker to throw him across the room; a droog is tossed from a great height onto a table below, which smashes to smithereens. The mood in the scene can be described as light-hearted and comical, which initially seems wholly inappropriate to scenes of rape and violent bloodshed. Clearly some moods are ethically inappropriate to certain types of subject matter, because moods express attitudes or perspectives.

Yet in this case, I would argue, the perspective developed through the mood is less clear than that of *Blood Diamond*. There is no space here for a full examination of *A Clockwork Orange*, but a few observations might be helpful. For one, it is difficult to tell if the mood of the scene in question is a focalized expression of the droogs' perspective or the world-based perspective of the narration. If the mood is meant to capture the droogs' outlook and mental state, and if that outlook and mental state is elsewhere subjected to criticism or rejection, then the claim that the *narration* takes a light and comic attitude toward rape and violence would be wrong. But supposing that we decide that the mood of this scene *does* express the perspective of the narration. The next question to ask is this: what is the target of the perspective taken? We saw that in the case of *Blood Diamond*, the events depicted are presented as having strong analogies to actual events of a similar nature. I would contend that Kubrick has something else in mind. He does not mean for the scene to be representative of actual historical events, or to embody a permissive attitude toward actual rape and violence, so much as a distanced comment on human nature and its propensity for violence. That is, the comic tone may be expressive of a light and ironic perspective on rape and violence, but only in the context of an irreverent thematic examination of human nature generally.

My purpose is not to excuse Kubrick for the mood of this and other troubling scenes in the film. It could be argued that Kubrick's philosophical interests cannot justify the ironically cheerful treatment of sexual violence. But neither is it the case that *A Clockwork Orange* simply revels in sexual violence. We should make a distinction between sympathetic and distanced narratives.[36] Sympathetic narratives encourage strong emotional responses in relation to the plight of one or more characters, while distanced narratives encourage curiosity, fascination, disdain, and sometimes ironic distance, but not strong sympathies. *A Clockwork Orange*, like many other Kubrick films, is a cerebral narrative that sacrifices strong concerns for characters with a more distanced consideration of abstract themes regarding human nature.

Considerations of mood are important in ethical criticism of films, then, in part because films can be seen as contributions to cultural conversations about ethical issues, and their perspectives or worldviews are subject to ethical concerns.

151

mood and ethics two: mood and moral understanding

Narrative films are also subject to ethical criticism because they may be thought to contribute to moral understanding or moral confusion. One argument against the moral significance of narrative fictions (and other works of art) is the argument from cognitive triviality. The claim here is that works of art cannot make a serious contribution to moral understanding because they presume simple moral precepts or truisms that audiences already know. Noël Carroll responds to this argument by making a distinction between knowing that and knowing how. He makes an analogy to illustrate the difference between the two:

> It is one thing to be told that roadways in Mumbai are massively overcrowded; it is another thing to be given a detailed description full of illustrative incidents, emotively and perceptively portrayed. The first presents the fact; the second presents the flavor. The first tells you that the streets are congested; the second gives you a sense of what that congestion is like.[37]

If works of art and especially narrative fictions can be morally instructional, it is arguably through this "knowing how" more than "knowing that." Moral knowledge can be increased not merely by knowing that war is hell, but in becoming acquainted with what it is like to be in a war. My moral understanding of homelessness or loneliness or oppression is enhanced if a work of art can give me a sense of what it feels like to be homeless or lonely or oppressed. Narrative fiction can also hone the viewer's ethically relevant skills and powers, for example, by engaging audiences in a constant process of moral evaluation. Good narrative art can exercise our emotions and imagination in ways that can fine-tune our judgments and understanding, just as an athlete practices an athletic skill.[38]

If this is true, how does mood fit into the process of moral instruction? The claim or intuition here is that interacting with narrative fictions is a bit like engaging in a game of social simulation, in which narrative situations are presented with clarity and perceptual realism, and in which viewers must make sense of a film or scene in relation to the actions, motivations, and emotions of the characters. What narrative film offers in this regard is an experience of social reality that is closer to conscious experience than perhaps any other art form. The film may include photo-realist depictions of characters that reveal facial expression, gesture, posture, and body movements; sounds that reveal tonality, emotion expression, and the grain of the voice; movements and dialog and interaction and reaction rooted in complex character behavior in a social setting. The experience of a narrative film engages the intellect and affect in an evolving and wholly interconnected temporal sequence.

The mood of a film or a film scene is just *one* important element of this experience, but it is an important one. I have always admired *The Silence of the Lambs* (1991) because I find it to expertly portray what I imagine it must be like for a woman to work in environments dominated by men.[39] In this case, the woman is Clarice Starling (Jody Foster), whom we initially meet as she trains to become an agent of the Federal Bureau of Investigation, a law enforcement agency of the United States government. Mood establishes a sense of anxiety and threat, the threat of dangerous killers with whom she must consort, and the less lethal but still significant threats that emerge from operating in a professional world dominated by men. This mood of darkness, threat, and anxiety is established in the film's first scenes through color schemes dominated by blues, the use of fog, vaguely suspenseful music, the looks of male agents at Clarice, shots such as the elevator shot that emphasizes Clarice's female face among the taller and physically close men, and close-up shots of Clarice's furrowed brow, suggesting determination but also discomfort. All work to establish a mood that audiences can not only intellectually understand but also feel. This in turn works into our understanding of Clarice's experience in light of her gender.

mood and ethics three: mood and spectator effects

Beside an interest in a film's claims or implications and the possible moral knowledge or confusion it offers viewers, ethical critics are also interested in the *effects* of narrative films on spectators. We might think of this as the moral rhetoric of narrative fiction. Films might imply a perspective on a moral or political issue, but how can films make that perspective persuasive? Aristotle, in his *On Rhetoric*, wrote that the persuasive orator, in addition to fashioning a compelling argument and developing a trustworthy ethos, needed to arouse the emotions of listeners. Aristotle defines an emotion as a kind of feeling caused by a kind of thinking. A skilled rhetorician, he says, can reverse the causality, leading the audience to think a certain way by causing them to feel a certain way.[40] Assuming that this is true, we might speculate about why this is so. How can affects elicited by an oration or fiction alter or affirm ways of thinking? For one thing, strong emotions in the spectator presuppose rapt attention to the cause of the emotion. If I am made angry or disgusted by a narrative film, it goes without saying that it is making an impression on me. Strong emotions have a way of forging a place for their elicitors in our memory. If *The Silence of the Lambs* provides me with a powerful affective impression of Clarice Starling's discomfort in a world dominated by men, I will not soon forget this. It may also be that human beings have a tendency to take their affective responses as justified, realistic, or trustworthy, even when elicited by a skilled orator or a powerful work of narrative fiction. If we take our response as justified

or realistic, I would take that to mean that we accept the perceptions or judgments on which the response is based as *legitimate*.

To put these ideas squarely in the realm of moral change and the ethics of fiction, we should consider the claims of the social intuitionist model of moral judgment. Jonathan Haidt and others have argued that moral judgments are intuitions rather than reasoned conclusions, and that moral intuition is a kind of cognition, but not a kind of reasoning.[41] As Haidt notes, the social intuitionist model of moral judgment is anti-rationalist, but only in one narrow sense: that is, in its claim that moral reasoning is rarely the direct cause of moral judgment. The social part of the model derives from its insistence that moral judgment is an interpersonal process, emerging from innate tendencies that are modeled through learning within a cultural context. For the social intuitionist, moral judgments can sometimes be altered by private reasoning, but are more likely to be altered by triggering "affectively valenced intuitions" in listeners or viewers.

How do moods in cinema play into this? If a film presents a perspective on an issue, it does so in part through the affectively charged qualities that we call mood. Mood and emotion work in tandem, but each plays a role in the moral intuitions triggered by a film. Perhaps I had never seriously thought about what it means to be a woman in a male-dominated workplace; upon seeing *The Silence of the Lambs*, my sympathy for Clarice Starling, together with the oppressive and anxious mood of the film, can trigger a valenced moral intuition about the difficulties of working in such a situation and, more importantly, of how it ought not to be that way. If a film acquaints us with fictional characters and narrative situations that in principle can alter our moral understanding, and if it can do so in such a way that it simultaneously triggers powerful and memorable moral intuitions, then a story can be effective in affirming and/or altering our moral intuitions about types of characters and situations. Mood plays an important role in the triggering of such intuitions, in part by providing an atmosphere within which such intuitions seem right and compelling.

In summary, then, mood in narrative cinema relates to ethical criticism because it is one of the primary ways through which a film can express a perspective and develop a worldview; mood can strongly affect the viewer's moral understanding of characters and narrative situations; finally, mood can contribute to affectively-valenced intuitions that have the capacity to influence the spectator's moral judgments. Moods in narrative cinema are certainly not the whole story, but their importance in ethical criticism should not be neglected.

notes

1. Throughout this essay I use the term "film," but most of my claims apply to television as well and, more broadly, to what we might call "audiovisual fiction."

2. For an examination of the rhetoric of emotion in narrative film that uses disgust as a case study, see Chapter 7: "The Rhetoric of Emotion: Disgust and Beyond," in my *Moving Viewers: American Film and the Spectator's Experience* (Berkeley: University of California Press, 2009), 198–220.

3. *Blood Diamond*, director Edward Zwick (Burbank: Warner Brothers, 2006).

4. Murray Smith, *Engaging Characters: Fiction, Emotion, and the Cinema* (Oxford: Clarendon, 1995), 187–227; Murray Smith, "Gangsters, Cannibals, Aesthetes, or Apparently Perverse Allegiances," in *Passionate Views: Film, Cognition, and Emotion*, ed. Carl Plantinga and Greg M. Smith (Baltimore, MD: Johns Hopkins University Press, 1999), 217–238; see also my "'I Followed the Rules, and They All Loved You More': Moral Judgment and Attitudes Toward Fictional Characters in Film," *Midwest Studies in Philosophy* 34, no. 1 (2010): 34–51.

5. "Narrative Desire," in Plantinga and Smith, 198.

6. Good starting points for examinations of mood in film are Greg M. Smith, *Film Structure and the Emotion System* (Cambridge: Cambridge University Press, 2003); Robert Sinnerbrink, "*Stimmung*: Exploring the Aesthetics of Mood," *Screen* 53, no. 2 (2012): 148–163; and Carl Plantinga, "Art Moods and Human Moods in Narrative Cinema," *New Literary History* 43, no. 3 (2012): 455–475. On mood in the arts generally, see Noël Carroll, "Art and Mood: Preliminary Notes and Conjectures," *The Monist* 86, no. 4 (2003): 521–555.

7. Robert C. Roberts, *Emotions: An Essay in Aid of Moral Psychology* (Cambridge: Cambridge University Press, 2003), 60–179; Plantinga, *Moving Viewers*, 53–59.

8. Useful discussions of the nature of mood in relation to affect generally can be found in *The Nature of Emotion: Fundamental Questions*, ed. Paul Ekman and Richard J. Davidson, Series in Affective Science (New York: Oxford University Press, 1994), 49–96.

9. *Singin' in the Rain*, directors Stanley Donen and Gene Kelly (Beverly Hills: Metro-Goldwyn-Mayer, 1952); *Strangers on a Train*, director Alfred Hitchcock (Burbank: Warner Brothers, 1951).

10. *Oklahoma!*, director Fred Zinnemann (St. Louis, MO: Magna Theatre Corporation, 1955); *Double Indemnity*, director Billy Wilder (Los Angeles: Paramount Pictures, 1944); *Murder, My Sweet*, director Edward Dmytryk (Los Angeles: RKO Radio Pictures, 1944); *The Sting*, director George Roy Hill (Los Angeles: Zanuck/Brown Productions, 1973); *Ocean's Twelve*, director Steven Soderbergh (Burbank: Warner Brothers, 2004).

11. *Ugetsu Monogatari*, director Kenji Mizoguchi (Tokyo and Kyoto: Daiei Studios, 1953).

12. *2001: A Space Odyssey*, director Stanley Kubrick (Beverly Hills: Metro-Goldwyn-Mayer, 1968).

13. The first film in the Star Wars saga to be released was *Star Wars Episode IV: A New Hope*, director George Lucas (San Francisco: Lucasfilm, 1977).

14. Leo Tolstoy, "What is Art?", and R. G. Collingwood, "The Principles of Art," in *Aesthetics: A Comprehensive Anthology*, ed. Steven M. Cahn and Aaron Meskin, Blackwell Philosophy Anthologies (Malden, MA and Oxford: Blackwell, 2008): 233–242, 282–295.

15. Georg Wilhelm Friedrich Hegel, *The Philosophy of Fine Art*, trans. F. P. B. Osmaston (London: B. Bell and Sons, 1920).

16. Richard Wollheim, *Painting as an Art* (Princeton, NJ: Princeton University Press, 1987).

17. See Jenefer Robinson, *Deeper Than Reason: Emotion and its Role in Literature, Music, and Art* (Oxford: Oxford University Press, 2005), 251–253.

18. Derek Matravers, "Art, Expresssion, and Emotion," in *The Routledge Companion to Aesthetics*, ed. Berys Gaut and Dominic McIver Lopes, 2nd ed. (London and New York: Routledge, 2005), 445–456.

19. In my book *Moving Viewers* I refer to this phenomenon as "synesthetic affect." See 156–168.

20. Sinnerbrink, 152.

21. *Rebecca*, director Alfred Hitchcock (Culver City: Selznick International Pictures, 1940).

22. Plantinga, "Art Moods and Human Moods."

23. Sinnerbrink, 151–161, quotation 161.

24. *North by Northwest*, director Alfred Hitchcock (Beverly Hills: Metro-Goldwyn-Mayer, 1959).

25. Greg M. Smith, *Film Structure and the Emotion System*.

26. It is important to remember here that moods and emotions are different sorts of affect, such that one can influence the other.

27. On the capacity of mood in film to elicit human moods, see Plantinga, "Art Moods and Human Moods"; also see Carroll, "Art and Mood."

28. Noël Carroll, "Film, Emotion, and Genre," in Plantinga and Smith, 28–29.

29. Carroll, "Art and Mood," 527–530.

30. David M. Clark and John D. Teasdale, "Diurnal Variation in Clinical Depression and Accessibility of Memories of Positive and Negative Experiences," *Journal of Abnormal Psychology* 91, no. 2 (1982): 87–95; Alice M. Isen, "Toward Understanding the Role of Affect in Cognition," in *The Handbook of Social Cognition*, Vol. 3, ed. Robert S. Wyer, Jr. and Thomas K. Srull (Hillsdale, NJ: Lawrence Erlbaum Associates, 1984), 179–236.

31. Alice M. Isen, "Positive Affect and Decision Making," in *The Handbook of Emotions*, ed. Michael Lewis and Jeanette M. Haviland (New York: Guilford Press, 1993), 261–277; Robert C. Sinclair and Melvin M. Mark, "The Influence of Mood State on Judgment and Action: Effects on Persuasion, Categorization, Social Justice, Person Perception and Judgmental Accuracy," in *The Construction of Social Judgments*, ed. Leonard L. Martin and Abraham Tesser (Hillsdale, NJ: Lawrence Erlbaum Associates, 1992).

32. Richard J. Davidson, "On Emotion, Mood and Related Affective Constructs," in Ekman and Davidson, 52.

33. Joseph P. Forgas, "Introduction: The Role of Affect in Social Cognition," in *Feeling and Thinking: The Role of Affect in Social Cognition*, ed. Joseph P. Forgas, *Studies in Emotion and Social Interaction*, Second Series (Cambridge and Paris: Cambridge University Press and Maison des Sciences de l'Homme, 2000), 11.

34. Michael Inwood, *Heidegger: A Very Short Introduction*, Very Short Introductions (Oxford: Oxford University Press, 2002), 40–44.

35. *A Clockwork Orange*, director Stanley Kubrick (Burbank: Warner Brothers, 1971).

36. Plantinga, *Moving Viewers*, 170–172.

37. Noël Carroll, "Art and Ethical Criticism: An Overview of Recent Directions of Research," *Ethics* 110, no. 2 (2000): 362.

38. Ibid., 367.

39. *The Silence of the Lambs*, director Jonathan Demme (Strong Heart/Demme Production, 1991).

40. Aristotle, *On Rhetoric: A Theory of Civic Discourse*, trans. George A. Kennedy (New York: Oxford University Press, 1991), 139.

41. Jonathan Haidt, "The Emotional Dog and its Rational Tail: A Social Intuitionist Approach to Moral Judgment," *Psychological Review* 108, no. 4 (2001): 814–834.

effects of entertaining violence

nine

a critical overview of the general aggression model

dirk eitzen

When we watch violent movies and play violent videogames, we necessarily entertain violence, which is to say we think about it and imagine it. Brain science shows that when we imagine an action or situation, we rehearse it in those parts of the brain involved in similar situations in the real world. We do not merely observe and judge violence that we see on the screen, in other words; we are actively involved in it, even if only imaginarily. There is no question that this kind of involvement has physiological, psychological, behavioral, and cultural effects. Since real world violence is harmful, it behooves us to weigh carefully what these effects are. Yet we should be careful about jumping to conclusions.

If we want to tease out the relationship between imagined violence and actual violence, we need to be absolutely clear that these are different things. There is nothing intrinsically harmful about violence on a screen or in somebody's head. Imaginary violence is not an actual problem; real violence is. It is only when imaginary violence spills over into actual harm in some way that it becomes a problem. Still, the possibility of such spillover

warrants caution and concern. We need to keep in mind that just because something is "fun," this does not mean it is harmless.

But we also need to keep in mind that just because something is dangerous, this does not mean it is "bad." Consider cars. Cars maim and kill countless people every year. They poison the environment and contribute to global warming. They are a huge risk factor for several kinds of calamity. Yet in our culture, most of us cannot get by without them. Their immediate benefits—such as the ability to travel long distances quickly and conveniently—outweigh their longer-term risks. But it would be foolish to ignore the risks of cars, so we do what we can to mitigate these, with safety belts, catalytic converters, speed limits, mass transit systems, and so on. The question we ask of cars is not, "How can we avoid them?" (We cannot. Even the Amish, with their buggies, have to contend with automobile traffic and occasionally need to hitch or hire rides in cars and vans.) The question we ask is, "How can we use them for appropriate purposes while minimizing their potential for causing harm?" That is the same question we need to ask of violent entertainments.

Social scientific research into media violence is indispensable for answering this question. Unfortunately, most of it ignores the first half of the question. It looks at risks without considering rewards. It ignores or dismisses positive aspects of aggressive behavior, such as play. It puts violent thoughts and violent deeds on the same scale, as though the difference between them is merely a matter of degree. As a result, it tends to be used to support alarmist and all-or-nothing solutions rather than deliberate, discriminating, socially appropriate uses of depictions of violence. What is needed is a more holistic way of thinking about the effects of entertaining violence.

the limits of scientific data

It is quite reasonable to suppose that the casual violence we see routinely in popular movies may make us just a little bit less likely to notice and care about suffering we may encounter in the real world. In 2008, media researchers Brad Bushman and Craig Anderson devised a couple of clever experiments to test this hypothesis.[1] In one, they positioned a woman on crutches just outside a movie theater, had her drop a crutch on cue, and timed how long it took passing theater patrons to help her pick it up. When people were on their way into a movie, whether it was a violent R-rated movie (*The Ruins*) or a non-violent PG-rated adventure movie (*Nim's Island*), they were equally prompt to help her.[2] Coming out of the movies, however, the results changed. Folks who had seen the non-violent movie helped just as quickly as before. People coming out of the violent movie helped, too, but it took 26 percent longer. The authors conclude, "People

exposed to media violence become 'comfortably numb' to the pain and suffering of others."[3]

It is interesting to compare this experiment to a similar one, published in 1975.[4] On a stretch of sidewalk, a man with a cast on his arm dropped a pile of books. The researchers tallied the percentage of passersby who stopped to help. The variable in this experiment was a nearby lawnmower, with which somebody appeared to be tinkering. In half the trials, the lawnmower was on and roaring; in the other half, it was off and silent. When the lawnmower was silent, 80 percent of the passersby stopped to help. When it was running, only 15 percent did: fewer than one fifth as many. One might reasonably suppose that, if empathy with others is the goal, it is much more important to steer clear of noisy lawnmowers than of violent movies.

There are two important points I wish to make with this comparison. These are things every social scientist knows but which sometimes get swept under the rug. One of these is *not* that we cannot trust the results of empirical research. On the contrary, the two experiments recounted above clearly show *something*. We just do not know how that applies to other situations. Varying even an apparently minor detail, like the cast on the arm in the second experiment, can change the results dramatically. In fact, in a no-cast silent-mower variation of the experiment, only 20 percent of the passersby stopped to help, down from 80 percent. The point is that making sense of the data generated by empirical research always requires inference and extrapolation, which are just other names for guesswork.

A second point is even more important. Without a theory to make sense of it, scientific data is meaningless. Without a theory, there is no way to extrapolate from the specifics of a study to other circumstances. The theory behind the lawnmower experiment is that background noise interferes with our ability to pick up on social cues, such as the fact that somebody needs help. But it might equally be that the noise just irritates us and thereby makes us less inclined to help. From this experiment, we have no way of knowing. One might devise other experiments to gauge whether lawnmower noise affects subjects' attentiveness and irritability, but the explanatory power of those experiments would also be limited. The point is that *theories* are always needed to make sense of empirical data.

the general aggression model

There is a mountain of empirical data that suggests that media violence is a significant risk factor for antisocial behavior. Since the early 2000s, most of this research—and more importantly, most of the *interpretation* of this research—has been driven by a theory called the general aggression model or GAM, developed by Anderson and Bushman, among others.[5] I will explain the theory with a story. I have included the social scientists' own

Figure 9.1 Proximate causes of aggression.

Source: Craig A. Anderson, Douglas A. Gentile, and Katherine E. Buckley, *Violent Video Games Effects on Children and Adolescents: Theory, Research, and Public Policy* (New York: Oxford University Press, 2007), Figure 3.3, 45. (Reprinted with permission of Oxford University Press, USA.)

diagrams of their theory (Figures 9.1 and 9.2), adding lower-case letters in parentheses to link it to my story.

Thirteen-year-old Sammy has been grounded for bad behavior and feels peeved about that (a). He sits in the basement playing *Grand Theft Auto* on his Xbox (b).[6] Sammy has played through the game a few times already, so he is not particularly interested in the story. He is just jacking cars and doing outrageous things with them, for fun, and shooting cops when they catch up with him.

Sammy has an "attitude" when he starts playing. Partly it is because he is angry about being grounded. Partly, it is just because he is thirteen, full of piss and vinegar. Now, in the midst of playing *GTA*, he is feeling macho and full of himself, because he knows he is really good at the game (c). On top of this, he is wound up tight, since *GTA* is a tense and exciting game (d). Plus, he is imagining and even virtually enacting crazy, violent, antisocial behaviors, such as ramming cars and shooting cops (e). On account of all these factors, Sammy is *primed* for bad behavior.

I need to pause my story here to explain the term priming. There is a famous experiment in which college students were given scrambled words such as "they her thirsty see usually," and asked to construct grammatical

sentences with them, as quickly as possible.[7] For half the subjects, the scrambled words included words associated with the elderly, such as "wise," "wrinkled," "alone," "conservative," and "knits." Afterwards, the students were surreptitiously timed as they walked down the hall to an elevator. Students who had been exposed to the words associated with the elderly took significantly longer to make the trip. When debriefed, the students said they had no idea that they had been systemically exposed to words related to aging and denied that this could have affected their walking speed. This is an example of the phenomenon that psychologists call priming. The same effect has been demonstrated in countless other contexts.

Priming is easily understood in light of the basic function of the nervous system, which is to guide the body's interactions with the environment. The brain does not just register and interpret stimuli from the environment; it prepares the body and mind for potential action. If I show you a picture of a gun, it may trigger purely abstract associations, such as "Walther P38," but at a more primal level, we cannot avoid seeing the image in terms of what guns do, which is shoot. That involves an unconscious action-orientation related to shooting, to the point of activating neurons of the trigger finger in the motor cortex. Even just imagining a gun, as you are doing now, involves subtly and unconsciously orienting the body and mind toward the possibility of shooting (or being shot). If this imaginary activity is fun, as it is when playing *Grand Theft Auto*, that pleasure becomes part of the orientation, too. So when I say that Sammy is primed for bad behavior, I am not just using a figure of speech; I am referring to a psychological fact.

At this juncture in my story, Susie enters the scene (f). Susie is Sammy's sister. She is eleven and mom's little minion. There is a sensible rule in Sammy's house that Xbox play is supposed to be limited to an hour a day. Susie has taken it upon herself to enforce this rule. She tells Sammy, "You've been playing Xbox for more than an hour. If you don't stop, I'm going to tell mom."

If you pause for a moment here to look at the diagram (Fig. 9.1), it appears that I have gone out of order. "Social Encounter" (f) is on the other side of the diagram. In fact, the diagram does not map out a linear process but a complex of feedback loops. In other words, all of the elements in the diagram are present all the time and all of the processes can take place simultaneously. So when Susie gets into Sammy's business, she is not at all out of order, at least in terms of the model.

Anyway, Sammy reaches for a balled-up sock on the coffee table next to him and throws it at Susie. "Mind your own business, you little bitch!" he says (g). Bad call. Susie immediately runs upstairs to tell their mother that, not only has Sammy been playing on the Xbox for more than an hour, he just called her the B-word. But Sammy could have done worse. Right

162

Figure 9.2 Background causes of aggression.

Source: Craig A. Anderson and Nicholas L. Carnagey, "Violent Evil and the General Aggresion Model," in *The Social Psychology of Good and Evil*, edited by Arthur G. Miller (New York: Guilford Press, 2004), Figure 8.4, 179. (Reprinted with permission of Guilford Press.)

next to the balled-up sock on the coffee table was a shoe. Sammy could just as easily have thrown the shoe at Susie, but he did not (h). This is not exactly a "Thoughtful Action," since Sammy did not really think about it. He just did not do it. But in terms of the theory, that amounts to the same thing. It is not surprising that Sammy did not throw the shoe, by the way, because that might have landed him in *real* trouble (f, again: a serious "Social Encounter" with mom), but the fact that he opted not to throw the shoe is notable. We will have to think more about this later. First, though, there is some important "backstory" to relate.

Sammy plays a lot of *Grand Theft Auto*. He has been playing it off and on for more than a year. As a result, he has become quite deft with the Xbox controller. He has learned what he calls "mad skills." He did not set out to learn these skills; he just picked them up. He picked up a lot of other things in the same way. For instance, he has learned a lot of crazy and aggressive things you can do with cars (i). Such ideas occasionally cross his mind when he is going somewhere in a real car. "Wouldn't it be fun to run over that old lady!" he thinks. Sammy would never really do such a thing, of course,

but he enjoys the idea (j). In fact, every time he gets into a car, he cannot help but see it as a potential weapon—a fun kind of weapon, not a dangerous one (k). He does not realize that he sees cars in this way. He might even deny it. It is just part of the unconscious background of his thought, part of the way he has been conditioned to think about cars. Furthermore, because *GTA* really is a cool game, Sammy has also been conditioned to feel that aggressive driving is cool (l). He has started watching auto racing on TV and, when he does, he gleefully anticipates the crashes (m). Because of the coolness of guns in *GTA*, Sammy has become interested in guns, too. All of these factors subtly influence the kind of person Sammy is becoming. He is becoming someone who relishes and even admires certain kinds of aggressive behavior (n). None of this made Sammy throw a sock at Susie and call her a bitch, of course, but it was there in the background and therefore part of the mix.

the mountain of evidence

This theory may seem complicated but it boils down to two simple mechanisms: *priming*, which I explained earlier, and *learning*, which needs no explanation. Priming and learning are not theories; they are facts. The theory lies in supposing that they allow us to attribute some considerable part of Sammy's bad behavior to playing *Grand Theft Auto*. It is possible to accept the facts and discount the theory. One can say, for example, "Priming is a short-term effect. It really does not explain long-term behavior." Or one can say, "What Sammy learns in *GTA* applies only to *GTA*. When Sammy gets his driving permit, he is going to learn to drive a real car, which involves a completely different set of experiences and rules than controlling a virtual car for the purpose of play. There is no way he is going to get these two activities mixed up." These arguments are both sound. It would be easy to accept that they more or less debunk the theory I just described, except for one thing: the mountain of empirical data I mentioned earlier.

I am not going to review this mountain of data here or even explain the various means by which it was derived. I will give you just one example: a chart (Table 9.1) from an appropriately skeptical, methodologically meticulous study, performed by an interdisciplinary group of researchers associated with Harvard Medical School, published in a 2008 book entitled *Grand Theft Childhood*.[8]

The subjects of this chart are boys in middle school (this study also looked at middle-school girls and found effects every bit as pronounced, but I include just the boys' data, here, in the interest of space). M-rated video games are games for "mature" players (as opposed to T-rated games for "teens," and E for "everybody"). This includes games such as *Grand Theft Auto*, *Call of Duty*, and *Halo*, which are all very violent and all very popular with

Table 9.1 Problem behaviors in boys and M-rated game preferences

Type of Problem	Type of Behavior in Previous 12 Months	Percentage of Boys with Problem Behavior	Percentage of M-Gamers	Percentage of Non-M-Gamers
Aggressiveness and Bullying	Participated in physical fight	44.4%	51%	28%**
	Hit or beat up another person	53.2%	60%	39%**
	Involved in bullying another student†	9.2%	10%	8%
Delinquency	Damaged property for fun	18.6%	23%	10%**
	In trouble with police	4.9%	6%	2%
	Theft from a store	10.5%	13%	6%*
Problems at School	Poor grades on report card	31.6%	35%	23%**
	Skipped school/classes without reason	11.2%	13%	8%
	In trouble with teacher or principal	52.9%	60%	39%**
	Suspension from school	20.1%	22%	15%
Victimization	Threatened or injured with weapon	12.6%	15%	6%**
	Bullied at school	10.2%	8%	15%*

* Statistically significant difference (within gender) between M-Gamers and non-M-Gamers at the P<.05 level
** Statistically significant difference (within gender) between M-Gamers and non-M-Gamers at the P<.01 level
† Bullying at school occurred at least two to three times per month over past few months; Olweus Bully/Victim Questionnaire Definitions

Source: Data reproduced from Lawrence Kutner and Cheryl K. Olson, *Grand Theft Childhood: The Surprising Truth About Violent Video Games and What Parents Can Do* (New York: Simon & Schuster, 2008), 98.

teenagers and even pre-teens.[9] "M-Gamers" on the chart are those boys who played M-rated games "a lot in the past six months." A much higher percentage of M-Gamers got into fights, shoplifted, got poor grades, and so on. As you can see for yourself, the numbers are compelling.

This chart shows the results of a "correlational" study, which means that it compares or correlates different things. As is well known, a correlation does not demonstrate a cause. In the case of this study, it is just as likely that rough boys are drawn to violent games as it is that violent games lead to bad behavior. For this reason, social scientists like to triangulate findings like these with the findings of other kinds of research, including experimental studies, like the crutch-dropping experiment I described above, and "longitudinal" studies, which measure the way in which correlations change over time when, for example, one group of children plays a lot of M-rated video games and another group does not. But by itself this chart tells us nothing about causal connections.

Even so, the empirical findings reported in this chart are solid, striking, and self-evidently significant. We cannot wish them away. They require explanation. We do not know what caused the pattern we see, but we know that *something* caused it. Heavy M-rated video game play could be a symptom rather than a cause, but it is clearly involved. The chart suggests that there is likewise a connection between shoplifting and bullying. One of these does not cause the other, but they are evidently part of the same syndrome. M-rated video games are part of that syndrome, too. That is real cause for concern.

grounds for dismissal?

When confronted by apparently overwhelming evidence such as this, a skeptic has essentially three options. The first is to challenge the evidence by finding fault with the study.[10] It is indeed quite easy to poke holes in the *The Ruins/Nim's Island* experiment I described earlier.[11] But this strategy tends to be *ad hoc*. It does nothing to diminish the significance of robust and repeated findings, such as those in Table 9.1 above. More importantly, it does nothing to *explain* such findings, apart from claiming that the research is biased.

166

Bias is an issue, to be sure. Most media violence researchers are pre-occupied with harmful effects. That is what they set out looking for. And so they construe potentially healthy emotions such as anger as harmful and tend to ignore or dismiss the pleasure of play and everything else that cannot be reduced to harmful effects or the opposite (helpful effects). Nevertheless, that bias does not disprove the robust and repeated findings of their research, such as those in Table 9.1 above.

A second way to dismiss compelling empirical evidence of harmful effects is to say, "I believe it, but it does not matter—not as much as other things, anyway." This is the position taken by the US Supreme Court in 2011, in rejecting a California statute that would have restricted the sale of violent video games to minors. Justice Scalia wrote, for the majority:

> Like the protected books, plays, and movies that preceded them, video games communicate ideas—and even social messages—through many familiar literary devices (such as characters, dialog, plot, and music) and through features distinctive to the medium (such as the player's interaction with the virtual world). That suffices to confer First Amendment protection.[12]

Scalia did not say that violent video games are harmless. On the contrary, he and other justices expressly stated that they believe there are significant risks associated with violent video games, for children and for society. Still, when it comes to the law, the court judged that there are potential benefits to video games, even really violent ones, which outweigh the risks. So they looked at the evidence, took it seriously, then set it aside. The problem with this approach is that the evidence is hard to set aside. Bullying, fighting, stealing, and vandalism are serious forms of antisocial behavior. The evidence that violent entertainments are tied up with them in some way is striking and significant. It demands to be taken seriously.

The third way to challenge compelling empirical evidence of harmful effects of media violence is to try to *explain* it away, by calling on some alternative to the priming/learning theory I described above. The alternative theory might challenge the way the evidence is interpreted or it might call into question the evidence itself. As it happens, humanists have such a theory ready to hand: a popular and well-known theory of entertaining violence called catharsis.

The idea of catharsis stems from Aristotle's *Poetics* but was elaborated and made popular by Freud and his followers. The idea, to put it simply, is that the impulse to commit violent acts can be diminished by entertaining violent thoughts, through a process akin to "letting off steam." Psychiatrist Lenore Terr explains it like this: "[B]y enacting play stories with feeling, [children] *release* much of the powerful emotion that has built around their internal conflicts or their experiences with outside events."[13] Scientists have roundly rejected this theory, because the evidence does not support it. Thinking violent thoughts does not wind down violent impulses; it cranks them up. What actually happens is *priming*, not catharsis. So, if we are skeptical of the general aggression model and want to find an alternative theory, we need to look elsewhere.

reason and restraint

Here, I want to return briefly to the story of young Sammy and the question of why he did not throw the shoe at his sister. Fear of consequences played a role. Sammy knew that if he deliberately hurt his sister, he would be in serious trouble. That inhibited Sammy's impulsive behavior. And because Sammy is a good kid at heart, empathy played a role, too. Sammy knew that throwing a shoe could really hurt his sister. In spite of his anger and impulsivity, he did not want to do that. So, without thinking or deliberating about it at all, Sammy exercised reason and self-restraint.

In his magisterial study of the history of violence, psychologist Steven Pinker found that, in spite of all the wars and genocides of the twentieth century, violence has been in dramatic and fairly continual decline since the Humanitarian Revolution that began in the seventeenth century.[14] The reason, he argues, is that societies have become progressively better at fostering and practicing reason and restraint. He supposes, incidentally, that the rise of literacy and literature contributed to this, by cultivating empathy.

Studies of actual violence, in fields ranging from anthropology to forensic psychology, demonstrate repeatedly that the critical factor is not the presence of aggressive impulses, as the general aggression model suggests; rather, it is the reduction or circumvention of self-restraint and inhibitions against violence. Sociologist Randall Collins studied hundreds of instances of actual violence, from bar fights to police actions.[15] He found that, normally, fear and anxiety prevent or inhibit violence. When violence actually occurs, it is because something in the situation works to bypass or overcome these normal inhibitions: alcohol, in the case of bar fights; body armor, nightsticks, numbers, and training, in the case of police actions. Army psychologist Dave Grossman found that the same is true in war.[16] Soldiers viscerally recoil from killing. Remote control killing (with drones for example) and dehumanizing enemies (by referring to them as "targets," for example) are deliberate means of reducing this resistance.

Empathy is normally a powerful emotional constraint against violence. Recent research into psychopathic violence, such as that of Simon Baron-Cohen, suggests that the root of much such violence is a failure of empathy, which can result from brain abnormalities.[17] A recent book on genocidal violence by philosopher David Livingstone Smith concludes that the cause is not just hostility of one group toward another but also the suppression of empathy through systematic dehumanization of that group.[18]

Textbooks on violence among children, such as *Youth Aggression and Violence*, indicate that it is not violence that children learn as they develop, but empathy and self-control.[19] As child development expert Laurence Steinberg states:

> Kids start off in life being aggressive. Fifty percent of all kids' interactions with other kids during the pre-school years are aggressive. But most kids show a steady and dramatic decline in aggression over time. The question is what enables some kids to *stop* being aggressive, not to start being aggressive.[20]

The answer is that, as children grow up, they learn and become better able to master their emotions and regulate their behavior. Even in testosterone-fueled male adolescence, violent and risky behaviors may have less to do with increased anger and aggression than with the relatively late development of the brain's self-control systems.

Finally, inhibitory mechanisms play a crucial role in the basic operation of the brain. A purely additive or excitatory system—in which the firing of one neuron activates others, which activate still others, and so on—would result in self-amplifying feedback loops that would quickly be overwhelmed by noise (think of audio feedback). In fact, the brain is shot through with inhibitory cells and circuits, from the lowest level—such as the retina of the eye—to the highest, such as the conscious self-control systems in the prefrontal cortex. It is not at all clear how or even if neural inhibitions relate to inhibitions against violence. I bring them up mainly because the general aggression model is, by its authors' own statement, a "cumulative" one: aggressive thoughts lead to aggressive impulses, which accumulate until they spill over into violent behaviors.[21] Studies of actual violence indicate that this is not how violence works. Neuroscience indicates this is not how the brain works, either.

The pattern seems clear: the most critical factor in explaining actual violence is not aggressive thoughts and impulses *per se*. These are everyday occurrences that rarely spill over into actual violence. The critical factor is the failure of internal mechanisms of inhibition and self-control, including reason and restraint.

desensitization and disinhibition

It would be unfair to say that the general aggression model makes no allowance for reason and restraint. There is in fact a space for it, indicated by the box in the lower left of Figure 9.1 labeled "Appraisal and Decision Processes." That is where Sammy decided to throw the sock and not the shoe. The model also allows for factors such as parental involvement that are said to "reduce, mask, or attenuate" the effects of exposure to media violence, presumably by promoting reason and restraint.[22] Furthermore, there is a long tradition of media violence research, dating back to the 1960s, which suggests that violent entertainments contribute to aggressive behavior precisely by *undermining* reason and restraint, through mechanisms

169

labeled desensitization and disinhibition. These mechanisms are implicit in the general aggression model.

Desensitization is a form of learning. It is a well-known psychological phenomenon that takes place from the cellular level to the highest cognitive level. At the cellular level, for example, if you touch the gills of a sea slug once, they reflexively retract. If you gently touch them twenty times in a row, they stop reacting, as a result of a chemical change in the nerve cells. At the cognitive level, the mind actively tunes out constants in the environment, like a background noise or a smell. We become inured to it. As a result of constant media exposure, we might become inured to violence in the same way—or "comfortably numb," as the authors of the crutch-dropping experiment put it.

Disinhibition is a social phenomenon. You are more likely to engage in some sort of bad behavior if you feel that it is acceptable or expected. An important cue for what is acceptable or expected is what you see other people do. For example, you are more likely to disobey a traffic signal if you see other people doing so. Media violence may have a similar effect. When you see two modern gladiators beat each other bloody in an MMA cage fight, for example, you might subconsciously think, "Well, I saw it on TV, so it must be okay." Even if you are not likely to go out and punch somebody yourself, your acceptance of such violence may be marginally raised.

So, the general aggression model has room for reason and restraint. The only problem with the model is that people who apply it routinely look at only one half of the phenomenon of violence: the impulse-action loop. They tend to completely ignore inhibition and self-control. When they consider reason and restraint at all, it is chiefly in terms of how those can be short-circuited.

In other words, scholars who apply the general aggression model tend to focus exclusively on the question, "What is the harm of violent entertainments?" That is like asking, "How dangerous are cars?" Given that we drive cars a lot (and with good reason), it is also crucial to ask the question, "What can we do to make cars safer?" Likewise, with respect to violent entertainments, given how much we are drawn to them (and with good reason), we need to ask the question, "How can we use them in healthy and relatively safe ways?" What is needed, again, is a more holistic approach.

170

a more holistic approach

The general aggression model focuses on how aggressive thoughts spark aggressive impulses, which in turn contribute to aggressive behaviors. This might be called an impulse-action model. With feedback loops removed, for simplicity, it looks essentially like this:

DEPICTIONS OF VIOLENCE

⇓

AGGRESSIVE IDEAS
AGGRESSIVE IMPULSES
AGGRESSIVE BEHAVIORS

⇓

LEARNED HABITS

Even though this model leaves room for what might be called safety factors, such as parental involvement, it leads to a preponderate focus on risk (in terms of Sammy's story, it pays a great deal of attention to why Sammy threw the sock and very little to why he did not throw the shoe). The simplest way to remedy this problem is to expressly add to the model and thereby call attention to those things that brake the impulse-action train: namely, inhibition and self-control. This revised impulse-action model might be called an impulse-plus-inhibition model. It looks essentially like this:

DEPICTIONS OF VIOLENCE

⇓

AGGRESSIVE IDEAS
AGGRESSIVE IMPULSES

+

INHIBITION / SELF-CONTROL

⇓

RESTRAINED AGGRESSIVE BEHAVIORS

⇓

LEARNED HABITS

What is *primed* in this model is not just violent ideas and impulses, but anti-violent responses as well, such as disgust, empathy, and concern for consequences. What is *learned* is not just bad behavior, but social boundaries and self-control. So, while the wildly aggressive "driving" in *Grand Theft Auto* does indeed prompt the idea and maybe even the impulse to drive the same way in the family car, there is no way that the game can lift ordinary inhibitions against driving that way. Lower those inhibitions, with alcohol or peer pressure, and you have a recipe for trouble. Such trouble is hardly the fault of the video game, however, and taking away the video game will not eliminate it.

As is evident in the chart (Table 9.1) I showed earlier, the disturbing fact remains that teenagers who play a lot of games such as *Grand Theft Auto* get into an unusual amount of trouble. There is some real causal connection here—a syndrome, I called it. The general aggression model says the connection is that violent stimuli lead to violent thoughts and impulses, which naturally spill over into antisocial behavior. The best way to counteract the syndrome is to eliminate as many of those stimuli as possible. That means getting rid of *Grand Theft Auto*. It also means getting rid of backyard football, novels like *The Hunger Games*, superhero movies, and television news.[23]

The impulse-plus-inhibition model, in contrast, supposes that the critical connection is poor impulse control and the failure of inhibitions against antisocial behavior. In other words, it is likely that teenagers who play a lot of violent video games have more self-control issues than teenagers who do not. Where do these self-control issues come from? That is the big question. Violent gaming may play a role, but probably not a major one. It is more likely a manifestation than a cause, just like getting into fights and achieving consistently poor grades.

If lack of self-control is the problem, the solution is not to tiptoe around all aggressive impulses; it is to help people learn to deal with such impulses in healthy ways. It is quite possible that, in some situations, violent pastimes could actually help with this. For example, a bunch of kids playing backyard football might be learning how to play by the rules, how to keep high emotions in check, how not to hurt someone, and how to respond when someone does get hurt. A group of kids getting together to play *Halo* could, in principle, be learning the same kind of thing.

Play research tends to support this theory. Neuroscientists Sergio and Vivien Pellis found that rats that are deprived of opportunities to engage in rough-and-tumble play with other rats are dramatically impaired as adults, socially and in other ways.[24] They get into fights, they are unusually fearful, and they do not perform well in novel situations. They tend to overreact to all kinds of stimuli. Pellis and Pellis conclude that the purpose of play is to facilitate bonding, to develop a repertory of social skills, to develop confidence in one's physical abilities and, most important of all, to test emotional limits and thereby fine-tune the stress-response system. Among rats, this happens chiefly through physical interactions with other rats. Among humans, it happens through a much broader range of interactions, including imaginary and symbolically-mediated ones, such as online gaming and stories.

Gerard Jones, comic-book author, educator, and critic, arrives at much the same conclusion by studying the role of violent entertainments in children's lives.[25] Jones theorizes that by imagining what they fear in a safe context, children in effect practice their fear and so develop a sense of

control over both their emotional responses and the ideas that cause them. This is different from catharsis theory. It is not about discharging, releasing, or expunging troubling ideas; it is about learning to cognitively master them. By freeing us from our fears, Jones argues, stories and movies about violence can help us to respond more rationally and pragmatically to real world violence. This includes being better able to feel empathy and understanding for its victims.

Jones does not deny that violent entertainments involve risk factors. Children watching horror movies are exposed to horrible things, things from which parents have good reason to protect them. Children playing violent video games are invited to imaginatively involve themselves in terribly harmful behavior, without regard to the real world consequences of such behavior. For some children, in some contexts, this could easily promote actual harmful behavior. Jones points out that, even for emotionally healthy children in a non-violent environment, there is a considerable risk that, by spending time alone in front of a screen, they may miss out on some of the sort of invaluable social learning that takes place on a playground.

In the impulse-plus-inhibition model, the critical risk factor is not which games you play, how violent they are, or even how much you play them. It is *how* you play them. The way to minimize the risk of violence is not necessarily to prohibit or avoid entertaining violence; it is to provide a safe and healthy environment for all kinds of social play, whether or not that includes video games, imaginary violence, or play that is actually rough and aggressive, like football.

Jones offers a nicely alliterative rule of thumb for doing this: model, mirror, and mentor. Model: if you do not want your children to be violent, never use violence yourself. If you want them to cut back on their TV-watching, cut back on your own. Take them to the park, instead. Mirror: giving good feedback to your children starts by taking an interest in what interests them. You do not have to do what they do. You do not have to approve of it or even allow it. You can still affirm their ability to make good choices for themselves. Mentor: teach your children values. Intervene when necessary, but gently. Instead of trying to control them, teach them self-control.

Jones's evidence is largely anecdotal. Nevertheless, I find his more or less intuitive theory to be a spot-on corrective to the weaknesses of the general aggression model.[26] Instead of mixing up violent thoughts, violent impulses, and violent behavior, as the general aggression model tends to do, Jones's theory teases them apart. Instead of leading to the conclusion that the way to minimize violent behavior is to prevent violent thoughts and impulses, as the general aggression model does, Jones's theory supposes that the best way is to help people learn to control their violent impulses.

You cannot do that by altogether avoiding aggressive ideas and impulses; you can only do it by entertaining violence, in one way or another. The lesson here is that it matters less what kids play than how they play. It is the *context* of entertaining violence that ultimately determines whether it is healthy or harmful. Media effects researchers would do well to shift their focus to this context.

consequences are what matter

The discussion about entertaining violence is dominated by value judgments. These come from vastly different places. Some put the protection of children first, others the right to free speech, some the avoidance of violence, others the pursuit of pleasure, and so on. If we wish to weigh these competing values or even simply to avoid perennially talking past each other, we need to have some bedrock standard upon which we can all agree. "Material outcomes" is a good one. In fact, it is the only one that works. In trying to discern whether something is valuable or harmful, what matters is matter.

This is not just philosophical wordplay. It implies that what entertaining violence *does* is far more important than what it *shows*. Imagine a little girl who watches an episode of *The Walking Dead* and is terrified.[27] For weeks, she might have nightmares, lose sleep, and wet the bed because she is afraid to go to the bathroom during the night. At the same time, as a result of coping with her terror, she might become more emotionally resilient, a little bit more capable of dealing with frightening things in the real world. This illustrates that the value of entertaining violence, for good or ill, is not in images and ideas of violence themselves; it is in the consequences of these images and ideas. Those depend in very large part upon specific circumstances. And they are always complicated.

Actual violence causes actual harm. Actual violence is therefore one potential outcome of imaginary violence about which we need to be concerned and work especially hard to prevent. But the way in which images and ideas of violence contribute to actual violence is determined largely by the context in which they circulate. With respect to the danger of actual violence, therefore, it is the context of entertaining violence that should concern us most.

There is an assumption in much of the literature on media violence that if you regulate violent images, you can regulate violent impulses, which will in turn regulate potentially harmful actions and behaviors. In the real world, which serves up a welter of violent ideas, impulses, and images, not to mention actual violence, the consequences of restricting or engaging with entertaining violence do not play out in so simple or direct a fashion. There is another widespread assumption that as long as something is pleasurable,

it is relatively harmless. This is partly a product of our commercial culture, which tends to elevate the "entertainment" component of leisure activities above all other values. In a debate that is dominated by fairly single-minded discourses about "harm" on one hand and "entertainment" on the other, it behooves us to step back and try to get a bigger picture, to take into account the whole array of material consequences of imaginary violence. And we need to keep in mind that, at the end of the day, it is not images and ideas about violence that really matter; it is their consequences that count.[28]

notes

1. Brad J. Bushman and Craig A. Anderson, "Comfortably Numb: Desensitizing Effects of Violent Media on Helping Others," *Psychological Science* 20, no. 3 (2009): 273–277.
2. *The Ruins*, director Carter Smith (Universal City: DreamWorks SKG, 2008); *Nim's Island*, directors Jennifer Flackett and Mark Levin (Los Angeles: Walden Media, 2008).
3. Bushman and Anderson, 277.
4. Kenneth E. Mathews and Lance Kirkpatrick Canon, "Environmental Noise Level as a Determinant of Helping Behavior," *Journal of Personality and Social Psychology*, 32, no. 4 (1975): 571–577.
5. See, for example, Craig A. Anderson and Brad J. Bushman, "Effects of Violent Videogames on Aggressive Behavior, Aggressive Cognition, Aggressive Affect, Physiological Arousal, and Prosocial Behavior: A Meta-Analytic Review of the Scientific Literature," *Psychological Science* 12, no. 5 (2001): 353–359; and Craig A. Anderson, Douglas A. Gentile, and Katherine E. Buckley, *Violent Video Game Effects on Children and Adolescents: Theory, Research, and Public Policy* (New York: Oxford University Press, 2007).
6. *Grand Theft Auto*, video game, developer Rockstar North (New York: Rockstar Games, 1997–2012).
7. John A. Bargh, Mark Chen, and Lara Burrows, "Automaticity of Social Behavior: Direct Effects of Trait Construct and Stereotype Activation on Action," *Journal of Personality and Social Psychology* 71, no. 2 (1996): 230–244.
8. Lawrence Kutner and Cheryl K. Olson, *Grand Theft Childhood: The Surprising Truth about Violent Video Games and What Parents Can Do* (New York: Simon & Schuster, 2008), 98.
9. *Call of Duty*, video game, developer Infinity Ward and Others (Santa Monica: Activision, 2003–2012); *Halo*, video game, developer Bungie, Ensemble Studios, and 343 Industries (Redmond, WA: Microsoft Studios, 2001–2013).
10. The most notable/notorious example of this approach is Jonathan L. Freedman, *Media Violence and its Effect on Aggression: Assessing the Scientific Evidence* (Toronto: University of Toronto Press, 2002).
11. The sample size is small. The effect, even if it is statistically significant, is trivial in real world terms (around 1.5 seconds). Maybe the ending of *The Ruins* was more exciting. Maybe people coming out of that movie were talking more. Groups of teenagers go to movies like *The Ruins* and families to movies like *Nim's Island*. Maybe that made a difference. And what the experiment chose *not* to study is notable, too, such as whether people

coming out of *The Ruins* seemed more animated and happier, as may well have been the case.

12. Supreme Court of the United States, *Brown v. Entertainment Merchants Assn.*, 08-1448, Supreme Court of the US, http://www.supremecourt.gov/opinions/10pdf/08-1448.pdf (accessed July 2, 2012), 2.

13. Quoted in Gerard Jones, *Killing Monsters: Why Children Need Fantasy, Super Heroes, and Make-Believe Violence* (New York: Basic Books, 2002), 66, emphasis mine.

14. Steven Pinker, *The Better Angels of Our Nature: Why Violence Has Declined* (New York: Viking Adult, 2011).

15. Randall Collins, *Violence: A Micro-Sociological Theory* (Princeton, NJ: Princeton University Press, 2008).

16. Dave Grossman, *On Killing: The Psychological Cost of Learning to Kill in War and Society*, revised edition (New York: Back Bay Books, 2009).

17. Simon Baron-Cohen, *The Science of Evil: On Empathy and the Origins of Cruelty* (New York: Basic Books, 2011).

18. David Livingstone Smith, *Less Than Human: Why We Demean, Enslave, and Exterminate Others* (New York: St. Martin's Press, 2011).

19. Thomas G. Moeller, *Youth Aggression and Violence: A Psychological Approach* (New York: Routledge, 2001).

20. Quoted in Kutner and Olson, 199.

21. Anderson, Gentile, and Buckley, 51.

22. Ibid., 48.

23. Suzanne Collins, *The Hunger Games* (New York: Scholastic, 2008).

24. Sergio Pellis and Vivien Pellis, *The Playful Brain: Venturing to the Limits of Neuroscience* (London: Oneworld, 2010).

25. Jones.

26. Jones's book has flaws. It strays perilously close to catharsis theory at points; it is probably far too optimistic about the positive potential of entertaining violence; and it does not sufficiently engage with the kinds of harmful thoughts and impulses that entertaining violence can engender. I think, for example, of a scene in the popular horror movie *Hostel 2* (2007) in which one naked woman sadistically tortures and then murders another. This scene is not about mastering fear. It is about titillation. Its treatment of women as meat (literally) is appallingly inhuman and outrageously sexist. It is not Jones's purpose to address this kind of thing. Still, the fact that he ignores it is a weakness of his book. Nevertheless, *Killing Monsters* presents a compelling and coherent alternative to the general aggression model, from a humanistic perspective. Furthermore, Jones understands, refers to, and clearly respects the social scientific literature on media violence.

27. *The Walking Dead*, created by Frank Darabont (New York: American Movie Classics, broadcast 2010–2013).

28. My thanks to Stephen Prince and Douglas Gentile as well as to the editors of this anthology for their invaluable comments on previous versions of this essay.

a general theory

of comic

entertainment

arousal, appraisal, and

the PECMA flow

torben grodal

In this chapter I will discuss a general theory of comic entertainment.[1] The theory is a general one because it provides a unified account of the different mechanisms in the embodied brain that support and regulate comic entertainment and the evolutionary origin of these mechanisms. I will further show how such a theory links to the PECMA (Perception, Emotion, Cognition, and Motor Action) flow model, which describes the fundamental features of the experience of audiovisual entertainment.

The theory claims that comic entertainment consists of five elements: (1) *Priming of the comic event to come.* The priming may come from many sources: from actor reputation; cues in the film or in the title of the entertainment (for example, stand-up, comedy); program and spoilers; media and other forms of communication. (2) *Some comic entertainment inputs that create arousal.* (3) *Entertainment-internal signals* of the playful nature of the arousing input, that serve as an invitation to make a play contract between the provider of the comic input and the viewer, and possibly a play community among an actual or a virtual audience. (4) *Appraisal processes* in audience members that evaluate the arousal that the input creates as "not real but playful."

(5) *The appraisal*: playful, not real, leads to a change in the hedonic tone: that is, the evaluation of an experience on a scale from pleasant to unpleasant, so that even arousal by causes that are normally unpleasant will provide mirth and pleasure.

The major theories of the comic take aspects of these elements and mechanisms as their point of departure, whereas a general theory explains the interaction of all the elements: priming, arousing input, signaling of playfulness, appraisal process, and change in hedonic tone. I will later return to how the different theories relate to the general theory.

I use the term "comic entertainment" as a common denominator for a wide variety of phenomena—from jokes and puns to stand-up and comedies—that all elicit mirth, underpinned by smile and laughter. Comic entertainment must be explained by means of those mechanisms that, in non-entertainment contexts, also elicit comic, humorous experiences, because comic entertainment is the artistic refinement of comic interaction in everyday life. By means of psychological theory, we can explain the mechanisms that producers of comic entertainment tap into to elicit comic reactions. Comic entertainment is aimed at creating an experience in the brain, and an awareness of psychology therefore provides an essential context for understanding how this experience is achieved.

The difficulty in describing comic entertainment is that different viewers' responses vary much more widely than they do in relation to other forms of entertainment, such as romance, horror, or action. Situations or processes that some people find funny will not be experienced as funny at all by other people. The cause of this variation is that the comic experience demands that the audience member reshuffle his or her normal relations to people and events. For instance, normal empathic suffering with the misfortune of others may be transformed to pleasurable arousal in the comic mode. This transformation of suffering into pleasure may either take place with a background of empathy—as in most viewers' relation to Charlie Chaplin, or other characters experienced as funny and likeable at the same time—or as a scornful pleasure, as in scenes from *Borat* which invite viewers to laugh at characters.[2] Disgust may be transformed into pleasure, paradoxes experienced as pleasurable, and failure to achieve goals perceived as funny and pleasurable.

Given the same (entertainment) stimulus, some people will react by having a comic experience, while others will not. A theory of comic experiences therefore cannot focus exclusively on the input, the comic events. "Humorous experiences" have many causes and many forms, therefore comic entertainment cannot be described solely in terms of stimuli such as incongruence and absurdity. Rather, a theory of comic entertainment must centrally focus on the appraisal processes that trigger laughter, and the social and psychological negotiations that underpin the appraisal processes. In the following discussion I will therefore focus on the

interaction between entertainment stimuli and those mechanisms that redefine and reappraise the experiencer's normal emotional appreciation of events.

the evolutionary origin of the comic

The point of departure for understanding comic entertainment is the evolutionary development of, and biological underpinnings of, comic behaviors and experiences. The evolutionary origin is linked to one of the central mammalian features: play.[3] Playing consists of performing actions that are not "fully real," such as play-fighting and rough-and-tumble, or play-chasing, that are performed by most mammalian young. Playing in humans also has advanced forms such as pretend play, as when children make mudpies and pretend to eat them. The ability to play and thus to make hypothetical actions has been central for the development of a sophisticated intelligence that uses hypotheses for learning, problem-solving, and planning.

The oldest type of playing is linked to social interaction among conspecifics in the aforementioned activities: play-chasing, play-fighting, and rough-and-tumble. The playful execution of these activities—chasing and fighting—is characterized (1) by simulations of goal-directed actions. (2) The actions are supported by arousal (the technical term is sympathetic arousal). (3) The individuals need to signal that the actions are not real: that is, that they are not intended to hurt the playmate(s). They may do so by laughing—thus rats emit some high chirping tones to signal playfulness,[4] and monkeys display a play-face[5]—just as human participants in play-chase emit laugh signals. (4) The arousal changes form during playful interactions so that it is no longer fully goal-directed. Playmates do not want to hurt or eat one another; the activity is pleasurable in itself. The importance of the mechanisms of playing for understanding comic entertainment is that the play activities—the chasing or the effort to escape being caught—are in many respects identical or similar to the real ones. The significant difference is the *play solicitation* and the *play-contract*: the different signals of play between the players that lead to the trans-formation of the arousal from being fully goal-directed to a more means-oriented form.

embodied arousal and comic entertainment

Comic entertainment presupposes arousal. To better understand comic entertainment let us therefore look into the mechanisms of arousal. Central to the functioning of the embodied brain is the so-called auton-omic nervous system that has two opposed mechanisms: the sympathetic

nervous system that supports all kinds of coping, and the parasympathetic system that supports relaxation and the uptake of food. When the body prepares for action, for instance, the sympathetic nervous system—by means of neurotransmitters like adrenaline—will arouse the body and the brain. Sympathetic arousal will activate a series of body mechanisms, the main objectives of which are to provide energy and an ample blood supply to the muscles, and to block digestive processes so that the body can be fully focused on action and coping. Saliva disappears so the mouth becomes dry; the stomach shuts down; blood disappears from the skin and sweat takes over the cooling processes; and the heart works hard to send an ample blood supply to the (tense) muscles. Normally, sympathetic arousal will set the embodied brain in a state that aims at performing motor actions that will reduce the arousal. Fear, for example, elicits the planning of flight or the actual motor activation aimed at flight, and the possibility of safety that will reduce the arousal.

The basic narrative forms are based on such arousal, whether the genre of the film is action, horror, romance, erotica, or crime, because they all are based on simulating situations in which some agents must perform some actions in order to achieve specific goals. The actions need not be physical actions; thoughts are also "actions," and are controlled in those frontal parts of the brain that also control muscular actions. Paradoxes and ambiguities may activate strong cognitive activities, supported by arousal and also by heightened activity in different muscle groups.[6] Crime fiction will often evoke a form of arousal which motivates the viewer to solve mysteries, and all kinds of films may produce an arousal linked to cognitive processes. Surprises are also central causes of arousal; our brains are constructed to predict and control, and surprises will set the brain in a state of aroused alert.

Comic entertainment uses basic arousing situations and processes as their input to create an arousal upon which the play-mechanisms may work. Take the classic banana peel scenario in slapstick comedy: a person slips on a banana peel, which creates empathic arousal in the viewer[7] due to the fear of pain and the basic mechanism to control an upright position. The arousal may then be redefined, reappraised as comic and pleasurable. A sudden surprising appearance of a person in a comedy may create arousal that is then redefined, from being experienced as strongly aroused alertness (surprises may be dangerous) to being comic and pleasurable. Disgusting experiences, sounds, and odors create arousal, and much puerile humor is linked to arousal by disgust: for instance, things related to body excrements and odors. Violations of codes of decency create arousal. As mentioned, comic entertainment to a large extent feeds on arousal that normally creates negative experiences and violations of normal empathy. Other comic forms such as jokes are based on paradoxes, absurdities, or cognitive

incongruences that at first provide a jolt of arousal due to the surprise-driven re-framing of the understanding of such stimuli and cognitive overload. The understanding of such heterogeneous and surprising stimuli "overloads" the brain's capacity. The humor theoretician Jerry Palmer[8] discusses a humorous graffiti: "JESUS SAVES!" was written on a wall, and below: "And Keegan scores on the rebound!" Here, surprise is caused by a cognitive-semantic reorientation. There is also a heavy cognitive load constituted by the brain's activity of splicing together two different spheres, and an arousing profanation (the suggestion that Jesus is less skilled than a famous football player). All these elements create strong arousal that some will release by laughter, others by acts of distancing—for the message might be evaluated as gross or inappropriate. Other humorous situations consist of raising expectations about a painful outcome; the banana peel example may, for instance, first take place as a surprising event, and the next time be framed by the viewer's arousal by expecting a specific outcome. Slapstick achieves much of its arousal through depicting problems in basic motor control and other simple behaviors, whereas the arousal prompted by standard comedies arises from shame and related social processes.

Contrary to many theories that ascribe the comic to specific comic inputs—for instance, the popular incongruence theories that I will deal with later—there are no specific input stimuli that are linked to comic entertainment. Comic entertainment is a "meta-form" that piggybacks on top of whatever may create arousal. Therefore there are also comic versions of the standard genres, including horror comedies, action comedies, romantic comedies, and mystery comedies.

the play contract

Play activities such as play-fight and play-chase are fundamentally social, and the playful intent must continuously be communicated between the participants to avoid the play being experienced as too real or as having real consequences. When producing comic entertainment it is important to establish such a play contract. The solicitation of the play contract may be based on cues in the comic performance, and it is strongly supported by audience laughter because laughter is not only a reaction, but also a central element in the negotiation and affirmation of the play contract. The psychologists Provine and Fischer[9] have shown that people are thirty times more likely to laugh when they are with others than when they are alone. Until very recently comic entertainment was only experienced when viewers were part of an audience that signaled their acceptance of the play contract as a group by laughing, and mutually reinforced the willingness to experience the arousal as playful. Comic entertainment was enjoyed in theaters, cinemas, or in private social gatherings.

Laughter functions as a rhythmic coordination of social groups, similar to that of other paratelic,[10] that is, repetitive, non-goal-directed actions such as dance. Laughing members of a group strongly bond with each other. They diminish their normal individualistic self-control and delimitation from others within the laugh-group (even if this group bonding may be concomitant with an aggressive delimitation from other groups). It is important in experiencing comic pleasure to belong to a social group that, through laughter, reaffirms the play contract and by that also heightens the pleasure.[11] When television was invented it was considered necessary either to simulate such a social situation by performing the comic situations in front of a live audience, or to provide a laugh track. Comic entertainment viewed alone subtracts from the pleasure of the experience. However, easy access to TV, streaming, or DVD/Blu-ray may motivate viewers to trade away optimal comic pleasure in the same way that they trade away the pleasures of a large screen for easy access. While viewing comic entertainment in private environments is less fun, it is also less energy consuming.

acceptance or refusal of the play contract

A key issue when establishing a play contract is: with whom is the contract established? In comic entertainment the contract may be between one or several characters in the comic entertainment, so that the viewer laughs *with* the characters in an inclusive playfulness in which negative events are belittled. However, the viewer may also laugh *at* the characters, so that a kind of audience in-group is formed—one that laughs at out-group characters in the comic entertainment.

Play signals are often more difficult to emit in comic entertainment than in basic children's play, such as chase or rough-and-tumble play, because laughter emitted by characters may diminish the build-up of arousal; it may diminish arousal to see a character approach a banana peel, who laughs beforehand to show that the slip and fall to come will be a comic act. Some of the characters in comic entertainment may emit laughter—as when Laurel and Hardy and other characters in the classic *The Music Box* laugh at each other, but other comic characters and performers will deliver deadpan performances to boost arousal.[12] Laughter may therefore be replaced by, or supplemented with, other play signals from clowns, entertainers, and actors that tacitly or explicitly communicate their playful intentions. Often the play signals are intertwined with behaviors that are meant to create arousal, such as Jim Carrey's distorted facial expressions or John Cleese's exaggerated movements in his "silly walks."[13]

Such exaggerations are play signals in comedy and slapstick that may be accepted or refused by viewers. Some people will accept the playfulness of

Jim Carrey's hyperbolic facial expressions, while the expression itself will at the same time create strong arousal. Other people may experience strong disgust, and it is impossible for them to accept the play contract and make a comic appraisal of their arousal even if they know that the facial expressions are intended to be funny. Likewise, John Cleese's funny walks may, for some viewers, provide strong negative feelings associated with being disabled, or of making fun of the disabled, so that the acceptance of play signals is blocked.

Many play signals are similar to those of high seriousness, such as the exaggerated and stereotypical behavior aimed at being strongly expressive that we find, for example, in religious and political ceremonies, or as a characteristic of military behavior. Thus it is easier to make parodies of such activities, as in Chaplin's *The Great Dictator*.[14] Therefore the comic use of such stereotypical behavior may rely on redundant play signals and also on the viewer's interpretations or inclinations as to what kind of appraisal they want to make. Seeing a parade of soldiers in the Third Reich or in North Korea may create nationalistic elation among some, fear in others, and laughter in yet others—this is because they choose to see the marching behavior as both arousing and as an unintended play signal, whereas others accept a nationalistic-ritualistic situation contract. Similarly, the ability to laugh at disgusting or painful events depends on the individual viewer's willingness to accept play signals.

It must be emphasized that paradox or incongruity, often identified as an important cause of humor, is mostly ill-defined, as most differences may be described as paradoxes and incongruities. Further, paradoxes and incongruities do not necessarily elicit laughter. In religious contexts paradoxes and incongruities signal the need for seriousness and worship,[15] such as the paradox of a child begotten by a virgin and a holy ghost, or that of a figure that is God, man, and spirit at the same time. In fantasy, paradoxes and incongruities create salience.[16] In crime fiction they elicit arduous mental efforts of detection. Thus, paradoxes and incongruities often demand a basic play setting in order to be funny, and they are often not a primary cause of arousal but serve as play signals that allow people to reappraise and find a humorous outlet for arousal created by other means. These other means are, for instance, the erotic, aggressive or empathic-painful elements as argued by Freud,[17] although in some jokes the cognitive arousal and the play-signal aspects of the incongruity are heavily inter-twined.

the comic redefinition of reality status

The process of appraising something as funny is one of the central aspects of the comic. The appraisal often takes place in split seconds, even if the

disposition to laugh is strongly heightened by those social circumstances, play signals, and negotiations that have been dealt with above. The comic appraisal process belongs to a group of appraisal processes that I have called reality status evaluations.[18]

The term "reality status" refers to a cognitive evaluation of whether a given phenomenon in consciousness affords physical actions or not, because what is experienced as real is what affords action. Memories of past events are less real than online perceptions, and they do not afford actions; fantasies or dreams are less real than online perceptions. Even remote mountains or landscapes seen through fog are experienced as less real because it is more difficult to interact with such phenomena,[19] whereas that which can be grasped, touched, or kicked is very real. Such evaluations of what kind of reality a given experience possesses will tone the experience, and these evaluations are very important for aesthetic effects, especially in audiovisual fiction. They typically provide lyrical feelings and serve to reduce arousal and action tendencies, but may provide a sense of elation—as when reduced light at sunset creates romantic, lyrical feelings or when fantastic, supernatural scenes create an atmosphere of eeriness.

The result of the comic reality status appraisal differs in significant ways from those associated with lyrical and elated feelings. The appraisal processes that provide reduced action tendencies—for instance in lyrical experiences—are often slow, in contrast to comic appraisals that tend to be split-second reactions even if they have been primed for some time by several means. Further, the comic appraisal often boosts arousal, rather than reducing it. However, as I shall discuss in more detail later, it redirects the action tendencies from the exterior world (by hands and legs) with "actions" directed at one's own body by laughing.

The cognitive parts of the comic appraisal mechanisms are most likely located close to the pre-motor areas of prefrontal cortex where motor action is controlled. An important area for reality status evaluation is the medial anterior prefrontal cortex,[20] and these brain centers are also important for humor appreciation.[21] That is, reality status centers in the frontal part of the brain are gatekeepers for motor action, and they evaluate whether "this is real and should be acted on in full," or if "this is unreal and should not cause action, or only pretend action." Adjacent centers in the prefrontal cortex evaluate whether an occurrence is a brain event, such as a fantasy or a memory, or if its source is in the exterior world. Malfunction of prefrontal reality status centers is central in pathological illusions—for example, in schizophrenia. Reality status evaluations in the prefrontal cortex are therefore central for higher cognitive and emotional processes, and humor appraisal is a central aspect of these processes.

The comic appraisal may be described as a kind of involuntary judgment: "I find this funny." However, the comic appraisal may sometimes also be

described as an involuntary bailout reaction, similar to crying, caused by an arousal overload. Laughing and crying are in most respects very similar, even down to the neurological and anatomical elements in the two reaction patterns. Even if laughter is usually linked to positive emotions, hysterical laughter demonstrates the role of laughter as a bailout reaction to arousal overload. Similar effects are shown in relation to crying: strong positive overload may be released in tears, as at the end of melo-dramas.[22]

It is important to emphasize that the comic appraisal mechanisms are meta-appraisal-functions that serve to bracket experiences and to insulate the basic appraisal processes. Even if fear, pain, cognitive overload, sexual arousal or aggression are reappraised to be experienced as comic and unreal, they still retain their basic identities: aggression may still be felt even through the comic sugar-coating; likewise fear, pain, or desire may still lurk below comic insulators of "unrealness." Therefore the appraisal process is context-sensitive and relies very much on the values of the receiver. Sexual jokes about nuns may not appeal to religious people; people with strong empathic reactions may find it difficult to laugh at the misfortunes of others; and intellectuals may find gross body humor inconsistent with their own self-images. Moreover, the process is sensitive to social context because laughter has "epidemic" qualities of persuasion, and a viewer may be persuaded by the laughter of others.

the embodied brain's comic cascades

When the judgment "not real but playful and comic" is made in the prefrontal cortex, a cascade of events takes place within the brain and the body to provide a strong embodied experience. One aspect of this is a reduction of action tendencies towards the exterior world; there may be a very strong reduction of muscular tone in arms and legs concomitant with a strong muscular activity in the central body muscles around the lungs that provide the laughter.[23] When laughing, people may even collapse and fall down on the floor due to a total lack of muscular tone in the extrem-ities; this is similar to reactions of people with cataplexy, a temporary, sudden loss of muscle tone.[24] The brain mechanisms of this reduced muscle tone are similar to those of dreaming during REM sleep, during which the muscle tone is blocked (so that people do not act on their dreams).

The loss of muscle tone modifies a person's relation to the environment, including the muscular "intentional directedness" towards the physical environment. Instead of letting an arousal simulate outward-directed action, it activates centers in the brainstem, limbic system, and cerebellum that trigger laughter: that is, self-directed action in central body muscles, in contrast to the "world-directed" muscles in arms and legs.

The switch of arousal outlet from simulated action to self-modification by laughter is parallel to changes in the hedonic tone of the experience. Many comic scenes are based on highly painful experiences that, via empathy and mirror neuron simulation,[25] induce pain in viewers, readers, or listeners. However, when the appraisal of the arousal is "unreal," perception of the "comic" changes the hedonic tone into one of mirth or eventually just one of high interest. This is similar to dental patients receiving laughing gas (nitrous oxide); they still perceive the pain arousal, but without the strong pain and concomitant action tendencies of avoidance, the negative hedonic tone is diminished or even changed into a positive experience, just as alcohol and cannabis may change the reality status of the taker.[26]

The change of hedonic tone is related to the release of opioids (opium-related neurotransmitters) such as endorphins.[27] This makes sense: pain is an indicator of the need to act to avoid the causes of pain, and pleasure blocks such needs. Endorphins released by laughter reduce pain,[28] induce pleasure, and are central in establishing social bonds and positive social interaction. This explains the ambiguity of laughter that—since Plato—has divided the attitude to comic entertainment as either based on scorn or empathy, because the endorphins may reduce empathic pain and therefore incline viewers to be insensitive to the abuse and ridicule of characters. However, the brain chemistry of humor also supports warm feelings of empathy, such as when Chaplin and Buster Keaton inspire warm protective sympathy underpinned by endorphins. This sympathy has the warm glow of care that grownups feel at the motor inadequacies of small children or Bambi's helplessness on the ice, as opposed to the pity (or disgust) often felt when seeing motor inadequacies of disabled people. Humor may also in other contexts facilitate the integration of a comic character in the viewer's play community because the negative deeds of the character are perceived as "unreal" and playful and therefore pleasurable.

Romantic comedies often have a playful interaction between hero and heroine—see, for instance, the playful situations in *Bringing Up Baby* or *Groundhog Day*.[29] It may seem counterintuitive that romantic comedies often have a rather strong comic degradation of the protagonists' bodies or psyches, as in *Bridget Jones's Diary*.[30] The degradation, however, does not make the romantic protagonists less attractive—the Cary Grant figure in *Bringing Up Baby* does not become less attractive by being humorously degraded. The comic situations serve to diminish body autonomy: normally people try to control their bodies, but during playful and erotic interaction people enjoy being touched. As pointed out by Provine[31] and others, play forms such as rough-and-tumble presuppose that close body contact is not felt as dangerous or unpleasant. Laughter by tickling is an example of how a playful-humorous body contact is redefined as pleasurable. Play may thus

be an important element in negotiations of appeasement and bonding, and may also have an erotic function as a way to diminish body delimitation, as we see in many playful and flirtatious situations in romantic comedies.[32] The playfulness may further allow a steady build-up of erotic arousal because it makes the erotic desire less aggressive.

comic reactions and the PECMA flow

The link between laughter and diminished muscular tenseness strongly supports the general framework of the PECMA flow model of the embodied experience of films that I have laid forward in previous publications.[33] The acronym stands for Perception, Emotion, Cognition, and Motor Action. The PECMA flow model describes how the normal processing of audiovisual input is linked to the arousal of emotions that presses for an outlet, a "cognitive" plan for reactions to the emotional stimulus, eventually followed by a motor implementation of that plan. A brief example is as follows: See wolf close by (P), feel fear (E), make plan (escape, confrontation) (C), implement the escape plan by running (MA). In classic quests like *Raiders of the Lost Ark*, the narrative flow is controlled by the overarching goal, to get hold of the ark.[34] The narrative is therefore focused on performing actions directed at the physical world in order to achieve a goal; the achievement of that goal transforms the tense arousal to pleasurable relaxation at the end. In mysteries, cognitive "actions" and physical actions provide a similar curve, from goal setting to goal achievement.

The diminishing of the muscular tone during laughter provides, so to speak, the bodily evidence for the PECMA definition of reality as linked to outward-directed motor action. The core of the humorous reaction is that the event should not be perceived as real, even if it is very real; we know this from hysterical laughter in relation to crisis situations. According to the PECMA theory, the experience of real-ness or unreal-ness is only loosely related to the actual reality status of a given phenomenon, but is centrally related to the phenomenon's affordances for the experiencing subject as a reflection of his or her appraisal. Just as very real distant mountains may appear unreal, because they do not afford actions, so the laughter at very real pain expresses that there is nothing you can do about a given calamity and therefore it is felt as unreal.

My previous account of the relation between PECMA flow and humor in *Moving Pictures* presupposed that the redefinition of reality status and the blocking of motor intentions and motor action was concomitant with a switch from sympathetic to parasympathetic reactions of relaxation. However, the mirthful laughing state induced by comic situations is a special variant of sympathetic arousal.[35] Comic arousal is special, because even if prolonged comic entertainment produces high levels of arousal it

187

does not have the normal effects of extended periods of high arousal, that is, stress. Laughter and humorous situations may cause rather high levels of stress neurotransmitters such as adrenaline and cortisol, although it may also cause secretions of opioids such as endorphins that tend to counteract stress.

The remarkable feature of the comic is therefore that it affords high arousal without the stress normally linked to high levels of arousal, because of the way in which laughter processes provide a continuous outlet by means of central body muscles linked to the functioning of the lungs and facial muscles that are both expressive of pleasure and communicative play signals. The release of pleasure-evoking opioids may equally quell stress. Laughter thus diverts the use of other-directed muscles in arms and legs. Prolonged laughter may, however, provide mental and bodily weakness, and, as mentioned, even lead to cataplexy, a "melt-down" of muscular function in arms and legs.[36]

The comic experience is therefore a remarkable variant of the normal narrative PECMA flow in films and entertaining narratives, because it does not fully motivate goal-oriented seeking and does not provide an urge to diminish arousal. On the contrary, many fast-paced comedies feature a continuous increase in arousal, and each comic incident may provide an arousal platform on which the next incident may build. Unlike the normal narratives that are driven by an urge to provide pleasure-payoff by reducing arousal by goal-achievement along the way and at the end, in comic entertainment the pleasure-payoffs are provided along the way because all kinds of arousal are positive for the audience, whether they are caused by success or failure, pleasure or pain.

However, even if comic situations in one dimension possess self-amplifying elements due to the high level of arousal that is inherited from previous comic elements that may make any new stimulus "funny," they need central sympathetic drivers—such as anger in Monty Python's "The Parrot Sketch," fear in horror comedies, or sexual desire in erotic comedies.[37] Thus humor piggybacks on top of ordinary arousal in the same way that play-fighting piggybacks on real fighting. Comedies are normally meta-forms of other narrative forms, as in action comedies, horror comedies, or crime fiction comedies, which all piggyback on arousal built up by narratives based on perceiving actions and emotions as real. Tragicomedies may even exploit the fact that laughter and crying in many ways share the same biological bailout mechanisms, because both divert an arousal from being directed toward the exterior world by muscular action to bodily reactions of self-modification. However, whereas crying is supposed to transform the arousal to a parasympathetic reaction of relaxation (albeit with a negative hedonic tone), laughter increases sympathetic arousal.

Because many forms of comic entertainment piggyback on top of normal, goal-motivated narrative forms, they might often "give up" the comic negation of the pleasures of goal-achievement at the end so that the characters achieve their goals. Thus you may have your cake and eat it: defeat becomes pleasurable and so does achievement.

a flow model of comic experiences

As I have demonstrated, comic entertainment is experienced in a flow, a temporal progression comprised of the following components: elements that prime expectations of experiencing something comic; elements that cause arousal; signals of play; the comic appraisal "this is not for real"; and cascades of changes in muscular activities and the release of pleasure-evoking neurotransmitters. Elements may have a double function: exaggerated movements may elicit arousal but also be play signals, and arousal may be so strong that the overload forces the embodied brain to bail out by an appraisal that elicits laughter (or crying). The appraisal "this is not real" may not only turn on a redefinition of reality status in laughter, but also boost arousal by the appraisal of the degree of deviation from what is normal. Laughter is a result of the arousal-appraisal process, but it also serves as a negotiation of a play community and as an affirmation of a play contract. Some of the elements may be omitted. For instance, a comic situation may come un-primed and/or un-negotiated, while the appraisal processes in the viewer's brain do the job.

The general elements and the temporal flow in comic entertainment may therefore be described as follows, although a particular instance of comic entertainment may choose or elide some of them:

1a. *Priming*: this is mostly, if not always, foreknowledge in viewers about a comic play situation to come that primes a comic appraisal.
1b. *The arousing input.*
1c. *Input from social context* or cues in input that point to a comic appraisal and a play contract. The play contract may or may not be established before the beginning of the humorous event; it may be cued by the comic input, or only established at a later step in the process.
2. *Sympathetic arousal* in response to input: for example, aggression; fear; sexual arousal; surprise; cognitive overload (for example, by paradoxes and incongruities); empathy-induced pain; embarrassment; arousal induced by problematic motor control, as in slapstick.
3. *Appraisal in the prefrontal cortex of reality status*: "this is unreal, comic, playful." The appraisal is elicited by evaluation of cues from input and/or elicited by the size of the arousal and/or by means of play signals. The appraisal may boost the arousal, for instance by accepting the arousing stimuli

to work freely due to the play-acceptance of diminishing a normal arousal control.

4. *Change of hedonic tone* (partly or in full) into pleasure, even of input that normally has a negative hedonic tone. Diminishing of action tendencies, including reduced muscular tension in arms and legs, release of opioids, body-activation by self-directed muscular activity by laughter, and other body language cues of play are often concomitant with an experience of laughter-bonds with groups such as virtual or actual audiences.

5. The comic laughter experience may provide the platform for further humorous experiences in comic events that accumulate comic arousal and mirth, as in prolonged humorous events such as comedies and stand-up.

The flow model of comic entertainment provides a framework for understanding how comic entertainment relies on a cluster of functionally related processes. Each process-element may play a smaller or larger part in comic entertainment, depending on the type of entertainment.

the general theory and existing theories

The major existing theories of humor have focused on different aspects of the total comic processes as described in my general theory. One group of theories may be called *stimulus-oriented* because they have focused on specific eliciting factors in the humorous stimulus. Prominent stimulus theories are linked to the form of the stimulus. They have argued that the comic is caused by some stimuli that are paradoxical and incongruent. Prominent proponents of formal stimuli theories are Arthur Schopenhauer and Arthur Koestler. But as argued, theories that link the comic exclusively to specific stimuli forms are problematic, partly because many other non-paradoxical and non-incongruent inputs may create the necessary arousal, and partly because incongruence and paradox do not necessarily lead to a comic appraisal: it could also lead to cognitive interest or religious worship. Incongruence is thus one of several elements in humor elicitation.

Other important stimulus theories focus on the stimulus content. The most prominent is Sigmund Freud's theories of wit, humor, and comic phenomena as outlets of suppressed sexual and aggressive drives.[38] From the point of view of the general theory, sexual and aggressive drives are some of the sources of arousal, but so are surprise, fear, and cognitive overload. Furthermore, those who laugh at sex and aggression often suppress these drives less than the average population.[39] Freud's focus on sexuality and aggression must therefore be supplemented with many other kinds of arousal. Freud furthermore was interested in the way in which jokes and

similar comic activities depend on a sophisticated elaboration of form; he thought that this served as a legitimation of dealing with normally suppressed content. This idea can easily be integrated in a general theory as a way to signal playfulness and establish a play contract—even if the reason for establishing such a contract is not only to circumvent suppression of lust in a Freudian sense, but also, for instance, to deal with painful events and also as plain playing with arousal, as in arousal by surprise or cognitive overload.

An equally important group of theories of the comic focuses on its social function; these analyze the type of play contract that is established. These theories may be divided between those that emphasize *social exclusion*, and those that emphasize *social inclusion*. To emphasize the comic as a means of social exclusion, in which one group or person laughs at another group or person, is a very old and prominent position that was already described by Plato, and later on by David Hume, for instance, who saw humor as a way of showing one's superiority vis-à-vis other people. Similarly, Henri Bergson[40] regarded humor as an element in exerting social discipline in relation to behavior that was machine-like; Mikhail Bakhtin[41] perceived humor as a body-based popular revolt against upper class stiffness; and Michael Billig[42] emphasized laughter as ridicule.

In contrast, numerous people[43] have described humor as an element of social integration and bonding. They have described laughter as a kind of "social grooming" that supports bonding and leads to the release of pleasure-evoking neurotransmitters, endorphins in the brain that reduce or insulate the brain from experiences of pain. This accords with Stephen W. Porges' polyvagal theory, which emphasizes how group bonding by body language—including tone of voice—plays a central role in affect regulation, based on a specific mammalian rewiring of affect regulation linked to social bonding.[44]

From the point of view of my general theory, both the inclusive and the exclusive function of laughter and the comic are central possibilities. The redefinition of actions as being playful and unreal facilitates bonding, but it also reduces the perceived cost of the hostile and scornful behavior for those who exhibit such behavior, because the ridicule and scorn is just "for fun."

A few theories focus on the comic appraisal. Michael Apter[45] describes two mental forms: the goal-directed, telic, that craves for arousal-reduction by achieving the goals; and the paratelic, non-goal-directed, that finds pleasure in high arousal and activities for their own sake. Furthermore, a group of theories focuses on the physiological processes underpinning laughter and mirth.[46] Related to this group are evolutionary descriptions of the functions of laughter and play.[47]

Most of these theories provide important insights, and many are not mutually exclusive but address different aspects of comic and humorous

experiences. My general model provides the tools for understanding the interaction between the different aspects of the comic complex: the arousing stimuli, the social contextualization and negotiation, the comic appraisal of reality status, and the transformation of arousal to laughter and mirth.

in conclusion

Comic entertainment allows social groups to share their emotions, and even the negative ones such as social conflicts or painful experiences can be dealt with, due to the way in which the comic appraisal of un-realness and the concomitant mirth makes possible the joyful experience of all aspects of human existence. Comic appraisals and reactions are central elements in the human regulation of emotions because they constitute meta-reactions that modify or change other emotional reactions.

On the one hand, comic appraisals and reactions may be regarded as "self-regulations," because play appraisal mechanisms redirect the PECMA flow action tendencies aimed at modifying the world through motor action towards self-modification through laughter. On the other hand, comic entertainment is fundamentally social, based on establishing a common play contract so that the participants in the entertainment insulate the group—through laughter—from the negative valence of the content and from the need to act out the arousal. Comic entertainment is therefore a kind of frame for social grooming and bonding.

Certain forms of humor, such as satire, express slightly veiled aggressive tendencies, as pointed out by Hume and others. According to Jaak Panksepp,[48] play may also serve as a system of establishing dominance: the strongest one may be identified, while humor provides a shield for the most bitter consequences of a power struggle. The play situation sugarcoats the aggression. Thus humor (and play) may be inclusive or exclusive in its effects.

Comic reactions may be released by many different stimuli and techniques, whether aggression; surprise; obscenity; incongruity and paradox; or derision or exaggerations. The stimuli may be part of cueing arousal but some of the techniques may also be part of a social negotiation; the re-appraisal of the situation may change the experience from being painful or aggressive into being playful and "unreal," not cause for action that may combine high arousal and pleasure. Thus the central part of the comic is the negotiation of the redefinition of reality status. Freud believed that jokes were cover-ups for letting sexual and aggressive emotions have free play, and he may be right in pointing to humor techniques as being about the acceptance of playfulness; however, the arousal underpinning humor is not only related to power and sex but also, often, a series of negative emotions that are "groomed" away by establishing a laughter community.

Due to the need for negotiation of a play contract, comic entertainment mostly requires some shared values among the viewers. Perhaps for that reason comic entertainment is often linked to a local environment. Whereas genres like action and animation are shared globally, comedies are mostly linked to smaller communities.[49]

notes

1. The theory is an expanded and revised version of a theory laid forward in Torben Grodal, *Moving Pictures: A New Theory of Film Genres, Feelings, and Cognition* (Oxford: Clarendon Press, 1997), Chapter 8.
2. *Borat: Cultural Learnings of America for Make Benefit Glorious Nation of Kazakhstan*, director Larry Charles (Beverly Hills: Four by Two Films, 2006).
3. See Jaak Panksepp, *Affective Neuroscience: The Foundation of Human and Animal Emotion* (New York: Oxford University Press, 1998); Robert Provine, *Laughter: A Scientific Investigation* (New York: Penguin, 2000); and Rod A. Martin, *The Psychology of Humor: An Integrative Approach* (London: Elsevier, 2007).
4. See Panksepp.
5. For more information on the concept of the play-face, see Jan Van Hooff, "A Comparative Approach to the Phylogeny of Laughter and Smiling," in *Non-Verbal Communication*, ed. Robert A. Hinde (London: Cambridge University Press, 1972), 209–241.
6. Robert B. Malmo, *On Emotions, Needs and Our Archaic Brain* (New York: Holt, Rinehart & Winston, 1975).
7. Mirror neurons in the viewer's brain simulate aspects of the movements of others. See for example, Christian Keysers, *The Empathic Brain: How the Discovery of Mirror Neurons Changes Our Understanding of Human Nature* (Kindle E-book: Social Brain Press, 2011).
8. Jerry Palmer, *The Logic of the Absurd: On Film and Television Comedy* (London: BFI, 1987), 52.
9. Robert Provine and Kenneth R. Fischer, "Laughing, Smiling and Talking: Relation to Sleeping and Social Context in Humans," *Ethology* 83, no. 4 (1989): 295–305.
10. See Michael Apter, *Reversal Theory: The Dynamics of Motivation, Emotion and Personality* (Oxford: Oneworld, 2007).
11. See, for example, Martin, Chapter 5.
12. *The Music Box*, director James Parrott (Beverly Hills: Metro-Goldwyn-Mayer, 1932).
13. *Monty Python's Flying Circus*, created by Graham Chapman, John Cleese, Terry Gilliam, Eric Idle, Terry Jones, and Michael Palin (London: BBC, 1969–1974).
14. *The Great Dictator*, director Charles Chaplin (Hollywood: Charles Chaplin Productions, 1940).
15. Pascal Boyer, *Religion Explained: The Human Instincts That Fashion Gods, Spirits and Ancestors* (London: William Heinemann, 2001).
16. Ara Norenzayan, Scott Atran, Jason Faulkner, and Mark Schaller, "Memory and Mystery: The Cultural Selection of Minimally Counterintuitive Narratives," *Cognitive Science* 30, no. 3 (2006): 531–553.
17. Sigmund Freud, *Jokes and Their Relation to the Unconscious* (London: Hogarth Press, 1960).

18. Grodal, *Moving Pictures.*
19. Torben Grodal, *Embodied Visions: Evolution, Emotion, Culture, and Film* (New York: Oxford University Press, 2009), especially Chapter 10.
20. Jon S. Simons, Richard N. A. Henson, Sam J. Gilbert, and Paul C. Fletcher, "Separable Forms of Reality Monitoring Supported by Anterior Prefrontal Cortex," *Journal of Cognitive Neuroscience* 20, no. 3 (2008): 447–457.
21. Prathiba Shammi and Donald T. Stuss, "Humour Appreciation: A Role of the Right Frontal Lobe," *Brain* 122, no. 4 (1999): 657–666.
22. Ed S. H. Tan and Nico H. Frijda, "Sentiment in Film Viewing," in *Passionate Views: Film, Cognition, and Emotion,* ed. Carl Plantinga and Greg M. Smith (Baltimore, MD: John Hopkins University Press, 1999), 48–64.
23. Martin; Sophie Schwartz, Aurelie Ponz, Rositsa Poryazova, Esther Werth, Peter Boesiger, Ramin Khatami, and Claudio L. Bassetti, "Abnormal Activity in Hypothalamus and Amygdala During Humour Processing in Human Narcolepsy with Cataplexy," *Brain* 131, no. 2 (2008): 514–522.
24. Sebastiaan Overeem, Walter Taal, E. Öcal Gezici, Gert Jan Lammers, and J. Gert Van Dijk, "Is Motor Inhibition During Laughter Due to Emotional or Respiratory Influences?" *Psychophysiology* 41, no. 2 (2004): 254–258; Schwartz et al., "Abnormal Activity."
25. Keysers.
26. On YouTube (http://www.youtube.com/watch?v=_Ha-ZrUPJ_E) you may watch how persons under the influence of nitrous oxide (laughing gas) totally lose motor control.
27. Anna J. Machin and Robin I. M. Dunbar, "The Brain Opioid Theory of Social Attachment: A Review of the Evidence," *Behaviour* 148, no. 9–10 (2011): 985–1025.
28. Robin I. M. Dunbar, Rebecca Baron, Anna Frangou, Eiluned Pearce, Edwin J. C. van Leeuwen, Julie Stow, Giselle Partridge, Ian MacDonald, Vincent Barra, and Mark van Vugt, "Social Laughter is Correlated with an Elevated Pain Threshold," *Proceedings of the Royal Society of Biological Sciences* 279, no. 1731 (March 22, 2012): 1161–1167.
29. *Bringing Up Baby,* director Howard Hawks (Los Angeles: RKO Radio Pictures, 1938); *Groundhog Day,* director Harold Ramis (Culver City: Columbia Pictures Corporation, 1993).
30. *Bridget Jones's Diary,* director Sharon Maguire (New York: Miramax, 2001).
31. Provine.
32. Grodal, *Moving Pictures;* Francis F. Steen and Stephanie A. Owens, "Evolution's Pedagogy: An Adaptationist Model of Pretense and Enter-tainment," *Journal of Cognition and Culture* 1, no. 4 (2001): 289–321; Mette Kramer and Torben Grodal, "Partner Selection and Hollywood Films," in *The Psychology of Love, Volume 2: Emotion and Romance,* ed. Michele E. Paludi (Santa Barbara: Praeger, 2012), 3–22.
33. Grodal, *Moving Pictures;* Torben Grodal, "The PECMA Flow: A General Theory of Visual Aesthetics," *Film Studies* 8 (2006): 1–11; Grodal, *Embodied Visions.*
34. *Raiders of the Lost Ark,* director Steven Spielberg (Hollywood: Paramount Pictures, 1981).
35. Martin, 60–62.
36. Schwartz et al.
37. *Monty Python's Flying Circus.*

38. Freud.

39. Martin.

40. Henri Bergson, *Laughter: An Essay on the Meaning of the Comic* (New York: Macmillan, 1911).

41. Mikhail Bakhtin, *Rabelais and His World*, trans. Hélène Iswolsky (Cambridge, MA: MIT Press, 1968).

42. Michael Billig, *Laughter and Ridicule: Towards a Social Critique of Humour* (London: Sage, 2005).

43. See, for example: Panksepp; Provine; Dunbar et al.

44. Stephen W. Porges, *The Polyvagal Theory: Neurophysiological Foundations of Emotions, Attachment, Communication, Self-Regulation* (New York: Norton, 2011).

45. Apter.

46. See Martin, Chapter 6.

47. For example: Provine; Panksepp.

48. Panksepp.

49. "Genre and International Box Office," *Film Victoria Australia* website. http://www.film.vic.gov.au/_data/assets/pdf_file/0006/969/AA6_Genre_and_Intenational_BO.pdf (accessed May 27, 2013).

postcolonial humor, attachment, and yasujiro ozu's *early summer*

eleven

patrick colm hogan

Like everyone, colonized people laugh, even if they may have less to laugh about. The general principles of their laughter are also like those of anyone else, built on the same neuro-affective mechanisms, derived from the same evolutionary history. Nonetheless, conditions following the onset of colonization enhance certain properties of humor and particular attitudes toward colonialism make certain uses of humor more salient in those conditions. This chapter begins by considering the difference between conditions and attitudes after the onset of colonialism. It then turns to the general nature of humor and its relation to properties of childhood. The third section extends the treatment of humor to colonialism. From here, the chapter takes up an instance of colonialism (albeit one rarely discussed in postcolonial studies)—the US military occupation of Japan after World War II. The final section considers part of Yasujiro Ozu's *Early Summer* (1951)[1] in relation to the preceding analysis.

the postcolonization condition and the postcolonial stance

"Postcolonial" is a category that orients our description and explanation or interpretation of a work. Thus it takes its place among many such categorizations, each of which is likely to have different orienting effects. Specifically, it is a category that highlights a work's relation to the political, economic, and cultural conditions of colonialism itself or to the lingering political, economic, and cultural effects of colonialism after independence. For example, we are likely to understand Muzaffar Ali's *Umrao Jaan* (1981) one way if we see it as a postcolonial film and another way if we see it as, say, a Sufi film.[2] In the former case, we might stress the narrative function of the 1857 Uprising against British Rule as presented in the film and we might construe the violations of continuity editing as acts of cultural resistance. If we classify the film as Sufi, however, we are likely to focus on the mystical poetry recited in the story and we may interpret the violations of continuity editing as fostering the sort of disorientation and uncertainty that characterizes some Sufi teaching.

Interpretive categories come in at least two varieties. One involves some situation or non-elective property—for example, "woman"; the other involves an attitude—for example, "feminist." In Marxist terms, one involves origin and one involves stance.[3] The distinction holds generally, but is particularly important in cases in which social hierarchies are involved. The situation and attitude of writers and other artists after the onset of colonialism is clearly one such case. I will refer to the situation as a "postcolonization condition." I will refer to the attitude, drawing on the Marxist term, as a "postcolonial stance."[4]

The distinction bears on different aspects of cultural production and reception. For example, Fredric Jameson's famous insistence on reading postcolonial works as national allegories[5] presumably applies to works with a postcolonial stance rather than works merely produced in the postcolonization condition (although, even then, it is overstated—as, for example, Aijaz Ahmad has stressed).[6] In other words, the postcolonization condition alone probably does not produce national allegory. In contrast, it may be that the condition alone fosters resentment toward the colonizers and their culture. This may underlie the emphasis on "resistance" found in so much postcolonial theory. Yet here too this stress on resistance is almost certainly overstated. The emotional responses of colonized people to the postcolonization condition are, on the whole, almost certainly better characterized as ambivalent. This means that colonized people to a great extent both resent and admire, reject and aspire toward the culture, attitudes, and even the physical features of the higher-prestige colonizers. At the same time, they feel both resentment and admiration toward the traditions and current practices of their own colonized in-group.[7] Indeed,

a postcolonial stance is not so much a pure commitment that manifests an unequivocal motivational orientation. Rather, it is much more like the management of ambivalence, a simplification of impulses that are usually much more equivocal and contradictory.

These general points apply no less to laughter than to anger or sorrow. In speaking of postcolonial humor, then, we may distinguish between humor that arises from a postcolonization condition and humor that expresses a postcolonial stance. Postcolonization condition humor is simply humor that is rendered more likely through the conditions of colonialism. An obvious case of this would involve translation errors. Such errors may lead to laughter at the colonizer or the colonized, in keeping with the ambivalence we have just noted. In contrast, postcolonial stance humor involves some strategic aim. Put differently, the study of postcolonization condition humor involves examining the ways in which general mechanisms of humor are characteristically specified in postcolonization works. The study of postcolonial stance humor involves both the examination of such mechanisms and the further study of the characteristic social and political uses to which humor is put in postcolonial works.

laughing

In order to consider these issues more fully, we need to begin with a basic sense of what makes us laugh. I have argued elsewhere that the mechanisms of humor derive from errors in thought, speech, and action that are characteristic of childhood—specifically, errors that tend to occur when children are striving beyond their developmental level.[8] Clearly, I cannot go through the entire account here. However, a few points are worth noting. First, I take *humor* to refer to the eliciting conditions that produce activation of the various systems that constitute the emotion of *mirth*. Mirth itself involves a phenomenological tone or feeling (roughly, a form of joy or happiness); attentional orientation toward the humorous target; expressive outcomes (such as laughter); effects on other (non-mirth) emotional systems; and so on. The relations between emotion systems are particularly important. These may be excitatory or inhibitory. It seems clear that mirth and various forms of aversive emotion (such as disgust or sorrow) are mutually inhibitory. That inhibition is directional for certain thresholds. Specifically, it would seem that, at low levels of aversive emotions—including empathic versions of those emotions—mirth temporarily suppresses the aversive emotion. However, at higher levels, the aversive emotion systems suppress mirth. Put simply, humor suppresses disgust only to a certain point; at that point, we start gagging rather than laughing.

The basic contention of the evolutionary account of mirth begins with the standard point that evolution produces mechanisms that approximate

functions. Slithering things on the ground trigger the fear system. This is a mechanism prepared for by evolution. It approximates the function of avoiding poisonous snakes. But it is not, of course, identical with that function since it also leads us to avoid innocuous slithering things (unless we habituate to them or modulate our fear response). The same mechanism versus function distinction applies to mirth. The basic claim of the evolutionary account of mirth is that the mechanisms at issue have developed in such a way as to benefit childrearing. Specifically, the mechanisms at issue orient parental attention and qualify parental empathic response in ways that foster attentiveness, but that also limit excessive emotional response to trivial mishaps—or excessive censoriousness in response to errors (think, for example, of the response to breaches of decorum or even simple speech errors). In this way, then, the mechanisms at issue arise due to their function bearing on children.

However, as usual, the mechanisms operate outside of their functional domain. Thus the mechanisms bear on adults as well as children. There are, of course, qualifications, since other emotion systems as well as prefrontal modulation of emotion systems operate differently with respect to children and adults. The point is that mirth-eliciting mechanisms themselves are the same in the two cases. These mechanisms range from the lack of certain sorts of motor coordination (as in pratfalls and comic drunks), to under-inhibited right-hemisphere language processing (as in puns), to various forms of social gaffes (characteristic of not having learned proper social rules).

I should stress that the point here is not, for instance, that verbal humor is confined to the types of puns that children would produce. Rather, the point is, again, that there are certain mechanisms governing children's errors. These include the sort of right-hemisphere language processing that overproduces meanings—or, rather, does not eliminate contextually irrelevant meanings. This leads to various sorts of children's speech errors. Adults may produce statements that manifest the same mechanisms, either by accident or by design. When they do so, they are unlikely to confine their overproduction to meanings known by children. For example, an adult may pun on technical terms in Heideggerian philosophy, though these would be familiar to only a small percentage of children. The mechanism of the humor is, nonetheless, the same.

Of course, it is possible that a child might inadvertently make a pun on Heideggerian philosophy. Indeed, children inadvertently make sexual jokes with some frequency. This leads to another important qualification of this account. Again, it is the mechanisms of childhood errors that produce humor. These mechanisms need not require any intention to be funny. In their basis, they do not involve any such intention at all. They bear, again, on errors, not cleverness. Indeed, children's self-conscious jokes are notoriously unfunny.

Here, too, it is valuable to draw a distinction roughly parallel to that which exists between postcolonization condition and postcolonial stance. On the one hand, there is the spontaneous instantiation of an error (such as we find in children's mistakes), but also in slips of the tongue or certain sorts of unintentional falls (such as those caused by an unnoticed banana peel). On the other hand, there is the intentional manipulation of mirth-generating mechanisms. We may refer to the former as a *humorous condition* and the latter as a *comedic stance*.

One aspect of this distinction, likely to strike many readers immediately, is that a humorous condition is not always humorous for the person in the condition. Indeed, it may be humiliating for him or her. Put differently, the distinction between the humorous condition and the comedic stance is roughly parallel to the distinction between laughing at and laughing with.[9] The point obviously has bearing on any use of humor within conditions of social hierarchy.

Of course, not all *laughing at* is derisive. After all, one may laugh at oneself without self-loathing or even embarrassment. In keeping with this, not every instance of a humorous condition gives rise to derisive laughter. The childhood-based account of humor helps us to understand just how the humorous condition can give rise to derisive laughter. First, by this account, viewing someone's condition as humorous tacitly involves placing them in the position of an erring child. This is necessarily to some extent belittling. However, I would not consider that minimal belittling to be derisive in itself. If this were the case, then every time a parent laughed at his or her child, that would count as belittling the child, which is surely not the case. Two closely interrelated factors enter here, and both concern empathy.

The first factor is empathic sensitivity. Insofar as a humorous condition involves harm to the person in the condition, the observer's empathy should serve to inhibit his or her mirth in response to that condition. Suppose Jones slips on a banana peel and, flailing his arms about, manages to grab hold of something nearby that slows his fall, which is still ludicrously awkward. This is quite a different situation than if he slips on a banana peel and cracks his skull, begins bleeding, and is unconscious, even if the awkward flailing is the same. My empathic response in the second case should serve to inhibit my mirthful response. If it does not, then we have a case of derisive laughing at.

Here as elsewhere, empathic response rests on one's sensitivity to the other person's suffering. It is also bound up with the second factor—one's emotional inclination toward the other person, thus how one is affected by his or her suffering (whether in a parallel or a complementary way). Both sensitivity and inclination bear on colonialism, because both bear on in-group and out-group relations. We are far more likely to be aware of the harm done to members of our own group than to members of out-groups. For example, in a war, we may find the escapades of our brave soldiers to

be delightful, as we do not have a clear sense of the suffering of enemy soldiers. In addition, in-group/out-group divisions tend to produce complementary rather than parallel emotions (for example, joy over an enemy's fear). Thus I am more likely to be moved by the suffering of an in-group member (an American soldier) than by that of an out-group member (an Afghani civilian).

In keeping with this, Jones may find my response to his fall objectionable even if he is entirely unharmed. From Jones's point of view, it is a matter of trust. Put simply, Jones may not be sure that I would have responded differently even if he had been injured. Of course, Jones does not think through the issue this way, but this is roughly what his feeling means. From my point of view, the correlate of Jones's trust would be (empathic) benevolence. If I feel benevolence, then I merit his trust (whether or not he recognizes this). Benevolence may be understood as an orientation toward supporting the other person's interests (that is, providing aid in his or her distress). Jones is likely to feel greater trust to the extent that he has greater certainty of my benevolence. That benevolence may be general: a broad inclination toward helping everyone, or everyone in an in-group. But it may also be particular. In the second case, it is generally a function of attachment—whether the attachment of friends or spouses, or the even more fundamental attachment of parents and children. This, of course, returns us to the sources of humor. Most of us feel very strongly that the amused response of parents to children should not be derisive. This is because parents should feel attachment bonds with their children, and these should promote both empathic sensitivity and benevolent caregiving.

Again, part of my argument about humor has been that its primary evolutionary function is the regulation of adult response to children's failures—or, more generally, the discrepancies between children's efforts or performance and their developmental stage—particularly in connection with attachment. This involves an intensification of interest in, and attention to, children. Put simply, without our mirthful response, children would be excruciatingly boring and we would be inclined to stop paying attention to them rather quickly. Moreover, the interaction of our emotional "mirth system" with empathic worry involves inhibition in both directions. Mirthful response tends to inhibit excessive worry, which would limit children's necessary risk-taking. But danger above a certain level inhibits comic response, so that the children are not risking serious harm. The point fits with research showing that "availability, noninterference, and encouragement" of an attachment figure are highly beneficial characteristics for both children and adults.[10]

A particularly significant implication of the preceding analysis is that attachment should not only enhance empathic response. It should also enhance mirth. From an evolutionary perspective, enhanced empathy is

important to aiding one's children when they are in genuine need or in genuine danger. However, that enhanced empathy could render the comic response null, undoing its functional role of preventing excess "mothering." One consequence of the attachment-based enhancement of mirth is that, in cases of non-harm, we should be more likely to find our own children (or other attachment figures) amusing—hence the propensity of parents to recount the most banal stories about their children's latest utterances and gurgle with delighted laughter over them. Indeed, we may contrast derisive mirth with what we might call "celebratory" mirth. Just as derisive mirth is prototypically associated with out-groups (for instance, in racist cartoons), celebratory mirth is prototypically associated not only with in-groups, but with attachment figures particularly. Examples would include parents' often excessive enthusiasm for their children's newest mala-propisms.

In sum, then, mirth is a response to certain properties and actions, and so on, conforming to mechanisms that characterize children's failures in striving beyond their developmental level (or, in some cases, discrepancies between the child's developmental level and the expectations of the observer).[11] This response may be enhanced, and made celebratory, by attachment. However, it may be inhibited by empathic sensitivity and benevolence, which are themselves enhanced by attachment. Humor is derisive to the extent that it is inadequately empathic.

The observer of a humorous situation (the "comic subject") and the person in that situation (the "comic object") have different perspectives on the situation. Given this, we would expect some cases wherein the comic object views laughter as derisive, whereas the comic subject does not. In other words, we would expect cases of misunderstanding. Moreover, as with other emotions, we would expect some degree of ambivalence in many comic situations, for both comic subjects and comic objects, even when the comic subject and comic object is the same person.

Finally, the spontaneous instantiation of mirth-triggering mechanisms produces a humorous situation. However, the self-conscious manipula-tion of such mechanisms involves a comedic stance. The comedic stance involves not only a comic subject and a comic object but a comic narrator who construes or recounts the comic situation, directing attention, select-ing relevant aspects of the condition, and so on.

202

colonialism and humor

Given this analysis, what sort of humor would we expect to find in colonial (that is, colonizing or colonized) societies? As to humorous situations, we would expect to find a great deal of mirth over the discomfort of out-group members. Moreover, we would expect that discomfort to derive from the particular conditions of postcolonization society, insofar as those conditions

give rise to situations in some ways parallel to those facing children. Obvious cases of this include errors in language or in etiquette. Just as children make mistakes in learning language or in internalizing social rules, colonizers and colonized people are likely to make mistakes in learning the other group's language and interacting with members of the other group socially. We would also expect to find that the mirth provoked by these errors is greater for out-group objects than in-group objects, due to the inhibition of empathy. For example, we would expect American soldiers in Japan to find Japanese English humorous. In keeping with this, the well-known Japanese difficulty in distinguishing between "r" and "l" has given rise to anecdotes concerning Japanese enthusiasm for Americans arranging to have elections in Japan. We would also expect Americans to see more humor in Japanese English than do the Japanese. Thus we would expect some form of alienation between the two groups on this score.

Of course, not all Japanese would be inclined to categorize themselves as first and foremost "Japanese." Some may, rather, see the crucial division as "educated" and "uneducated." Thus they might categorize themselves with educated Americans, making uneducated Japanese and Americans into the out-group. Similarly, a particular American may identify more strongly with colonized people than with colonizers (this is an instance of the origin/stance distinction in Marxism). Nonetheless, the nature of the colonial system is such that no one in the colonial system can entirely avoid the emotional and cognitive effects of the colonial division of in-groups and out-groups. No matter how much a given Japanese person identifies himself or herself as "educated," he or she cannot help but recognize that many educated Americans will always categorize him or her as "Japanese." As a result, educated American laughter at uneducated Japanese is likely to make him or her feel ambivalent. Similar points apply to the American who takes a stand against colonialism.

It is a commonplace of postcolonial theory that colonized peoples are "resistant" to the colonizer.[12] It is perhaps more accurate to say that they are commonly ambivalent. The same point holds for the colonizer's attitude toward colonized people. The difference between being resistant and being ambivalent is important. On the one hand, both indicate that colonized people are not simply conduits for the glorification of the colonizer—although that point should have been obvious all along. In addition, both indicate that, even in the most pacific and cooperative conditions, the relation of colonizer and colonized may always have an element of instability. But what the emphasis on resistance fails to acknowledge is that there may be a great deal of sincere cooperation with the colonizer as well—not merely a superficial acquiescence that masks a seething rage. It also fails to indicate that there may be wide-spread anger, resentment, disgust, and other negative responses to the practices and ideas of one's own colonized group. Finally, it fails

to indicate that emotional responses may shift both individually and collectively. Specifically, the emotions contributing to the ambivalence may change their relative strength—sometimes being quite pacific, even warm, then quite hostile.

In short, the emotional relationship between colonizer and colonized—with respect to humor or anything else—is much more volatile and complex than is usually recognized. As with so much else, this complexity may be simplified in one's self-conscious categorizations or construals. Thus we may, as usual, distinguish between condition and stance. There is the condition of postcolonial ambivalence, but then there is a stance. That stance may be favorable to the colonizer; favorable to the colonized; favorable to some combination of their properties and practices; or something else. Moreover, that stance will interact with the condition, altering the dynamics of ambivalence—sometimes in such a way as to shift between opposites (for example, from mimetic aping of the colonial culture to a reactionary affirmation of indigenous tradition). Finally, a particular, self-conscious stance on the part of colonized people may lead to planned resistance or planned collaboration with colonizers. On its own, however, the postcolonization condition is more likely to lead to alternating and unself-conscious acts of both spontaneous resistance and spontaneous collaboration.

As all of this indicates, most of us probably think about a comedic, postcolonial stance as, first of all, an unempathic confrontation across the division between in-group and out-group. Our prototypes are likely to be the racist joke of the colonizer and the grandiosity-puncturing joke of the colonized. There are, of course, jokes of each sort. Moreover, colonized people seem quite happy to tell the same sorts of racist jokes about colonizers as the latter make about them.

But humor after the onset of colonization is actually much more complex than our initial intuitions might lead us to believe. There are two reasons for this. First, as already stressed, the actual emotional relations across groups are more ambivalent than we generally imagine, even if stances tend to simplify this complexity. Second, in general, colonized people are more concerned with their own society than with that of the colonizers. Their daily lives are much more bound up with other members of the colonized group than with colonizers. Moreover, in public contexts, there are often constraints on just what one can say about colonizers (for example, in literature and film). In this way, expression is even more fully oriented toward colonized people.

japan, colonialism, and humor

Good examples of the preceding points may be found in the opening period of the American occupation of Japan, which lasted from 1945 to 1952. As

John W. Dower notes, this was clearly a colonial (or, as he prefers, "neocolonial") situation.[13] The Americans were politically, economically, and socially dominant, a foreign nation that controlled the Japanese. They had the usual privileges of colonists. They and their culture enjoyed the usual prestige as well.[14]

What was the Japanese reaction to this? On the one hand, the Japanese had been adjured to believe that their emperor was divine and that the war was holy.[15] At the same time, even while widely expressing support for the emperor and the war effort, it is clear that they felt considerable ambivalence. The negative component of this ambivalence increased as the war dragged on and the sufferings of people on the home front increased. Thus, on the one hand, many Japanese wept when the emperor announced the surrender. But many Japanese accepted the Americans enthusiastically, embracing the changes that they brought. Certainly, they felt some antagonism toward what was, in effect, an American dictatorship. Certainly, they felt some nostalgia for the traditional cultural practices that they saw being replaced with American imports. They also resented the relative prosperity of the occupiers. But at the same time they felt angry at the Japanese governments that had brought them to this condition—governments that drove them to extremities of self-sacrifice, then abandoned them to collaborate with the enemy. Moreover, ordinary Japanese people also felt critical of many traditional cultural practices. Every society underprivileges some people relative to others. A broad change in social practices offers the opportunity for the underprivileged to alter their status. Finally, while resenting the prosperity of the occupiers, many Japanese also wished to emulate the occupiers in order to achieve that prosperity themselves.

None of this suggests that colonialism is in any way a just form of international relations. However, it does suggest that the feelings of men and women in colonial situations are complex. Admittedly, this is more obvious in the case of the American domination of Japan. The Japanese had been aggressors in the war and soon came to realize this (and blame their leaders for it). Indeed, there are two colonialisms at issue in this context— the earlier, Japanese colonialism as well as the subsequent, US colonialism. Moreover, in the early stages, the occupation did bring genuinely beneficial political reform, even if it did so in highly undemocratic ways. But, at the same time, the US war against Japan had been marked by great cruelty against civilians, and the judgment of Japanese war crimes was clearly marked by a hypocritical double standard. Thus we cannot view Japanese ambivalence as the result of a unique benevolence on the part of the American colonizers.

In any case, Japanese ambivalence is evident in comedy from the period. There were certainly jokes that took the occupiers as their target. For example, in 1946, an entertainer asked, "How can we have democracy with two emperors?"[16] The two emperors were, of course, Hirohito and

General MacArthur. The joke relies on a childlike naivety that serves to undermine the pretentions of adults—in this case, the pretence that democratic equality results from imposing a dictator, who himself supports another dictator (for MacArthur took pains to assure the continuation of Hirohito's imperial rule).[17] This is, of course, just the sort of joke we would expect intuitively—or, rather, half of it is the sort of joke we would expect intuitively. The joke at least seems to lampoon Hirohito as well as MacArthur, and in that sense could just as readily have been told, with some rephrasing, by a disgruntled American. In short, the joke is critical of both the colonizer and of the colonized society.

There were no doubt many jokes of this sort told in private. Dower recounts a riddle that relied on a pun (thus indicating childlike right-hemisphere processing).[18] Specifically, "the imperial 'We'" and a slang word for "penis" were both pronounced "chin." The joke was that MacArthur was the navel of Japan because he was above the "chin," thus above emperor or penis.[19] Note here too we have the dual criticism of the colonizer and the traditional order.

Indeed, these two examples suggest that the difference between the powerful and the powerless is perhaps a more important axis of comic opposition than that between colonizer and colonized. Certainly, the suppression of humor may account for part of this, since the occupation authorities were very sensitive to any criticism of the colonizers (for example, the comedian who asked about democracy with two emperors found his show closed down).[20] But we should not take this to mean that public humor over-represents criticism of social hierarchies within the in-group, for these too were inhibited. Indeed, the constraints on humor directed at the emperor were, in some ways, more severe. For instance, a worker turned up at the 1946 May Day celebration with a poster carrying a mock "Imperial Edict." The gist of the edict was that ordinary Japanese should starve to death. He was sentenced to eight months in prison.[21]

More interesting than these criticisms of the powerful are the satires of broader social tendencies. Puns transformed "military uniforms" (*heitai fuku*) into "defeat suits" (*haisen fuku*), "military footwear" into "defeat shoes," and so on.[22] This too may be understood as to some extent redrawing the lines between the in-group and the out-group. Humor directed at the emperor served to separate the Japanese people from the leaders whose incompetence and deceit led to the colonial occupation. There may have been a similar impulse in humor directed at soldiers.

Of course, "defeat suits" would have involved self-directed humor to the extent that the phrase was used by soldiers themselves. A similar point may be made about the revision of a "saccharine" children's song to apparently celebrate the Black Market.[23] Since virtually everyone had to participate in the Black Market, both the singers and those who listened and laughed may have been partially implicated in its operation.

Even so, all of this "self-criticism" remains somewhat superficial. In most of these instances, we still find a basically confrontational and identity-related use of humor. It is largely humor that relies on the inhibition of empathy. Indeed, this is true even of self-directed humor. One function of self-directed humor would seem to be inhibiting one's own empathy with oneself—since what is called "self-pity" or "feeling sorry for oneself" is, fundamentally, a form of self-empathy. Laughing at oneself may operate to disrupt cycles of self-enhancing self-empathy. Specifically, this would involve a prefrontal modulation of one's response to one's own situation by taking up a comedic stance toward that situation. During the period of "*kyodatsu*" or despair that was epidemic in Japan after the surrender (see Chapter 3 of Dower), such humor was particularly important. As one writer put it, "I seriously feared Japan would collapse if the situation continued where people forgot even to laugh."[24] This is important and goes beyond the usual imagination of antagonistic humor after colonization—even beyond the extension of antagonism to elements of the home society.

Thus we see cases in which humor in occupied Japan addresses in-group/out-group antagonism and serves the largely negative function of "mood repair" (the operation of emotion systems to alter dysphoric states).[25] In principle, it is possible that these are the only significant functions of humor in postcolonization societies. But, if the evolutionary function of humor is bound up with attachment, this would be very surprising. It would mean that, following colonization, the largely positive (attachment-related) functions of mirth do not carry over to either humorous conditions or comedic stances, that humor becomes entirely negative and the celebratory element is lost.

yasujiro ozu and attachment

This brings us to Yasujiro Ozu. Making films during the American occupation of Japan, Ozu presents an unusual, but compelling vision of the problems surrounding colonial cultural hegemony. Ozu, I believe, sought to separate the treatment of culture from identity categories—thus large in-group/out-group divisions—and to redirect it toward intimate personal relations. Colonialism leads to rapid cultural, political, and economic change. The rapidity (and to some extent the nature) of that change may lead to emotional estrangement among people who have attachment bonds (for example, parents and children)—though it may also lead to the formation of bonds that would otherwise have been impossible. Ozu's view on colonialism seems to have been that we should evaluate cultural changes in their specificity—not by reference to their broad cultural origin or their location within national traditions, but by reference to their effects on practical human life, particularly attachment relations. His use of humor directly serves that purpose.

More specifically, in *Early Summer*, Ozu presents us with the sort of child-centered humor that is paradigmatic for the preceding account of mirth.[26] For example, in the first scene, we are introduced to the heroine, Noriko (Setsuko Hara); her brother Koichi; her sister-in-law, Fumiko; her parents; and the two young children of Koichi and Fumiko—Minoru (maybe nine years old) and little Isamu (perhaps four years old). Noriko observes that Isamu has not washed his face. Though she is correcting Isamu for this, she never stops smiling and looking at him in an affectionate and amused manner. Indeed, sometimes she even giggles at his antics, while the others largely ignore him. Hara's way of playing the relation between aunt and nephew suggests how the viewer might respond to the young boy as well. Isamu patters out, enters the bathroom, picks up the towel, dampens it without touching his face, and returns the towel to the rack. The scene is very funny, and it predictably relies on Isamu's littleness in reaching the towel, the tap, and so forth. Though she clearly suspects that Isamu has pulled a trick, Noriko does not press the point when he returns, but continues her affectionate and amused look. The mood of mirth linked with childhood is enhanced by the music box-like soundtrack.

Not long after, we find Mr Mamiya cutting Isamu's toenails. He gives Isamu a treat in exchange for Isamu saying, "I love you." However, after four treats, Mr Mamiya decides that is enough. Isamu stomps off and says, "I hate you." Though he is not simply joking, he does not make the statement with much emotion. It is, in a way, part of the game. Now that no treats are involved, he can simply say whatever he wants—and he says the opposite of what his grandfather wishes. Although the humor does not come across in a description, it is a funny scene—and Mr Mamiya reacts with the sort of attachment-based laughter we would expect. Despite the scene's evidently apolitical nature, this sort of sweet indulgence and humor is not without political resonance. It runs against the fetishization of filial piety that characterized Imperial Japan.[27]

In other scenes, the relation between colonialism and humor is much more straightforward. Ozu's gently critical humor[28] is aimed at both Japanese and Western practices. For example, the film includes a comic monologue on the Americanized Japanese woman: "I imagined you'd live Western-style, with a flower garden, listening to Chopin. In your tiled kitchen, you'd have a refrigerator filled with Coca-Cola." The mirth of the scene is bound up with the childlike fantasy of an endless supply of soda and no concern for staples (a real concern in postwar Japan). At the same time, the film associates tradition with a toothless, near-deaf old uncle—a sympathetic, but very funny (and, despite his age, childlike) character. As already indicated, it also includes a great deal of celebratory humor, aimed at children and appreciated by the film's (adult) heroine, Noriko. Most importantly, Ozu's comedic stance does not support any identity category or identity group (Japanese or American). Rather, it operates to foster

attachment relations, and to implicitly criticize colonialism—perhaps especially Japanese colonialism—by that means.

More precisely, much of the film uses celebratory humor to cultivate the audience's affection for little Isamu. Once this attachment has been developed, Ozu presents us with a crisis. Though not humorous in itself, it relies on the mirth-based cultivation of attachment that has developed up to this point. Moreover, it makes clear some of the main thematic concerns of the film, and thus bears closer scrutiny (unfortunately, constraints of space prevent exploration of the entire film).

Specifically, much of the plot in the first part of the film concerns the family's attempt to arrange a marriage for Noriko. Noriko repeatedly shows great mirthful warmth for children—not only her nephews, but also the daughter of her dead brother's school friend, Kenkichi Yabe, a widower. When Koichi and Minoru (his older son) quarrel, the two boys (Minoru and Isamu) run away from home. After many hours, they do not return. Koichi is concerned and regrets his behavior, but he does not take an active part in finding them. Neither does their mother, Fumiko. But Noriko goes out searching. She goes to the Yabes and asks if the boys have gone there. Kenkichi volunteers to help. Kenkichi's mother suggests that they check the train station. The suggestion is a good one. Ultimately, Noriko and Kenkichi find the boys "starving, just sitting in the train station."

Of course, the prospect of children being lost is always frightening. But in the context of postwar Japan, this sequence of events is particularly resonant. The chaos at the end of the war had separated many families. A 1948 report of the Ministry of Health and Welfare estimated that over 80,000 children had "lost their parents, or simply become separated from them, in the turmoil that accompanied the end of the war." These homeless children often "lived in railroad stations," from which they were "commonly rounded up and loaded on trucks like cattle," then sent to "militaristically authoritarian" detention centers.[29] This entire complex of historical associations is triggered by the separation of the boys, their hunger, and their appearance in the train station.

This is, I believe, the key ethical, and anti-colonial, moment in the film. It is the point at which both Noriko and Kenkichi show that they care about children—most crucially, other people's children. This may seem incidental to issues of colonialism. But, in context, it is not. Indeed, it is perhaps particularly revealing in context, as it points to Japanese colonialism rather than to the American colonialism that followed. Moreover, it once again indicates the emotional complexity of colonial relations and the key difference between origin and stance. Specifically, in 1945, the feminist reformer Hani Setsuko wrote in *Asahi Shimbun* that the Japanese colonial commission of atrocities in Manila and elsewhere was inseparable from "the low position of women in Japanese male psychology, as well as the general disregard Japanese held toward other people's children."[30]

She was not the only one to make a diagnosis of this sort. When asked about the terrible condition of postwar street children, Osaragi Jirō, "a distinguished author respected for his humanism," blamed a lack of love "toward strangers." He even went so far as to worry whether "Japanese were shallower than other peoples when it came to love."[31] The actions of Noriko and Kenkichi indicate that Osaragi's worries were misplaced and simultaneously present a model for viewers to imitate. Most important for our purposes, they implicitly criticize the group divisions that allow for colonialism by making us indifferent to other people's children.

The point is stressed in the remainder of the film. Soon after this scene, Noriko agrees to marry Kenkichi. Her family is distressed, to a great extent because she will have to be a mother to someone else's daughter. Noriko responds simply, "But I love children." Noriko's attitude is given emotional force by the prior cultivation of celebratory mirth, thus Ozu's comedic (and postcolonial) stance in the early parts of the film. The film nicely intertwines the development of attachment bonds between the lovers and attachment bonds between adults and children, bonds inseparable from celebratory mirth.[32]

In sum, the postcolonization situation gives rise to many possible types of humorous situation. Various postcolonial stances are compatible with different sorts of comedic stance. To a great extent, we would expect these situations and stances to be derisive, founded on an inhibition of empathy which itself derives from in-group and out-group divisions. Moreover, we would expect this whether the colonizer is laughing at the colonized or vice-versa. However, there is at least one use of humor that is directly opposed to this, a use that is celebratory across some forms of group division. This is what Ozu takes up. This is important in part because Japanese colonial atrocities were not unique. Colonialisms all involve atrocities. Moreover, the home populations go along with colonialisms for the same reasons. The imperial Japanese were not exceptional in their inhibitions on empathy and attachment. Indeed, one could perhaps go so far as to say that, in general, colonialism is enabled by the home population's inability to feel celebratory mirth for other people's children.

notes

1. *Early Summer*, director Yasujiro Ozu (Japan: Shôchiku Eiga, 1951).
2. *Umrao Jaan*, director Muzaffar Ali (Integrated Films, 1981).
3. Marxist analyses commonly distinguish class origin or class position from class stance or class attitude. One's class origin or class position is the class to which one belongs by reason of one's location in the political economy of a society. (Technically, there is a distinction between class origin and class position, since one's initial class position may change—for example, someone of proletarian origins may become a capitalist. I will leave aside this distinction in the following pages as it does not generally bear on the

patrick colm hogan

210

issues we will be considering.) One's class stance or attitude is one's commitment to the interests of a particular class. For example, petit bourgeois intellectuals may throw in their lot with the proletariat, adopting a proletarian class stance despite their petit bourgeois class origin or class position.

4. In postcolonial theory, the word "postcolonial" is often taken to suggest a partial overcoming of colonialism or at least an attitude toward it (commonly one of resistance). "Postcolonization," in contrast, suggests more simply the state of things after the onset of colonization.

5. Fredric Jameson, "Third-World Literature in the Era of Multinational Capital," *Social Text* 15 (1986): 70.

6. Aijaz Ahmad, *In Theory: Classes, Nations, Literatures* (New York: Verso, 1992).

7. For example, it is a commonplace of Indian political discourse that many Hindus and Sikhs were pleased that Muslim domination was displaced, even if they also resented the British domination that replaced it. As to ambivalence about in-group traditions, the history of Indian reformism often shows clearly that many political activists blamed national subjugation on internal weaknesses (for example, fragmentation of national society by caste divisions).

8. See Patrick Colm Hogan, *What Literature Teaches Us About Emotion*, Studies in Emotion and Social Interaction, Second Series (Cambridge and New York: Cambridge University Press, 2011), 144–174. For a discussion of the topic in relation to film, see Hogan, *Understanding Indian Movies: Culture, Cognition, and Cinematic Imagination*, Cognitive Approaches to Literature and Culture (Austin: University of Texas Press, 2008), 115–118.

9. Of course, "laughing at" and "laughing with" are ordinary language phrases, not technical terms. Thus different readers are likely to have somewhat different senses of just what they involve. In the following paragraphs, I distinguish a form of laughing at that is derisive. If I get a bad haircut and my wife laughs on seeing my hair standing on end, I would call that "laughing at" but not "derisive laughing at." It would only count as laughing with if, say, I made a joke about looking like some sort of crested fowl and she laughed at the joke.

10. Brooke C. Feeney and Roxanne L. Thrush, "Relationship Influences on Exploration in Adulthood: The Characteristics and Function of a Secure Base," *Journal of Personality and Social Psychology* 98, no. 1 (2010): 57.

11. Again, it is important that it is the mechanisms that are at issue here—for example, right-hemisphere lexical processing—even when these operate in decidedly non-childlike ways.

12. We see this, for example, in the idea of "resistance literature" or in the focus on "writing back." For valuable and influential discussions of these concepts, see Barbara Harlow, *Resistance Literature* (New York: Routledge, 1987) and Bill Ashcroft, Gareth Griffiths, and Helen Tiffin, *The Empire Writes Back: Theory and Practice in Post-Colonial Literatures*, 2nd ed., New Accents (New York: Routledge, 2002).

13. John W. Dower, *Embracing Defeat: Japan in the Wake of World War II* (New York: W. W. Norton, 1999), 27.

14. See, for example, Dower, 136–137.

15. Ibid., 34.

16. Quoted in Kyoko Hirano, *Mr. Smith Goes to Tokyo: Japanese Cinema Under the American Occupation, 1945–1952*, Smithsonian Studies in the History of Film

and Television (Washington, DC: Smithsonian Institution Press, 1992), 72.

17. One reader worried that this example could be interpreted differently by advocates of other accounts of humor. That is undoubtedly true, not only here but also for most other cases of humor. It would be very strange if a widely respected theory of humor simply had no way of accounting for any cases of mirth. In short, we should expect considerable overlap in the data compatible with different theories—just as a great deal of data is compatible with both geocentric and heliocentric theories. Specifically, this reader noted that there is an incongruity in the joke and that one account of humor explains it in terms of incongruity. However, the incongruity remains if we rephrase this, not as a joke, but as a serious argument—"The Americans claim they are bringing democracy. However, they support the Japanese emperor in various ways and they place another, even more absolute authority above him. This double authoritarianism is clearly incompatible with democracy." This suggests that the humor is not due to the incongruity as such, but to the framing of the question as naïve.

18. On right-hemisphere processing in puns and jokes, see Hogan, *Understanding Indian Movies*, 116–117 and citations.

19. Dower, 305.

20. Ibid., 405

21. Ibid., 266–267

22. Ibid., 170.

23. Ibid., 170.

24. Quoted in Dower, 174.

25. See Joseph P. Forgas, "Affect and Information Processing Strategies: An Interactive Relationship," in *Feeling and Thinking: The Role of Affect in Social Cognition*, ed. Joseph P. Forgas, Studies in Emotion and Social Interaction, Second Series (Cambridge and Paris: Cambridge University Press/Maison des Sciences de l'Homme, 2000), 258 and citations.

26. Humor in Ozu has been treated by other critics, though in a very different theoretical context. For a complementary discussion of the comic Ozu, see David Bordwell, *Ozu and the Poetics of Cinema* (Princeton: Princeton University Press, 1988), 151–159.

27. See Dower, 277.

28. Speaking generally, Richie notes that "Ozu's criticism, always oblique, was never stern"; in Donald Richie, *Ozu: His Life and Films* (Berkeley and Los Angeles: University of California Press, 1974), 206. The point applies well to his postcolonial stance humor.

29. See Dower, 277.

30. As Dower summarizes Setsuko's argument, 506.

31. Dower, 63.

32. Critics seem not to have recognized the importance of attachment bonding here. Thus Mellen says that Noriko "consents" to marry a man "whom she clearly does not love," largely because the only alternative is "serfdom." By "love" here, she seems to have sexual passion in mind. It is difficult to say whether two such restrained and decorous people would provide any overt signals of sexual passion, so it is far from clear that "passion between these two seems inconceivable"; Joan Mellen, *The Waves at Genji's Door: Japan Through Its Cinema* (New York: Pantheon, 1976), 256. But, more importantly, the more enduring aspect of love is attachment. In that sense, it seems clear that there is love here.

In connection with this, it is also worth remarking that some critics believe that Ozu presents us few cues to "mental states" of his characters, thus making it "difficult to . . . determine how a decision has been arrived at" (Bordwell, *Ozu and the Poetics of Cinema*, 71). At least in this case, I believe that Ozu gives us many indications of the feelings and motivations of his characters. But we are likely to miss those cues if we are not attentive to the relevant emotion systems—crucially, attachment.

avant-garde film

in an evolutionary

twelve context

paul taberham

The evolutionary approach to aesthetics, I shall demonstrate, often dismisses the value of avant-garde and modernist art—sometimes inadvertently, and other times consciously. Exploring some of the major evolutionary accounts of the origins and functions of art, I will advance an alternative to existing theories, which will frame the avant-garde as a valuable phenomenon which develops aesthetic sensitivities and skills of engagement. While scholars engaged with the avant-garde typically focus on the historical and social conditions that fostered its emergence,[1] I will focus on the evolutionary-psychological conditions that may have enabled its existence.

Some of the central texts that have applied a cognitive approach to film analysis have focused on emotional arousal, character, and narrative engagement,[2] and this has skewed discussion largely towards conventional, narrative-dramatic films which explicitly and unambiguously exploit the skills of comprehension, identification, and emotional engagement that we are endowed with. In turn, however, alternatives to traditional storytelling risk being used primarily as foils to ordinary comprehension. Those who

look at cinematic engagement from the perspective of the evolutionary psychologist are particularly prone to characterizing the challenges of the avant-garde as an aberration from the widespread understanding that art, in its many forms, should be easily understood. Within this framework, scholars ask how the evolutionary history of the human species created "a legacy of psychological features, functions and preferences" which continue to affect us directly or indirectly, long after the environment in which these features were adaptively formed disappeared.[3] In 1996, Joseph D. Anderson's *The Reality of Illusion: An Ecological Approach to Cognitive Film Theory* offered evidence that movies exploit pre-existing skills of ordinary perception, inherited through evolution.[4] Filmic perception, he suggests, requires minimal specialized code-reading because movies engage mental habits that were originally developed to interact with the natural environment.

While evolutionary explanations have been productive in illuminating our understanding of the way cinema engages our evolved perceptual and cognitive skills, what needs to be accounted for is the emergence of forms of art that may (at least initially) confound comprehension—as found in the work of Maya Deren, Nathaniel Dorsky, Stan Brakhage, and Ken Jacobs, to name a few examples. The goal of this discussion, however, is not to suggest that there is a purely evolutionary explanation for the existence of avant-garde art. Rather, it will be suggested that evolutionary theory can illuminate some of the preconditions that were necessary for it to emerge from particular socio-historical contexts.

In *Dreams of Chaos, Visions of Order: Understanding the American Avant-Garde Cinema*, James Peterson takes a predominantly "constructivist" approach, which focuses on human sense-making skills, rather than placing existing cognitive facilities in an evolutionary context when discussing avant-garde film.[5] As such, he considers *how* viewers engage with the films. The question of *why* the avant-garde emerged becomes more pressing in the context of evolutionary accounts because existing explanations risk implicitly rejecting the avant-garde by focusing exclusively on widespread storytelling conventions which the avant-garde typically rejects. An evolutionary account of aesthetics generally begins by describing a capacity humans developed according to contingencies of survival, and then considers how this capacity is exploited in aesthetic contexts.[6] Invariably, avant-garde films resist exploiting these capacities and offer alternative paths of aesthetic interest for the viewer.

At their most conservative, evolutionary accounts of aesthetics explicitly deny the value of the avant-garde by claiming that it needlessly confounds our basic skills of comprehension. For instance, while arguing that cinematic techniques target capacities developed across the history of the human species, Anderson comments that marking change in the status of the image (for example, from present action to flashback/fantasy sequence/ dream) is of central importance for the viewer to understand what they

are engaging with: "in Alain Resnais' *Last Year at Marienbad*, if the viewer is either unable or unwilling to supply the transitional signals himself, the result is at least temporary bewilderment if not aversive incomprehension."[7] Although this comment is made as an aside rather than as part of a detailed analysis, one might infer that Resnais made an aesthetic error, since the spectator's response might be "aversive." Similarly, Torben Grodal comments on the difficulty in engaging with non-anthropomorphic figures:

> When watching a visual representation of phenomena without any centering anthropomorphic actants, we often "lose interest" owing to lack of emotional motivation for the cognitive analysis of the perceived, a fact which many makers of experimental films have discovered when presenting their films to a mass audience.[8]

If we assume that humans are "meaning seeking creatures," as evolutionary psychologists do,[9] why might filmmakers and cineastes put themselves through the ordeal of creating and experiencing art that problematizes comprehension or engagement? An evolutionary account of aesthetics begins to feel like the "enemy" of the avant-garde. In a more direct rejection of alternatives to traditional form in art more broadly, psychologist and cognitive scientist Steven Pinker discusses the aesthetic changes brought about by modernism, from which the avant-garde arose:

> Modernism certainly proceeded *as if* human nature had changed. All the tricks that artists had used for millennia to please the human palate were cast aside. In painting, realistic depiction gave way to freakish distortions of shape and color and then to abstract grids, shapes, dribbles [and] splashes . . . [i]n literature, omniscient narration, structured plots, the orderly introduction of characters, and general readability were replaced by a stream of consciousness, events presented out of order, baffling characters and causal sequences, subjective and disjointed narration, and difficult prose.[10]

After characterizing the influence of modernism on the arts as an act of "masochism," he concludes: "Once we recognize what modernism and postmodernism have done to the elite arts and humanities, the reasons for their decline and fall become all too obvious . . . they take all the fun out of art!"[11] Pinker does not interpret the changes that took place around the turn of the twentieth century as being motivated by the search for new channels of creativity or novel modes of experience in light of the rapid technological and industrial growth of the time, as others have suggested.[12]

Instead, he suggests that modern art emerged for ideological reasons, with the conviction that "weird and disturbing art was supposed to remind people that the world was a weird and disturbing place."[13] There are two levels on which Pinker's claim can be critiqued. Firstly, he applies a misconception that is sometimes referred to as a naturalistic fallacy. Secondly, he distorts existing theories of the avant-garde. Both of these will be detailed in turn.

The naturalistic fallacy refers to the assumption that what is natural is inherently good, and what is unnatural is inherently bad.[14] Pinker claims in the passage cited above that since we are born with an innate instinct for certain comprehension skills (for example, linear narrative) and particular standards of beauty (such as figurative over abstract), we should only make and consume art that appeals to these particular "natural" instincts. To do otherwise is to deny our basic human nature. By the same logic, however, one might claim that since we are born with an innate desire to eat salt and fat, we should subsist entirely on salty and fatty foods. Evidently, appealing to our natural instincts is not always beneficial. Furthermore, there are other "natural" behaviors which are neither desirable nor valuable. For instance, the tendency towards physical violence (particularly amongst young men) became a natural instinct because it was beneficial for survival during our evolution as hunter-gatherers[15] in the Pleistocene epoch.[16] Through law enforcement, civilization is designed to control and contain this "natural" impulse.[17]

Conversely, some desirable behavior patterns do not emerge naturally and need to be instilled through discipline. Children need to be taught self-control, delayed gratification, putting the interest of others above their own, and the benefits of eating a healthy diet. The same can be suggested regarding avant-garde and modernist art; while it does not appeal to our "natural hunger" for linear narratives and figurative imagery, it can still provide an enriching and engaging experience for the viewer. One finds, then, that evolutionary psychology does not license Pinker's artistic conservatism or dismissal of modernist art.

Pinker's argument can also be understood as a distortion of the claim amongst theorists such as Theodor Adorno that avant-garde art is motivated by ideological ambitions.[18] For some, this is true—the ideological challenge offered by modern art is manifest through its aesthetic and formal challenges. In this sense, aesthetic and ideological motivations are closely interlinked. Pinker's account of modernism shares elements with sympathetic theorists, yet his explanation is reductive, characterizing the challenges of modern art as being solely in the service of ideological motivations without acknowledging the intrinsic virtues of aesthetic challenge. We are left, in his explanation, with a wholly negative evaluation of modernist art.

While Pinker stakes the claim that modern art cannot be genuinely appreciated because it sacrifices aesthetic appeal in favor of perceived social value, he is not alone in the conviction that the challenges of modern art are in the service of a greater social purpose. Some scholars of avant-garde film have suggested that the challenges placed on the viewer are politically motivated, by arguing that Hollywood lulls its viewers into a passive state, while avant-garde films demand the viewer's active participation, which in turn provides a more intellectually engaged experience and implies greater social integrity.[19] Peter Gidal's *Materialist Film* (1989) argues that the only films worthy of being avant-garde are those that engage the viewer in a radical and self-referential critique of the technical, psychological, and social approaches of cinema.[20] In *Allegories of Cinema: American Film in the Sixties* (1989), David E. James argues that at its best, avant-garde film should make the social and economic conditions of a work's production, distribution, and reception visible and open to the kind of critical analysis that could change them, and society, for the better.[21]

The conviction that modernism and the avant-garde are in the service of a social conscience, then, is a widely held position. It is also a shared ground, in a way, between Pinker and those he critiques. However, Pinker factors out the other rewards of the avant-garde—such as the enriching, novel, and visceral experiences it provides—irrespective of the social agenda that some claim the avant-garde possesses.

While the radical aesthetic changes that followed the onset of modernism heralded a more defined split between "elite" and "popular" arts, the elite arts cannot be solely understood as a wearying reminder that the world is "weird and disturbing," as Pinker characterizes it. Mainstream cinema prompts comprehension skills that are readily available to all viewers, while avant-garde films—which have endured on the cultural fringes in their multitudinous forms from the early twentieth century up to the present day—often problematize or prohibit such immediate pleasures. The fact that avant-garde filmmaking poses a challenge to the assumed wisdom of cognitive aestheticians, that art is tailored to be comprehended unproblematically, is not a reason to neglect it. On the contrary, it is all the more reason to investigate it. The avant-garde is not a natural "enemy" of evolutionary accounts of aesthetics. Rather, both areas can productively illuminate one another.

218

evolutionary accounts of the origins and functions of art

Up to this point, I have argued that evolutionary discussions of art sometimes invite an unwarranted dismissal of modernism and the avant-garde, and that while avant-garde films might not always exploit evolved, familiar habits of mind, they may still be enriching. Before advancing my own theory of avant-garde art within an evolutionary context, two principal

evolutionary explanations for the emergence of art and aesthetic experience in general will be detailed, and these will broadly be termed the "sexual display" and "socialization" accounts.

Before both theories are outlined, note that while some evolutionary theorists consider art-making and appreciation to be an adaptive behavior—a mechanism to enhance human chances of survival in the Pleistocene epoch—Pinker considers art to be largely a *by-product* of adaptive behaviors.[22] When a behavior is adaptive, it might be for the purpose of reproduction (as it is according to the "sexual display" account of art) or it might be for survival (according to the "socialization" account). In her books *What is Art For?* (1988) and *Homo Aestheticus: Where Art Comes From and Why* (1992), interdisciplinary scholar Ellen Dissanayake argues that art is a human adaptation which must have evolved for an evolutionary purpose.[23] There are three important features that suggest this. First, it is present across all cultures. Every human group responds to image-making, clothing, carving, and decorating, for instance. Secondly, evolution tends to make adaptive behaviors pleasurable, and the arts are sources of pleasure for both the artist and the viewer. Finally, effort is rarely invested in an activity without some adaptive rationale, and artistic production requires investments of time and energy. Since art is ubiquitous, costly, and pleasurable, it is unlikely to be a biological accident, according to Dissanayake's theory.[24]

Framing the creation of art as an adaptive behavior, psychologist Geoffrey Miller has suggested that artworks serve the purpose of sexual display. He comments that high-cost, apparent uselessness, and manifest beauty usually indicate that a behavior has a hidden courtship function. Rather than looking at the relatively recent and less widespread domain of art galleries and classical music, he accounts for the emergence of aesthetic experience by focusing on the primitive art of a diverse range of human civilizations and ornamentation of other species. Suggesting that body-painting, jewelry, and clothing were probably the first art forms, Miller claims that "[t]he production of useless ornamentation that looks mysteriously aesthetic is just what sexual selection is good at. Artistic ornamentation beyond the body is a natural extension of the penises, beards, breasts, and buttocks that adorn the body itself."[25]

Denis Dutton, Torben Grodal, Dissanayake, Leda Cosmides, and John Tooby[26] all broadly advance what I refer to as the "socialization" account of art, focusing on the narrative arts and framing them as adaptive. Dissanayake claims that we are attracted to stories, all of which contain humanly relevant themes which derive from evolved needs and interests. We have evolved to respond to archetypal themes that touch upon our own interests, life and death, struggles and outcomes, failing and succeeding, escaping harm, loving, being admired and demeaned, being shamed and redeemed, mating and helping one's offspring thrive. These themes and others stretch from ancient oral traditions and age-old myths to

contemporary movies, soap operas, and modern bestselling books.[27] She comments:

> Biological meaning—significance or value—implies that we have emotional investment in these fundamental things: that is, we have evolved to care about them. Cultures have in turn evolved to assure that we care by appropriately emphasizing what we need to care about most.[28]

According to Dissanayake, we are attracted by these and other humanly relevant themes which derive from evolved needs and interests.

Grodal similarly suggests that stories (specifically, fictional-narrative films) are often made to elicit strong emotional responses, activating innate emotional dispositions, whether these dispositions are appropriate to a modern-day environment or not. He comments:

> Certain central, innate dispositions cue our liking for stories about the attachment between children and parents or stories about romantic relations between adults. Fighting and aggression, as well as bonding with brothers-in-arms, are as prominent as ever in visual fictions and video games, even though most people nowadays live in societies in which the majority of adults never engage in violent confrontations. Horror stories still often focus on the fear of becoming food for some other, alien creatures.[29]

Themes that commonly appear in narrative fictions, then, appeal to our fundamental, innate dispositions, even though we sometimes have no first-hand experience in these scenarios.

Denis Dutton also suggests that fictional narrative possesses an adaptive power, just as it did during human prehistory. In the same way that our hunter-gatherer ancestors possessed an adaptive advantage by imagining in advance where food might be available and what the possible risks would be by entering new territories to obtain it, modern-day Pentagon war gamers similarly imagine various hypothetical scenarios and propose plans of action. By extension, today we envisage imaginary situations such as what it would have been like if we visited a different restaurant, took another job, or moved to a different city. Like picturing imaginary scenarios, stories allow for intellectual simulations, without the high-cost experimentation of actual practice. Instead, they provide a low-cost, low-risk surrogate experience, which serves as a richly instructional source of information. They also encourage us to explore the points of view, beliefs, and motivations of other human minds, developing potentially adaptive social capacities. In other words, they provide regulation for social behavior.

reflection on existing theories

Now that the "sexual display" and "socialization" accounts have been outlined, I will suggest that explaining art or aesthetic experience as a wholesale entity, suitable for a singular theory, might be problematic. Instead, there are multiple overlapping explanations which are plausible, which address what purposes art serves, why it emerged, why it is created, and why it is enjoyed. The sexual display and socialization accounts can peaceably live side by side as long as one does not try to frame either explanation as all-encompassing. While they are both classified as "art," self-ornamentation (leading to fashion and perhaps to visual design more generally) plausibly originates from an early form of sexual display; it is equally possible that narrative fiction stems from an early adaptive facility to "socialize" the spectator. Art has aided both reproduction and socialization, and the sexual selection and socialization accounts can productively cohabit.[30]

I would suggest, however, that neither theory provides a satisfying explanation for why the avant-garde exists. According to the theory of sexual display, avant-garde art can be understood as a radical demonstration of skill and intelligence—albeit a relatively inefficient one, since its appeal is so marginal. But it goes some way towards explaining the demonstration of the intelligence, virtuosity, and creativity manifest in the works of Peter Tscherkassky, Robert Breer, and Peter Hutton, for instance, all of whom carry the legacy of our hunter-gatherer ancestors who also valued patience, careful execution, and technical perfection.[31] Note, however, that while technical mastery is a common value in commercial filmmaking, there are avant-garde works that put a higher value on demonstrating intelligence and creative invention than skill—such as Andy Warhol's *Sleep* (1963), which was intentionally made with minimal judgment and intervention from the artist.[32] One might also ask why women such as Marie Menken, Mary Ellen Bute, and Su Friedrich choose to produce films if the display of intelligence and creativity for reproduction purposes is traditionally the task of the man.

Since avant-garde art seldom engages in putatively "normal" human behavior, it provides little in the way of socialization. The theory of socialization does not tell us why the avant-garde exists, although it does shed light on one of the reasons its appeal is less widespread than that of narrative films. On some occasions, like instrumental music, avant-garde films deal exclusively with abstract patterning (in the work of Oskar Fischinger, for example). On other occasions, issues of fundamental human concern are addressed—such as gender equality in Maya Deren's *At Land* (1944),[33] or adolescent sexuality in Bruce Conner's *Valse Triste* (1978),[34] but they are addressed in an oblique way. As such, avant-garde films in general do not provide a clear form of regulation for social behavior in the way that traditional narrative dramatic storytelling does.

Whatever the virtues or shortcomings of the avant-garde are, it exists as a phenomenon in art. As such, its emergence needs to be explained, and neither of the cited explanations of art from an evolutionary perspective seems to offer an entirely satisfactory account.[35] As I have already suggested, art is a multifaceted entity and likely serves a multitude of functions, whatever its origins are. In the same way that one may postulate that human lips most likely evolved for the purpose of eating, they are also used today for speaking, kissing, and expressing emotion. By the same token, art may have emerged for the purposes of sexual display and socialization, but it has come to serve other purposes as well.

cognitive play with pattern

The avant-garde may not be an ideal entity with which to explore the origins of art as a whole since the avant-garde emerged in the mid-nineteenth century, while art as a broad phenomenon stretches back to human prehistory. However, the avant-garde signals a *development* in the history of art that can be productively addressed. In the next part of my discussion, I will suggest that avant-garde art might help to cultivate and develop sensitivities that are generally under-rehearsed when engaging in aesthetic experience, as well as in ordinary life. Before that theory is advanced, however, I will summarize one more evolutionary explanation of art that sets the foundation for my own theory.

In *On the Origin of Stories*, Brian Boyd advances his own evolutionary account of art that bears parallels with the socialization explanation, but is broad enough to also encompass non-narrative art such as abstract paintings, music, and sculpture. Boyd frames the pleasure of art as the motivational mechanism that compels us to fine-tune our systems through regular rehearsal. He frames art as a human adaptation that derives from play, a behavior that spreads across animal classes and is universal in mammals. When lion cubs play-fight and children engage in chase games in the schoolyard, they are unconsciously rehearsing adult activity in situations of low urgency so that they might fare better in moments of high urgency in the wild. After playing repeatedly, humans and animals refine their survival skills and sharpen sensitivities. As such, play is rewarding, motivating humans and animals to engage in it time and again, enhancing muscle tone and improving their capacity and performance skills.[36] Art, by extension, provides a form of "psychological play" that does not involve exercising the body. Unlike our interactions with the natural environment, art provides a refined and intensified system of patterning, from narrative form to song structure and visual composition.

Boyd argues that as humans, we gain most of our advantages from our intelligence, rather than from physical strength and coordination. In turn, we possess an appetite for information, especially patterns that fall into

222

meaningful arrays from which we can make rich inferences. This might include social narration through fictional narrative, but it also includes art that primarily targets our senses of sight and sound, such as the visual arts and music. Why does Boyd place this level of importance on patterns? Defining them as orders discernible in objects, actions, ideas, and situations, he suggests that predicting what may come next can make life-or-death differences to living organisms, since we live in a world that swarms with patterns on every level. Discerning patterns signals regularities in the world, rather than mere chance. He comments:

> Pattern occurs at multiple levels, from the stable informa-
> tion of spatial conditions and physical processes to
> highly volatile information about individuals and their
> moods, actions, and intentions. Pattern recognition lets us
> distinguish animate from inanimate, human from non-
> human, this individual from all others, this attitude or
> expression from another. The capacity to identify not only
> individuals but also higher-order tendencies in their behav-
> ior, personality, and powers allows for invaluably precise
> prediction.[37]

Discernible in music, visual art, dance, and storytelling, our perception of patterns can evoke strong emotional reactions in a variety of ways. Boyd summarizes his theory:

> We can define art as cognitive play with pattern. Just as
> play refines behavioral options over time by being self-
> rewarding, so art increases cognitive skills, repertoires, and
> sensitivities. A work of art acts like a playground for the
> mind, a swing or a slide or a merry-go-round of visual or
> aural or social pattern. Like play, art succeeds by engaging
> and rewarding attention, since the more frequent and
> intense our response, the more powerful the neural conse-
> quences. Art's appeal to our preferences for pattern ensures
> that we expose ourselves to high concentrations of
> humanly appropriate information eagerly enough that
> over time we strengthen the neural pathways that process
> key patterns in open-ended ways.[38]

Art, then, operates as a stimulus and training for flexible minds, with high concentrations of pattern that stimulate the human brain more than the routine processing of natural environments, offering what biologists call "supernormal stimulus."[39] The high concentration of patterns that art delivers engages the human mind "to modify key human perceptual, cognitive, and expressive systems, especially in terms of sight, hearing, movement, and social cognition."[40]

Boyd's account of art and aesthetic experience encompasses myriad different art forms, and does not risk dismissing the value of the avant-garde, although it does not fully explain its existence. This shall be called the "cognitive play with pattern" account. In the next section, Boyd's perspective will be used as a springboard for my own theory that attempts to account for the emergence of the avant-garde within an evolutionary context.

building on the hunger for aesthetic experience

Now that a range of evolutionary accounts of art have been summarized and reflected on, I will suggest that the emergence of the avant-garde might be dependent on a psychological precondition, as well as a series of cultural factors. A speculative argument will be advanced, which offers a plausible psychological theory that helps to account for the emergence of the avant-garde, and it will be an alternative to prior evolutionary postulations that it emerged for ideological reasons. Before proposing the theory, however, I should emphasize that rather than claiming a fact, I am offering a hypothesis, albeit one supported by a number of factors.

As Boyd and others have suggested, we may have been born with a predisposition towards non-utilitarian experiences—such as the appreciation of art and the enjoyment of games—because they exercise the mind in ways that would have enhanced our fitness for survival in the Pleistocene epoch. Games can rehearse strategic, inferential, and reflexive responses (in chess, crosswords, and videogames, for example). Narrative fiction usually engages our skills of comprehension unproblematically, and it also exercises our ability to engage with other agents, and vicariously experience hypothetical situations relevant to human survival. In these instances, the activities are inherently rewarding because they key in with abilities that enhanced survival skills in our evolutionary past.

The desire to engage with avant-garde films, by contrast, may stem from an impulse to strengthen skills and sensitivities that pre-exist in the viewer, but are not typically rehearsed in other forms of aesthetic experience. They may compel the spectator to reflect on their existing habits of mind, and they may also enhance skills that were not as pressing for survival but may still develop aesthetic sensitivities. If we gain most of our advantages from our intelligence, as Boyd suggests, we may also possess an instinct to stretch the range of ways in which we are able to discern meaningful arrays of information from stimuli, which might not necessarily appeal to putatively "natural" aesthetic preferences such as linear stories and representational (rather than abstract) paintings. Here, then, we move from the tendency to play with patterns, to the desire to develop our skills at identifying them.

From the perspective of the "cognitive play with patterns" account, it may be the case that we initially sense beauty in "the rule of order over

randomness, of pattern over chaos."[41] Boyd quotes zoologist Paul Weiss, who similarly comments that our sense of beauty depends on our sense of "pattern over chaos . . . the beauty of forms rest on the lawfulness of their formation."[42] This does not mean, however, that the most easily discernible patterns in art are the most rewarding. If we benefit from our intelligence, our skills of discerning beauty are stretched outwards. On occasion, the more indiscernible the patterns are, the more rewarding their identification may be. Simple pictures that infants respond to, symmetrically formed with primary colors, eventually give way to more complex works of art in later life. Repetitive children's songs become tiresome to mature listeners and they give way to more complex forms of music. This can be the case in multiple traditions, from pop to world music, classical, and jazz. The avant-garde, in all its manifestations, may be understood as a radicalized extension of this development, whereby the spectator learns to discern patterns in increasingly complex forms. This may be the cognitive precondition that facilitated the emergence of the avant-garde.

With this proposal in place, two points should be raised to clarify my argument. First, I do not mean to suggest that the avant-garde always necessarily produces the most profound, the most mature, or the most enriching artworks. Rather, it stretches out the human skill of discerning "meaningful patterns," in Boyd's terms, to a radical degree. Secondly, one may ask why more people do not appreciate the avant-garde if we have an evolved propensity to expand and refine our ability to detect patterns. The answer may be that most viewers reach a plateau or "comfort zone" from which they have no desire to stray once they develop a basic appreciation for art. Once this is developed, it takes a special kind of effort to learn to appreciate Arnold Schoenberg's twelve-tone serial music, James Joyce's modernist literature, or Maya Deren's psychodramas, and not everybody is willing to make that effort.

Returning to the previous evolutionary theories of art, from the perspective of the "socialization" account, avant-garde works of art do not generally dramatize humanly relevant themes or offer a form of social regulation. Instead, for one filmic example, they may train the spectator to attend to their visual array and assess the graphic details without gauging their semantic content—as Len Lye's films often do. They may also exercise the viewer's ability to make creative inferential leaps, or attend to the films with more patience. The micro-articulations of changes in light in a Brakhage film, the poetic inferences and associations evoked by a Maya Deren psychodrama, or a sensitivity to the transition from still pictures to moving images in a Robert Breer film, for example, all develop the viewer's skills of engagement, compelling them to attend to movies in ways they had not before. Likewise, Oskar Fischinger's films invite the viewer to identify audiovisual correspondences, and Bruce Conner's films invite the viewer to discern exotic metaphors in his visual juxtapositions.[43] Jordan

Belson's films place the viewer in a state of ambient entrancement, rather than the intentional directedness of narrative fiction, while Peter Hutton offers cinema as an occasion for quiet restfulness and contemplation, rather than the thrill of a well-told tale. Instead of telling a story, Hollis Frampton's *Zorns Lemma* (1970) famously invites the spectator to mentally bind a collection of images into a series of chronological and thematic groups.[44] The creative output of all these filmmakers exercises the viewer's mind in a way it is not exercised in traditional narrative-dramatic cinema.

Since avant-garde films do not generally offer a form of socialization, and they do not always offer information that falls into meaningful arrays from which spectators can make rich inferences without specialized training (as commercial movies arguably do),[45] the viewer's response may instead depend upon their level of acculturation. To draw a comparison, one may need a particular background of experience and training in order to appreciate fine wine and food. While we are all born with an innate instinct for particular flavors and textures, the education needed to appreciate them fully builds on these instincts. Likewise, the appreciation of avant-garde art builds on existing instincts to engage with art more generally, but it becomes a highly specialized pursuit, which sometimes requires a level of education and training to fully appreciate (although curiosity and a desire to understand the work is always the first necessary step). Furthermore, avant-garde films are not typically designed to seamlessly interface with existing habits of mind when engaging with cinema. Since avant-garde filmmaking exercises mental capacities that are generally under-rehearsed when watching films, widely held conventions for film viewing are not exploited, and an artist may develop a unique system of viewing requirements that the viewer needs to call upon when engaging with their work. The spectator may also need to suppress certain mental skills routinely employed when watching other forms of cinema, skills that are typically used unconsciously and effortlessly, such as narrative comprehension and character engagement. This is, perhaps, why so few people come to it spontaneously.

I will emphasize that I am not claiming that avant-garde art aids or improves the evolutionary process, nor does it help survival. The instinct to engage in narrative fiction or popular music (in which arrays of information usually fall into easily discernible patterns) may be an adaptive behavior, designed to enhance socialization or strengthen cognitive patterning skills; avant-garde filmmaking is one particular cultural tradition that draws upon this instinct in a radicalized form which does not rehearse the same accessible engagement skills that artists have traditionally used, and instead stretches our ability to discern otherwise imperceptible patterns. Avant-garde films focus on skills that are under-rehearsed in commercial cinema, and they are not always as immediately rewarding, since viewers might not be able to arrange the onscreen information into

"meaningful patterns" without a degree of specialist training that builds on a prior hunger for aesthetic experience.

Note that I suggest that the instinct to stretch one's range of aesthetic sensitivities sets the *preconditions* for avant-garde art, rather than directly claiming that we have an evolved predisposition for avant-garde art. Why would I not claim that evolution endowed us with an appreciation for the avant-garde? First of all, since the avant-garde has only existed for 150 years or so, it would have emerged much sooner if it was adaptively advantageous. Secondly, the only way one could prove that we have an adaptive, evolved predisposition for avant-garde art would be to show that connoisseurs of this type of work are more likely to survive and reproduce than others, or to demonstrate that people who enjoy avant-garde art are more mentally flexible than those who do not. In neither case do we have the evidence, and either way, both propositions seem unlikely. In addition, if all people had an evolved predisposition for this type of work, its appeal would be more widespread, and would not only be enjoyed by a niche audience.

As such, the appreciation of avant-garde art is not itself an adaptive behavior, since it did not come into existence to enhance our fitness for survival during evolution. Rather, it appeals to a prior instinct for aesthetic experience, which may be adaptive, and builds on it, stretching the spectator's range of aesthetic sensitivities. The hunger for aesthetic experience, conceived in terms of "cognitive patterning" as an extension of play, is the adaptation, while avant-garde art is a by-product of this. Other institutional, industrial, and cultural factors needed to be in place in order for the avant-garde to emerge, alongside this psychological precondition.

cultural accounts

One cultural explanation for the emergence of modernism and the avant-garde was offered by Robert Hughes, who commented that the period roughly between the 1880s and the 1910s saw the invention of Edison's light filament bulb; the movie camera; Marie Curie's discovery of radium; the first radio signal; the Wright Brothers' first powered flight; the development of Einstein's theory of relativity; and automobiles (the most visible sign of the future) becoming commercially available as an alternative to the horse and cart. While many were not initially affected by some of these developments, Hughes suggests that there was a feeling of an accelerated rate of change in all areas of human activity. Artists sought to produce work that reflected the shifts in consciousness that this change in the technological landscape implied, evoking "a parallel dynamism to the machine age without falling into the elementary trap of just becoming a machine illustrator."[46] Modern art offered a variety of solutions for reflecting this type of consciousness.

Similarly, Malcolm Turvey's book *The Filming of Modern Life: European Avant-Garde Film of the 1920s* discusses the emergence of modernism and the avant-garde within it, to demonstrate how early avant-garde films from the 1920s share a concern with modern life, and the rapid and disrupting changes it brought about.[47] While the avant-garde is frequently described as a rejection of bourgeois modernity, Turvey suggests that the relationship between the avant-garde and bourgeois modernity is more complex. One reason for this, he proposes, might be that in spite of the belief that avant-garde artists opposed the bourgeoisie and their attitudes, it was nevertheless a bourgeois phenomenon acting out the contradictions of middle-class existence. Instead of attacking the bourgeois from the outside, then, the assault of the avant-garde was an expression of a conflict that came from its own core.[48]

These cultural explanations offered by Hughes and Turvey should be understood as complementary to my own evolutionary account of the preconditions that facilitated the emergence of the avant-garde. Without the relevant social conditions, it would not have come about. Equally, the avant-garde, in the form that we have it, could not have emerged without the pre-existing perceptual and cognitive capacities wrought by evolution, and illuminated by cognitive scientists.

conclusion

There are several discussions about the controversies of evolutionary psychology that have not been addressed here due to lack of space. Some of them are considered by Malcolm Turvey in this anthology. One common charge against theories of evolutionary psychology is that they are "just-so stories"—they do not rest on testable evidence, only on their own internal logic. While this will not be addressed in detail, I will respond in brief by stating that my use of evolutionary psychology was as a hypothesis-generator rather than a source of "the facts," since my postulations are unprovable. While there may not be tangible evidence to prove my theories, I offer tentative, speculative conclusions, by way of inference to the best explanation. That is to say, my ideas are not irrefutably provable, but neither is anything else and I believe they are the best available.

In outlining what I have referred to as the "sexual display" and "socialization" accounts, I have attempted to demonstrate how the evolutionary discussion of aesthetics oftentimes risks dismissing the value of avant-garde and modern art. Using the "cognitive play with pattern" account as a springboard, I advanced an alternative theory of the avant-garde within an evolutionary context, characterizing it as an entity that stems from an evolved disposition to expand the way we attend to our sensory experiences without changing our perceptual architecture. While

this instinct serves as a precondition for art more generally, the avant-garde (specifically film, in my discussion) helps strengthen skills and sensitivities that may pre-exist in the viewer, but are not typically rehearsed in conventional cinema. Instead of employing widely-held conventions for film viewing, avant-garde films call upon the viewer to develop a unique set of viewing habits which can vary according to each film and filmmaker.[49]

notes

1. Renato Poggioli, *The Theory of the Avant-Garde* (Cambridge, MA: Harvard University Press, 1981); Robert Hughes, *The Shock of the New: Art and the Century of Change* (London: Thames & Hudson, 2009).
2. For example, see: Torben Grodal, *Embodied Visions: Evolution, Emotion, Culture, and Film* (New York: Oxford University Press, 2009); Carl Plantinga, *Moving Viewers: American Film and the Spectator's Experience* (Berkeley: University of California Press, 2009); Murray Smith, *Engaging Characters: Fiction, Emotion, and the Cinema* (Oxford: Clarendon Press, 1995); David Bordwell, *Narration in the Fiction Film* (London: Routledge, 1986).
3. Murray Smith, "Darwin and the Directors: Film, Emotion, and the Face in the Age of Evolution," in *Evolution, Literature, and Film: A Reader*, ed. Brian Boyd, Joseph Carroll, and Jonathan Gottschall (New York: Columbia University Press, 2010), 259.
4. Joseph D. Anderson, *The Reality of Illusion: An Ecological Approach to Cognitive Film Theory* (Carbondale: Southern Illinois University Press, 1996).
5. James Peterson, *Dreams of Chaos, Visions of Order: Understanding the American Avant-Garde Cinema* (Detroit: Wayne State University Press, 1994). The term "constructivism" is not to be confused with the Russian arts movement with the same name. An overview of constructivism as a branch of psychology is available in *Constructivism: Theory, Perspectives, and Practice*, ed. Catherine Twomey Fosnot, 2nd ed. (Williston, VT: Teachers College Press, 2005).
6. Anderson, *The Reality of Illusion*.
7. Ibid., 123.
8. Torben Grodal, *Moving Pictures: A New Theory of Film Genres, Feelings, and Cognition* (Oxford: Clarendon Press, 1997), 89.
9. Anderson, 44.
10. Steven Pinker, *The Blank Slate: The Modern Denial of Human Nature* (London: Allen Lane, 2002), 410.
11. Ibid., 411–412.
12. Hughes, 16.
13. Pinker, 412.
14. Oliver Curry, "Who's Afraid of the Naturalistic Fallacy?" in *Evolutionary Psychology* 4 (2006): 234–247.
15. Richard Wrangham and Dale Peterson, *Demonic Males: Apes and the Origins of Human Violence* (New York: Houghton Mifflin Company, 1996).
16. The Pleistocene is a geological period of time which lasted from about 2,588,000 to 11,700 years ago. Current scientific evidence indicates that humans evolved into their current form during this time.
17. Pinker's own recent book *The Better Angels of Our Nature: Why Violence Has Declined* (New York: Viking Adult, 2011) makes a similar point, emphasizing

the impact of culture, law, and civilization on human behavior, alongside evolved dispositions.

18. Theodor W. Adorno, *Aesthetic Theory*, ed. Gretel Adorno, Rolf Tiedemann, and Robert Hullot-Kentor; trans. Robert Hullot-Kentor, Continuum Impacts (London and New York: Continuum, 2004), 72.

19. See: Regina Cornwell, "Some Formalist Tendencies in the Current American Avant-Garde Film." *Studio International* 184, no. 948 (1972): 110–114; Malcolm Le Grice, *Abstract Film and Beyond* (London: Studio Vista, 1976), 90; Anthony McCall and Andrew Tyndall, "Sixteen Working Statements," *Millennium Film Journal* 1, no. 2 (1978): 29–37.

20. Peter Gidal, *Materialist Film* (London and New York: Routledge, 1989).

21. David E. James, *Allegories of Cinema: American Film in the Sixties* (Princeton, NJ: Princeton University Press, 1989).

22. A by-product of another adaptive behavior is sometimes referred to as a "spandrel"—a term coined by paleontologist Stephen Jay Gould. While my discussion leans towards framing the avant-garde as a spandrel, this topic will be explored more fully another time. For a full discussion of this concept, see: Stephen Davies, *The Artful Species: Aesthetics, Art, and Evolution* (Oxford: Oxford University Press, 2012), Chapter 9.

23. Ellen Dissanayake, *What Is Art For?* (Seattle: University of Washington Press, 1988); *Homo Aestheticus: Where Art Comes From and Why* (Seattle: University of Washington Press, 1992).

24. For another defence of art as an adaptation, see Brian Boyd, *On the Origin of Stories: Evolution, Cognition, and Fiction* (Cambridge, MA: Harvard University Press, 2010), 69–79.

25. Geoffrey Miller, "Arts of Seduction," in Boyd, Carroll, and Gottschall, 258.

26. For the preservation of space, John Tooby and Leda Cosmides will not be outlined in this article, but see "Does Beauty Build Adapted Minds? Toward an Evolutionary Theory of Aesthetics, Fiction, and the Arts," in Boyd, Carroll, and Gottschall, 174–183, for another example of the "socialization" account of art.

27. Ellen Dissanayake, "Art and Intimacy: How the Arts Began," in Boyd, Carroll, and Gottschall, 153.

28. Ibid., 151.

29. Grodal, *Embodied Visions*, 6.

30. Also note that the sexual display theory largely addresses the *creation* of art, while the socialization theory focuses more on the *appreciation* of art.

31. Miller, 282.

32. *Sleep*, director Andy Warhol (1963).

33. *At Land*, director Maya Deren, 1944. See Maria Pramaggiore's "Seeing Double(s): Reading Deren Bisexually," in *Maya Deren and the American Avant-Garde*, ed. Bill Nichols (Berkeley: University of California Press, 2001), 247–252, for a thematic reading of *At Land*.

34. *Valse Triste*, director Bruce Conner (San Francisco: Canyon Cinema, 1978). See James Peterson's discussion of *Valse Triste* in *Dreams of Chaos, Visions of Order: Understanding the American Avant-Garde Cinema* (Detroit: Wayne State University Press, 1994), 168–170.

35. A third evolutionary theory of art advanced by Pinker has been omitted from my discussion for reasons of space. In brief, the theory frames art as a non-adaptive pleasure technology, what he famously refers to as "cheesecake for the mind." Pinker suggests that we have an evolved

preference for particular sets of stimuli, which art exploits through various media. Like the socialization and sexual display accounts, this theory is also problematic when considered in relation to the avant-garde, since these works of art tend not to "press our pleasure buttons" in a direct way. For a critique of Pinker's pleasure technology theory, see Chapter 6 of Joseph Carroll's *Literary Darwinism: Evolution, Human Nature, and Literature* (New York and London: Routledge, 2004), entitled "Pinker, Dickens, and the Functions of Literature."

36. Boyd, *On the Origin of Stories*, 14.
37. Ibid., 88.
38. Ibid., 14–15.
39. Ibid., 94.
40. Ibid., 87.
41. Ibid., 88.
42. Paul Weiss, "Beauty and the Beast: Life and the Rule of Order," *Scientific Monthly* 81, no. 6 (1955): 286.
43. Peterson, 168–170.
44. *Zorns Lemma*, director Hollis Frampton, 1970.
45. See Anderson, 144–158.
46. Hughes, 16.
47. Malcolm Turvey, *The Filming of Modern Life: European Avant-Garde Film of the 1920s* (Cambridge, MA: MIT Press, 2011).
48. Ibid., 12.
49. Thanks to Murray Smith, Malcolm Turvey, Jonathan Frome, and Ted Nannicelli for their helpful comments.

cognitive

theory and

media forms

cognitive theory

and the individual

film

the case of *rear window*

william seeley and
noël carroll

introduction

Motion picture theory—or the theory of the moving image, as we prefer
to call it—has been highly suspect amongst movie makers and critics alike.
The major source of the skepticism here is the same in both instances. Movie
makers and critics care about individual motion pictures—the one they
are making or the one they are analyzing. Theory is, well, too theoretical;
they want something practical—that is, something that they can put into
practice. It is all well and good to speculate abstractly about the nature of
the interaction between film and its audience. But the devil is, here as
everywhere else, in the details, in the nuts and bolts of motion picture
production and in the ways actual consumers are engaged by actual movies.
Theory, it is charged, is too broad, too abstract to be of use; movie makers
and critics want something more down to earth.

These misgivings are voiced whenever theory is mentioned in the
presence of practitioners. And in some cases, such as that of much recent

poststructuralist theorizing, these anxieties are well warranted. However, we would argue that the very best moving image theorizing is not remote from either the production or the analysis of individual movies. Rather, it grows out of these practices in a way that illuminates them. The writings of Rudolf Arnheim, Sergei Eisenstein, and André Bazin, among others, were (and still are) eminently exemplary in this regard.

Cognitivism is a recent entry into the conversation of moving image theory. It only joined the discussion among film theorists in the 1980s, gradually gathering volume over the succeeding two and a half decades. Cognitivist theorizing is apt to strike the movie maker and the critic as something of dubious value, particularly given its roots in the academy. Like previous theorizing, practitioners will question its value with respect to the illumination of individual movies. The purpose of this essay is to allay those doubts. To that end, we will apply the resources of a particular cognitivist framework to Alfred Hitchcock's classic film *Rear Window*.[1] In articulating the way *Rear Window* works from a cognitivist perspective we hope to demonstrate that the approach has broad applicability to the category of mainstream narrative films to which the movie belongs.[2]

rear window: an overview

Rear Window, as most readers already know, is the story of a professional photographer L. B. "Jeff" Jefferies, who has been recently injured while covering an auto race. He is convalescing in his apartment in Greenwich Village. He is immobile. His leg is in a cast. He is visited regularly by an insurance company nurse who doubles as his physical therapist (Stella) and by his girlfriend Lisa Fremont. Jeff spends his day at his window—a rear window overlooking an enclosed courtyard—doing what he does best, visually cataloging the unfolding narrative within his purview in terms of the kinds of dramatized themes of human interest that are attractive to newspaper publishers and magazine editors. As the camera pans across the adjoining apartments, the image outside his window resembles nothing so much as a photographer's contact sheet. Jeff's attention is particularly drawn to the lives of a traveling salesman and his invalid wife—the Thorwalds—who live directly across the way. His close inspection of snapshot glimpses of their lives leads him to the conclusion that the husband, Lars Thorwald, has murdered his wife, and he sets about proving this hypothesis with the aid of his girlfriend and the therapist.

Given Jeff's immobility, *Rear Window* is often interpreted as an allegory for *sedentary film viewing*. His bay window can be taken to represent the surface of a screen, a window onto a world that is itself presented through and across other apartment windows in bracketed glimpses that resemble cinematic shots and sequences. But the argument can also be made that it is more

aptly interpreted as an allegory of *active movie making*. Jeff's eyesight is good enough to provide him with a long view of his neighbors' doings. Nonetheless, armed with a pair of binoculars and the kind of telephoto lens that a photographer keeps in his toolkit, he can move in for closer and closer views, as he effectively sorts, catalogs, and stitches together a photojournalist's narrative account of what he observes from a distance. Jeff builds his case against Thorwald—tells his story—by shifting his viewpoint from far views to close-ups—operating as if he were a stand-in for Hitchcock himself, editing *Rear Window* on the fly from within the film out of bracketed glimpses of the lives of his neighbors. Consequently, one may construe *Rear Window* as a self-conscious model for an entire class of movie making and thus a perfect opportunity to display the explanatory power of cognitivism, both for movie makers who are interested in what will work and critics interested in what has worked.

explaining how *rear window* works

Perceptual psychology has established that our visual system is calibrated to track change in our environment, especially the kinds of relatively abrupt changes that signaled the potential presence of predators or prey for our prehistoric forebears. Movies are typically constructed from a multiplicity of different images, usually in the form of discrete shots. These shot transitions glue the spectator to the screen by titillating this natural perceptual disposition to track and interpret change, thereby securing the movie maker's first objective: commanding the audience's attention. *Rear Window* consists of 816 shots with an average shot length (ASL) of 8.62 seconds distributed over the 110 minutes and 32 seconds of the movie.[3] These figures resemble other Hollywood movies in the 1950s and early 1960s whose ASLs were in the range of 8–11 seconds. This pattern of perceptual change constantly rejuvenates the viewer's attention to the screen. At minimum, therefore, the very fact that the camera's shifting viewpoint is finely tuned to the activation of the audience's innate processes of attention represents an important way in which the movie maker—in this case, Hitchcock—exploits the natural tendencies of everyday perception.

It is not enough, though, for a movie maker to hold onto the audience's attention through cuts and other means. The audience's attention must be guided. And if the motion picture in question is a narrative, the audience's attention must be guided toward what is pertinent for following the story as it unfolds. To this end, movie makers, such as Hitchcock in *Rear Window*, employ a suite of formal-compositional devices in order to assure that viewers attend to precisely what they need to be attending to at any given moment in order to follow the narrative—not only to

237

continually refresh the viewer's angle on the action and, thereby, to keep them from turning away from the screen, but also to supply them with the information they need to comprehend the story on a need-to-know basis.

Of these devices—which, like films themselves, we will refer to as *attentional engines*—*variable framing* is fundamental.

variable framing

Variable framing is a mechanism for changing the viewing position—which for convenience we will call the camera position—on the emerging course of events and/or states of affairs in the movie world. Movie makers use variable framing to direct attention to salient information by changing the viewer's visual perspective on depicted objects, states of affairs, events, and actions. A striking example of variable framing occurs in the opening of *Rear Window*. The camera moves from a shot of Jeff's leg in a cast, to a broken camera on a side table, to a photograph of a car crash above it on the wall, two race cars looming in the foreground, tumbling towards the viewpoint of the photographer's lens. By selecting these details and framing them saliently—that is, by guiding the audience's attention to them and controlling the context of their presentation—Hitchcock deftly and economically explains how Jeff broke his leg. The camera then moves on to draw our attention to a photograph of an atomic explosion, the negative of a fashion model's head-shot, and finally a magazine cover featuring the same photograph. Thus, by means of variable framing, Hitchcock informs us that Jeff is a magazine photo-journalist and foregrounds our introduction to his girlfriend, Lisa Fremont, suggesting that they met on a fashion shoot when we meet her in a later scene. This sequence of selective reframing offers an illustrative lesson in how movies narrate visually. It also supplies a key for the viewer that indicates how variable framing will be used to structure the rest of *Rear Window*.

There are three prominent ways to implement variable framing: editing (cutting from one camera position to another); camera movement (panning or tracking from point A to point B); or lens movement (zooming in or zooming out). These physical means of altering our viewpoint on the action, furthermore, illustrate and support the three basic functions of variable framing: *indexing*, *scaling*, and *bracketing*. Indexing refers to the rudimentary capacity of the camera to call our attention to something by pointing at it. When the camera moves toward something by cutting, tracking, panning, or zooming in, it functions ostensively, pointing towards some feature of interest in the scene. Its direction signals "Look at this!" Ostension or simple pointing is perhaps the most basic form of human communication. When the camera shifts its position on the action in this way, it typically indexes something that plays a critical, contributing role

in the viewer's capacity to recognize and understand the unfolding of the story. For example, when we see a close-up of Jeff's thermometer, this informs us of the stifling heat that, in turn, establishes an insistent source of irritation, reinforcing the atmosphere of edginess that suffuses the story world.

Scaling is typically a natural consequence of indexing in contexts like these. As the camera moves closer to the target subject of the shot, it takes up more space in the visual field. The attendant change in the size of the target indicates its importance to the story. Changing the relative size of an object or agent on the screen is a simple but important way of communicating its importance. As a general rule of thumb, what is large on screen is important; conversely, what is small is of lesser significance. Of course, there are cases of indexing without scaling—that is, without altering screen size. Relative movement can achieve the same effect by detaching an object or agent from the background in a scene—for example, tracking shots which maintain the subject in a central position against a moving and changing backdrop, or a pan of a character as he or she walks a short distance. The opening camera movement in *Rear Window*, which introduces us to the courtyard, is an instance of indexing without scaling. It is akin to a sweeping gesture—indicating in effect that this whole environment is to be the locus of our attention—without changing the relative scale of the apartments. However, scaling and indexing most frequently occur in tandem insofar as typically shifting indices often automatically involve alterations in scale.

A third function of variable framing is bracketing. Like scaling, it is also generally a natural consequence of indexing. As the camera viewpoint is moved by editing, tracking, panning, or zooming towards the subject, elements of the scene once visibly present become occluded beyond the frame of the screen, altering the context of presentation. The frame acts as a bracket. What is outside the frame has been literally bracketed out and is no longer available to be seen. What lies within the bracket on screen is most often what the viewer needs to attend to. When Lisa signals to Jeff that she has Mrs. Thorwald's marriage ring, the close-up not only points to what is significant and marks it by enlarging the amount of screen space it occupies, but the shot also excludes any potential distractions. Moreover, this compositional strategy can also be used to alert us to something off screen, as when a character looks apprehensively beyond the frame of the shot, when a noise penetrates the scene from outside the bracket, or when the viewer has been made aware of, or been made to expect, something off screen that the characters are either unaware of or unprepared for. For instance, when Lisa suddenly looks apprehensively off screen and encourages Jeff to recount his suspicions about Lars Thorwald, we are alerted to the fact that the next important item of narrative information is outside the frame—here, the fact that Thorwald is binding a large piece

of luggage with rope. This kind of exclusive (as opposed to inclusive) bracketing demands active perceptual and cognitive engagement. It is incumbent on a viewer to track, update, and interpret the indexed information off screen by tracking and interpreting the actions that are explicitly perceptually present in the scene.

erotetic narrative structure

Variable framing can be used for a range of purposes in the movies—for example, to *depict an environment*; to *draw contrasts and comparisons* among actions, events, characters, and settings; to *make and support arguments*; or to *express emotions*. However, we believe that there can be little doubt that the most common and paradigmatic role of variable framing is to develop and articulate movie narratives by guiding attention to critical story information, highlighting the salience of this information via indexing, scaling, and bracketing, and presenting it in a sequence that facilitates our construction of a coherent, intelligible, unified, and compelling story. This is a process that requires active cognitive engagement on the part of viewers. Moreover, it suggests that cognitivist theory is a resource that can be fruitfully employed to track and explain the range of ways these devices have been used to engage key aspects of human cognitive and perceptual architecture in order to articulate the particular narrative structure of particular films. In the remainder of this section we will explore the use of variable framing in concert with the *erotetic narrative structure* of Hitchcock's *Rear Window* in order to motivate this hypothesis.[4]

Movies are constructed from sets of spatio-temporally disjoint shots, scenes, and sequences that adeptly direct viewer attention, in order to deliver just what information is needed just when it is needed for the development of a globally-cohesive overarching narrative. This formal-compositional fact about movies raises two questions: *What binds spatio-temporally disjoint shots and sequences into locally coherent scenes, actions, and events? What are the governing principles viewers use to stitch these spatio-temporally disjoint scenes, actions, and events into a unified and cohesive narrative whole?* We argue that the answer to both of these questions is that most movies generally employ erotetic narrative structures.

Erotetic narratives are constructed by generating and answering questions about the actions and events depicted in a text or movie and then answering them. In ordinary run-of-the-mill contexts, audiences respond to depicted actions and events by asking questions about their causes and effects—about where they came from and where they are headed. Actions, the goal-directed intentional behaviors of characters, are the primary subject matter of the movies. Actions differ from events in that their causal source lies primarily in the mental states of the acting agent. Our inferences to causes in answering erotetic narrative questions at the movies will

therefore ordinarily involve interpretations of the beliefs, desires, emotions, and motives of characters as psychological causes of target actions. The fragmented presentation of information in the scenes and sequences in movies thereby prompts questions about the causes and potential effects of depicted actions and events that the movie goes on to answer. The attribution of psychological states to characters also serves two further purposes in these contexts. It opens up a range of possibilities, raising questions about what will happen subsequently in the narrative—how the characters will behave, what they will do, and how they will interact with one another. It can also bring to light information about foregrounded objects, events, and actions, retrospectively framing their salience in the context of present narrative possibilities. The attribution of mental states to characters therefore guides what we call the *forward* and *retrospective articulation* of narrative structure.

Consider for instance a scene that plays out across our bracketed views of the Thorwalds' apartment early on in *Rear Window*. It is the middle of the morning. Mr. Thorwald has just returned home with his samples case. He takes off his hat, jacket, and tie, and goes into the next room where his wife is in bed. They argue. Mrs. Thorwald points to her watch, narrowing our focus within the bracket of the bedroom window while she admonishes him about the time. We infer that she is nagging him, asking, "Where have you been all this time?"[5] This automatically leads us to wonder where this marriage is headed. That is, by bracketing the couple's argument and indexing the current time, audience members are alerted to be on the lookout for new information, the *assimilation* of which will contribute to their understanding of these local and global narrative questions within the Thorwalds' sub-narrative, thereby enabling them to *accommodate* it and retroactively update their grasp of the story.

Variable framing is generally coordinated with erotetic narration, as this example of indexing (without scaling) and bracketing suggests. In the typical case, variable framing functions to ensure that the first item or gestalt of items the viewers see with a new camera viewpoint is the item or items that are most relevant to following the evolution of the story at that point in its presentation. This may involve the posing or answering of questions, or both. In the current example, our attention is focused on the odd timing of Mr. Thorwald's return home, an action that is initially framed for the audience by a view of his wife's aggravated but inquisitive posture in the next room; this view is inclusively bracketed for the viewer by the bedroom window, thus serving the erotetic narration by raising questions (arousing curiosity) about the status of this relationship. In sum, variable framing is used in order to ensure that those elements of a cinematic sequence are salient that will advance the network of questions and possibilities that drive the narration forward.

There are two major classes of questions that movies pose: micro-questions and macro-questions. Micro-questions emerge within scenes and sequences and supply the connectives between shifting camera positions. For instance, Lisa's face becomes worried and inquisitive, raising the question of why, and then the variable framing answers that question immediately by foregrounding Thorwald tying up the large trunk. Here, once again, the variable framing drives the local erotetic structure of the sequence.

Macro-questions are overarching questions that sustain our attention through all or most of the story. In *Rear Window*, two such macro-questions drive two, hierarchically related sub-narratives: a macro-question about the evolving status of Lisa and Jeff's relationship drives the global romance narrative and a subordinate macro-question about the outcome of Jeff and Lisa's sleuthing drives the dynamics of their relationship. The latter macro-question is itself articulated by three subordinate narrative questions: will Jeff be able to convince Lisa of Thorwald's crime; once he does will they together be able to collect enough evidence to convince the police of Thorwald's guilt; and once they do will Thorwald thwart them in their effort, bringing the romance narrative to a close with their tragic demise?

The various subplots that unfold within the frames of the neighbors' apartment windows are likewise driven by their own subordinate macro-questions, each of which itself articulates a question salient to one or both of the romance and adventure narratives. Will Miss Lonelyhearts find a mate? Will the composer successfully finish his new song? Who will Miss Torso choose? These questions each evoke their own narrative possibilities. As the story unfolds the range of available possibilities is pruned, until finally we have answers to all of these pressing questions. Thorwald is captured, Lisa and Jeff are closer than ever before, Miss Lonelyhearts is romancing the successful composer, and Miss Torso's true love has returned from the wars. Thus the individual narrative questions have been answered, resolved, or explicitly set aside for a sequel, and the narrative comes to an end, or achieves *closure*.

erotetic narrative and variable framing

Lens movements, camera movements, and cuts function to variably frame narrative elements by means of indexing, scaling, and bracketing. These activities are used to visually assert the significance of information within shots and cinematic sequences, thereby guiding attention and shaping the narrative. As we have seen, indexing can be achieved by moving the camera viewpoint closer to the subject, scaling the visual perspective on the target. As the camera position moves in closer to the subject it increases in visual size, indicating its importance. Consider the initial sequence with the telephoto lens. It begins with a long shot of Jeff's unassisted perspective on

Thorwald cleaning his samples case. This piques his curiosity. He asks Stella to retrieve his binoculars. Now his perspective is moved closer in. The action is scaled larger, from a long to a medium shot that reveals Thorwald restocking his samples case. When Jeff changes to his telephoto lens, he perceives Thorwald cleaning his saws and wrapping them in newspaper in the kitchen; this action is scaled larger again, in a close-up, signaling that this information is even more visually important. Here indexing functions as a means to collect evidence in support of Jeff's hypothesis about Thorwald's crime, which prunes the range of narrative possibilities and narrows the range of possible answers to the question of what has happened to Thorwald's wife.

Hitchcock exploits scaling as an attentional engine throughout the movie to deliver information critical to its erotetic narrative structure. For instance, the thermometer fills the screen in close-up each time it is shown, signaling the importance of the information it carries. The pan across the courtyard in the opening sequence comes to rest on an extreme close-up of Jeff's supine face and head, which overflow the screen. The camera lingers here momentarily to capture a bead of perspiration break free and roll across his head. As the bead of sweat reaches the hairline above his sideburns the camera cuts to the thermometer, scaled to overflow the screen as well. It reads a sweltering, claustrophobic 94 degrees, signaling the start of an oppressive New York City summer day, a time when tempers are apt to be short, anger ready to flare, and anything might happen. In this sequence, scaling is used to narrow the focus of our attention: it begins with an establishing shot of the setting, next moves to the establishment of Jeff's importance as the main character, and then captures his confined state of mind, trapped as he is in the hot and stuffy apartment. Scaling visually foregrounds information, the significance of which is amplified by Jeff's subsequent telephone conversation with his editor, to whom he comments, "If you don't pull me out of this swamp of boredom I'm going to do something drastic."

The thermometer plays a similar framing role at the start of the scene in which Lisa comes to recognize the validity of Jeff's hypothesis. Here it reads an oppressive 82 degrees at 10 o'clock at night. In this case Hitchcock uses the shot to accentuate the close, frustrated tone of their bickering. Finally, the same close view of the thermometer opens and anchors the closing pan that marks the end of the movie. Here it reads a comfortable 70 degrees, signaling that the heat, like the romantic crisis in their life, has broken. New York has settled into a comfortable temperate climate that mirrors their now secure relationship.

An analogous story can be told about the way variable framing is used to indicate the narrative salience of Jeff's telephone. It is first introduced as the center of our attention on the side table when the camera zooms out from Jeff's cast in the opening sequence, prior to panning to the broken

camera, foregrounding his phone dialog with the magazine editor. It is likewise scaled to fill the screen in the shot following Lisa's realization about Thorwald's crime. When it rings, it is Lisa calling to report that she has managed to discover Thorwald's name and apartment number, thus initiating the adventure narrative and her role as Jeff's physical proxy in action and risk. Finally, it is Jeff's gaffe on the phone that leads Thorwald to him as the architect of the investigation in the penultimate scene.

Bracketing (inclusive) is a natural consequence of Jeff's use of the binoculars and telephoto lens to watch the Thorwalds and Miss Lonelyhearts. The oculus used to denote this mode of attention reveals the details of Jeff's obsessions and signals his myopic focus. This myopic focus also produces exclusive bracketing in some cases. Consider the pan from the alley to Lisa and Stella's feet and the hole they have dug in the garden. This camera movement calls attention to the failure of the search for evidence here, to the lack of evidence within the frame of the bracket. But it also signals that Jeff has forgotten to keep watch for Thorwald's return through the alleyway that is now outside the bracket. Similarly, exclusive bracketing is critical to Lisa's encounter with Thorwald in his apartment. We cannot see where she has gone to hide in between the rooms. Thorwald's body language not only tells us that he has found her in this bracketed space, but also allows us to interpret her unseen actions in response to his behavior. In each of these cases, narrative expectations about what we currently cannot see outside the bracket of the camera give life and pressing significance to particular narrative possibilities, increasing the level of suspense in the scene.

The range of questions and answers that define erotetic narrative structure can, as discussed above, be arranged hierarchically into microquestions, macro-questions, and presiding macro-questions. Presiding macro-questions organize the plot as a whole. In *Rear Window* the presiding macro-question is ultimately the question about the outcome of Jeff and Lisa's relationship negotiations, which structures the romance narrative. Simpler macro-questions are questions that organize large portions of the movie, but do not structure the plot as a whole. The adventure narrative drives a significant part of the second half of the movie. It can be divided into two overlapping subordinate narratives: a mystery story and a suspense story. The mystery story is structured around the question of what has happened to Mrs. Thorwald, and the subsidiary questions of whether Jeff can convince Stella and Lisa that something is awry and whether, once he has convinced them, they can together collect sufficient evidence to convince Detective Doyle of Thorwald's guilt. The suspense story takes over the structure of the mystery story once Lisa and Stella leave the apartment in search of evidence of Thorwald's crime. It includes an additional question of whether Thorwald will be apprehended before he harms either Jeff or Lisa.

Micro-questions are questions about local obstacles to the overarching goals of the protagonist defined by macro-questions. The solution to these problems is, more often than not, related to macro-questions as a means to an end. The use of variable framing to pose and answer micro-questions is thereby a critical device that contributes to the resolution of macro-questions. For instance, the suspense in the scene where Lisa searches Thorwald's apartment is driven by the question of whether she will be caught. The local obstacle to her escape is her motivation to find Mrs. Thorwald's handbag and wedding ring. The discovery of her ring is a means to the end of establishing Thorwald's guilt, solving the mystery, establishing closure in the adventure narrative, and thereby securing a positive outcome to the romance narrative. Variable framing is used to raise and then answer these questions, first by indexing the emptiness of the handbag, focusing on a medium close-up of Lisa shaking it out to show Jeff the ring is not there, and then, once the police have arrived to save her, scaling the view of the wedding ring on Lisa's finger in a close shot to show that she has found it.

Answering this micro-question—will she find the ring?—answers the macro-question about what has happened to Mrs. Thorwald. It resolves the mystery narrative, secures the outcome of the suspense narrative by providing the evidence necessary to convince Detective Doyle to apprehend Thorwald, and thereby secures the outcome of the adventure story.

point-of-view editing

Although the moving image is a cultural invention, it is useful never to lose sight of the fact that in many ways it succeeds as well as it does because it freely avails itself of our biological heritage. The motion picture is an art form, but, as with art in general, we must not suppose that it is solely an affair of the mind. Motion pictures address our bodies as well.[6]

Point-of-view editing (POV) is a powerful attentional strategy in the movies which is particularly fine-tuned to our biological repertoire of cognitive routines. Minimally it involves the deployment of two shots, a point/glance shot and a point/object shot.[7] The point/glance shot captures the gaze direction and facial expression of a character looking off screen. The point/object shot putatively captures what the character sees. These shots can be related both prospectively and retrospectively. Prospectively, the point/glance shot suggests the mode of attention the viewer should adopt by revealing the current emotional disposition of the character. Retrospectively, the content of the point/object shot, in turn, articulates and clarifies the emotional state expressed by the character. The structure and role of these shots can be iterated in a range of ways. The character can be depicted alone or in a crowd. The character can be the central focus of the shot or a tangential element that serves to capture and shift the focus

of attention. Multiple instances of the two types of shots can be strung together to guide attention through an unfolding event or action.

Our capacity to follow what other people are attending to in the environment by tracking their gaze is a natural mechanism for interpreting their goals, interests, and emotions in ordinary social contexts. POV in cinema builds upon this innate propensity to track a glance to its target, juxtaposing the character's look to what is looked at, while deleting the space in between. POV enhances the resources of variable framing by adding the gaze of the character to indexing, scaling, and bracketing as another lever for focalizing what is relevant in the story world and directing the audience's attention to it. Moreover, it is an especially smooth device for accomplishing this, since, as we have noted, it mimics a natural perceptual pathway—that of following the trajectory of another's glance to its target.

POV is a perceptual strategy that is regularly used to guide and control the viewer's attention in *Rear Window*. It is the predominant visual strategy in the film. The number of object shots in the film that are covered as being within (or possibly being within) the gaze of another character is quite stunning. Consider the scene where Jeff observes Thorwald cleaning his samples case and knives. The sequence begins with a shot of Jeff; his attention is sharply focused on what is happening across the yard, behind the camera position. A cut to Jeff's view reveals a long shot in which we can see Thorwald cleaning his samples case through his living-room window. But the view is not very detailed. Jeff asks Stella for his binoculars. We see him bring them to his eyes. The camera cuts to a medium close shot of Thorwald restocking his cleaned samples case. Jeff puts the binoculars down, and with a curious but concerned look rolls back into the shadows. He installs a telephoto lens onto the body of his camera. When he looks again we see a close shot of Thorwald in the kitchen, cleaning some big saws and knives, wrapping them in newspaper, stretching, yawning, and retiring to the couch for a mid-afternoon nap. When the camera returns to Jeff he pulls pensively away from his camera; a look of concerned horror washes over his eyes. The structure of this sequence provides just the information we need to interpret the thoughts and emotions that underwrite Jeff's facial expressions and link them to their objects. It also guides the viewer, here providing the viewer with a key to the use of POV editing throughout the rest of the movie.

One might think of these processes as putting ourselves into Jeff and Lisa's shoes, as automatizing information transfer in our experience of the movie by hijacking a natural attentional strategy. However, we think this is the wrong way to interpret what is going on. We think, rather, that POV sequences are representations of the visual experiences of characters that we easily recognize and assimilate because they ride piggyback on a structural resemblance to our own natural perceptual practices. In other words, to the degree that we simulate perspectival seeing in our engagement with

point/object shots, we do so in order to collect information salient for understanding the depicted visual experiences of characters. However, we do not, in so doing, put ourselves into the narrative. The easiest way to see this is to note that precise eye-line matching is not a necessary condition for the success of POV sequences. A glance in the right general direction will do. In fact, in *Rear Window*, although Jeff's optical perspective sits at one end of the axis of action, it is often quite difficult to interpret the precise direction of his gaze vis-à-vis the different apartments across the way.

This all makes sense structurally. In ordinary contexts, we do not track someone's gaze literally as a line traced in space. We are rather presented with its endpoints, the glance and its target, which naturally fall at the two ends of a saccade. A POV sequence likewise delivers the glance and target as discrete objects, as the two endpoints of a natural attentional strategy. If eye-line matching was systematically inconsistent or consistently out of line with the spatial structure established for a scene, we would likely be distracted. But as long as there is a general match to direction, everything should work out fine. Viewers recognize POV sequences as what they are, representations of the perceptual experiences of viewers designed to direct our attention to critical information and to articulate the mental states of characters.

Directors use POV sequences as a communicative device to deliver narratively salient information. These sequences perform this function fluidly because their structure is fine-tuned to natural, biologically-rooted attentional strategies that we deploy in ordinary social contexts in order to collect information about the goals, interests, and mental states of others, as well as the target objects of their intentional behaviors. What this should make clear is that the purpose of POV shots is rarely just to deliver information about the target of the point/object shot alone. Their broader purpose is to articulate a relationship between the perceiving agent and the object of their perception, which is constitutive of the mental and emotional states of characters. Facial expressions are usually not neutral. Or perhaps better, even a neutral facial expression is just as informative about the mental states and emotional dispositions of an agent in a context as are its angry, joyous, or fearful cousins. For an example of how the face in the point/glance shot emotively evaluates its object, consider the way in which the anguished look on Jeff's face imbues the shot of Thorwald wrestling with Lisa with heightened anxiety.

Movie makers exploit this fact to guide the modes of attention viewers bring to bear on the point/target shot in POV sequences. Again, this is a consequence of our natural perceptual repertoire. There is a close coupling between motor mimicry, affective response, and attention in facial recognition. We naturally mimic perceived facial expressions.[8] The low-level muscle responses associated with this process are accompanied by autonomic responses that are congruent with the autonomic responses

constitutive of the experience of the emotions expressed, even in the context of perceived pictures of expressive faces. These autonomic responses are, in turn, the consequence of affective processes that are also responsible for priming perception to the salience of a stimulus to an agent's well-being. This entails that our affective dispositions actively shape attention and perception.[9] Thus, information present in the point/glance shot prospectively inflects the affective narrative salience of the target before we see it in the point/object shot.

This relationship is reciprocal. The point/glance and point/object shots perform different kinds of functions. The point/object shot, in conjunction with the tools of variable framing, focuses attention on critical pieces of narrative information. The point/glance shot prospectively inflects the presentation of that information by shaping the mode of emotive attention a viewer brings to bear on the point/object shot by ascribing valenced affective salience to its target. The object in the point/object shot, in turn, retrospectively refines our understanding of the emotional states expressed in the point/glance shot by articulating its content.

The *Kuleshov Effect*—named after the early twentieth-century Russian filmmaker Lev Kuleshov, who designed these shots—can be used to illustrate how POV sequences are used to articulate the emotional states of characters.[10] Kuleshov cut shots of the expressionless face of an actor with shots of a range of scenes and objects in these experiments, for instance a bowl of soup; a woman on a divan; a girl in a coffin; and flying birds framed against the sky. He reported that viewers perceived the actor's facial expression differently in each case, taking it to express hunger, desire, grief, and a yearning for freedom respectively. Kuleshov's demonstration was not a controlled experiment. Nonetheless, it illustrates the communicative power of editing strategies in film. Viewers naturally connect juxtaposed images across cuts, binding them in space and time. POV sequences are perceived in this way as inflections of the mental states of characters, their thoughts, goals, desires, and emotions. Of course, the point/glance shots are not ordinarily built from neutral expressions. Rather, just as persons acting in ordinary contexts, movie actors are depicted with facial expressions that are congruent with their narrative context, with the way they are situated in their environment, with the bearing that the target of their gaze is likely to have on their well-being or that of others. A case in point is the helplessness and anxious fear expressed by Jeff's face and body language throughout the point/glance shots that depict him watching Lisa search Thorwald's apartment and get caught.

We readily recognize gross basic categories of emotions like anger, fear, disgust, contempt, joy, sadness, and surprise in expressive faces in ordinary contexts. There is evidence of cross-cultural convergence in this capacity.[11] Individuals across cultures tend to agree in their categorizations of the

248

basic category of emotions expressed in close-up photographic portraits of decontextualized expressive faces. This convergence is higher in cases in which the photograph has been posed to amplify features diagnostic for the expressed emotion (and de-emphasize muscle responses associated with other aspects of ordinary behavior such as speaking, shifting gaze, or reorienting one's face to track the dynamics of scene). The cross-cultural capacity to recognize the emotions expressed in decontextualized posed portraits suggests that this is also a biologically-rooted, innate aspect of our basic, shared perceptual repertoire. In film contexts it enables directors to prospectively inflect the narrative salience of the target of a point/object shot, and enable viewers to bootstrap their way into an understanding of characters and the contents of scenes prior to the elaboration of narrative context, perhaps providing the foundation of narrative understanding.

This account of POV provides an explanation of one mechanism directors can use to communicate the basic general categories of emotions expressed by characters. However, emotions are more fine-grained than this. They are motivational states that encode the value of their object to an organism in a context. We do not flee fear. We flee because of our fear of something. As philosophers say, emotions have intentionality. They are directed at aspects of the world that are constitutive of their content. The character and motivating force of our fear, for instance, is determined by the bearing its object has on our well-being and that of others. This suggests that the emotion expressed in a point/glance shot alone is under-determined, ambiguous, or vague, a complication that is further exacerbated by the fact that it is difficult to disambiguate some basic emotions, for example, distaste from concern, or fear from shock or surprise, in facial expressions.

The solution: POV sequences are fine-tuned to the structure of our ordinary perceptual recognition capacities. Just as we use the target of an agent's gaze to disambiguate and articulate the particular content of their emotional states in ordinary contexts, the point/target shot delivers the information requisite to retrospectively articulate the emotional states expressed in the point/glance shot in POV sequences—POV shots are both prospectively and retrospectively articulated. Consider Lisa's expression at the end of the dialog preceding her recognition of Thorwald's guilt. She has been testily admonishing Jeff for his putatively unhealthy interest in the personal lives of his neighbors. She looks towards the drawn shade of the newlyweds next door and says, "Why, for all you know there may be something far more sinister going on behind those windows." The camera cuts to Jeff, who turns to see what she is looking at, and then he turns back to the camera and says, laughing, "No comment." (It has been insinuated that they have been incessantly making love for days on end.) The camera cuts back to Lisa. Her expression transforms from mild

amusement to distracted reflection, and then to deepening concern. Given the current context framed by the immediate sequence of shots and current dialog, we initially read the distracted reflection as a self-reflective response to Jeff's sarcastic comment about the newlyweds.

But her look of concern deepens and she slowly stands. The camera cuts to Jeff. His eyes follow her as she rises off-frame. The camera cuts back to a medium shot of the two of them. Her gaze has become intently focused on events outside the window. Jeff retrieves the binoculars. When the camera cuts back to the courtyard, we are shown a medium shot of Thorwald tying up the trunk, thereby resolving and clarifying the source and emotional tone of Lisa's concern. Clarifying the focus of Lisa's gaze thus disambiguates the emotional content of her original facial expression, retrospectively articulating that her mental state is one of externally-directed apprehensive concern, not of internally-directed, self-reflective remorse.

Here we see that the point/glance and the point/object shots interact reciprocally in promoting our understanding of what is going on. The point/glance shot, by dint of Lisa's facial expression, gives us a global sense of her attitude toward what she is seeing; she is somehow concerned. But her visage does not fully define the nature of that concern. Rather the point/glance shot does, by showing us what she is concerned about. Her concern involves apprehensiveness, since the shot adds to her calculation of the probability that Mrs. Thorwald has been murdered. That is, the point/glance shot yields a broad characterization of Lisa's emotional state—it establishes the range of emotions that Lisa might be experiencing. And then the point/glance shot specifies the particular emotional state by showing us or focusing upon what Lisa's concern is about.

The point/object shot works this way insofar as the emotions are appraisals that are governed by criteria. The various emotions have criteria for what will count as the appropriate sorts of objects for that kind of emotion. Thus, we glean the emotional state of movie characters by matching the emotional facial expression found in the point/glance shots with what the point/object shots exhibit in terms of the criteria of emotive appropriateness that they satisfy. The point/object shots can operate in this way because they have been pre-selected by the movie maker by virtue of the emotive criteria they fulfill. In this regard, we say that the objects in the point/object shots have been *criterially prefocused*—that is, they have been selected and staged because they are the sorts of things that are apt to raise the affects the movie makers wish to evoke at that point in the motion picture. Apprehensiveness is what Hitchcock is aiming for, so he fills in Lisa's visual field with a gruesomely suggestive object.

Criterial prefocusing is one of the primary ways in which movie makers govern the affective reactions of spectators. By means of variable framing,

they select and make salient objects that are criterial for the elicitation of the emotional states they mean us to occupy. The emotions are attentional engines in everyday life and they perform in a comparable fashion in motion pictures—both to rivet our attention to the screen and to mold our affective response to it. In most narrative movies, criterial prefocusing is a leading mechanism for securing audience engagement. Moreover, critierial prefocusing can obtain within or without a POV structure. However, although criterial prefocusing occurs quite often without POV structures in a great many films, in *Rear Window* it is rarely deployed independently of said structures, since almost every image in Hitchcock's film is or could be the point/object shot of some or another character (including the composite view of the assorted neighbors, conceived of as a collective). Thus, cognitive film theory enables us to zero in on one of the most distinctive and creative dimensions of Hitchcock's achievement in *Rear Window*, namely the use of criterial prefocusing almost exclusively within POV sequences as a formal-compositional device, as an attentional strategy to direct viewers' narrative engagement with the movie and its characters and articulate its content.[12]

summary

Theoretical approaches to the motion picture are often criticized for having little or nothing to say about individual movies. Although this blanket reservation might also be leveled at cognitivist approaches, in this chapter we have attempted to defeat this worry by illustrating the way in which a cognitivist approach to Hitchcock's *Rear Window* can illuminate how that movie works to hold and guide the viewer's engagement with the film. *Ex hypothesi*, this should be of interest to movie makers and analysts alike— to those who wish to make movies by recruiting reliable strategies, and to those who wish to figure out how specific movies manage to shape audience response.

We have introduced a series of cognitivist concepts as well as hypotheses about their applicability. These include the notions of variable framing, indexing, scaling, bracketing, erotetic narration, micro-questions, macro-questions, and criterial prefocusing. These concepts, we maintain, enable movie makers and critics alike to understand how Hitchcock succeeds in engaging his audiences. Moreover, our framework helps to explain the way in which Hitchcock used criterial prefocusing to articulate the content of POV shots, isolating and articulating perhaps the most distinctive stylistic feature of *Rear Window*.

Thus, we hope to have demonstrated that cognitivism need not be rejected as offering at best a superficial account of particular works. Rather, it is arguably a way of understanding movies ever more deeply.

notes

1. *Rear Window*, director Alfred Hitchcock (Hollywood: Paramount Pictures, 1954).
2. See Noël Carroll, *The Philosophy of Motion Pictures*, Foundations of the Philosophy of the Arts (Malden, MA: Blackwell, 2009); Noël Carroll and William P. Seeley, "Cognitivism, Psychology, and Neuroscience: Movies as Attentional Engines," in *Psychocinematics: Exploring Cognition at the Movies*, ed. Arthur P. Shimamura (Oxford and New York: Oxford University Press, 2013), 53–75.
3. We are grateful to David Bordwell for information about the number of shots in *Rear Window*. See also James E. Cutting, Jordan E. DeLong, and Kaitlin L. Brunick, "Visual Activity in Hollywood Film: 1935 to 2005 and Beyond," *Psychology of Aesthetics, Creativity, and the Arts* 5, no. 2 (2011): 115–125.
4. Although erotetic narration is not the only analytic model that has been proposed for understanding movie narratives, we think it is a powerful tool that is well-suited to handle the structure of most popular movies.
5. An inference prompted and reinforced in part by the concurrent phone dialog between Jeff and his editor about marriage and relationships.
6. Carroll, *The Philosophy of Motion Pictures*, 189.
7. Edward Branigan, *Point of View in the Cinema*, Approaches to Semiotics 66 (Berlin: Walter de Gruyter, 1984), 103.
8. Paula M. Niedenthal, "Embodying Emotion," *Science* 316, no. 5827 (2007): 1002–1005.
9. See L. F. Barrett and Moshe Bar, "See it with Feeling: Affective Predictions During Object Perception," *Philosophical Transactions of the Royal Society B: Biological Sciences* 364, no. 1521 (2009): 1325–1334; Carroll and Seeley, in Shimamura 53–75; Luiz Pessoa, Sabine Kastner, and Leslie G. Ungerleider, "Attentional Control of the Processing of Neutral and Emotional Stimuli," in *Cognitive Brain Research* 15, no. 1 (2002): 31–45.
10. See David Bordwell and Kristin Thompson, *Film Art: An Introduction*, 8th ed. (New York: McGraw-Hill, 1999), 227–229. Kuleshov's own claims about the results of his experiments differ from our claims about point/glance shots. He did not think this device contributed to a viewer's understanding of the shot/sequence. Given that the actor in the shot was utterly expressionless, he thought the viewers had misperceived the sequence.
11. Noël Carroll, "Toward a Theory of Point-of-View Editing: Communication, Emotion, and the Movies," reprinted in Noël Carroll, *Theorizing the Moving Image*, Cambridge Studies in Film (Cambridge: Cambridge University Press, 1996), 125–138.
12. Noël Carroll, "Art, Creativity and Tradition," in *Art in Three Dimensions* (Oxford: Oxford University Press, 2010).

cognitive theory and video games

fourteen

andreas gregersen

A "formal/functional" approach has arguably been one of the central threads in cognitive film theory.[1] The approach, broadly construed, assumes that formal elements and structures of film function to elicit specific effects in audience members, and this perspective has been taken in work on, for example, narrative,[2] character predicaments and emotion,[3] and characters and sympathy,[4] to name some of the main areas of study. The formal/functional perspective is adopted in this chapter to show the way in which the formal structures of many video games fit with fundamental structures of human cognition. The chapter thus gives a bare bones sketch of a cognitive poetics of video games: video-game design is, like other mass and popular arts, craftsmanship under specific conditions.[5] An important cross-cultural aspect of these conditions is human cognition, in that cognition both constrains and enables successful video-game design. I will focus on certain video-game genres, mainly action and adventure, and this will gloss over many nuances: the purpose is not to defend general claims about all video games but rather to show the relevance of particular aspects of cognitive theory, which have not yet been at the forefront of

cognitive film theory. The most important of these are the conceptual-ization of players as embodied intentional agents and the universal cognitive structures related to recognition and conceptualization of objects and agents, which are referred to as core cognition in the following.

players, intentional agency, and conflict

With the notable exception of work by Torben Grodal, Jonathan Frome, and Bernard Perron on video games,[6] cognitive film theory has focused pre-dominantly on the spectator and investigated the interplay between film and the activity of viewers. Intuitively, however, people do not just *view* video games—they *play* them. It is thus necessary for us to construct a theoretical position for people as players. Philosophy of action and cognitive theory can help us do this by describing people as embodied intentional agents:[7] our cognitive powers and embodied experiences are tied directly to our capabilities to exercise intentional agency. That is, human experi-ence is necessarily tied to situated experiences of ourselves as "people who *do* things." Humans perform intentional actions in particular situations and we have an embodied awareness of these intentional actions as meaningful—cognition is not just in the head, it entails activity in the world.

So, players are embodied intentional agents. What about the games they play? Video-game scholarship has, as a fairly young academic discipline, struggled somewhat with the issue of defining its object of study. Narrative, game, and play have all been investigated and privileged as key concepts in analysis, and these discussions have tended toward both theoretical integration and segregation. Integrative attempts have been made by Brenda Laurel,[8] Torben Grodal,[9] Marie-Laure Ryan,[10] and Henry Jenkins,[11] among others. Common to these contributions is the practice of taking established models from other aesthetic domains—most of them models of narrative structure—and applying them to the video-game medium. Film formalist terms have also been applied to games, since many games employ stylistic strategies of audiovisual representation well known from film and television.[12] In addition, so-called semantic, iconographic, and thematic aspects of genre fiction are also shared between video games and other media; plenty of video games employ iconography and themes well known from westerns, war films, crime fiction, fantasy, or science fiction.[13]

Other theorists have, however, sought a more segregationist position, which will not be adopted here, but rather mined for important points to integrate further. Espen J. Aarseth's[14] seminal contributions focus less on narrative and style and more on games with virtual environments simu-lated by interactive computational systems.[15] Gonzalo Frasca[16] also argues for simulation, while Jesper Juul[17] argues that the study of video games

should be subsumed under the general study of games, not narratives (a discussion which has been referred to as the narratology vs. ludology discussion).[18] Juul's key contribution is the consolidation of a formal framework specific to games, that is, "the classic game model," and an influential source for Juul's model is Elliott M. Avedon and Brian Sutton-Smith's oft-quoted definition of games: "An exercise of voluntary control systems in which there is an opposition between forces, confined by a procedure and rules in order to produce a disequilibrial outcome."[19] This definition will be adopted here, but instead of "procedure and rules" we will substitute the overall design of a video-game system, which prototypically offers challenging activities for the player focusing on control and mastery.[20] Many examples of successful game design may thus be analyzed as a system which simulates and represents virtual environments wherein player actions become part of an "opposition between forces"— that is, a conflict between the embodied intentional actions of the player and some element of opposition. This opposition may be represented as taking place between antagonistic intentional agents—for example, humans or monsters—or as a hostile environment, such as a particularly difficult jump over a crevice.[21]

This focus on player agency set against a system designed to oppose the player can be tied to a conceptualization of video games as interactive media. Although the media and communications literature often introduces the concept of interactivity as either too vaguely or too broadly defined,[22] a reasonable characterization would construe interactivity as an exchange of information between two units of observation: the traditional senders and receivers of information become, potentially at least, participants in a reciprocal relationship which is most often modeled over face-to-face interpersonal communication.[23] This focus on reciprocity and mutual influence is important, but more useful for present purposes is Jonathan Steuer's[24] early treatment of interactivity, which derives from presence research in relation to virtual reality technologies. Presence research investigates technology and experience in situations wherein users may come to feel present in spaces where they are not physically located. As a result, Steuer's conception of an interactive system is one which allows users to navigate and act in virtual environments by mapping user actions to the virtual environment in order to foster presence—a feeling of "being there." He uses the concept of vividness to describe the interactive simulation, distinguished by breadth and depth: breadth covers the range of perceptual input (such as sound, vision, and haptics), whereas depth refers to the sophistication of these individual modal channels. This idea of simulated action in vivid virtual environments dovetails directly with the work summarized above. It is, further, directly amenable to integration with work in game studies which has identified forms of interactivity specific to video-game genres, whereby players are tasked with goals and objectives

which more often than not involve exploration and navigation in a hostile virtual environment.[25]

The prototypical reciprocal interaction of video games, then, is that of being able to navigate and manipulate a simulated virtual environment by way of mapping player input to audiovisual representations—in which the system offers meaningful and challenging opposition for players in the process. In accordance with cognitive formalism/functionalism, this overall system can be seen as tailored directly to human cognition and the way we perceive and act. In the following, I will briefly outline a set of fundamental cognitive powers under the label of core cognition: these cognitive powers are part of the scaffolding of everyday existence, but they also allow us to identify some fundamentals of game structure. If video games are, as claimed by Aarseth,[26] "the art of simulation," this art of interactive simulation is often tailored directly to core cognition.

cognitive universals: core cognition

The phrase "core cognition" originates with developmental psychologist Susan Carey.[27] The following exposition synthesizes several sources from developmental psychology, but Carey will be the main reference point.[28] I will be sacrificing a fair amount of complexity by using the term core cognition as a blanket term to refer to a plausible set of universal cognitive capacities;[29] many of these principles are active as early as a few months after birth and develop further through life. Note that core cognition operates sub-personally—the phrase does not refer to conscious processes of thought, but rather to cognitive machinery that underpins our conscious thoughts and experiences.

The most relevant parts of core cognition are the assumptions and principles related to the domains of objects and agents. Our understanding of objects is based on keeping track of individual objects in space and time by applying principles of cohesion, spatio-temporal continuity, contact, support, occlusion, and containment.[30] Embodied intentional agents conform to these principles (since they are physical objects as well), but additional and distinct principles applicable to agents are those of being self-propelled, goal-directed, achieving goals by efficient means, and acting contingently and reciprocally (especially in relation to other agents). Gaze direction is also thought to be highly important for understanding agents, and biological motion is another prime candidate for stimuli which may lead to categorization as an agent, since animals, including humans, move in quite distinct ways due to the functioning of the skeleton and muscles.

Understanding of event structures also involves causality. Here, objects do not move of their own accord but conform to contact causality, a process which involves force transfer (as in collisions between cue balls

and billiard balls). Agents, however, can both instigate force transfer and resist or even avoid force transfer intentionally:[31] agents can push or push back against objects or step out of the way. Objects, agents, and causality can be supplemented with concepts from cognitive linguistics,[32] which identifies canonical event structures and canonical roles for agents and patients. One canonical event structure emphasizes force dynamics, whereby an agent (active) transfers physical force to a patient (passive), often with the use of an instrument.[33] Hitting a baseball with a bat or cutting a piece of food would be prime examples; the role of the agent in this example could be said to represent a canonical agent.

To this composite framework we can add the ability to navigate and explore the spaces in which objects and agents are situated. James J. Gibson[34] has argued convincingly that our organism and perceptual and cognitive apparatus are integrated and fundamentally designed for movement, active exploration, and action in our ecological niche. In addition, Gibson's notion of affordances as features of the environment which "afford" uncomplicated embodied actions has found widespread use within design theory and, to a lesser extent, media theory.[35] This line of thinking has both intuitive and theoretical explanatory power—we just "know" how to get around and do plenty of things without devoting much thought or effort to these doings.

Joseph D. Anderson[36] has argued that Gibson's and Ulric Neisser's accounts of active exploration of the environment can be applied fruitfully to film perception, and with interactive virtual environments this argument seems even stronger: the yoking of perception and intentional action can be simulated much more efficiently with interactive systems, since the simulation has the potential to react to player input. We will need, however, a caveat: Gibson's emphasis is on the physically embodied acting organism with its actual limbs, but virtual environments are explored by proxy by simulating a controllable mobile viewpoint, and different simulated actions are more often than not performed by manipulating the same thumbsticks and buttons. In other words, while sensori-motor action is important for video-game understanding, we should not overemphasize the importance of actual body movements. This does not mean that the actual embodied operations of players are irrelevant—far from it, and we will return to them later. For now, the main point is that video games can simulate active navigation and manipulation of a virtual environment which accords well with core cognition, active perception, and goal-related action (including canonical agency) within that virtual environment.

game design and core cognition

As mentioned in the introduction, the explanatory framework proposed here sees game design as craftsmanship operating within a space of

constraining and enabling factors, and it is in the latter part where core cognition plays its role: it fundamentally constrains and enables design decisions by way of the necessary fit with players and their cognitive powers. The core cognition framework invokes fairly simple cognitive capacities, but they are universal, widely applicable to games, and can lead to interesting and complex experiences when exploited by clever designers.

To start, anything designed in conformity with core cognitive principles is aligned with universal human cognitive powers. If one wants to make audiovisual representations and interactions easily and widely understood —as is the tendency with mass art—conforming to core cognition is a good strategy. Core cognitive principles can thus help explain why even extremely primitive representations are able to cue people into seeing things such as ghosts, giant apes, princesses, plumbers, cowboys, knights, platforms, and pits; even if many modern video games may look quite photorealistic, the medium established itself on the basis of a repertoire of extremely stylized representations, and many of today's so-called casual games still employ relatively primitive representations. By exploiting simple principles—for instance, contingent movement, self-propulsion, and efficient motion paths—designers can cue us to categorize very simple stimuli as agents who run away when chased, or who try to avoid obstacles.[37]

My further contention is that widespread conformity with core cognition to a large extent underpins the success of video games as a mass art medium, both in its past and in its present. The paradigmatic cognitive universe of video games is predominantly a world of relatively simple locomotion and physical manipulation—in other words, a world of core cognition and controllable canonical agency. The key game mechanics and player challenge of the genre of platform games is (a) to control an animated virtual agent and (b) to always make sure that this agent does not fall to his or her death due to a lack of physical support. Further, the virtual agent must avoid all contact with antagonist agents—with the exception of deliberate force transfer by way of punching or kicking. Once we consider the potential usage of blunt and sharp instruments and further add to the canonical agency role the capacity to transmit force through missile weapons, we get a structure of exploration coupled to canonical agency as a simple but vigorous force transfer. This design structure is more or less the underlying formula for the whole of the action genre, from fighting games to role-playing games to shooters.

Finally, in conforming to the universality of core cognition, designers can ensure both wide appeal across ages and a high level of cross-cultural understanding. A recent global phenomenon such as *Angry Birds* is at its core a game about objects, support, and contact causality, with some creative character design playing around with agency (see below). All the mining and exploration in the indie hit *Minecraft* is another prime example of

canonical agency—hit blocks, place blocks, and avoid the dangerous contact causality of zombies and exploding Creepers![38]

The relevance of this framework might be exemplified in a bit more detail by considering one of the most iconic, successful, and long-running series of video games, namely the many games produced by Nintendo which feature Mario the Italian-American plumber. Starting with *Donkey Kong*, Mario's repertoire of actions fits core cognition and controllable canonical agency like hand in glove; the virtual environment features a wide range of objects and mostly hostile agents, and the prerogative for players is to always ensure support by way of various platforms while avoiding collision with hostile agents (since these will damage or kill Mario).[39] Some enemies can, however, be neutralized by transferring force to them by hitting them, jumping on top of them, or throwing objects as projectiles at them.

Core cognitive principles are absolutely central to the design patterns of most Mario games and, by extension, to the overall genre of platform games to which they belong and have helped define. These games, ostensibly at least, run on a very simple formula: a canonical agent with a limited and well-defined action repertoire faces an environment with hostile agents and physical objects to be manipulated. And this is indeed a cognitive paraphrase—a kind of deep structure, one might say—of many games, not just the Mario games. But games in the Mario series can be quite complex in their own playful way, and much of this complexity can be traced back to core cognition.

First, canonical agency can take several forms, where Mario's movement patterns and force transfer abilities can change. Mario can become tiny or gigantic (gaining access to some areas but barring him from others), and he can take the form of a bumblebee or a metal coil, for instance, both of which change the movement and attack capabilities. In some games the environments also feature dynamic and local changes in gravitational pull in all three dimensions, sometimes in combination with dynamically changing layouts where environmental features appear or disappear according to proximity—opportunities for support and contact change from moment to moment.

Second, a successful design strategy in many games is the manipulation of core cognitive principles to create salient category conflations. Again, the Mario games are paradigmatic examples, featuring a plethora of conflations and clever combinations of objecthood and agenthood: carnivorous plants and mischievous cacti will snap at Mario; homing missiles have both malevolent faces and arms with fists, and chase Mario instead of following linear object trajectories; and huge stone blocks with angry faces grunt when trying to flatten Mario—and so on. These games are playful in their design for cognition: they both play to and play around with core cognition in inspired ways.

player actions as p-actions, control, agency, and ownership

Mario is certainly not the deepest and most complex video-game character in existence, but our relationships as players with Mario and his ilk are, in one respect, much more direct than those we might have as spectators with, say, Stella Dallas or Tony Soprano: Mario acts in accordance with our intentions and not his own. How do we describe this relationship in more detail? A helpful first move is that of getting at the basic level of actions in the following way:[40] A person performs Action A *by* performing Action B: players thus move Mario *by* manipulating the controller, and players manipulate the controller *by* performing bodily movements. By moving down such a chain of action descriptions we end at mere body movements, here called primitive actions, or P-actions for short.[41] P-actions are performed intentionally, but the player's overall motivation—the main reasons for playing—is, of course, not to move his or her fingers but to make Mario succeed in the virtual environment.[42] P-actions have a tendency to fade into the background both in everyday activity and in gaming, but they are crucial for game interactivity; video games are usually controlled by using a physical control interface which forms the necessary causal link between P-actions and representations of actions by way of mapping. Video games may differ in their presupposed controllers, the required P-actions, and the (often very complex) ways in which P-actions are mapped onto audiovisual representations of in-game actions. These modes of embodied interaction are most often highly generic in that they fit with certain game formulas and genres: most first-person shooters for PC utilize the so-called WASD + mouse control scheme for locomotion, aiming, and firing, while consoles generally use standard controllers with thumbsticks and triggers for similar mappings. Different genres thus offer generic combinations of P-actions and meaningful mappings in what could be called interaction modes—generic patterns of embodied interaction.[43]

One common aspect across most interaction modes is that P-actions are often mapped to an avatar—a player-controlled representation of an embodied agent in the virtual environment. To analyze this mapping relationship between player and avatar and the resulting potential for player experiences, Torben Grodal and I[44] have proposed a model based on the work of Shaun Gallagher's analysis of the structure of embodied experience.[45] First, the model distinguishes between the experience of agency (ownership of actions) and the ownership of one's body, although these are fused in the exercise of everyday embodied activity. To see how the senses of agency and ownership can be teased apart, consider Gallagher's example of intentionally walking down a flight of stairs versus accidentally falling down one. In the first case one would experience ownership of both the action and the body since it is under voluntary

control. In the second case, the body is still owned, but the overall experience lacks agency, since this is not something one does intentionally —rather, something is happening to one's own body. Applied to the player–avatar relationship we get two sets of actions (which might be experienced as owned) and two bodies (whereby the player can feel ownership).

We can introduce three further aspects of the experience of our bodies in action. First, efferent motor commands from brain to body are involved in moving the muscles of the human body. These signals are only present when the body moves intentionally. Second, afferent signals provide feedback about the state of the physical body to the brain; key parts of afferent signaling are proprioception (also called the muscle sense), the sense of touch, and visual perception. Efferent signals tell the body to move, afferent signals tell the brain whether and how the body is moving; efference and afference thus seem to play dominant roles in ownership of actions and ownership of bodies respectively.[46] Efference and afference, however, only cover the realm of P-actions, and they work sub-personally. A third aspect of intentional action is the cognitive structure of goals and higher-order intentions accessible to consciousness: players want to defeat opponents, acquire certain items, finish a difficult game level, or discover clues to finding hidden passages, for example. In order to scaffold this higher-order and, to many players, more deeply meaningful level of intentional action, the majority of game genres, especially adventure and role-playing games, use vivid audiovisual representations of avatars in situations of conflict—the deeper meanings of many player actions are thus to be found not just in P-actions, but in more complex combinations of spectacular audiovisuals and traditional thematics of fiction. I will, however, concentrate on some of the very simplest but fundamental aspects of avatar relationships in the following, since these higher-order meanings piggyback on the fundamental embodied experiences of agency and ownership.

isomorphism, incongruence, and the ubiquity of canonical agency

The three factors of efference, afference, and higher-order intentions can be used to differentiate between different structures of embodied interaction with video games. A reasonable hypothesis is that isomorphism between player and avatar embodiment (that is, the similarity between actual body movements and avatar representations) fosters ownership of both the virtual body and its actions, whereas incongruity will lead to a decrease in ownership of the virtual body and its actions, all else being equal, of course. Players have always moved their physical bodies to interact with video games, and most video games employ interaction modes which

involve a minimum of physical movement. However, the advent and success of the so-called motion-gaming genre and its peripherals for home consoles, spearheaded by Nintendo's Wii console, made more extensive embodied interaction much more prominent and widespread in video-gaming experiences. In addition to giving the motor channel more depth (using Steuer's terms), the Wii did so in a specific way, namely by allowing for a higher degree of isomorphism between the actual and represented body. For instance, players in *Wii Boxing* strike opponents not by moving thumbsticks but by throwing actual punches in the air while holding the Wiimote.[47]

In games employing such motion sensor technologies as the Wiimote, the Move, and the Kinect, the interaction modes often involve a fairly extensive isomorphic body mapping to deliver a more vivid experience. In addition, the majority of such games conform neatly to principles of core cognition and canonical agency by offering quite primitive simulations of sports such as tennis, fencing, or boxing. One problem, however, is that current hardware–software setups cannot meet requirements for full isomorphism in situations involving contact causality due to lack of afference, that is, body feedback. Consider a strike to hit an object or agent: full isomorphism of intention, efference, and afference can be met by the initial movements of a strike with players holding the Wiimote, since players are intentionally moving their own limbs and can visually register the isomorphic movements of the avatar. But when a collision occurs in the virtual environment—fist vs. body or bat vs. ball—the expected afferent signals of resisting force cannot be delivered by the simulation: the represented body might conform to expectations of force transfer, but the actual body will not, since the blow in the living room does not connect with anything. As compensation, most of these games use audiovisual spectacle—loud noises, brightly-colored flashes, and distortion of the visual images—to convey collision and force transfer. In other words, one channel increases depth and stylistic sophistication to cover up the lack of depth in others and the resulting incongruity.[48]

In cases of potentially incongruous information across channels where the design intention is still the experience of presence in the virtual environment, one might venture a "less-is-more + more-is-more" hypothesis for the analysis. That is, since motor isomorphism cannot be fully delivered by the game system, the game system is better off minimizing player P-action and maximizing audiovisual representation of avatar actions. An example of this can be seen in the close-quarters combat in a fantasy action game such as *Skyrim*, the most recent game from the *Elder Scrolls* series.[49] *Skyrim* is played with traditional interfaces and thus involves minimal body P-action, but the game employs frequent animations of muscular bodies swinging very large and heavy melee weapons; the

andreas gregersen

simulated combat conforms directly to canonical agency. Since the player controls these represented actions, efference and higher-order intentions will scaffold ownership of the acting virtual body; the problem is, again, the inability of the system to deliver powerful signals of afference, for example, when a hit connects. However, since the player does not swing his or her own limbs, the player will not suffer as much from unfulfilled expectations (that is, there will be less incongruence). To further involve players in the consequences of actions, such as the contact causality of a killing blow, *Skyrim* often shows such events in slow-motion and offers vivid representations of limbs breaking, blood spurting, and bodies being thrown aside by the forceful impact—a sight not unusual within the genre of action adventure. As such, part of the explanation for the quite extravagant and gratuitous violence found in many games may simply be that the most simple of cognitive experiences, namely that of material reality resisting our embodied canonical agency, cannot be truly simulated; instead one gets audiovisual representations "dialed way up" to compensate for this lack.[50]

conclusion

This chapter has sketched the outlines of a cognitive poetics of video games, emphasizing the importance of embodied player agency, canonical agency, core cognition, and the connections between these concepts. It has used a formal/functional framework to unpack prominent aspects of dominant genres of the video-game medium. Of course, this analysis barely scratches the surface of the medium as defined by its manifold different genres. The categories outlined above can thus be used to differentiate between different variations of canonical agency, both intra-game and across games and genres. Games will use a variety of audiovisual cues to create different experiences of agency and ownership in relation to various kinds of opposing forces. The focus here has been on describing only the most basic aspects of player agency, but moral dilemmas in games, particularly those found in genres such as role-playing games, cannot be analyzed without a much richer set of action-descriptions at several levels, and player motivations may come in conflict with avatar motivations in several ways. Also, cognitive theory can be applied to other aspects of video-game structure and experience.[51] Of particular interest to cognitive film theory should be discussions of game genres, characters and avatars, morality, emotions in games, and such overall effects as suspense and surprise, as well as the element of play and fictionality. However we choose to deal with these issues, we need to analyze people as players, not viewers: a conceptualization of player agency as intentional embodied action will thus be a necessary although not sufficient component of any cognitive analysis of video games.

notes

1. David Bordwell, "Neostructuralist Narratology and the Functions of Filmic Storytelling," in *Narrative Across Media: The Languages of Storytelling*, ed. Marie-Laure Ryan (Nebraska: University of Nebraska Press, 2004), 203–219. See also Noël Carroll, *A Philosophy of Mass Art* (Oxford: Oxford University Press, 1998), where the discussion of criterial focus outlines a similar approach.
2. David Bordwell, *Narration in the Fiction Film* (London: Routledge, 1986).
3. Ed S. Tan, *Emotion and the Structure of Narrative Film: Film as an Emotion Machine* (Mahwah, NJ: Lawrence Erlbaum Associates, 1996); Torben Grodal, *Moving Pictures: A New Theory of Film Genres, Feelings, and Cognition* (Oxford: Clarendon Press, 1997).
4. Murray Smith, *Engaging Characters: Fiction, Emotion, and the Cinema* (Oxford: Clarendon Press, 1995).
5. On poetics, see David Bordwell, "Poetics of Cinema," in *Poetics of Cinema* (New York: Routledge, 2008). On mass art, see Carroll, *A Philosophy of Mass Art*.
6. See Jonathan Frome, "Representation, Reality, and Emotions Across Media," *Film Studies* 8 (2006): 12–25; Bernard Perron, "From Gamers to Players and Gameplayers," in *The Video Game Theory Reader*, ed. Mark J. P. Wolf and Bernard Perron (New York and London: Routledge, 2003), 237–258; Bernard Perron, "A Cognitive Psychological Approach to Gameplay Emotions," in DiGRA 2005 International Conference, Simon Fraser University, Vancouver, Canada; Torben Grodal, "Stories for Eye, Ear, and Muscles: Video Games, Media, and Embodied Experiences," in Wolf and Perron, 129–155.
7. See Donald Davidson, *Essays on Actions and Events*, 2nd ed. (Oxford: Clarendon Press, 1980); Michael Tomasello, Malinda Carpenter, Josep Call, Tanya Behne, and Henrike Moll, "Understanding and Sharing Intentions: The Origins of Cultural Cognition," *Behavioral and Brain Sciences* 28, no. 5 (2005): 675–691; Shaun Gallagher, *How the Body Shapes the Mind* (Oxford: Oxford University Press, 2005); Shaun Gallagher and Dan Zahavi, *The Phenomenological Mind: An Introduction to Philosophy of Mind and Cognitive Science* (Abingdon and New York: Routledge, 2008).
8. Brenda Laurel, *Computers as Theatre* (Reading, MA: Addison-Wesley, 1993).
9. Torben Grodal, "Video Games and the Pleasures of Control," in *Media Entertainment: The Psychology of its Appeal*, ed. Dolf Zillmann and Peter Vorderer (Mahwah, NJ: Lawrence Erlbaum Associates, 2000), 197–213; Torben Grodal, "Stories for Eye, Ear, and Muscles."
10. Marie-Laure Ryan, *Narrative as Virtual Reality: Immersion and Interactivity in Literature and Electronic Media* (Baltimore, MD: Johns Hopkins University Press, 2001).
11. Henry Jenkins, "Game Design as Narrative Architecture," in *First Person: New Media as Story, Performance, and Game*, ed. Noah Wardrip-Fruin and Pat Harrigan (Cambridge, MA: MIT Press, 2004), 118–130.
12. Geoff King and Tanya Krzywinska, "Film Studies and Digital Games," in *Understanding Digital Games*, ed. Jason Rutter and Jo Bryce (London: Sage, 2006), 112–128.
13. For an overview of what I refer to as semantics and themes of these genres, see Steve Neale, *Genre and Hollywood* (London: Routledge, 2000). For an argument that these are in fact shared by film and games, see Andreas Gregersen, "Generic Structures, Generic Experiences: A Cognitive Experientalist Approach to Video Game Analysis," *Philosophy & Technology*, prepublished online August 13, 2013. DOI: 10.1007/s13347-013-0125-8.

14. Espen J. Aarseth, *Cybertext: Perspectives on Ergodic Literature* (Baltimore, MD: Johns Hopkins University Press, 1997).
15. Espen J. Aarseth, "Playing Research: Methodological Approaches to Game Analysis," presentation at MelbourneDAC: The 5th International Digital Arts and Culture Conference, May 2003; Espen J. Aarseth, "Genre Trouble: Narrativism and the Art of Simulation," in Wardrip-Fruin and Harrigan, 44–55; Espen J. Aarseth, "Doors and Perception: Fiction vs. Simulation in Games," in *Proceedings, Digital Arts and Culture Conference 2005* (Copenhagen: ITU, 2005); Espen J. Aarseth, "Quest Games as Post-Narrative Discourse," in Ryan, *Narrative across Media,* 361–376; Esben J. Aarseth, "From Hunt the Wumpus to EverQuest: Introduction to Quest Theory," in *Proceedings, Entertainment Computing: ICEC 2005: 4th International Conference* (Sanda, Japan: 2005), 496–506.
16. Gonzalo Frasca, "Simulation Versus Narrative: Introduction to Ludology," in Wolf and Perron, 221–235.
17. Jesper Juul, *Half-Real: Video Games Between Real Rules and Fictional Worlds* (Cambridge, MA: MIT Press, 2005).
18. See various chapters in *First Person,* ed. Wardrip-Fruin and Harrigan; and for discussion see Jan Simons, "Narrative, Games, and Theory," *Game Studies* 7, no. 1 (2007): http://gamestudies.org/0701 (accessed July 4, 2013).
19. Elliott M. Avedon and Brian Sutton-Smith, *The Study of Games* (New York: John Wiley & Sons, 1971), 7.
20. John M. Roberts, Malcolm J. Arth, and Robert R. Bush, "Games in Culture," *American Anthropologist* 61, no. 4 (1959): 597–605; and Grodal, "Video Games."
21. Various elements of such opposition can be and are usually combined, as seen in the *Tomb Raider* series, for instance.
22. See Edward J. Downes and Sally J. McMillan, "Defining Interactivity: A Qualitative Identification of Key Dimensions," *New Media Society* 2, no. 2 (2000): 157–179; Carrie Heeter, "Implications of New Interactive Technologies for Conceptualizing Communications," in *Media Use in the Information Age: Emerging Patterns of Adoption and Consumer Use,* ed. Jerry L. Salvaggio and Jennings Bryant (Hillsdale, NJ: Lawrence Erlbaum Associates, 1989), 217–236; Carrie Heeter, "Interactivity in the Context of Designed Experiences," *Journal of Interactive Advertising* 1, no. 1 (2000): http://www.jiad.org/article2 (accessed July 4, 2013); Jens F. Jensen, "'Interactivity': Tracking a New Concept in Media and Communication Studies," in *Computer Media and Communication: A Reader,* ed. Paul A. Mayer, Oxford Readers in Media and Communication (Oxford: Oxford University Press, 1999), 160–187; Spiro Kiousis, "Interactivity: A Concept Explication," *New Media Society* 4, no. 3 (2002): 355–383; Sally J. McMillan, "A Four-Part Model of Cyber-Interactivity: Some Cyber-Places Are More Interactive Than Others," *New Media Society* 4, no. 2 (2002): 205–229; Sally J. McMillan, "Exploring Models of Interactivity from Multiple Research Traditions: Users, Documents, and Systems," in *The Handbook of New Media: Updated Student Edition,* ed. Leah A. Lievrouw and Sonia Livingstone (London: Sage, 2006), 205–229.
23. See Nancy K. Baym, "Interpersonal Life Online," in *Handbook of New Media: Social Shaping and Social Consequences of ITCs,* ed. Leah A. Lievrouw and Sonia Livingstone (London: Sage, 2006), 35–54; Nancy K. Baym, *Personal Connections in the Digital Age,* Digital Media and Society (Cambridge: Polity, 2010), for influential statements.

24. Jonathan Steuer, "Defining Virtual Reality: Dimensions Determining Telepresence," in *Communication in the Age of Virtual Reality*, ed. Frank Biocca and Mark R. Levy, LEA's Communication Series (Hillsdale, NJ: Lawrence Erlbaum Associates, 1995), 33–56.

25. See *The Medium of the Video Game*, ed. Mark J. P. Wolf (Austin: University of Texas Press, 2001); Simon Egenfeldt-Nielsen, Jonas Heide Smith, and Susana Pajares Tosca, *Understanding Video Games: The Essential Introduction* (New York: Routledge, 2008), on overall game genres; and Aarseth, "Quest Games"; Aarseth, "From Hunt the Wumpus,"on games in virtual environments.

26. Aarseth, "Genre Trouble."

27. Elizabeth S. Spelke uses the term "core knowledge": see Elizabeth S. Spelke, "Core Knowledge," *American Psychologist* 55, no. 11 (2000): 1230–1233; Elizabeth S. Spelke and Katherine D. Kinzler, "Core Knowledge," *Developmental Science* 10, no. 1 (2007): 89–96.

28. Susan Carey, *The Origin of Concepts*, Oxford Series in Cognitive Development (Oxford: Oxford University Press, 2009). Carey summarizes and discusses a large body of work by prominent psychologists such as Renee Baillargeon, Elizabeth Spelke, Jean Mandler, Gergely Csibra, and Alan Leslie, as well as others, and the reader is referred to both Carey and these sources for further discussion.

29. While most developmental psychologists seem to agree to a reasonable extent on the principles leading to categorization—and these principles are what I refer to here as core cognition—there is some controversy in discussions of innate vs. learned capacities as well as that between perceptual vs. conceptual knowledge; see ibid. and Jean Matter Mandler, *The Foundations of Mind: Origins of Conceptual Thought*, Oxford Series in Cognitive Development (New York: Oxford University Press, 2004), for discussions. On the issue of innate capacities I find the nativist position of Carey and others quite compelling, but my claim here would be that little of the following depends on resolving this issue, since I aim at a plausible universal baseline of cognitive powers and not a phylogenetic or ontogenetic explanation.

30. See Carey; Spelke and Kinzler, "Core Knowledge," and Renée Baillargeon, "The Acquisition of Physical Knowledge in Infancy: A Summary in Eight Lessons," in *Blackwell Handbook of Childhood Cognitive Development*, ed. Usha Goswami, Blackwell Reference Online, 2004, http://au.wiley.com/Wiley CDA/WileyTitle/productCd-1405191163.html (accessed July 4, 2013).

31. Carey.

32. Ronald W. Langacker, *Concept, Image, and Symbol: The Cognitive Basis of Grammar*, 2nd ed. (Berlin: Mouton de Gruyter, 2002). See also John I. Saeed, *Semantics*, 3rd ed. (Malden, MA: Wiley-Blackwell, 2009).

33. On the concepts of force and force dynamics, see Leonard Talmy, *Toward a Cognitive Semantics, Vol. 1: Concept Structuring Systems* (Cambridge, MA: MIT Press, 2000); and Alan M. Leslie, "ToMM, ToBY, and Agency: Core Architecture and Domain Specificity," in *Mapping the Mind: Domain Specificity in Cognition and Culture*, ed. Lawrence A. Hirschfeld and Susan A. Gelman (Cambridge: Cambridge University Press, 1994), 119–148.

34. James J. Gibson, *The Ecological Approach to Visual Perception* (Boston: Houghton Mifflin, 1979).

35. Donald A. Norman, *The Design of Everyday Things* (New York: Basic Books, 2002); and Ian Hutchby, "Technologies, Texts and Affordances," *Sociology* 35, no. 2 (2001): 441–456.

36. Joseph D. Anderson, *The Reality of Illusion: An Ecological Approach to Cognitive Film Theory* (Carbondale: Southern Illinois University Press, 1996). See Gibson; see Ulric Neisser, *Cognition and Reality: Principles and Implications of Cognitive Psychology* (San Francisco: W. H. Freeman, 1976).

37. This is, of course, the principle behind the seminal work of Fritz Heider and Marianne Simmel, "An Experimental Study of Apparent Behavior," *American Journal of Psychology* 57, no. 2 (1944): 243–259.

38. *Angry Birds,* video game, developer Rovio Entertainment (Redwood City: Chillingo/Electronic Arts, 2009); *Minecraft,* Sandbox Indie Game, developer Mojang (Redmond, WA: Mojang/Microsoft Studios, 2011).

39. *Donkey Kong,* video game, developed by Nintendo and Others (Kyoto: Nintendo, 1981).

40. The following is based on Donald Davidson, *Essays on Actions and Events,* 2nd ed. (Oxford: Clarendon Press, 1980), and Jennifer Hornsby, *Actions,* International Library of Philosophy (London: Routledge & Kegan Paul, 1980).

41. See Andreas Gregersen and Torben Grodal, "Embodiment and Interface," in *The Video Game Theory Reader 2,* ed. Bernard Perron and Mark J. P. Wolf (London: Routledge, 2009), 65–83.

42. Georg Henrik von Wright, *Explanation and Understanding,* Cornell Classics in Philosophy (Ithaca, NY: Cornell University Press, 1971).

43. Andreas Gregersen, "Genre, Technology and Embodied Interaction: The Evolution of Digital Game Genres and Motion Gaming," *MedieKultur. Journal of Media and Communication Research* 27, no. 51 (2011): 94–109.

44. Gregersen and Grodal.

45. Gallagher, *How the Body Shapes the Mind.*

46. Manos Tsakiris, Gita Prabhu, and Patrick Haggard, "Having a Body Versus Moving Your Body: How Agency Structures Body-Ownership," *Consciousness and Cognition* 15, no. 2 (2006): 423–432; Manos Tsakiris, Simone Schütz-Bosbach, and Shaun Gallagher, "On Agency and Body-Ownership: Phenomenological and Neurocognitive Reflections," *Consciousness and Cognition* 16, no. 3 (2007): 645–660.

47. *Wii Sports,* developed by Nintendo EAD Group No. 2 (Kyoto: Nintendo, 2006).

48. This problem is not faced by dance games, most of which seem to maximize agency and ownership of the player's actual body instead of a virtual body.

49. *The Elder Scrolls V: Skyrim,* video game, developed by Bethesda Game Studios (Rockville, MD: Bethesda Softworks, 2011, 2013).

50. On the "volume" of violence and its history, see Stephen Prince, *Classical Film Violence: Designing and Regulating Brutality in Hollywood Cinema, 1930–1968* (Piscataway, NJ: Rutgers University Press, 2003).

51. For a brief overview, see Andreas L. Gregersen, "Cognition," in *The Routledge Companion to Video Game Studies,* ed. Bernard Perron and Mark J. P. Wolf 417–426 (New York: Routledge, 2014).

fifteen

blinded by familiarity

partiality, morality, and engagement with tv series

margrethe bruun vaage

The episode "Second Opinion" in the television series *The Sopranos* (1999–2007) offers a pleasurable depiction of vengeance.[1] Tony Soprano is the boss of the New Jersey mafia, and his uncle Junior has cancer. Junior is worried about the treatment he has been given, but his oncologist, Dr. Kennedy, does not return his calls. This infuriates Tony. He approaches Dr. Kennedy on the golf course, and scares him into taking better care of his patient. Murray Smith writes of this scene: "If we isolate the miniature drama that unfolds between Soprano and Kennedy during 'Second Opinion,' there's no doubt that Soprano comes across as the more sympathetic character, largely on moral grounds."[2] I agree with Smith that we perceive Tony as the more sympathetic character. I would assume that a typical reaction is to enjoy the humiliation of Dr. Kennedy, and cheer for Tony. But is our perception of Tony as most sympathetic really made on moral grounds? The doctor may be arrogant, and negligent towards his patients, but as long as Junior is given the proper treatment, this is no crime; however, intimidating people with threats of violence is. Is it not obvious,

on reflection, that even if we isolate this sequence, the doctor is morally preferable to Tony? So why do we as spectators see Tony as morally right?

In this chapter, I argue that when engaging in fiction we become partial towards the characters we know best (with some qualifications). First, I lay out the theoretical background in cognitive film theory, in particular Smith's theories, to show what is at stake. Then, I explore how recent work in moral psychology sheds light on this issue. I go on to argue that television series in particular take advantage of our tendency towards partiality, as the very duration of television series activates this mechanism more strongly than a relatively short fiction film can. I elaborate on this claim with examples from *The Sopranos* and *Breaking Bad* (2008–present),[3] and suggest an explanation for why, after *The Sopranos*, there have been so many recent American television series with morally transgressive main characters.

does sympathy entail moral evaluation?

In his seminal work *Engaging Characters*, Smith argues that the spectator's engagement in a film is primarily shaped by the film's *structure of sympathy*.[4] The spectator's engagement in the narrative, and his or her emotional response to it, are anchored in engagement with the characters through the processes of *recognition* (establishing the characters as agents); *alignment* (filtering the spectator's access to and information about the characters); and *allegiance* (whereby the spectator evaluates the characters morally). For Smith, the distinction between alignment and allegiance is important. While earlier theorists such as Wayne Booth, Mieke Bal, and Seymour Chatman have "all argued or implied that alignment with a character necessarily creates a basic sympathy for that character," Smith holds that "[i]t is particularly important that we grasp the distinction between alignment and allegiance."[5] Although fiction film typically aligns the spectator with the character(s) he is also supposed to see as morally preferable and feel sympathy towards, this is not necessarily the case, according to Smith. Otherwise, he argues, how are we to conceive of films with antiheroes, characters with whom we are aligned but who remain unsympathetic? Smith holds that alignment is neither sufficient nor necessary for us to sympathize with a character, in the sense of seeing the character as representing morally preferable traits.

In two later papers, Smith argues that if the spectator sympathizes with a perverse character (a character who deviates from that which is right and proper), such as Hannibal Lecter in *The Silence of the Lambs*,[6] or Tony Soprano in *The Sopranos*, it is basically because other characters in the narrative are portrayed as morally inferior.[7] As spectators, we preserve a moral compass while engaging in fiction—we side with the morally preferable, relatively speaking, in the fictional universe. Thus, in Smith's theory, moral evaluation is given an important role in the spectator's engagement.

269

Although he does not claim that moral evaluation determines the spectator's sympathetic and antipathetic responses, and also points to other factors that may influence the spectator's moral evaluation, he maintains that "[m]oral assessment of characters . . . constitutes a kind of center-of-gravity that amoral factors may inflect, but not displace."[8]

Carl Plantinga questions the degree to which sympathy with, or liking of, a character always entails a moral evaluation.[9] Plantinga argues that the spectator's sympathy with and liking of fictional characters is influenced by many non-moral factors. A character's affiliation, physical attractiveness, and similarity to the spectator influence the spectator's liking, and a character being subject to unfair treatment and needing protection, among other things, enhances the spectator's sympathy. Plantinga suggests that we should distinguish liking and sympathy from allegiance, and recognize that only the latter entails a moral evaluation. Nevertheless, Plantinga praises Smith's distinction between alignment and allegiance. I argue that the relation between alignment and allegiance is more systematic than Smith acknowledges. Whom we get to know through alignment makes a systematic difference for our moral evaluation; we typically evaluate those we know well more favorably than those we do not know at all.

Let us start with a point made by Kwame Anthony Appiah:

> We know, too, how easily an engaging story can defeat our allegiance to this or that dictum. Should cars parked in front of fire hydrants, such as one belonging to Bob the accountant, be towed? Sure. Now tell me a story about Joanna, a good woman who's having a bad day, with details about her hopes and dreams, her kindness to an ailing friend, her preoccupation with a troubled child. I don't want *her* car to be towed.[10]

Knowing the moral trespasser's background makes us prone to treat the act as an exception—we might still agree that in general such trespassing is immoral; nevertheless, in this special case, there are mitigating factors. This could be extended to the following rule of human psychology: the more one learns about a specific case, the more one is willing to treat it as special—that is, not to judge it as one would if one had only a more generic description of the case to go by. Learning about someone's background and their reasons for doing something works as an excuse for why the general rule does not apply so easily.[11]

In relation to fiction, moral evaluation of the characters should not be seen as an objective and impartial evaluation of all characters, independently of whether or not we know them well. Returning to my opening example from *The Sopranos*, our alignment with, and access to, Tony has profound effects on our judgment of him. The spectator has followed Tony through his anxiety attacks, learned about his psychopathic mother, his troubled

conscience, and about how much he cares for a little family of ducks that have lived in his pool for a summer. We do not learn much about Dr. Kennedy, besides his arrogance as a doctor. All these pleas for making excuses on Tony's behalf, and none on behalf of Dr. Kennedy! What if Dr. Kennedy is somehow negligent towards his patient because he is going through a divorce? Or what if being forced to take better care of Junior means that some other poor cancer patient, like the ageing charity worker Eva, who has no relatives to fight for her interests, gets less attention? Would this not entirely change our perception of Tony when he threatens Dr. Kennedy on the golf course? However, we are not invited to imagine in this way in relation to the doctor. It is only Tony's reasons for intimidating Dr. Kennedy that we learn about. It is Tony's point of view we are invited to share, and Tony perceives Dr. Kennedy as arrogant. No wonder the spectator perceives Tony as morally right. But from an impartial point of view he is not. Threatening whomever one perceives as arrogant is not morally right. Our evaluation of Tony's behavior is not grounded in general moral laws and principles.

One needs to recognize the systematic way in which alignment influences allegiance. Knowing someone well makes us evaluate their behavior more favorably. At some points, Smith touches upon this issue in his theory. He indicates that alignment may make the spectator "exonerate actions" that would otherwise be "easier to condemn."[12] And he asks:

> Am I not inclined to forgive, or at least overlook, the immoral actions of someone whom I like or love rather more than in the case of someone I dislike or detest? Surely our judgments of particular traits and actions continually contaminate or inflect one another. This might not reflect our moral ideals, but it is surely a reality of our moral existence.[13]

We do need to take the reality of our moral existence seriously. Let us then examine the notion of partiality.

moral philosophy, psychology, and partiality

In moral philosophy, partiality is a well-known problem for universalistic moral theories. According to consequentialism, one ought to do whatever has the best consequences, whereas deontological theories of ethics argue that one ought to follow certain moral rules, even if, considering the consequences, it would (sometimes) be better to break these normative rules. We need not go into detail on these theories here, as it is sufficient to point out that both consequentialism and deontology prescribe impartial moral evaluations. Nevertheless, in reality we have a tendency towards showing partiality to family, friends, and loved ones. Furthermore, we also

tend to see this as morally good; I feel a special obligation toward my partner, my mother, or my long-time friend, and it seems morally right, to a certain extent, to favor these individuals over complete strangers.[14] Personal relations make us biased and partial. We tend to show favoritism towards the ones we know well and love, and we feel morally warranted in doing so. Arthur Raney has proposed an explanation for why this is so. Evaluating something rationally from an impartial perspective is cognitively taxing, and on the whole we are cognitive misers. Hence, if we like and love certain people, it is by far more comfortable for us to go on loving and liking them, and thus we see everything they say and do through a lens of favoritism.[15]

From an evolutionary perspective, this tendency towards partiality to members of our own group is not surprising; keeping the group together and caring for in-group members must have been of utmost import-ance throughout human evolution. Our tendency to be biased and show favoritism towards in-group members may have simplified cooperation in the group. Jonathan Haidt argues that morality evolved not as a truth-seeking rational enterprise, but as a mental mechanism to enhance a social agenda—to "defend the teams we belong to."[16] Partiality makes sense in such a picture. This is also mirrored in the philosophical debate on partiality; partiality for loved ones may be seen as cultivating virtuous character traits such as empathy, loyalty, and understanding. While (in Western societies) our collective sense of morality is now also shaped by the transition to large societies (wherein our laws build on impartial, universalistic reasoning), emotionally we are still easily manipulated into favoritism and partiality. This tendency was an evolutionary advantage to our forebears living in small groups, and it is not something we have left behind altogether.

Haidt argues for a position labeled *social intuitionism*; our moral judg-ments are most often based on intuitions.[17] The human mind has two routes to a moral (or other kind of) judgment—one is quick, intuitive, and schematic; the other route is slower and involves rational, deliberate reasoning. Daniel Kahneman also captures this in his popularized labels of "system 1" (intuitions) and "system 2" (deliberate reasoning),[18] and Haidt uses an equivalent model.[19] While we would like to think that we mostly deliberate rationally, we usually rely heavily on intuitive, quick-and-dirty, schematically-based inferences. Our rational judgment of something is usually quickly replaced by stereotyped intuitions. For example, we jump to conclusions based on what we see (something Kahneman labels as the WYSIATI principle: What You See Is All There Is). In one experiment, a group of respondents was exposed to a legal scenario about a union representative suing a drugstore chain after being arrested by the police and charged with trespassing when carrying out a routine union visit. Half the respondents heard only one of the two parties' lawyers, while the other

half heard both sides. Hearing only one side had a pronounced effect on the respondents' judgments, despite being fully informed that they heard only one side. Furthermore, those who had heard only one side were more confident about their judgments than those who had heard both sides.[20]

Hearing only one side of the story is one way to make us biased (and often oblivious to the fact that we are). Another way is to tell positive things about one person first, while starting with the negative traits of another person. For example, respondents are presented with description of two persons, Alan and Ben:

Alan: intelligent–industrious–impulsive–critical–stubborn–envious

Ben: envious–stubborn–critical–impulsive–industrious–intelligent

Respondents are then asked for comments on each personality. People view Alan much more favorably than Ben.[21] Alan and Ben are described using the exact same words, but in Alan's case the positive labels are presented first, and in Ben's they are presented last. Kahneman labels this a halo or framing effect. One can hypothesize that the way a narrative frames a character, event, or situation must have quite an effect on how the spectator evaluates what or who is right and wrong in the narrative.

Furthermore, we are typically unaware of the fact that we quickly form moral judgments intuitively. Haidt and a colleague hypnotized their subjects to feel disgust in response to neutral words—one group to the word "take" and the other to the word "often." The subjects then read six moral stories in which "take" or "often" were used. The flash of disgust they felt—when the word they had been disposed to feel disgusted towards appeared in one of these stories—made their moral condemnation of the story more severe, as expected. But the most interesting finding is when a seventh story involving no moral violation was included:

> Dan is a student council representative at his school. This semester he is in charge of scheduling discussions about academic issues. He [tries to take/often picks] topics that appeal to both professors and students in order to stimulate discussion.[22]

The majority of the subjects were able to override their feeling of disgust but, interestingly, one third of them were not. They saw Dan's actions as morally wrong, and made up reasons to justify this. To be sure, the justifications were not very good, as there is no obvious reason to see Dan as morally wrong in the story quoted above. Haidt labels this kind of puzzled inability to justify an intuitive moral conviction *moral dumbfounding*.[23] In order to explain his suspicion towards Dan, subjects under the influence of hypnotically-induced disgust said things like, "It just seems like he's up

to something" and "It just seems so weird and disgusting."[24] The subject obviously feels that Dan is doing something morally wrong, but finds it hard to explain rationally why this is so.

Kahneman compares our intuitive judgments to cognitive illusions.[25] As captured by Haidt's term "moral dumbfounding," although all rational arguments against Dan doing something morally wrong are refuted, one still feels that there is something wrong with Dan's behavior. Perhaps partiality is a kind of cognitive illusion. I may deliberately reason my way to the conclusion that Dr. Kennedy is morally preferable to Tony. Yet, when seeing the episode again, I am still likely to enjoy Tony's revenge over the doctor. I seem to perceive Tony as morally right when he humiliates Kennedy, even if I know that, rationally speaking, he is not. Or, in line with Plantinga's theory, I might still sympathize with Tony because I feel he has been subject to unfair treatment—although, rationally speaking, I know that he has not been.

In Smith's theory, it sounds like allegiance is equivalent to impartial, rational evaluation of a character's moral traits. However, a growing number of empirical investigations suggest that we seldom rely on such a deliberate rational evaluation when assessing the morality of something, even in real life. Furthermore, one can question how likely it is that the spectator of fiction typically engages in a fully rational, deliberate moral evaluation. Arthur Raney suggests that because we engage with fiction for diversion, entertainment, and relaxation, there is all the more reason to believe that we avoid the cognitively taxing operation of rational, moral deliberation.[26] Considering something from an impartial point of view would be similarly taxing. Raney therefore postulates that "emotional involvement with entertainment *requires* partiality."[27] He labels this as *moral disengagement for the sake of enjoyment*, and explains it as follows:

> Enjoyment is desired and the feelings of pleasure can be experienced cheaply; partiality removes the need for moral scrutiny and contemplation . . . Embracing the cognitive-miser urge, viewers trade moral scrutiny for partiality and favoritism. Their desire to enjoy themselves is of utmost importance; thus, they freely give protagonists great moral license to ensure that enjoyment is experienced.[28]

I make a related point elsewhere. The institution of fiction typically relieves us from considering the consequences of a character's actions or attitudes.[29] As spectators of fiction, we rely more strongly on moral emotions than on moral reasoning. I call this *fictional relief*. Raney makes great progress in explaining what mental mechanisms cause such a circumvention of our moral engagement. Here I want to pursue this line of inquiry in another direction.

In considering the difference between fiction film and long-term narration such as television series, what difference does it make for the spectator that a fiction goes on for months and years? Robert Blanchet and I have argued that long-term narration in television series partly activates the same mental mechanisms as do personal relations in real life.[30] Knowing someone well invokes a feeling of familiarity that is pleasurable in itself. This is known as the "familiarity principle."[31] Furthermore, we argue that television series activate these mechanisms more strongly than the fiction film, which is relatively short. A television series may create a strong bond with its characters that in some respects resembles the bonds people have with friends in real life. The longer we have followed and bonded with a character, the more it probably takes to change our minds. Television series may make the spectator partial to a greater degree. Most relevant for my discussion here, this has implications for our moral judgments. We explain away whatever moral trespassing they do as an exception to the rule, or as warranted for reasons we have come to learn through our long-time engagement with the character. We are blinded by familiarity. We see the characters we know the best, those most familiar to us, as morally preferable.

Instead of repeating the arguments presented in my article written with Blanchet, I will corroborate this claim indirectly here by turning to the last question in this chapter, namely why there are currently so many television series with morally bad main characters.

why so many television series with antiheroes?

The Sopranos is one of many American television series in recent decades featuring morally bad main characters, or antiheroes, with whom we are generally encouraged to like and feel sympathy.[32] *The Wire* (2002–2008), *Mad Men* (2007–present), *Breaking Bad* (2008–present), *The Shield* (2002–2008), *Sons of Anarchy* (2008–present), *Boardwalk Empire* (2010–present), *Boss* (2011–2012), and *Dexter* (2006–present) are some of the television series with antiheroes.[33] In television studies, this trend seen in critically acclaimed television series has been discussed as "quality television" and "complex TV."[34] The trend has been identified partly by its antiheroes, in contrast to the "more likable protagonists" of regular TV.[35] "One common trait shared by many complex television series is the prominence of unsympathetic, morally questionable, or villainous figures, nearly always male . . . at their narrative center," Jason Mittell writes.[36] The fictional universe of a quality television series is often not Manichean; with antiheroes like mobster Tony Soprano, drug kingpin Walter White in *Breaking Bad*, and serial killer Dexter in the series of the same name, quality television series often wade in morally murky waters. But why are there so many antiheroes? I suggest

that partiality plays an important part in one sort of appreciation these kinds of series encourage.

First, it is important to point out that making the spectator sympathize with antiheroes requires some narrative stage setting. I have previously mentioned two strategies used to enhance sympathy for antiheroes: making some other characters in the narrative morally worse, and making a plea for excuses on a character's behalf. Second, when enhancing sympathy for the antihero initially, the strategies used in television series are probably no different from the strategies used in fiction film to promote sympathy for antiheroes. There is nothing distinctly televisual about antiheroes—the antihero is a gangster genre convention in film, for example. Furthermore, in order to explain the appeal of antiheroes both in film and television, enjoyment of the transgression is surely an important explanation, although I will not explore that idea further here. With the antihero as an old gangster film convention, we still do not have an explanation for the proliferation of antiheroes in current TV series, and this is my concern here.

With the long duration of television series, sympathy for the antihero is allowed to develop over an extended period. Blanchet and I have argued, as we have seen, that there is reason to believe that the very duration of the television series facilitates partiality more than does fiction film, which is not serialized across a period of months and years. So, the spectator forms a strong bond with the antihero and enjoys the narrative. In addition to the enjoyment of engaging in a narrative, arguably an important attraction of these series is a response I will label *appreciation*. We can differentiate between enjoyment and appreciation by saying that enjoyment is tied to involvement or engagement in the unfolding narrative as entertainment and relaxation. Appreciation, on the other hand, is tied to awareness of the narrative as an artifact—to its plot and style elements, as argued by Ed S. Tan,[37] or, relatedly, to a narrative's more thought-provoking features.[38] In exploring this division empirically, Mary Beth Oliver and Anne Bartsch write that "whereas enjoyment . . . may be associated with fleeting feelings of pleasure and excitement, deep appreciation of some entertainment offerings should result in greater levels of reflection, deeper levels of processing, and more extensive contemplation."[39] There are many ways in which quality television series enhance appreciation (including highly rated actors; high budgets affording film-like quality and style; intertextuality or other forms of playful narration; and so on).[40] This, I suggest, is also the crux of the question of why there are so many quality television series with an antihero. The long duration of television series makes the spectator stubbornly partial, and, unreflectively, to perceive the antihero as morally in the right. On reflection, however, we do not actually think he is morally right. Thus, if the narrative reminds us of this conflict, we marvel at the fact that we like this character so much.

This spectator response might be a fictionally-induced relative of Haidt's concept of moral dumbfounding—the spectator feels sympathy for the antihero, but finds it hard to justify this rationally. The spectator has been relying on intuition (system 1), and has become partial—but then the narrative encourages activation of deliberate, rational evaluation (system 2). The moral judgments made by system 1 and system 2 are not the same, and this is thought-provoking.[41] The spectator finds his or her liking of, and sympathizing with, these characters puzzling and fascinating. These television series thrive on their antiheroes because they add a thought-provoking, puzzling effect in addition to their engaging narratives. It is one of the ways in which these series enhance appreciation of their construction.[42]

In order to cash in on the spectator's tendency towards partiality towards the antihero, these television series regularly put the spectator's sympathy with the antihero to the test.[43] A striking and elegant example of such a test in *The Sopranos* is found in the episode "College."[44] Tony accompanies his daughter Meadow to college interviews. Approaching one of the colleges, he recognizes a former mafia member-turned-government witness against the mafia—a "rat"—relocated through the witness protection program. The prospect of revenge over this much-hated man is too tempting for Tony. While Meadow is busy at one of the colleges, Tony hunts the witness down and strangles him, slowly; this is shown to us in close-up shots of the dying man and Tony struggling to finish him off. The strangling is unusually brutal and uncomfortable in its graphic violence. It is one of the first times we see the brutality of which Tony is capable, after a whole lot of excuses have been made on his behalf.

I suspect many spectators experience doubt about their sympathy for Tony during the strangling sequence in "College"—after all, were this in real life, most of us would not applaud killing government witnesses. After the witness is strangled, the spectator sees Tony in an overview shot, and there, in the sky, what captures Tony's and the spectator's attention is a flock of ducks flying by. The scene seems to poke fun at the spectator: so this is the man you sympathize with—all because he cares about some ducks? The spectator has been enjoying the chase between Tony and the witness, where the spectator feels suspense for Tony, and then this thought-provoking sequence asks the spectator to take a critical stance on his or her own engagement and enjoyment, thus enhancing appreciation. Notably, the narrative slows down in this sequence to allow the spectator time for this kind of reflection. One of several reasons why *The Sopranos* has been so successful is that it encourages both enjoyment and appreciation. Not all spectators will reflect deliberately on their own engagement, but I propose that spectators typically waver in their sympathy for Tony in relation to this and related sequences, and appreciate the oscillating sympathy structure in the series. At the very least, there is a momentary

loss of, or doubt about, one's sympathy for Tony, and an appreciation of the narrative being challenging in this way.

One can speculate that the critical acclaim and audience success of *The Sopranos* triggered other recent American so-called quality series to copy this aspect of *The Sopranos*.[45] *Breaking Bad* is a good example. The initial episode makes a plea for excuses: the main character Walter White is a humiliated man. His wife seems to have little respect for him, demonstrated by her watching an eBay auction on the Internet while unenthusiastically masturbating him (after all, it is his birthday). His chemistry class students at high school could not care less about what he wants to teach them. After school, he works in a car wash to make ends meet—and naturally, as he is ordered out to clean a car's wheels, some of his students see him, record the whole thing, and put it on the Internet. As if this were not enough, he is also diagnosed with terminal cancer, and told he has little time left. So, when he "breaks bad" and uses his abilities as a chemist to "cook" the highest quality methamphetamine that Albuquerque has ever seen in order to secure his family's finances before he dies, the spectator enjoys his assumption of control, and wants him to succeed. The first episode is remarkably effective in constructing sympathy for Walter.

Other, conventional means of encouraging sympathy for Walter are also in use. In Season 2, for example, the drug kingpin Tuco is portrayed as thoroughly cold-blooded and evil, and serves as a contrast to make Walter appear morally preferable. Much suspense is created in the first two episodes of this season in relation to Tuco, and we as spectators root for Walter and his partner-in-crime, Jesse Pinkman. Jesse uses and deals drugs and is not portrayed as altogether bright. The interplay between the two is often comical—the very intelligent chemist coupled with the slacker Jesse. Nevertheless, it is Jesse who has a conscience, and as he and Walter are pulled deeper into the crime world, the consequences of their way of living torment Jesse. One such sequence, in which Jesse literally faces the consequences of their drug dealing, is in the episode "Peekaboo."[46] One of Jesse's drug dealers was robbed by two junkies, and Walter orders Jesse to track them down, get their money back, and gain respect. Jesse finds out where they live, and ventures into their house, which is a nightmarish slum. As Jesse waits for the two junkies to return home, a little boy of about four years awakes and comes into the living room. He is half-naked, snotty and dirty, and does not speak a word. This sequence spells out for Jesse —and for us—who is suffering the consequences of their drug-dealing escapade. Momentarily, this child takes the fun out of *Breaking Bad*. When Jesse tells Walter about his ordeal in the junkies' house, Walter seems relatively unaffected. He does, however, let others believe that it was Jesse who killed one of the junkies, finding this rumor useful to strengthen their "street cred."

Many spectators will experience doubt about their sympathy for Walter at various intervals while engaging in *Breaking Bad*, as Walter's criminal nature takes him one step further into the abyss. "Peekaboo" is one example; another is the finale of the fourth season, "Face Off."[47] Here, Jesse and Walter are up against drug kingpin Gus. Jesse's girlfriend has a son, little Brock, who suddenly falls ill and is hospitalized. In ferocious anger Jesse confronts Walter, and accuses him of poisoning his son. But Brock recovers, and the doctors believe he had accidentally poisoned himself by eating Lily of the Valley berries. So, in the end, Jesse and Walter reconcile. The final shot, however, cuts to Walter's back yard, where the camera zooms in on a plant—Lily of the Valley. Thus it is suggested that it was indeed Walter who poisoned Brock in an ingenious but deeply selfish and immoral plan to set things in motion and get to Gus. As a spectator, one is shocked—would Walter really do such a thing? Using an innocent boy in such a scheme is reprehensible, and again our sympathy for Walter is put to the test. As Walter is drawn into the shady world of drug dealing, from one season to the next, the spectator grows increasingly unsympathetic toward Walter. It creeps up on the spectator that Walter White is slowly losing his sense of compassion and loyalty. He seems to have no scruples.

In his analysis of *Breaking Bad*, Mittell points out that it is hard to imagine one becoming involved in a series with a main character like Walter White as he stands at the end of the fourth season.[48] Nonetheless, having watched the series from the beginning, Mittell finds himself connected to Walter. In an interview, series creator Vince Gilligan points to a slow transformation of our feelings towards Walter, but also emphasizes how long it takes for us to stop liking him:

> Our hero has become, episode by episode, a villain . . .
> *Breaking Bad* has been an experiment in television, as you said.
> Walter White has come very far down the road of badness,
> and he's pretty much an indefensible guy at this point.
> Viewers have noticed that, but it was interesting to me that
> they hung in there liking Walt as long as they did. It points
> out interesting things about the storytelling process. When
> we choose to invest in a story we're reading or watching,
> we invest a certain amount of psychic energy into the main
> character, and therefore it can be hard to come to grips with
> the idea that this character may not be worth sympathizing
> with.[49]

This testifies to how stubborn we are as sympathizers, if first encouraged to sympathize with someone. It is in itself a good illustration of the psychological force of partiality, that if we first like someone, we tend to want to go on liking them.

The spectator has a remarkable tendency to ease back into a sympathetic attitude towards Walter once the thought-provoking sequence is over. The same effect applies to Tony in *The Sopranos*. The sympathetic orientation we started out with plays a major role here. When the narrative explicitly reminds us of the consequences of their actions, we may drift out of sympathy momentarily, but, once the narrative moves on, we tend to bounce back into sympathetic allegiance. It takes an astonishingly long time for us to shake off the sympathetic attitude towards Walter and Tony with which we started out.

Breaking Bad and *The Sopranos* are like long (suspenseful and amusing) tests of how stubborn the spectator's sympathy for a character can be. How long do the initial excuses hold? Perhaps it is Walter's betrayal of his partner Jesse that represents the greatest challenge to our sympathy with him: if Walter is treacherous towards his own allies, does he then deserve our loyalty? And in Tony's case, when he kills a person he refers to as his own nephew, Christopher Moltisanti; when his wife Carmela accuses him of "playing the depression card until it is worn to shreds" to gain other people's sympathy; and when his own psychiatrist Dr. Melfi ends treatment of him because she realizes he is a sociopath, this also represents a serious blow to the spectator's sympathy for Tony in the last season.[50] Nonetheless, although our sympathy is repeatedly put to the test, time and again, we seem to forgive and forget and return to the sympathetic orientation we started with regarding Walter and Tony.[51] Activating deliberate moral evaluation of these characters makes us as spectators distance ourselves from them; however, as the story continues, intuitively, what guides our engagement with these characters is the bond we have already formed with them. We care for them, we like them, we know them very well. Like with old friends, we cut them some slack. Getting to know these characters so well makes us overlook, explain away, and minimize their many moral flaws.

conclusion

To sum up, there is a systematic relation between alignment and allegiance. Alignment with a character influences our moral evaluation of that character, and increases the spectator's sympathy. One qualification is that, for alignment to work in this way, the narrative must entail pleas for excuses for a morally bad character. If we are aligned with a character that has no redeeming traits, we are given no reasons to like him. Furthermore, if this character is also the morally inferior character in the fictional universe—in that no other characters make him morally preferable—alignment probably does not work to enhance sympathy either. With these two qualifications in place, the relation between alignment and allegiance

is systematic and predictable—alignment makes us partial. It is not surprising that we are easily influenced into partiality to those we know best —the evolutionary advantage of in-group loyalty is quite obvious. Partiality is part of our moral psychological make-up, and many recent so-called quality television series thrive on this tendency we have to become biased. By first encouraging sympathy with an antihero, and combining this with thought-provoking sequences that put the spectator's sympathy to the test at regular intervals, the narrative confronts us with our inclinations towards favoritism, and encourages us to marvel at our own engagement. These television series with antiheroes exploit our tendency to be blinded by familiarity.[52]

blinded by familiarity

notes

1. *The Sopranos*, "Second Opinion," Season 3, Episode 7, director Timothy Van Patten, written by Lawrence Konner, New York: HBO, first aired April 8, 2001.
2. Murray Smith, "Just What Is It that Makes Tony Soprano Such an Appealing, Attractive Murderer?," in *Ethics at the Cinema*, ed. Ward E. Jones and Samantha Vice (New York: Oxford University Press, 2011), 78.
3. *Breaking Bad*, created by Vince Gilligan, New York: AMC, first aired January 20, 2008.
4. Murray Smith, *Engaging Characters: Fiction, Emotion, and the Cinema* (Oxford: Clarendon Press, 1995).
5. Smith, *Engaging Characters*, 187.
6. *The Silence of the Lambs*, directed by Jonathan Demme (Los Angeles: Orion/Strong Heart/Demme Production, 1991).
7. Murray Smith, "Gangsters, Cannibals, Aesthetes, or Apparently Perverse Allegiances," in *Passionate Views: Film, Cognition, and Emotion*, ed. Carl Plantinga and Greg M. Smith (Baltimore, MD: Johns Hopkins University Press, 1999); and Smith, "Just What Is It."
8. Smith, "Just What Is It," 84.
9. Carl Plantinga, "'I Followed the Rules, and They All Loved You More': Moral Judgment and Attitudes Toward Fictional Characters in Film," *Midwest Studies in Philosophy* 34, no. 1 (2010): 34–51.
10. Kwame Anthony Appiah, *Experiments in Ethics* (Cambridge, MA: Harvard University Press, 2008), 104.
11. Cf. J. L. Austin, "A Plea for Excuses: The Presidential Address," *Proceedings of the Aristotelian Society*, New Series 57 (1956–1957): 1–30.
12. Smith, *Engaging Characters*, 223.
13. Smith, "Gangsters, Cannibals," 228.
14. See, for example, *Partiality and Impartiality: Morality, Special Relationships, and the Wider World*, ed. Brian Feltham and John Cottingham (Oxford: Oxford University Press, 2010); and Bennet Helm, "Friendship," in the *Stanford Encyclopedia of Philosophy*, 2009, Stanford University, http://plato.stanford.edu/entries/friendship/ (accessed May 22, 2013), for overviews of this line of debate.
15. Arthur A. Raney, "Expanding Disposition Theory: Reconsidering Character Liking, Moral Evaluations, and Enjoyment," *Communication Theory* 14,

281

no. 4 (2004): 348–369. Raney's paper reworks the influential "dispositional theory of emotion" in media psychology (see, for example, Dolf Zillmann, "Basal Morality in Drama Appreciation," in *Moving Images, Culture and the Mind*, ed. Ib Bondebjerg (Luton: University of Luton Press, 2000), 53–63), and can be seen as related to my critique of Smith's theory here, as Zillmann and Smith make similar assumptions about the role of moral evaluation in response to media entertainment.

16. Jonathan Haidt, *The Righteous Mind: Why Good People Are Divided by Politics and Religion* (London: Allen Lane, 2012), xiv.
17. See, for example, Jonathan Haidt, "The Emotional Dog and Its Rational Tail: A Social Intuitionist Approach to Moral Judgment," *Psychological Review* 108, no. 4 (2001): 814–834; Jonathan Haidt and Frederik Bjorklund, "Social Intuitionists Answer Six Questions About Morality," in *Moral Psychology, Vol. 2: The Cognitive Science of Morality: Intuition and Diversity*, ed. Walter Sinnott-Armstrong (Cambridge, MA: MIT Press, 2008); Jonathan Haidt and Selin Kesebir, "Morality," in *Handbook of Social Psychology*, 5th ed., ed. Susan T. Fiske, Daniel T. Gilbert, and Gardner Lindzey (Hoboken, NJ: Wiley, 2010); and Haidt, *Righteous Mind*.
18. Daniel Kahneman, *Thinking, Fast and Slow* (London: Allen Lane, 2011).
19. Haidt, *Righteous Mind*.
20. Kahneman, 86–87.
21. Ibid., 82.
22. Thalia Wheatley and Jonathan Haidt, "Hypnotic Disgust Makes Moral Judgments More Severe," *Psychological Science* 16, no. 10 (2005): 782.
23. Haidt, *Righteous Mind*, 25.
24. Wheatley and Haidt, 783.
25. Kahneman, 27–28, 216–217, 417.
26. Arthur A. Raney, "The Role of Morality in Emotional Reactions to and Enjoyment of Media Entertainment," *Journal of Media Psychology* 23, no. 1 (2011): 18–23.
27. Ibid., 20.
28. Ibid., 21.
29. Margrethe Bruun Vaage, "Fictional Reliefs and Reality Checks," *Screen* 54, no. 2 (2013): 218–237. I do not argue that fiction never makes us reflect on moral issues—on the contrary, I show how some fictions deliberately encourage moral reasoning at specific times in the narrative.
30. Robert Blanchet and Margrethe Bruun Vaage, "Don, Peggy and Other Fictional Friends? Engaging with Characters in Television Series," *Projections* 6, no. 2 (2012): 18–41.
31. See, for example, Robert B. Zajonc, "Attitudinal Effects of Mere Exposure," *Journal of Personality and Social Psychology Monograph Supplement* 9, no. 2, part 2 (1968): 1–27; and Robert F. Bornstein, "Exposure and Affect: Overview and Meta-Analysis of Research, 1968–1987," *Psychological Bulletin* 106, no. 2 (1989): 265–289.
32. An antihero has traditionally denoted unsympathetic main characters in film theory, but it has become common to discuss the bad main characters in these series as antiheroes—although the spectators tend to sympathize with them.
33. *The Wire*, created by David Simon, New York: HBO, June 2, 2002–March 9, 2008; *Mad Men*, created by Matthew Weiner, New York: AMC, July 19, 2007–present; *The Shield*, created by Shawn Ryan, Dallas: FX, March 12,

2002–November 25, 2008; *Sons of Anarchy*, created by Kurt Sutter, Dallas: FX, September 3, 2008–present; *Boardwalk Empire*, created by Terence Winter, New York: HBO, September 19, 2010–present; *Boss*, created by Farhad Safinia, Meridian, CO: Starz, October 21, 2011–October 19, 2012; *Dexter*, developed by James Manos, Jr., New York: Showtime, October 1, 2006–present.

34. By using the notion "quality TV series" I merely intend to highlight the status these television series have in critical reception as well as in the TV industry. For a critical discussion of problems tied to the notion, see Michael Z. Newman and Elana Levine, *Legitimating Television: Media Convergence and Cultural Status* (New York: Routledge, 2012). See Jason Mittell, "Narrative Complexity in Contemporary American Television," *The Velvet Light Trap* 58 (2006): 29–40; and Jason Mittell, *Complex TV: The Poetics of Contemporary Television Storytelling* (pre-publication edition, MediaCommons Press, 2012), for use of the alternative term "complex television." For historical overviews, see, for example, Trisha Dunleavy, *Television Drama: Form, Agency, Innovation* (London: Palgrave Macmillan, 2009); Robin Nelson, *State of Play: Contemporary "High-End" TV Drama* (Manchester: Manchester University Press, 2007); and Robert J. Thompson, *Television's Second Golden Age* (New York: Continuum, 1996).

35. Ryan and Holmes referred to in Newman and Levine, *Legitimating Television*, 34.

36. Mittell, *Complex TV*, "Character", paragraph 44.

37. Ed S. Tan, *Emotion and the Structure of Narrative Film: Film as an Emotion Machine* (Mahwah, NJ: Lawrence Erlbaum Associates, 1996), 32ff.

38. See Mary Beth Oliver and Anne Bartsch, "Appreciation as Audience Response: Exploring Entertainment Gratifications Beyond Hedonism," *Human Communication Research* 36, no. 1 (2010): 53–81; and Mary Beth Oliver and Anne Bartsch, "Appreciation of Entertainment: The Importance of Meaningfulness via Virtue and Wisdom," *Journal of Media Psychology* 23, no. 1 (2011): 29–33.

39. Oliver and Bartsch, "Appreciation as Audience Response," 59.

40. See for example Dana Polan's analysis of *The Sopranos'* gentle mockery of its target audience in Dana Polan, *The Sopranos* (Durham, NC: Duke University Press, 2009), and the analysis of "operational aesthetics" in Mittell, *Complex TV*.

41. Raney, "The Role of Morality," explores a similar point about thought-provoking turns in a narrative activating moral reasoning, but does not tie this to television series specifically.

42. I do not argue that this applies only to recent so-called quality television series. Soap opera audiences might have enjoyed and appreciated these effects long before the recent boom of antiheroes. For example, in his study of Norwegian spectators watching *Dynasty*, Jostein Gripsrud notes that although his respondents claimed only to identify with the female protagonist Crystle, he observed "laughter of ambivalent relief at Alexis's [the main "bad" female character] actions when watching *Dynasty* with very mature housewives (in their sixties)," in *The Dynasty Years: Hollywood Television and Critical Media Studies* (London: Routledge, 1995), 158.

43. In Vaage, "Fictional Reliefs," I discuss this as "reality checks."

44. *The Sopranos*, "College," Season 1, Episode 5, director Allen Coulter, written by James Manos, Jr. and David Chase, New York: HBO, first aired February 7, 1999.

283

45. Through interviews with various TV executives and producers, TV critic Alan Sepinwall shows how others deliberately tried to copy *The Sopranos*, for example AMC executives saying, "We need a *Sopranos*," in *The Revolution was Televised: The Cops, Crooks, Slingers and Slayers Who Changed TV Drama Forever* (New York: Touchstone, 2012), 302.

46. *Breaking Bad*, "Pekaboo," Season 2, Episode 6, aired April 12, 2009, director Peter Medak, writers Vince Gilligan and J. Roberts.

47. *Breaking Bad*, "Face Off," Season 4, Episode 13, aired October 9, 2011, director Vince Gilligan, writer Vince Gilligan.

48. Mittell, *Complex TV*, "Character," paragraph 77.

49. http://www.mynorth.com/My-North/February-2012/Traverse-City-National-Writers-Series-Vince-Gilligan-Breaking-Bad/ (accessed August 28, 2013).

50. *The Sopranos*, "Kennedy and Heidi," Season 6, Episode 18, director Alan Taylor, written by Matthew Weiner and David Chase, first aired May 13, 2007; "The Second Coming," Season 6, Episode 19, director Timothy Van Patten, written by Terence Winter, first aired May 20, 2007; "The Blue Comet," Season 6, Episode 20, director Alan Taylor, written by David Chase and Matthew Weiner, first aired June 3, 2007 (New York: HBO, 2007). I suspect that spectators who had followed the whole series never fell out of a sympathetic allegiance with Tony altogether.

51. As I write this, the final part of the fifth and last season of *Breaking Bad* has still not been aired, so the fate of Walter White—and our sympathy with him—has not yet been sealed.

52. This chapter was first presented as a paper at the SCSMI in New York in June 2012. I have also discussed it in a Master's course at the Norwegian University of Science and Technology in the spring of 2012 and 2013. I thank the participants on all occasions for stimulating discussions. Thanks also to Steffen Borge, Jason Mittell, and to the editors for their comments on written drafts.

coming out

of the corner

the challenges of a broader

media cognitivism

greg m. smith

Cognitive film studies has been a distinctly recognizable subfield for about twenty-five years now, and in that period of time our academic subfield has developed several schemata (if I may apply a cognitive term to our own scholarly activity): prototypes of what constitutes "film" as an object of study and procedures for analyzing that object (from neoformalist approaches to fMRI studies of clips). We cognitivists (like most humans) tend to follow certain norms; we share a set of broad assumptions and a collective history. We are bound together by a belief that the perceptions, cognitions, and emotions of a film viewer have much in common with normal, everyday processes. We believe that the traditions of empirical cognitive psychology and the philosophy of mind have produced rich insightful explanations of human experience. In my experience, cognitivists warmly welcome those who value these beliefs, traditions, and practices, regardless of their disciplinary training.

These theoretical, affective, and interpersonal patterns have served us well; they have produced both rigorous scholarship and a generous community of scholars. In this chapter, I want to point out how our

community's history has led us toward certain kinds of media and away from others. Although the central organization for this academic subfield broadly proclaims it is interested in the cognitive study of the moving image,[1] most of us are film people. As we look to open up other media to cognitive approaches, it is a good moment to consider how our joint assumptions have found a good fit in film, and how other media (including television and games) will present different challenges to our cognitive approach. Applying cognitive research schemata (assumptions about what the "text" is, for instance) to television or games may not be as simple as exchanging one object of study for another. This chapter explores some of the ways that a broader media cognitivism may call for us to interrogate and resituate film cognitivism's current place within the academy as a whole.

how we found common ground

Simply put, cognitivists like film. We are interested in understanding the basic processes of how movies work: how they are structured, how they convey meaning and evoke emotion. This deep and broadly-held affective preference extends to the language we use. When Uri Hasson and his colleagues talk about "neuroCINEMAtics" (emphasis mine), they are talking about the same aesthetic devices that are used by television and many computer games, though they choose a term that emphasizes their heritage in film.[2] Although many of us maintain interests in other media, cinema is the common ground on which we stage our discussions.

This preference has historical roots in how the field developed within the academy. The modern application of cognitive theories to media emerged within the humanistic discipline of film studies. Though the interest in cognition and film has classical roots dating back to Hugo Münsterberg's work, most would date modern film cognitivism back to David Bordwell's 1985 *Narration in the Fiction Film*.[3] *Narration* contains many now-familiar ideas about narrative comprehension (spectators apply mental schema to film and make hypotheses about future plot occurrences, and so on), but at the time this was not a work that clearly announced itself as "cognitivism." Instead, the book's first two chapters differentiate Bordwell's approach from diegetic and mimetic theories of narration. The book is clearly a work of narrative theory, but it did not send out a clarion call for a new approach to film studies. *Narration* appeared to be in sync with the neoformalist model of film analysis proposed in Kristin Thompson's later *Breaking the Glass Armor*, sharing many of the same assumptions about spectatorial processes but emphasizing how norms change over time for historical audiences and filmmakers.[4] These works appeared to be the theoretical wing of the push for a historical poetics in film, a ballyhooed and much debated movement (associated with the monumental *The Classical Hollywood Cinema*)[5] arguing for an account of aesthetics grounded in

the details of industrial practice (both in terms of technology and economic structure) rather than focusing on the ideological ramifications of Hollywood style. In retrospect, Bordwell's and Thompson's work seems obviously grounded in cognitivist conceptions; at the time it looked more like a historical and theoretical extension of Russian Formalist writings within the film studies tradition.

The cognitivist underpinnings of *Narration* and *Glass Armor* became clearer with Bordwell's 1989 "A Case for Cognitivism."[6] Here is a call to put film studies into conversation with work from distinctly different fields: philosophical work and empirical research on mental representation and mental models. This article sketched an approach to the cognitive study of film that far exceeded a focus on narration or textual analysis, a broad program that film cognitivism is still working to accomplish. Around this same time Noël Carroll's 1988 *Mystifying Movies* attacked film studies' reliance on hermeneutic interpretive readings and psychoanalytic theories of spectatorship (with their emphasis on irrationality and on pathological states of mind).[7] This was more a clearing of the theoretical ground (anticipating Bordwell's and Carroll's *Post-Theory*)[8] than an explicitly cognitivist project, a book that was critical of film studies but well within the field as it was constructed.

By the 1990s film cognitivism had taken recognizable shape as a distinct subfield, and it opened up new vistas within that paradigm. Gregory Currie's *Image and Mind* made a substantive contribution to cognitivism from the philosophy of mind tradition.[9] Joseph D. Anderson's *The Reality of Illusion* expanded film cognitivism's theoretical groundings to include Gibsonian work on perception.[10] Torben Grodal and Ed Tan helped to start a vibrant European counterpart to American film cognitivism, and they also addressed questions of emotion, which were off the table in the "Cognitive Revolution" in the 1970s that provided many of the theoretical foundations behind early film cognitivism.[11] The 1999 edited collection *Passionate Views* also focused on emotion, pairing first-generation film cognitivists like Carroll and Currie with second-generation film cognitivists (those who were trained within the paradigm), such as Carl Plantinga, Greg Smith, Berys Gaut, Dirk Eitzen, and Murray Smith (whose *Engaging Characters* had appeared in 1995).[12] By the early 2000s, film cognitivism had further broadened to include European empirical work in neurocognition and eye tracking (Uri Hasson, Tim Smith, Monika Suckfüll, John Bateman, and others) and mechanical measurements of films using computer technology (Yuri Tsivian, and the "big data" work of James Cutting and colleagues).[13]

I conclude this necessarily sketchy portrait of how film cognitivism arrived at our currently shared common ground by emphasizing the origins of the subfield. Film cognitivism originated in the ongoing discussion within film studies about viewer processes. On the American scene,

academic film studies grew out of literary studies and as an explicitly qualitative alternative to the dominant, quantitative perspective of "media effects." Cognitive film theory (unlike much of the work done by film studies scholars) was receptive to empirical research, but this gained a place within American academic film studies in no small part because those early pioneers had established reputations within the humanistic tradition. They were insiders who were well-versed in the film studies literature, as opposed to outsiders from the vilified "media effects" perspective. This helped them establish a place for future contributions by those who were outside the academic tradition of film interpretation.

This subfield grew by focusing on certain aspects of cinema, and I shall focus on that common ground. Our shared penchant toward film has much to do with characteristics of the film text itself. One advantage of the cinema is that film is temporally limited. An hour-and-a-half running time makes it easier for the cognitively-based textual analyst to master the text, and it also makes possible the use of films in empirical experiments as well. In addition, the cinema is a medium of obvious cultural significance; movies are seen globally and have a centrally acknowledged place of privilege in the cultural spotlight. There is little need these days to justify our curiosity about such an aesthetically complex medium. Intricately constructed mainstream films can still be widely comprehended by popular audiences, which gives experimenters an advantage: they can count on broad competencies without needing to "train" experimental subjects in the viewing task. Another advantage is that films are widely available in the video era, which also encourages their broad use in studies. All of these characteristics are apparent, even commonplace, but these obvious assumptions about film have helped to keep cognitivists focused on the cinema.

I emphasize that these are assumptions because they remain important even when they are no longer quite true. Film is temporally bounded, yes, but it can be practically difficult to collect data on subjects watching an entire feature film, and so it can be easier to use a segment of the film in empirical study. Assumptions play an important part here: if cognitive research is about better understanding the basic processes of viewing, then a segment should be sufficient to allow us to investigate the way that feature-length films function. Empirical cognitivists sometimes recognize the problems caused by artificially isolating a section from the narrative whole, and so some choose short films as experimental prompts. Short films make data collection more practically manageable, though one sacrifices a bit of film's cultural significance, since film shorts are much less widely seen than feature-length films.[14]

Cognitivist work has understandably tended to focus on basic questions, such as: How do we understand narrative information? What guides our visual perception? How does genre influence the viewing process? How do films elicit emotion? We have thus far not paid as much attention to

variations on the assumed basic viewing process: a viewer watching a narrative film for the first time. We are only beginning to look at the various forms of viewing made possible in today's complex media environment: different sized screens, or viewers who have seen a beloved film multiple times. Within film cognitivism we have not yet deeply studied the importance of specific prior viewer knowledge (increasingly important in an age when people can purchase and scrutinize a media text) or subcultural practices.

The point here is not to criticize film cognitivism's progress. My guess is that most cognitivists would agree that all these different avenues should be explored; we just haven't got there yet. What I do want to point out is how certain theoretical assumptions and institutional histories have led us down a particular path toward understanding basic film viewing. As we seek to apply the cognitive approach to other media, we need to keep these seemingly obvious factors in mind. As we shall see, the things that inclined us to study film through a cognitive lens may make it difficult to focus on other media.

long and short television

Television shares much more than a visual "language" with film. TV has long been a medium of cultural significance, at least as demonstrated by the number of its viewers, which dwarfs those of film. Increasingly, television is recognized for its aesthetic achievements, with narratively complex shows such as *Lost*, *The Wire*, and *The Sopranos* (among others) receiving sustained analytical attention from popular critics and academics, as well.[15]

Our assumptions about what we call "film" and "television" are important here. An experiment in "film" viewing can take place not on a screen projecting celluloid images but instead using a television monitor playing a text originally intended for cinematic exhibition. "Film," then, becomes a set of textual/viewing practices, with the actual technology of capture and presentation being of less crucial import. "Television" also then comes to describe text made to be shown first on television broadcasting, cable, and satellite systems, even though many "film" texts are seen on those technologies as well. With a focus on the similarities between contemporary film and television, it seems that it might be a relatively simple matter to extend film cognitivism to a broader "media" cognitivism.

Some texts made for television may even have distinct advantages for the cognitive researcher. For example, short-form television is much more widespread and popular than short film. The half-hour format (twenty-two minutes without commercials in its standard modern broadcasting form) of the American sitcom makes it much more practically manageable to screen an entire text[16] in an experimental situation. And yet the sitcom,

with all its advantages in practicality and cultural significance, is basically unstudied by cognitive researchers. Our patterns of institutional attention have led us away from short television in spite of its advantages.

But even screening a twenty-two-minute episode of *Friends* does not quite capture the televisual distinctness of the medium.[17] Viewers of *Friends* are most likely not to be first-time visitors to the Central Perk coffee house. Although the plot for an individual episode may be new to the viewer, the basic settings and character relationships are often familiar. Series television favors the ritualistic repetition of a familiar diegetic world, luring audiences back to experience variations on previously pleasurable plots. Of course film relies on previous viewer experience, and in a mainstream environment that increasingly depends on sequels, film audiences can also choose to revisit familiar universes. But the experience of series television is much more wrapped up in the logic of ritualistic reencounters with the same environments and characters, and so the cognitive study of television needs to grapple with the importance of intimate viewer knowledge.[18] Treating an episode of *Friends* as a free-standing text would do a kind of violence to dominant televisual experience.

An episode of *Friends* stands on its own much better than serial television, however. Although serialized contemporary television provides recaps and retellings to help viewers understand previous plot occurrences, deep serial pleasure requires significant knowledge and investment in the narrative world. This takes time, and extended time is difficult to capture in the laboratory. The serial pleasure of anticipating future plot occurrences is not entirely divorced from the question-and-answer form of classical narration,[19] but the sheer quantity of time between serial chapters expands narrative suspense into a qualitatively different experience. Similarly, the accumulated amount of character knowledge that a long-term serial viewer accumulates gives a richness of interpretation to any single installment.

In both instances (serial and episodic television), time spent watching both magnifies and multiplies the viewer's experience of the text. A devoted fan watches a series episode of *Friends* differently than a first-time viewer. The well-versed viewer's knowledge of a serial universe is similarly transformative, so that even a relatively self-contained episode of *Breaking Bad* ("Fly," for instance) offers different meanings to different viewers based on their level of familiarity.[20] Of course, all film and television programs produce multiple meanings in multiple viewers, and cognitive research is well equipped to handle this. This is not the problem. The difficulty with television texts is that the horizon of experience seems to vary widely based on time spent, producing an astonishing range of experiential possibilities.

In some sense, film has made it easy on us. By constraining the familiarity audiences have with the diegetic world in advance of actually watching

the film, this helps constrain the particular knowledge that different viewers use when making sense of the text.[21] Of course, the television text is not infinite in possibilities; viewers also use cognitive and affective patterns in long-term TV viewing as well. Serial television is certainly approachable from a cognitivist perspective.[22] The difficulty for empirical cognitivists is to find enough experimental subjects with a range of involvements to allow the researcher to make statistically significant explanations of expert and non-expert viewing. The difficulty for non-empirical cognitivists is that television viewing is such a different process for novice and well-versed viewers; it is almost like studying different texts.

In film, the particularly expert viewer (who has spent considerable time with the film, watching it multiple times) can be seen as an outlier, a case to be explored more once we understand the basic mechanisms of film viewing better. In television, however, this knowledgeable viewer is far from rare. In fact, the economic and narrative mechanisms of television focus on this form of viewing. Because of certain textual similarities, it is tempting to treat "television" with the same investigative processes we use to investigate "film." However, we should be aware of how our assumptions about the nature of the text—assumptions that have served us well thus far—may encourage us to do a disservice to television's distinctive viewing strategies.

gameplay as an object of study

Many articles about computer games begin with the same rhetorical move: establishing the cultural significance of the gaming industry by noting the massive profits from gaming software and hardware, profits that now exceed the box office take from the cinema.[23] This common rhetorical strategy seems intended to provide a reorientation for those who think the cinema is more culturally prominent. Many computer and video games operate with aesthetics borrowed from the cinema (the point-of-view shot, non-diegetic music, editing of cut-scenes), and so it seems also appropriate to extend the focus of film cognitivism to this relative newcomer in moving image media.

After all, games (like film or television) present an enclosed, audiovisual text that provides a moving representation of a diegetic world. Some game studies do focus on the aspects that are shared by games and film/television, particularly the gender/racial aspects of character representations, but these pay less attention to the central activity of gaming: play. A battle over the importance of gameplay gave rise to academic game studies as we know it. The "narratological" camp of theorists sought to emphasize the points of continuity between games and other storytelling media that had received more academic attention in film and television studies. The "ludological" branch of game studies wanted to emphasize games' distinction, that

gameplay itself is not a text or a story, though an individual player's traversal of the game space/time results in something that looks like a narrative text. Gameplay involves acting on the multiple possibilities available at any moment in a game's interactive environment. Any one of these actions transforms the state of the game, resulting in a new game state, which opens up new potential avenues for interaction. For the ludologist, this activity is radically different from the strong sequencing of story information that is at the heart of narration.[24] The challenge posed by gameplay is even larger for online gaming environments, where different players may be exploring different portions of the gameworld at the same time.

Focusing on gameplay provides some advantages from a cognitive perspective. One of the distinctive concerns for film cognitivism is the problem of identification/spectatorship: how does the physically "passive" viewer make the imaginative leap to ally himself or herself with the characters they see on screen? In gaming, this relationship is tighter because the player controls the onscreen avatar's actions. Issues of embodiment are still complicated through representation but they are more direct, since the player's physical actions have an immediate result on the onscreen character's depicted body. Although computer games (particularly role-playing games) can call upon the range of classical suturing film techniques that invite spectators to imaginatively participate in the diegetic world, they also have the added advantage of "interactivity,"[25] of direct cybernetic feedback between text and player. Without this imaginative bodily participation, the game (unlike the film) does not proceed. In gaming, the linkage between player and avatar is the basic condition for the medium and is a central pleasure for participants.

Another central pleasure for many games is their sheer expansive duration. A complicated single-player game can take eighty hours or more to complete. Massively multiple online role-playing games (MMORPGs or MMOs) depend on providing long-term engagement for players, who pay an ongoing subscription fee for access to the gaming world. MMORPGs have been a central focus for game studies for the past ten years, partly because their ongoing payment model makes them such a lucrative form of game entertainment, and partly because they depict a politically evoc-ative alternative public sphere where the fantasy of an online community can play out.[26] The ability of computer games to give lengthy pleasure is a key advantage for them in the modern entertainment marketplace. Because games can provide much longer than two and a half hours of engagement, this helps to justify the larger price tag for game purchases (compared to a feature film ticket or a DVD). What is sold in gaming is often the promise of duration, and this duration (like that of television) can be difficult for researchers to handle.

Games are long, yes, but they also pose a challenge to researchers because (unlike television) they do not present a single obvious "text." A long-running television series can extend for hundreds of hours, but at least there is a clearly central text to examine (although viewers may not have seen all of it). Of course, film and television viewers take their own mental "route" through the narrative, but they are still responding to the same visual and auditory stimulus. In gaming, the text's presentation of events, spaces, and characters varies in response to the gamer's commands. The game changes into a different reconfiguration as soon as the gamer begins playing.

What, then, is the object of study for a cognitive approach to computer games? Is it the software text itself, which is never experienced directly by the player but which governs the player's interactive possibilities? Is it the "gameworld," the preferred term of game designers, who tend to argue that they are not creating a "story"? Is it gameplay itself, an activity that is constrained by the gameworld and experienced individually by a player, each person improvisationally calling upon common game strategies?

Specific attention to the dynamics of gameplay is made more difficult because the majority of empirical research treats games as the newest instance of long-standing media research programs. Although we still understand very little about the cognitive, emotional, and physical fundamentals of gameplay, much empirical research proceeds as if we do, moving on to more complex issues such as the relationship between games and real world violence[27] or the use of games in education.[28] Making such an extended connection requires a set of linked processes that we simply do not understand well. If the primary interest is in how "games" can promote education or cause violence, the game becomes instrumental instead of being the focus of the research itself.

There is a growing body of empirical research on gaming that focuses directly on gameplay and gamers, their experiences, and their cognitive abilities, particularly concerning how expert gamers' attentional and perceptual capacities differ from novice gamers.[29] A real challenge for this line of research is the question of how generalizable the cognitive strategies and spatial skills gained in gaming are to broader real world applications. Certainly gamers are better at gaming, but does this alter more fundamental cognitive capacities? More recent research has begun to use the modern empirical cognitivist toolbox to examine real-time gameplay, including fMRI, EEG, skin conductance, eye tracking, pupil size, heart rate, and so on.[30] Although such research has not yet taken place under the auspices of the Society for Cognitive Studies of the Moving Image umbrella, this work would be readily recognizable to members of film cognitivist circles.

The cognitive film community has paid relatively little attention to games and gameplay thus far. Important exceptions include pioneering

essays by Torben Grodal and work by Andreas Gregersen, Jonathan Frome, and Bernard Perron.[31] Film cognitivism retains the basic orientation of film studies in general, that the cinema is a complex object of fascination, well worthy of being explored on its own terms. Computer gaming still struggles to achieve the aesthetic legitimacy that is regularly attributed to film, and so the quantitative study of games remains more interested in their sociological or instrumental capacities than their basic mechanisms. Quantitative game studies tends to happen within the paradigm of "media effects" research, a very different academic tradition from cinema studies. Cognitive media studies has long been interested in basic media processes because we have deep curiosity about the nature of our chosen medium (film). With few exceptions, quantitative study of gameplay tends to be more concerned with the medium's effects than with understanding the medium's affective and cognitive properties.

It took a while for empirical computer game research to emerge as a distinct concern from the broader exploration of human–computer inter-action (HCI) or computer-mediated communication (CMC). With the growing diversification of the category of "new media" came an awareness that different software applications had vastly different interface dynamics. Even the category of "computer games" or "video games" poses problems by giving a false sense of a coherent object of study, however. Contemporary games cover an extraordinary range from lushly detailed to playfully cartoonish, from simple pastimes to complicated quests, from abstract puzzles to fighting simulations, from small personal phone games to massive online community interactions. Of course, every researcher understands that any one single instance cannot represent the full range of members of any real world category, that every choice of object is imperfect. But choosing a single representative of the category of "com-puter games" is incredibly difficult. In film, researchers can at least examine fairly consistent modes of production and reception (classical cinema, art cinema, and so on). Computer games also have their own patterns of genre, but researchers all too often see a study of a particular game as giving insight into "games" in general, rather than insight into platform games or strategy games or sandbox games.

From a viewpoint within film studies, games look familiar in many ways: a broadly popular, affectively involving, culturally low/middlebrow med-ium of representational movement. As we begin to examine them, we need to think not only of the continuities between games and film but also about the differences: the sheer variety of what constitutes "games," their long duration, and particularly the way that gameplay fractures and multiplies the experience of a central "text."

media cognitivism's place within the academy?

As cognitivism begins to pay attention to other media, this raises broader questions that our community has not directly addressed. What exactly is the difference between the quantitative wing of cognitive media studies and the paradigm of "media effects" research? On American shores, film/television studies has maintained a strong distinction from the long tradition of quantitative research, with the two forms of study often taking place in different departments. Mainstream American film/television studies is often openly hostile to the dominant paradigm of media psychology/sociology, which it sees as too radically simplifying the polysemous processes of meaning-making and pleasure.[32] First-generation film cognitivism received some opposition within film studies,[33] but its entry into film studies was eased partly because of the personnel involved. Cognitivist pioneers were obviously members in good standing within film studies as it was constituted, and they were not themselves empirical researchers, though they treated empirical research as a valuable source of insight, rather than a fundamentally wrong-headed enterprise. This paved the way for future film cognitivists who actually did empirical research, including those from the Continent where the schism between quantitative and qualitative media scholarship does not seem as virulent as it does in America.

Because of this evolution, cognitive film studies has a tidy little corner within film studies as a whole, one that most media effects scholars have not yet entered. If we begin to look at the phenomenon of gaming, where there may be no central "text" experienced by all players, then empirical cognitive study begins to look a lot like portions of media effects research on games. For a long time, our community of film cognitivists has managed not to look like the boogeyman of media effects because we have been so centrally focused on basic cognitive and emotive processes in the cinema. If we examine media experiences in gaming that are not centrally organized around a specific set of moving images, will we disturb the "agree to disagree" relationship between media effects and cinema studies?

A move to incorporate other media can actually shift the kinds of questions we ask or alter the relationships in the field. From its beginnings, contemporary media cognitivism has embraced both empirical cognitive psychology/neurology and the philosophy of mind tradition as valued sources of insight, creating a productive space for sharing between practitioners of very different kinds of research. By promoting and valuing this interdisciplinary interchange, we have not asked the hard questions that have been asked elsewhere about the relationship between the brain and the mind.[34] In most cases we have proceeded as if empirical insights into the biological organ of the brain are congruent with our understanding of the mind.

Since contemporary film cognitivism began, other fields have shifted and taken on new questions. Film cognitivism has focused on one wing of contemporary philosophy (analytic) and largely ignored the other (Continental). This made perfect sense, since analytic philosophy housed the philosophy of the mind, while Continental philosophers were engaged in the deeply interpretive, hermeneutic tradition that cognitivism rejects. As film cognitivism turned its attention toward emotion, Continental philosophy made a parallel move, which is now termed the "affective turn," emphasizing the embodiedness of consciousness and the integration of thought and emotion.[35] Cognitivists and Continental philosophers now oddly find themselves converging on very similar concerns from very different intellectual traditions. Movement has become important to both fields,[36] with the discovery of mirror neurons allowing us to talk about how stationary viewers can mentally mimic the actions of onscreen characters. Writing on the affective turn by Continentally-grounded philosophers also frequently cites empirical work on perception and the nervous system.

And so with different chosen vocabularies (with "affect" being the preferred term for contemporary Continental philosophers),[37] we now find ourselves converging on very similar concerns: body, mind, and movement. If we add computer gaming to our interests, the emphasis on movement and the body can only increase in media cognitivism. So is there a place for certain Continental philosophies within media cognitivism after all? Should cognitivism accept the observational method of phenomenology as giving valid insight into consciousness? Just how different is the affective turn from the cognitive philosophies of mind that are at the heart of film cognitivism? Film cognitivism has long ago broached the Cartesian divide between mind and body. Should we also consider broaching the central chasm between Continental and analytic philosophy?

Similarly, film cognitivism has thus far emphasized "normal" or "typical" cognition, perception, and emotion. This focus was in part a reaction to previous psychoanalytic explanations of viewing that were grounded in "abnormal" states, such as Oedipal desires and fetishes. Instead of describing film viewing as an extension of pathological conditions, we pointed to the connections between watching movies and making functional sense of the everyday world. We would occasionally make mention of that highly suggestive but necessarily problematic font of ideas for cognitive research—the brain lesion study—but otherwise we paid primary attention to functional understandings of how the mind/brain works. Now the distance between "abnormal" and "normal" processing seems to have decreased. Many altered states now appear to be cognitive/perceptual extensions of normal states. Synesthesia and hallucination can be usefully conceptualized as exaggerations of certain typical mental processes.[38] If this is so, then what is the relationship between extraordinary

and ordinary cognitive processing in our field? Film cognitivism began with a firm embrace of "normal" viewing; now that our field has achieved a kind of maturity, should we broaden our focus to include more "abnormal" perceptual practices? Though we began by emphasizing the rational, hypothesis-making, data-evaluating processes of standard mentation, we quickly moved to a perspective that integrated biology with psychology as the line between body and mind broke down. Should we now do the same with the increasingly blurry distinction between pathology and functionality?

Is there a place for researchers on hallucination and fetishization within film cognitivism? We are open to work on Wittgenstein and film; how about someone who mingles Darwin and Derrida?[39] My instinct is to say yes, if this research from other fields shares one or more of our early commitments such as the tendency to take good empirical work as a perfectly acceptable source of insight into mediated practices, instead of prejudging quantitative research paradigms as being overly simplistic; a belief that media texts and processes are interesting and complicated enough to be studied on their own terms, without necessarily attaching them to larger agendas; and an interest in conscious cognition, even when the mind/brain is situated within the complicating architecture of the body. We have recently accepted into the cognitive fold some research into patterns that cannot be observed by individual viewers (work on "big data") because such work adopts some (but not all) of the beliefs that gave birth to film cognitivism. As we look to move beyond our initial focus on film, as we open up cognitive approaches to television and games, we should take stock of the challenges these media pose to our original research programs. We should also recognize our subfield's history of academic allegiances (our position within film studies) and differences (distinctions from media effects, cultural studies, and Continental philosophy). As we explore different media, we may have to reconsider our position vis-à-vis these other fields. The intellectual ground has shifted since our earliest beginnings. By investigating different media, we may need to revisit our situation within the broader academic conversation.

As we move into studying cognition in television and gaming, we may venture into fields that have different institutional trajectories from our own. This chapter acknowledges just how interconnected academic histories, intellectual boundaries, and media preferences are. Cognitivism has carved out a comfortable corner within film studies, where we have integrated analytic philosophy and empirical neurology/psychology to examine our preferred medium. As we venture out of that corner to investigate other media, we may need to reassess our connections to other fields that have studied those media before us.

notes

1. Society for Cognitive Studies of the Moving Image.
2. Uri Hasson, Ohad Landesman, Barbara Knappmeyer, Ignacio Vallines, Nava Rubin, and David J. Heeger, "Neurocinematics: The Neuroscience of Film," *Projections* 2, no. 1 (2008): 1–26.
3. Hugo Münsterberg, *The Photoplay: A Psychological Study* (New York: D. Appleton, 1916); David Bordwell, *Narration in the Fiction Film* (Madison: University of Wisconsin Press, 1985).
4. Kristin Thompson, *Breaking the Glass Armor: Neoformalist Film Analysis* (Princeton, NJ: Princeton University Press, 1988).
5. David Bordwell, Janet Staiger, and Kristin Thompson, *The Classical Hollywood Cinema: Film Style and Mode of Production to 1960* (New York: Columbia University Press, 1985).
6. David Bordwell, "A Case for Cognitivism," *Iris* 9 (1989): 11–41.
7. Noël Carroll, *Mystifying Movies: Fads and Fallacies in Contemporary Film Theory* (New York: Columbia University Press, 1988). See also his "The Power of Movies," *Daedalus* 114, no. 4 (1985): 79–103.
8. David Bordwell and Noël Carroll, *Post-Theory: Reconstructing Film Studies* (Madison: University of Wisconsin Press, 1996). Also in this era, Bordwell's *Making Meaning* examined the practice of film interpretation using an explicitly cognitive approach. See David Bordwell, *Making Meaning: Inference and Rhetoric in the Interpretation of Cinema*, Harvard Film Studies (Cambridge, MA: Harvard University Press, 1989).
9. Gregory Currie, *Image and Mind: Film, Philosophy, and Cognitive Science* (Cambridge: Cambridge University Press, 1995).
10. Joseph D. Anderson, *The Reality of Illusion: An Ecological Approach to Cognitive Film Theory* (Carbondale: Southern Illinois Press, 1996).
11. Torben Grodal, *Moving Pictures: A New Theory of Film Genres, Feelings, and Cognition* (Oxford: Clarendon Press, 1997); Ed S. Tan, *Emotion and the Structure of Narrative Film: Film As an Emotion Machine* (Mahwah, NJ: Lawrence Erlbaum Associates, 1996).
12. Carl Plantinga and Greg M. Smith, eds., *Passionate Views: Film, Cognition, and Emotion* (Baltimore, MD: Johns Hopkins University Press, 1999); Murray Smith, *Engaging Characters: Fiction, Emotion, and the Cinema* (Oxford: Clarendon Press, 1995).
13. James E. Cutting, Kaitlin L. Brunick, and Jordan E. Delong, "How Act Structure Sculpts Shot Lengths and Shot Transitions in Hollywood Film," *Projections* 5, no. 1 (2011): 1–16. Yuri Tsivian's work can be found at *Cinemetrics*, http://www.cinemetrics.lv (accessed July 1, 2013).
14. See, for instance, Monika Suckfüll, "Films That Move Us: Moments of Narrative Impact in an Animated Short Film," *Projections* 4, no. 2 (2010): 41–63; and Tan, *Emotion and the Structure of Narrative Film*.
15. Jason Mittell, "Narrative Complexity in Contemporary American Television," *The Velvet Light Trap* 58 (2006): 29–40; Dana Polan, *The Sopranos* (Durham, NC: Duke University Press, 2009); Linda Williams, *On The Wire* (Durham, NC: Duke University Press, forthcoming 2014); *Lost*, created by J. J. Abrams, Jeffrey Lieber, and Damon Lindelof (Burbank: ABC Studios, 2004–2010); *The Wire*, created by David Simon (New York: Home Box Office, 2002–2008); *The Sopranos*, created by David Chase (New York: Home Box Office, original broadcast January 10, 1999–June 10, 2007).

16. If one considers the "text" as the sitcom with the commercials excised, as they are shown on DVDs and paid streaming video sources.

17. *Friends*, created by David Crane and Marta Kauffman (Burbank: Warner Brothers Television, 1994–2004).

18. Jason Mittell's forthcoming book promises to consider the distinctiveness of television storytelling from a basically cognitive perspective, though his focus is more on contemporary "complex television" than the basic workings of earlier episodic series. See Jason Mittell, *Complex TV: The Poetics of Contemporary Television Storytelling* (pre-publication edition: MediaCommons Press, 2012–2013). See also Margrethe Bruun Vaage's contribution in this volume.

19. Which Noël Carroll calls "erotetic narration." See Noël Carroll, "Toward a Theory of Film Suspense," in *Theorizing the Moving Image* (New York: Cambridge University Press, 1996), 94–117.

20. *Breaking Bad*, created by Vince Gilligan (New York: AMC, 2008–present); "Fly," Season 3, Episode 10, director Rian Johnson and written by Vince Gilligan, Sam Catlin, and Moira Walley-Beckett (New York: AMC, first aired May 23, 2010).

21. Broader schemata about genre or narration are certainly brought to bear on watching an individual film, but the particular knowledge we have about the diegetic universe is usually limited to promotional/publicity materials, with the important exception of adaptations and sequels, which need more attention from film cognitivists.

22. See Robert Blanchet and Margrethe Bruun Vaage, "Don, Peggy, and Other Fictional Friends? Engaging with Characters in Television Series," *Projections* 6, no. 2 (2012): 18–41, and Margrethe Bruun Vaage's contribution in this volume.

23. The latest figures from the Entertainment Software Association state that "Consumers spent $20.77 billion on video games, hardware, and accessories in 2012." "Industry Facts," Entertainment Software Association, http://www.theesa.com/facts (accessed July 1, 2013).

24. For a useful summary dialogue about the narratology vs. ludology debate, see Noah Wardrip-Fruin and Pat Harrigan, eds., *First Person: New Media As Story, Performance, and Game* (Cambridge, MA: MIT Press, 2004).

25. Spiro Kiousis, "Interactivity: A Concept Explication," *New Media & Society* 4, no. 3 (2002): 355–383; Greg M. Smith, "What Is Interactivity?," in *What Media Classes Really Want To Discuss: A Student Guide* (Abingdon and New York: Routledge, 2011): 135–153.

26. Edward Castronova, *Synthetic Worlds: The Business and Culture of Online Games* (Chicago: University of Chicago Press, 2005); Celia Pearce and Artemesia, *Communities of Play: Emergent Cultures in Multiplayer Games and Virtual Worlds* (Cambridge, MA: MIT Press, 2011); T. L. Taylor, *Play Between Worlds: Exploring Online Game Culture* (Cambridge, MA: MIT Press, 2009).

27. Jonathan L. Freedman, *Media Violence and its Effect on Aggression: Assessing the Scientific Evidence* (Toronto: University of Toronto Press, 2002); Christopher John Ferguson, "The Good, The Bad, and the Ugly: A Meta-analytic Review of Positive and Negative Effects of Violent Video Games," *Psychiatric Quarterly* 78, no. 4 (2007): 309–316; Christopher P. Bartlett, Craig A. Anderson, and Edward L. Swing, "Video Game Effects—Confirmed, Suspected, and Speculative: A Review of the Evidence," *Simulation and Gaming* 40, no. 3 (2009): 377–403.

28. Much research on computer/video games by education researchers has tended to focus on games that are specifically designed to deliver overtly educational content, creating "serious games" or "persuasive games." The drawback is that such games constitute a tiny minority of gameplay, compared with major gaming franchises. See Clark C. Abt, *Serious Games* (New York: Viking, 1970); Ian Bogost, *Persuasive Games: The Expressive Power of Videogames* (Cambridge, MA: MIT Press, 2007); Ute Ritterfeld, Michael Cody, and Peter Vorderer, eds., *Serious Games: Mechanisms and Effects* (New York and London: Routledge, 2010). Those education scholars who are more focused on games that are more widely played tend to frame their discussions in terms of ongoing discussion of what constitutes "media literacy." See James Paul Gee, *What Video Games Have To Teach Us about Learning and Literacy* (New York: Palgrave, 2007); Jane McGonigal, *Reality Is Broken: Why Games Make Us Better and How They Can Change the World* (New York: Penguin, 2011); Constance Steinkuehler, Kurt Squire, and Sasha Barab, eds., *Games, Learning, and Society: Learning and Meaning in the Digital Age*, Learning in Doing: Social, Cognitive and Computational Perspectives (Cambridge and New York: Cambridge University Press, 2012).

29. C. Shawn Green and Daphne Bavelier, "Action Video Game Modifies Visual Selective Attention," *Nature* 423, no. 6939 (2003): 534–537; C. S. Green and D. Bavelier, "Enumeration Versus Multiple Object Tracking: The Case of Action Video Game Players," *Cognition* 101, no. 1 (2006): 217–245; C. Shawn Green and Daphne Bavelier, "The Cognitive Neuroscience of Video Games," in *Digital Media: Transformations in Human Communication*, ed. Paul Messaris and Lee Humphreys (New York: Peter Lang, 2006), 211–224.

30. J. Matias Kivikangas, Guillaume Chanel, Ben Cowley, Inger Ekman, Mikko Salminen, Simo Jarvela, and Niklas Ravaja, "A Review of the Use of Psychophysiological Methods in Game Research," *Journal of Gaming and Virtual Worlds* 3, no. 3 (2011): 181–199; *Evaluating User Experience in Games: Concepts and Methods*, ed. Regina Bernhaupt, Human–Computer Interaction Series (London: Springer, 2010); Niklas Ravaja, Timo Saari, Mikko Salminen, Jari Laarni, and Kari Kallinen, "Phasic Emotional Reactions to Video Game Events: A Psychophysiological Investigation," *Media Psychology* 8, no. 4 (2006): 343–367; Fumiko Hoeft, Christa L. Watson, Shelli R. Kesler, Keith E. Bettinger, and Allan L. Reiss, "Gender Differences in the Mesocorticolimbic System During Computer Game-play," *Journal of Psychiatric Research* 42, no. 4 (2008): 253–258; Jyoti Mishra, Marla Zinni, Daphne Bavelier, and Steven A. Hillyard, "Neural Basis of Superior Performance of Action Videogame Players in an Attention-Demanding Task," *Journal of Neuroscience* 31, no. 3 (2011): 992–998.

31. Torben Grodal, "Video Games and the Pleasures of Control," in *Media Entertainment: The Psychology of Its Appeal*, ed. Dolf Zillman and Peter Vorderer (Mahwah, NJ: Lawrence Erlbaum Associates, 2000): 197–213; Torben Grodal, "Stories for Eye, Ear, and Muscles: Video Games, Media, and Embodied Experiences," in *The Video Game Theory Reader*, ed. Mark J. P. Wolf and Bernard Perron (New York and London: Routledge, 2003), 129–155; Andreas Gregersen and Torben Grodal, "Embodiment and Interface," in *The Video Game Theory Reader 2*, ed. Bernard Perron and Mark J. P. Wolf (London: Routledge, 2009), 65–83; Jonathan Frome, "Why Films Make Us Cry but Videogames Don't: Emotions in Traditional and Interactive

Media," Ph.D. dissertation, Madison: University of Wisconsin, 2006; Bernard Perron, "A Cognitive Psychological Approach to Gameplay Emotions," DIGRA Conference, Vancouver, 2005.

32. For a historical tracing of the situation in the American academy, see Todd Gitlin, "Media Sociology: The Dominant Paradigm," *Theory and Society* 6, no. 2 (1978): 205–253.

33. See Joseph Anderson's opening remarks, Society for Cognitive Studies of the Moving Image Conference, Roanoke, Virginia, 2010.

34. Antonio Damasio, *Self Comes To Mind: Constructing the Conscious Brain* (New York: Random House, 2010); Todd E. Feinberg, *From Axons To Identity: Neurological Explanations of the Nature of the Self* (New York: Norton, 2009); *The Extended Mind*, ed. Richard Menary, Life and Mind: Philosophical Issues in Biology and Psychology Series (Cambridge, MA: MIT Press, 2010); Thomas Metzinger, *The Ego Tunnel: The Science of the Mind and the Myth of the Self* (New York: Basic Books, 2010). Murray Smith takes some steps in this direction in "Consciousness," in *The Routledge Companion to Philosophy and Film*, ed. Paisley Livingston and Carl Plantinga (London and New York: Routledge, 2009), 39–51. Gal Raz, Boaz Hagin, and Talma Hendler also issue a call for the integration of empirical neuroscience and Continental philosophy in dealing with film; see "E-Motion Pictures of the Brain: Recursive Paths Between Affective Neuroscience and Film Studies," in *Psychocinematics: Exploring Cognition at the Movies*, ed. Arthur P. Shimamura (Oxford and New York: Oxford University Press, 2013), 285–313.

35. Brian Massumi, *Parables for the Virtual: Movement, Affect, Sensation* (Durham, NC: Duke University Press, 2002); *The Affect Theory Reader*, ed. Melissa Gregg and Gregory J. Seigworth (Durham, NC: Duke University Press, 2010).

36. For theorists of the affective turn, "movement" unites several meanings, from the notion of a spectator/viewer being emotionally "moved" at a work of art, to the transitory, fluctuating experience of the senses, to the moving image itself. For Deleuze, movement becomes something like a first principle of the universe, with the "movement-image" and the "time-image" presenting different ways of understanding the world (the former a rationalistic, mechanical attempt to control the world, the latter an attempt to conceptualize the flow of the past into the future). See Gilles Deleuze, *Cinema 1: The Movement-Image*, trans. Hugh Tomlinson and Barbara Habberjam (Minneapolis: University of Minnesota Press, 1986); Gilles Deleuze, *Cinema 2: The Time-Image*, trans. Hugh Tomlinson and Robert Galeta (Minneapolis: University of Minnesota Press, 1989). Within film cognitivism, see the section devoted to "Sensory and Attentional Features of Movies," in Shimamura, 113–190.

37. As opposed to the preferred term "pleasure" in psychoanalytically grounded thought. The terminological territory here is messy. Some contemporary literary theorists and narratologists deal with the "theory of mind" in ways that are slightly different from the philosophy of mind tradition cited earlier. See *Narrative Theory and the Cognitive Sciences*, ed. David Herman (Stanford: Center for the Study of Language and Information, 2003); Lisa Zunshine, *Why We Read Fiction: Theory of Mind and the Novel* (Columbus: Ohio State University Press, 2006); *The Work of Fiction: Cognition, Culture, and Complexity*, ed. Alan Richardson and Ellen Spolsky (Aldershot: Ashgate, 2004).

38. See the discussion of synesthesia in Jennifer M. Barker, *The Tactile Eye: Touch and the Cinematic Experience* (Berkeley: University of California Press, 2009), and Carl Plantinga, *Moving Viewers: American Film and the Spectator's Experience* (Berkeley: University of California Press, 2009). For a popular presentation on hallucinations, see Oliver Sacks, *Hallucinations* (New York: Vintage, 2012).

39. Richard Allen and Malcolm Turvey, eds., *Wittgenstein, Theory and the Arts* (London and New York: Routledge, 2001); Ellen Spolsky, "Darwin and Derrida: Cognitive Literary Theory as a Species of Post-Structuralism," *Poetics Today* 23, no. 1 (2002): 43–62; Catherine Malabou, *What Should We Do with Our Brain?*, trans. Sebastian Rand, *Perspectives in Continental Philosophy* (New York: Fordham University Press, 2008); William E. Connolly, *Neuropolitics: Thinking, Culture, Speed*, Theory Out of Bounds Vol. 23 (Minneapolis: University of Minnesota Press, 2002).

bibliography

books and journals

Aarseth, Espen J. *Cybertext: Perspectives on Ergodic Literature.* Baltimore, MD: Johns Hopkins University Press, 1997.

———. "Doors and Perception: Fiction vs. Simulation in Games." In *Proceedings, Digital Arts and Culture Conference 2005.* Copenhagen: ITU, 2005.

———. "From Hunt the Wumpus to EverQuest: Introduction to Quest Theory." In *Proceedings, Entertainment Computing: ICEC 2005: 4th International Conference,* 496–506. Sanda, Japan, 2005.

———. "Genre Trouble: Narrativism and the Art of Simulation." In Wardrip-Fruin and Harrigan, 45–55.

———. "Playing Research: Methodological Approaches to Game Analysis." In MelbourneDAC, The 5th International Digital Arts and Culture Conference, May 2003.

———. "Quest Games as Post-Narrative Discourse." In Ryan, 361–376.

Abbott, H. Porter. *The Cambridge Introductin to Narrative.* 2nd ed. Cambridge Introductions to Literature. Cambridge: Cambridge University Press, 2008.

Abt, Clark C. *Serious Games.* New York: Viking, 1970.

Adams, Russell J. "An Evaluation of Color Preference in Early Infancy." *Infant Behavior and Development* 10, no. 2 (1987): 143–150.

Adorno, Theodor W. *Aesthetic Theory*, edited by Gretel Adorno, Rolf Tiedemann, and Robert Hullot-Kentor; translated by Robert Hullot-Kentor. Continuum Impacts. London and New York: Continuum, 2004.

Ahmad, Aijaz. *In Theory: Classes, Nations, Literatures*. New York: Verso, 1992.

Allen, Richard. *Hitchcock's Romantic Irony*. Film and Culture. New York: Columbia University Press, 2007.

Allen, Richard, and Murray Smith, eds. *Film Theory and Philosophy*. Oxford and New York: Oxford University Press, 1997.

Allen, Richard, and Malcolm Turvey, eds. *Wittgenstein, Theory and the Arts*. London and New York: Routledge, 2001.

Anderson, Barbara. "Eye Movement and Cinematic Perception." *Journal of the University Film Association* 32 nos. 1 and 2 (1980): 23–26.

Anderson, Craig A., and Brad J. Bushman. "Effects of Violent Video Games on Aggressive Behavior, Aggressive Cognition, Aggressive Affect, Physiological Arousal, and Prosocial Behavior: A Meta-Analytic Review of the Scientific Literature." *Psychological Science* 12, no. 5 (2001): 353–359.

Anderson, Craig A., Douglas A. Gentile, and Katherine E. Buckley. *Violent Video Game Effects on Children and Adolescents: Theory, Research, and Public Policy*. New York: Oxford University Press, 2007.

Anderson, Joseph D. *The Reality of Illusion: An Ecological Approach to Cognitive Film Theory*. Carbondale: Southern Illinois University Press, 1996.

Anscombe, G. E. M. *Intention*. 2nd ed. Oxford: Basil Blackwell, 1976.

Appiah, Kwame Anthony. *Experiments in Ethics*. Cambridge, MA: Harvard University Press, 2008.

Apter, Michael. *Reversal Theory: The Dynamics of Motivation, Emotion and Personality*. Oxford: Oneworld, 2007.

Aristotle. *On Rhetoric: A Theory of Civic Discourse*. Translated by George A. Kennedy. New York: Oxford University Press, 1991.

Ashcroft, Bill, Gareth Griffiths, and Helen Tiffin. *The Empire Writes Back: Theory and Practice in Post-Colonial Literatures*. 2nd ed. New Accents. London and New York: Routledge, 2002.

Austin, J. L. "A Plea for Excuses: The Presidential Address." *Proceedings of the Aristotelian Society*, New Series 57 (1956–1957): 1–30.

Avedon, Elliott M., and Brian Sutton-Smith. *The Study of Games*. New York: John Wiley & Sons, 1971.

Baird, Robert. "The Startle Effect: Implications for Spectator Cognition and Media Theory." *Film Quarterly* 53, no. 3 (2000): 12–24.

Bakhtin, Mikhail. *Rabelais and His World*. Translated by Hélène Iswolsky. Cambridge, MA: MIT Press, 1968.

Bargh, John A., Mark Chen, and Lara Burrows. "Automaticity of Social Behavior: Direct Effects of Trait Construct and Stereotype Activation on Action." *Journal of Personality and Social Psychology* 71, no. 2 (1996): 230–244.

Barker, Jennifer M. *The Tactile Eye: Touch and the Cinematic Experience*. Berkeley: University of California Press, 2009.

Barkow, Jerome H., Leda Cosmides, and John Tooby, eds. *The Adapted Mind: Evolutionary Psychology and the Generation of Culture*. New York: Oxford University Press, 1992.

Baron-Cohen, Simon. *Mindblindness: An Essay on Autism and Theory of Mind*. Learning, Development, and Conceptual Change. Cambridge, MA: MIT Press, 1995.

———. *The Science of Evil: On Empathy and the Origins of Cruelty*. New York: Basic Books, 2011.

Barratt, Daniel. "The Paradox of Fiction Revisited: A Cognitive Approach to Understanding (Cinematic) Emotion." Ph.D. Thesis. University of Kent, UK, 2004.
———. "Understanding Cinema: Poetic Films and Embodied Viewers." *The Evolutionary Review: Art, Culture, Science* 1, no. 1 (2010): 84–87.
Barrett, David A. "Multiple Realizability, Identity Theory, and the Gradual Reorganization Principle." *British Journal for the Philosophy of Science* 64, no. 2 (2013): 325–346.
Barrett, L. F., and Moshe Bar. "See it With Feeling: Affective Predictions During Object Perception." *Philosophical Transactions of the Royal Society B: Biological Sciences* 364, no. 1521 (2009): 1325–1334.
Bartlett, Christopher P., Craig A. Anderson, and Edward L. Swing. "Video Game Effects—Confirmed, Suspected, and Speculative: A Review of the Evidence." *Simulation and Gaming* 40, no. 3 (2009): 377–403.
Baym, Nancy K. "Interpersonal Life Online." In *Handbook of New Media: Social Shaping and Consequences of ITCs*, edited by Leah A. Lievrouw and Sonia Livingstone, 35–54. London: Sage, 2006.
———. *Personal Connections in the Digital Age*. Digital Media and Society. Cambridge: Polity, 2010.
Bellour, Raymond. "Deleuze: The Thinking of the Brain." *Cinema: Journal of Philosophy and the Moving Image* 1 (2010): 81–94.
Benjamin, Walter. *Illuminations*. Translated and edited by Hannah Arendt. New York: Schocken, 1968.
Bennett, M. R., and P. M. S. Hacker. *Philosophical Foundations of Neuroscience*. Malden, MA: Wiley-Blackwell, 2003.
Bergeron, Vincent, and Dominic McIver Lopes. "Aesthetic Theory and Aesthetic Science: Prospects for Integration." In *Aesthetic Science: Connecting Minds, Brains, and Experience*, edited by Arthur P. Shimamura and Stephen E. Palmer, 63–79. New York: Oxford University Press, 2012.
Bergner, Daniel. *What Do Women Want? Adventures in the Science of Female Desire*. New York: HarperCollins, 2013.
Bergson, Henri. *Laughter: An Essay on the Meaning of the Comic*. New York: Macmillan, 1911.
Bernhaupt, Regina, ed. *Evaluating User Experience in Games: Concepts and Methods*. Human–Computer Interaction Series. London: Springer, 2010.
Billig, Michael. *Laughter and Ridicule: Towards a Social Critique of Humour*. London: Sage, 2005.
Blanchet, Robert, and Margrethe Bruun Vaage. "Don, Peggy and Other Fictional Friends? Engaging with Characters in Television Series." *Projections* 6, no. 2 (2012): 18–41.
Block, Bruce. *The Visual Story: Seeing the Structure of Film, TV, and New Media*. Woburn, MA: Focal Press, 2001.
Bogost, Ian. *Persuasive Games: The Expressive Power of Videogames*. Cambridge, MA: MIT Press, 2007.
Bordwell, David. "A Case for Cognitivism." *Iris* 9 (1989): 11–41.
———. "A Case for Cognitivism: Further Reflections." *Iris* 11 (1990): 107–112.
———. *The Cinema of Eisenstein*. Cambridge, MA: Cambridge University Press, 1993.
———. "Cognitive Theory." In Livingston and Plantinga, 356–367.
———. *Figures Traced in Light: On Cinematic Staging*. Berkeley: University of California Press, 2005.
———. *Making Meaning: Inference and Rhetoric in the Interpretation of Cinema*. Harvard Film Studies. Cambridge, MA: Harvard University Press, 1989.

———. *Narration in the Fiction Film*. Madison: University of Wisconsin Press, 1985.

———. "Neostructuralist Narratology and the Functions of Filmic Storytelling." In *Narrative Across Media: The Languages of Storytelling*, edited by Marie-Laure Ryan, 203–219. Nebraska: University of Nebraska Press, 2004.

———. *On the History of Film Style*. Cambridge, MA: Harvard University Press, 1997.

———. *Ozu and the Poetics of Cinema*. Princeton, NJ: Princeton University Press, 1988.

———. "The Part-Time Cognitivist: A View from Film Studies." *Projections: The Journal for Movies and Mind* 4, no. 2 (2010): 1–18.

———. *Poetics of Cinema*. New York: Routledge, 2008.

———. "The Viewer's Share: Models of Mind in Explaining Film." In Shimamura, 29–52.

———. *The Way Hollywood Tells It: Story and Style in Modern Movies*. Berkeley: University of California Press, 2006.

Bordwell, David, and Noël Carroll, eds. *Post-Theory: Reconstructing Film Studies*. Wisconsin Studies in Film. Madison: University of Wisconsin Press, 1996.

Bordwell, David, Janet Staiger, and Kristin Thompson. *The Classical Hollywood Cinema: Film Style and Mode of Production to 1960*. New York: Columbia University Press, 1985.

Bordwell, David, and Kristin Thompson. *Film Art: An Introduction*. 6th edn. New York: McGraw Hill, 2001.

Bornstein, Marc H. "Qualities of Color Vision in Infancy." *Journal of Experimental Child Psychology* 19, no. 3 (1975): 401–419.

Bornstein, Robert F. "Exposure and Affect: Overview and Meta-Analysis of Research, 1968–1987." *Psychological Bulletin* 106, no. 2 (1989): 265–289.

Boyd, Brian. *On the Origin of Stories: Evolution, Cognition, and Fiction*. Cambridge, MA: Harvard University Press, 2010.

Boyd, Brian, Joseph Carroll, and Jonathan Gottschall, eds. *Evolution, Literature, and Film: A Reader*. New York: Columbia University Press, 2010.

Boyd, Robert, and Peter J. Richerson. *Culture and the Evolutionary Process*. Chicago: University of Chicago Press, 1985.

Boyer, Pascal. *Religion Explained: The Human Instincts That Fashion Gods, Spirits and Ancestors*. London: William Heinemann, 2001.

Branigan, Edward. *Narrative Comprehension and Film*. Sightlines. London: Routledge, 1992.

———. *Point of View in the Cinema*. Approaches to Semiotics 66. Berlin: Walter de Gruyter, 1984.

Brunick, Kaitlin L., and James E. Cutting. "The Physical Features of Children's Films." (forthcoming).

Brunick, Kaitlin L., Jordan E. DeLong, and James E. Cutting. "The Use of Hue and Saturation in Children's Film." 10th International Conference of the Society for the Cognitive Studies of the Moving Image, June 2012. Sarah Lawrence College, Bronxville, New York.

Bruun Vaage, Margrethe. "Fictional Reliefs and Reality Checks." *Screen* 54, no. 2 (2013): 218–237.

———. "Seeing is Feeling: Empathy and the Film Spectator." Ph.D. dissertation. Oslo: University of Oslo, 2009.

Buchan, Suzanne. "Ghosts in the Machine: Experiencing Animation." In *Watch Me Move: The Animation Show*, edited by Greg Hilty and Alona Pardo, 28–38. London and New York: Merrell, 2011.

Buchan, Suzanne, ed. *Animated 'Worlds.'* Eastleigh, UK: John Libbey, 2006.

Buckland, Warren. "Introduction." In *Film Theory and Contemporary Hollywood Movies*, edited by Warren Buckland. AFI Film Readers, 1–16. New York and Abingdon: Routledge, 2009.

Bulgakowa, Oksana. *Herausforderung Eisenstein [Challenge Eisenstein]*. Berlin: Akademie der Künste der DDR, 1988.

Buller, David J. *Adapting Minds: Evolutionary Psychology and the Persistent Quest for Human Nature*. Cambridge, MA: MIT Press, 2005.

Bushman, Brad J., and Craig A. Anderson. "Comfortably Numb: Desensitizing Effects of Violent Media on Helping Others." *Psychological Science* 20, no. 3 (2009): 273–277.

Buswell, Guy Thomas. *How People Look at Pictures: A Study of the Psychology of Perception in Art.* Chicago: University of Chicago Press, 1935.

Cahn, Steven M., and Aaron Meskin, eds. *Aesthetics: A Comprehensive Anthology*. Blackwell Philosophy Anthologies. Malden, MA and Oxford: Blackwell, 2008.

Carey, Susan. *The Origin of Concepts*. Oxford Series in Cognitive Development. Oxford: Oxford University Press, 2009.

Carmi, Ran, and Laurent Itti. "Visual Causes Versus Correlates of Attention Selection in Dynamic Scenes." *Vision Research* 46, no. 26 (2006): 4333–4345.

Carroll, Joseph. "An Evolutionary Paradigm for Literary Study." *Style* 42, nos. 2–3 (2008): 103–137.

———. *Literary Darwinism: Evolution, Human Nature, and Literature*. New York and London: Routledge, 2004.

Carroll, Noël. "Art and Ethical Criticism: An Overview of Recent Directions of Research." *Ethics* 110, no. 2 (2000): 350–387.

———. "Art and Mood: Preliminary Notes and Conjectures." *The Monist* 86, no. 4 (2003): 521–555.

———. *Art in Three Dimensions*. Oxford: Oxford University Press, 2010.

———. "Film, Emotion, and Genre." In Plantinga and Smith, 21-47.

———. *Interpreting the Moving Image*. Cambridge Studies in Film. Cambridge: Cambridge University Press, 1998.

———. "Modernity and the Plasticity of Perception." *Journal of Aesthetics and Art Criticism* 59, no. 1 (2001): 11–17.

———. *Mystifying Movies: Fads and Fallacies in Contemporary Film Theory*. New York: Columbia University Press, 1988.

———. *The Philosophy of Horror, or Paradoxes of the Heart*. London and New York: Routledge, 1990.

———. *A Philosophy of Mass Art*. Oxford: Oxford University Press, 1998.

———. *The Philosophy of Motion Pictures*. Foundations of the Philosophy of the Arts. Malden, MA: Blackwell, 2008.

———. "The Power of Movies." *Daedalus* 114, no. 4 (1985): 79–103.

———. "Prospects for Film Theory: A Personal Assessment." In Bordwell and Carroll, 37–68.

———. *Theorizing the Moving Image*. Cambridge Studies in Film. Cambridge: Cambridge University Press, 1996.

———. "Toward a Theory of Film Suspense." In Carroll, *Theorizing the Moving Image*, 94–117.

———. "Toward a Theory of Point-of-View Editing: Communication, Emotion, and the Movies." In Carroll, *Theorizing the Moving Image*, 125–138.

Carroll, Noël, and William P. Seeley. "Cognitivism, Psychology, and Neuro-science: Movies as Attentional Engines." In Shimamura, 53–75.

Castellote, Juan M., Hatice Kumru, Ana Queralt, and Josep Valls-Solé. "A Startle Speeds Up the Execution of Externally Guided Saccades." *Experimental Brain Research* 177, no. 1 (2007): 129–136.

Castronova, Edward. *Synthetic Worlds: The Business and Culture of Online Games.* Chicago: University of Chicago Press, 2006.

Child, Irvin L., Jens A. Hansen, and Frederick W. Hornbeck. "Age and Sex Differences in Children's Color Preferences." *Child Development* 39, no. 1 (1968): 237–247.

Chion, Michel. *Audio-Vision: Sound on Screen.* Edited and translated by Claudia Gorbman. New York: Columbia University Press, 1990.

Chiu, Lian-Hwang. "A Cross-Cultural Comparison of Cognitive Styles in Chinese and American Children." *International Journal of Psychology* 7, no. 4 (1972): 235–242.

Choi, Incheol, Richard E. Nisbett, and Ara Norenzayan. "Causal Attribution Across Cultures: Variation and Universality." *Psychological Bulletin* 125, no. 1 (1999): 47–63.

Chua, Hannah Faye, Julie E. Boland, and Richard E. Nisbett. "Cultural Variation in Eye Movements During Scene Perception." *Proceedings of the National Academy of Sciences of the United States of America* 102, no. 35 (2005): 12629–12633.

Clark, David M., and John D. Teasdale. "Diurnal Variation in Clinical Depression and Accessibility of Memories of Positive and Negative Experiences." *Journal of Abnormal Psychology* 91, no. 2 (1982): 87–95.

Collingwood, R. G. "The Principles of Art." In Cahn and Meskin, 282–295.

Collins, Randall. *Violence: A Micro-Sociological Theory.* Princeton, NJ: Princeton University Press, 2008.

Collins, Suzanne. *The Hunger Games.* New York: Scholastic, 2008.

Connolly, William E. *Neuropolitics: Thinking, Culture, Speed.* Theory Out of Bounds Vol. 23. Minneapolis: University of Minnesota Press, 2002.

Cornwell, Regina. "Some Formalist Tendencies in the Current American Avant-Garde Film." *Studio International* 184, no. 948 (1972): 110–114.

Cosmides, Leda, and John Tooby. "Cognitive Adaptations for Social Exchange." In Barkow, Cosmides, and Tooby, 163–228.

———. "The Modular Nature of Human Intelligence." In *The Origin and Evolution of Intelligence*, edited by Arnold B. Scheibel and J. William Schopf, 71–101. Sudbury, MA: Jones & Bartlett, 1997.

Cosmides, Leda, John Tooby, and Jerome H. Barkow. "Introduction: Evolutionary Psychology and Conceptual Integration." In Barkow, Cosmides, and Tooby, 3–15.

Coutrot, Antoine, Nathalie Guyader, Gelu Ionescu, and Alice Caplier. "Influence of Soundtrack on Eye Movements During Video Exploration." *Journal of Eye Movement Research* 5, no. 4.2 (2012): 1–10.

Crary, Jonathan. *Techniques of the Observer: On Vision and Modernity in the Nineteenth Century.* Cambridge, MA: MIT Press, 1990.

Currie, Gregory. *Arts and Minds.* Oxford: Clarendon Press, 2004.

———. *Image and Mind: Film, Philosophy, and Cognitive Science.* Cambridge: Cambridge University Press, 1995.

———. "Narrative Desire." In Plantinga and Smith, 183–199.

Currie, Gregory, Matthew Kieran, Aaron Meskin, and Jon Robson, *Aesthetics and the Sciences of Mind*. Oxford: Oxford University Press (forthcoming 2014).

Curry, Oliver. "Who's Afraid of the Naturalistic Fallacy?" *Evolutionary Psychology* 4 (2006): 234–247.

Cutting, James E., Kaitlin L. Brunick, and Ayse Candan. "Perceiving Event Dynamics and Parsing Hollywood Films." *Journal of Experimental Psychology: Human Perception and Performance* 38, no. 6 (2012): 1476–1490.

Cutting, James E., Kaitlin L. Brunick, and Jordan E. Delong. "How Act Structure Sculpts Shot Lengths and Shot Transitions in Hollywood Film." *Projections* 5, no. 1 (2011): 1–16.

Cutting, James E., Kaitlin L. Brunick, Jordan E. DeLong, Catalina Iricinschi, and Ayse Candan. "Quicker, Faster, Darker: Changes in Hollywood Film Over 75 Years." *i-Perception* 2, no. 6 (2011): 569–576.

Cutting, James E., and Ayse Candan. "Movies, Evolution, and Mind: From Fragmentation to Continuity." *The Evolutionary Review* 4, no. 3 (Spring 2013): 25–35.

Cutting, James E., Jordan E. DeLong, and Kaitlin L. Brunick. "Visual Activity in Hollywood Film: 1935 to 2005 and Beyond." *Psychology of Aesthetics, Creativity, and the Arts* 5, no. 2 (2011): 115–125.

Cutting, James E., Jordan E. DeLong, and Christine E. Nothelfer. "Attention and the Evolution of Hollywood Film." *Psychological Science* 21, no. 3 (2010): 440–447.

Damasio, Antonio. *Self Comes To Mind: Constructing the Conscious Brain*. New York: Random House, 2010.

Darwin, Charles. *The Expression of the Emotions in Man and Animals*. London: John Murray, 1872.

——. *On the Origin of Species*. 1859. Cambridge, MA: Harvard University Press, 1964.

Davidson, Donald. *Essays on Actions and Events*. 2nd ed. Oxford: Clarendon Press, 1980.

Davidson, Richard J. "On Emotion, Mood, and Related Affective Constructs." In Ekman and Davidson, 51–55.

Davies, David. "'This is Your Brain on Art:' What Can Philosophy of Art Learn from Neuroscience?" In Currie, Kieran, Meskin, and Robson (forthcoming 2014).

Davies, Stephen. *The Artful Species: Aesthetics, Art, and Evolution*. Oxford: Oxford University Press, 2012.

Davis, Michael. "The Mammalian Startle Response." In *Neural Mechanisms of Startle Behavior*, edited by Robert C. Eaton, 287–351. New York: Plenum Press, 1984.

de Waal, Frans. *Good Natured: The Origins of Right and Wrong in Humans and Other Animals*. Cambridge, MA: Harvard University Press, 1996.

Deleuze, Gilles. *Cinema 1: The Movement-Image*. Translated by Hugh Tomlinson and Barbara Habberjam. Minneapolis: University of Minnesota Press, 1986.

——. *Cinema 2: The Time-Image*. Translated by Hugh Tomlinson and Robert Galeta. Minneapolis: University of Minnesota Press, 1989.

Dennett, Daniel C. *The Intentional Stance*. Cambridge, MA: MIT Press, 1987.

Dissanayake, Ellen. "Art and Intimacy: How the Arts Began." In Boyd, Carroll, and Gottschall, 144–155.

——. *Homo Aestheticus: Where Art Comes From and Why*. Seattle: University of Washington Press, 1992.

——. *What Is Art For?* Seattle: University of Washington Press, 1988.

309

Dmytryk, Edward. *On Filmmaking*. London: Focal Press, 1986.

Dorr, Michael, Thomas Martinetz, Karl R. Gegenfurtner, and Erhardt Barth. "Variability of Eye Movements When Viewing Dynamic Natural Scenes." *Journal of Vision* 10, no. 10 (2010): 1–17.

Dower, John W. *Embracing Defeat: Japan in the Wake of World War II*. New York: W.W. Norton, 1999.

Downes, Edward J., and Sally J. McMillan. "Defining Interactivity: A Qualitative Identification of Key Dimensions." *New Media Society* 2, no. 2 (2000): 157–179.

Dunbar, Robin I. M., Rebecca Baron, Anna Frangou, Eiluned Pearce, Edwin J. C. van Leeuwen, Julie Stow, Giselle Partridge, Ian MacDonald, Vincent Barra, and Mark van Vugt. "Social Laughter is Correlated with an Elevated Pain Threshold." *Proceedings of the Royal Society of Biological Sciences* 279, no. 1731 (22 March 2012): 1161–1167.

Dunleavy, Trisha. *Television Drama: Form, Agency, Innovation*. London: Palgrave Macmillan, 2009.

Durst-Andersen, Per. "What Languages Tell Us About the Structure of the Human Mind." *Cognitive Computation* 4, no. 1 (2012): 82–97.

Dutton, Denis. *The Art Instinct: Beauty, Pleasure, and Human Evolution*. New York: Bloomsbury, 2009.

Egenfeldt-Nielsen, Simon, Jonas Heide Smith, and Susana Pajares Tosca. *Understanding Video Games: The Essential Introduction*. New York: Routledge, 2008.

Eisenstein, Sergei M. *The Film Sense*. Translated and edited by Jay Leyda. London: Faber & Faber, 1943.

——. *Notes of a Film Director*. Translated by X. Danko. New York: Dover, 1970.

Eitzen, Dirk. "Evolution, Functionalism, and the Study of American Cinema." *The Velvet Light Trap* 28 (1991): 73–85.

Ekman, Paul, and Richard J. Davidson, eds. *The Nature of Emotion: Fundamental Questions*. Series in Affective Science. New York: Oxford University Press, 1994.

Evans, Kris, Caren M. Rotello, Xingshan Li, and Keith Rayner. "Scene Perception and Memory Revealed by Eye Movements and Receiver-Operating Characteristic Analyses: Does a Cultural Difference Truly Exist?" *Quarterly Journal of Experimental Psychology* 62, no. 2 (2009): 276–285.

Eysenck, H. J. "A Critical and Experimental Study of Colour Preferences." *American Journal of Psychology* 54, no. 3 (1941): 385–394.

Feeney, Brooke C., and Roxanne L. Thrush. "Relationship Influences on Exploration in Adulthood: The Characteristics and Function of a Secure Base." *Journal of Personality and Social Psychology* 98, no. 1 (2010): 57–76.

Feinberg, Todd E. *From Axons to Identity: Neurological Explanations of the Nature of the Self*. New York: Norton, 2009.

Feltham, Brian, and John Cottingham, eds. *Partiality and Impartiality: Morality, Special Relationships, and the Wider World*. Oxford: Oxford University Press, 2010.

Ferguson, Christopher John. "The Good, The Bad, and the Ugly: A Meta-analytic Review of Positive and Negative Effects of Violent Video Games." *Psychiatric Quarterly* 78, no. 4 (2007): 309–316.

Fernández-Dols, José-Miguel, Flor Sánchez, Pilar Carrera, and Maria-Angeles Ruiz-Belda. "Are Spontaneous Expressions and Emotions Linked? An Experimental Test of Coherence." *Journal of Nonverbal Behavior* 21, no. 3 (1997): 163–177.

Findlay, John M., and Iain D. Gilchrist. *Active Vision: The Psychology of Looking and Seeing*. Oxford Psychology Series. Oxford: Oxford University Press, 2003.

Fodor, Jerry. "Let Your Brain Alone." *London Review of Books* 21, no. 19 (1999): 68–69.

——. *The Mind Doesn't Work That Way: The Scope and Limits of Computational Psychology*. Representation and Mind. Cambridge, MA: MIT Press, 2000.

——. *The Modularity of Mind: An Essay on Faculty Psychology*. Cambridge, MA: MIT Press, 1983.

Forgas, Joseph P. "Affect and Information Processing Strategies: An Interactive Relationship." In Forgas, *Feeling and Thinking*, 253–280.

——. "Introduction: The Role of Affect in Social Cognition." In Forgas, *Feeling and Thinking*, 1–28.

Forgas, Joseph P., ed. *Feeling and Thinking: The Role of Affect in Social Cognition*. Studies in Emotion and Social Interaction, Second Series. Cambridge and Paris: Cambridge University Press/Maison des Sciences de l'Homme, 2000.

Fosnot, Catherine Twomey, ed. *Constructivism: Theory, Perspectives, and Practice*. 2nd ed. Williston, VT: Teachers College Press, 2005.

Frasca, Gonzalo. "Simulation Versus Narrative: Introduction to Ludology." In Wolf and Perron, 221–235.

Freedberg, David, and Vittorio Gallese. "Motion, Emotion and Empathy in Esthetic Experience." *Trends in Cognitive Sciences* 11, no. 5 (2007): 197–203.

Freedman, Jonathan L. *Media Violence and its Effect on Aggression: Assessing the Scientific Evidence*. Toronto: University of Toronto Press, 2002.

Freud, Sigmund. *Jokes and Their Relation to the Unconscious*. 1904. London: Hogarth Press, 1960.

Frijda, Nico H. "Emotion Experience and its Varieties." *Emotion Review* 1, no. 3 (2009): 264–271.

——. *The Emotions*. Studies in Emotion and Social Interaction. Cambridge: Cambridge University Press, 1986.

——. "Impulsive Action and Motivation." *Biological Psychology* 84, no. 3 (2010): 570–579.

——. *The Laws of Emotion*. Mahwah, NJ: Lawrence Erlbaum Associates, 2007.

Frijda, Nico H., and Louise Sundararajan. "Emotion Refinement: A Theory Inspired by Chinese Poetics." *Perspectives on Psychological Science* 2, no. 3 (2007): 227–241.

Frome, Jonathan. "Representation, Reality, and Emotions Across Media." *Film Studies* 8 (2006): 12–25.

——. "Why Films Make Us Cry but Videogames Don't: Emotions in Traditional and Interactive Media," Ph.D. dissertation. Madison: University of Wisconsin, 2006.

Gallagher, Shaun. *How the Body Shapes the Mind*. Oxford: Oxford University Press, 2005.

Gallagher, Shaun, and Dan Zahavi. *The Phenomenological Mind: An Introduction to Philosophy of Mind and Cognitive Science*. Abingdon and New York: Routledge, 2008.

Gallese, Vittorio, Christian Keysers, and Giacomo Rizzolatti. "A View of the Basis of Social Cognition." *Trends in Cognitive Sciences* 8, no. 9 (2004): 396–403.

Gee, James Paul. *What Video Games Have To Teach Us about Learning and Literacy*. New York: Palgrave, 2007.

Gerrig, Richard J., and Matthew E. Jacovina. "Reader Participation in the Experience of Narrative." In *The Psychology of Learning and Motivation Vol. 51: Advances in Research and Theory*, edited by Brian H. Ross, 223–254. Burlington, MA: Academic Press, 2009.

Gibson, James J. *The Ecological Approach to Visual Perception*. Boston: Houghton Mifflin, 1979.

Giard, M. H., and F. Peronnet. "Auditory-Visual Integration During Multimodal Object Recognition in Humans: A Behavioral and Electrophysical Study." *Journal of Cognitive Neuroscience* 11, no. 5 (1999): 473–490.

Gidal, Peter. *Materialist Film*. London and New York: Routledge, 1989.

Gitlin, Todd. "Media Sociology: The Dominant Paradigm." *Theory and Society* 6, no. 2 (1978): 205–253.

Goldstein, Robert B., Russell L. Woods, and Eli Peli. "Where People Look When Watching Movies: Do All Viewers Look at the Same Place?" *Computers in Biology and Medicine* 37, no. 7 (2007): 957–964.

Gould, Stephen Jay. "Evolution: The Pleasures of Pluralism." *New York Review of Books* 44, no. 11 (June 26, 1997): 47–52.

———. "Sociobiology: The Art of Storytelling." *New Scientist* (November 16, 1978): 530–533.

Gould, S. J., and R. C. Lewontin. "The Spandrels of San Marco and the Panglossian Paradigm: A Critique of the Adaptationist Programme." *Proceedings of the Royal Society of London Series B, Biological Sciences* 205, no. 1161 (September 21, 1979): 581–598.

Granger, G. W. "Objectivity of Colour Preferences." *Nature* 170 (1952): 178–180.

Green, C. Shawn, and Daphne Bavelier. "Action Video Game Modifies Visual Selective Attention." *Nature* 423, no. 6939 (2003): 534–537.

———. "The Cognitive Neuroscience of Video Games." In *Digital Media: Transformations in Human Communication*, edited by Paul Messaris and Lee Humphreys, 211–224. New York: Peter Lang, 2006.

———. "Enumeration Versus Multiple Object Tracking: The Case of Action Video Game Players." *Cognition* 101, no. 1 (2006): 217–245.

Green, Melanie C., and Timothy C. Brock. "In the Mind's Eye: Transportation-Imagery Model of Narrative Persuasion." In *Narrative Impact: Social and Cognitive Foundations*, edited by Melanie C. Green, Jeffrey J. Strange, and Timothy C. Brock, 315–341. Mahwah, NJ: Lawrence Erlbaum Associates, 2002.

Gregersen, Andreas. "Genre, Technology and Embodied Interaction: The Evolution of Digital Game Genres and Motion Gaming." *MedieKultur: Journal of Media and Communication Research* 27, no. 51 (2011): 94–109.

Gregersen, Andreas L. "Cognition." In *The Routledge Companion to Video Game Studies*, edited by Bernard Perron and Mark J. P. Wolf, 417–426. New York: Routledge, 2014.

"Generic Structures, Generic Experiences: A Cognitive Experientalist Approach to Video Game Analysis." *Philosophy & Technology*. Prepublished online August 13, 2013. DOI: 10.1007/s13347-013-0125-8.

Gregersen, Andreas, and Torben Grodal. "Embodiment and Interface." In *The Video Game Theory Reader 2*, edited by Bernard Perron and Mark J. P. Wolf, 65–83. London: Routledge, 2009.

Gregg, Melissa, and Gregory J. Seigworth, eds. *The Affect Theory Reader*. Durham, NC: Duke University Press, 2010.

Gripsrud, Jostein. *The Dynasty Years: Hollywood Television and Critical Media Studies*. London: Routledge, 1995.

Grodal, Torben. *Embodied Visions: Evolution, Emotion, Culture, and Film*. New York: Oxford University Press, 2009.

———. *Moving Pictures: A New Theory of Film Genres, Feelings, and Cognition*. Oxford: Clarendon Press, 1997.

———. "The PECMA Flow: A General Theory of Visual Aesthetics." *Film Studies* 8 (2006): 1–11.

———. "Stories for Eye, Ear, and Muscles: Video Games, Media, and Embodied Experiences." In Wolf and Perron, 129–155.

———. "Video Games and the Pleasures of Control." In *Media Entertainment: The Psychology of its Appeal*, edited by Dolf Zillmann and Peter Vorderer, 197–213. Mahwah, NJ: Lawrence Erlbaum Associates, 2000.

Grossman, Dave. *On Killing: The Psychological Cost of Learning to Kill in War and Society*. Revised. New York: Back Bay Books, 2009.

Haidt, Jonathan. "The Emotional Dog and its Rational Tail: A Social Intuitionist Approach to Moral Judgment." *Psychological Review* 108, no. 4 (2001): 814–834.

———. *The Righteous Mind: Why Good People are Divided by Politics and Religion*. London: Allen Lane, 2012.

Haidt, Jonathan, and Frederik Bjorklund. "Social Intuitionists Answer Six Questions About Morality." In *Moral Psychology Vol. 2: The Cognitive Science of Morality: Intuition and Diversity*, edited by Walter Sinnott-Armstrong, 181–217. Cambridge, MA: MIT Press, 2008.

Haidt, Jonathan, and Selin Kesebir. "Morality." In *Handbook of Social Psychology*, edited by Susan T. Fiske, Daniel T. Gilbert, and Gardner Lindzey, 797–832. 5th ed. Hoboken, NJ: Wiley, 2010.

Harlow, Barbara. *Resistance Literature*. New York: Routledge, 1987.

Harnish, Robert M. *Minds, Brains, Computers: An Historical Introduction to the Foundations of Cognitive Science*. Malden, MA: Wiley-Blackwell, 2001.

Hasson, Uri, Ohad Landesman, Barbara Knappmeyer, Ignacio Vallines, Nava Rubin, and David J. Heeger. "Neurocinematics: The Neuroscience of Film." *Projections: The Journal of Movies and Mind* 2, no. 1 (2008): 1–26.

Hedden, Trey, Sarah Ketay, Arthur Aron, Hazel Rose Markus, and John D. E. Gabrieli. "Cultural Influences on Neural Substrates of Attentional Control." *Psychological Science* 19, no. 1 (2008): 12–17.

Heeter, Carrie. "Implications of New Interactive Technologies for Conceptualizing Communications." In *Media Use in the Information Age: Emerging Patterns of Adoption and Consumer Use*, edited by Jerry L. Salvaggio and Jennings Bryant, 217–236. Hillsdale, NJ: Lawrence Erlbaum Associates, 1989.

Hegel, Georg Wilhelm Friedrich. *The Philosophy of Fine Art*. Translated by F. P. B. Osmaston. London: B. Bell & Sons, 1920.

Heider, Fritz, and Marianne Simmel. "An Experimental Study of Apparent Behavior." *American Journal of Psychology* 57, no. 2 (1944): 243–259.

Henderson, John M., and Andrew Hollingworth. "High-Level Scene Perception." *Annual Review of Psychology* 50 (1999): 243–271.

Herman, David. *Story Logic: Problems and Possibilities of Narrative*. Frontiers of Narrative. Lincoln: University of Nebraska Press, 2002.

Herman, David, ed. *Narrative Theory and the Cognitive Sciences*. Stanford: Center for the Study of Language and Information, 2003.

Hirano, Kyoko. *Mr. Smith Goes to Tokyo: Japanese Cinema Under the American Occupation, 1945–1952*. Smithsonian Studies in the History of Film and Television. Washington, DC: Smithsonian Institution Press, 1992.

Hirschfeld, Lawrence A., and Susan A. Gelman, eds. *Mapping the Mind: Domain Specificity in Cognition and Culture*. Cambridge: Cambridge University Press, 1994.

Hoeft, Fumiko, Christa L. Watson, Shelli R. Kesler, Keith E. Bettinger, and Allan L. Reiss. "Gender Differences in the Mesocorticolimbic System During Computer Game-play." *Journal of Psychiatric Research* 42, no. 4 (2008): 253–258.

Hogan, Patrick Colm. *Cognitive Science, Literature, and the Arts: A Guide for Humanists*. New York: Routledge, 2003.

———. "For Evolutionary Criticism, Against Genetic Absolutism." *Style* 42, nos. 2–3 (2008): 202–206.

———. *Understanding Indian Movies: Culture, Cognition, and Cinematic Imagination*. Cognitive Approaches to Literature and Culture. Austin: University of Texas Press, 2008.

———. *What Literature Teaches Us About Emotion*. Studies in Emotion and Social Interaction, Second Series. Cambridge and New York: Cambridge University Press, 2011.

Hornsby, Jennifer. *Actions*. International Library of Philosophy. London: Routledge & Kegan Paul, 1980.

Hughes, Robert. *The Shock of the New: Art and the Century of Change*. London: Thames & Hudson, 2009.

Hurlbert, Anya C., and Yazhu Ling. "Biological Components of Sex Differences in Color Preference." *Current Biology* 17, no. 16 (2007): R623–R625.

Hutchby, Ian. "Technologies, Texts and Affordances." *Sociology* 35, no. 2 (2001): 441–456.

Hyman, John. "Art and Neuroscience." In *Beyond Mimesis and Convention: Representation in Art and Science*, edited by Roman Frigg and Matthew C. Hunter, 245–261. Boston Studies in the Philosophy of Science 262. Dordrecht and London: Springer, 2010.

Iacoboni, Marco. "Within Each Other: Neural Mechanisms for Empathy in the Primate Brain." In Coplan and Goldie, 45–57.

Inwood, Michael. *Heidegger: A Very Short Introduction*. Very Short Introductions. Oxford: Oxford University Press, 2002.

Isen, Alice M. "Positive Affect and Decision Making." In *The Handbook of Emotions*, edited by Michael Lewis and Jeanette M. Haviland, 417–435. New York: Guilford Press, 1993.

———. "Toward Understanding the Role of Affect in Cognition." In *The Handbook of Social Cognition*, edited by Robert S. Wyer, Jr., and Thomas K. Srull, 179–236. Vol. 3. Mahweh, NJ: Lawrence Erlbaum Associates, 1984.

Itti, Laurent. "Quantifying the Contribution of Low-Level Saliency to Human Eye Movements in Dynamic Scenes." *Visual Cognition* 12, no. 6 (2005): 1093–1123.

James, David E. *Allegories of Cinema: American Film in the Sixties*. Princeton, NJ: Princeton University Press, 1989.

Jameson, Fredric. "Third-World Literature in the Era of Multinational Capital." *Social Text* 15 (1986): 65–88.

Jenkins, Henry. "Game Design as Narrative Architecture." In Wardrip-Fruin and Harrigan, 118–130.

Jensen, Jens F. "'Interactivity': Tracking a New Concept in Media and Communication Studies." In *Computer Media and Communication: A Reader*, edited by Paul A. Mayer, 160–187. Oxford Readers in Media and Communication. Oxford: Oxford University Press, 1999.

Ji, Li-Jun, Kaiping Peng, and Richard E. Nisbett. "Culture, Control, and Perception of Relationships in the Environment." *Journal of Personality and Social Psychology* 78, no. 5 (2000): 943–955.

Jones, Gerard. *Killing Monsters: Why Children Need Fantasy, Super Heroes, and Make-Believe Violence*. New York: Basic Books, 2002.

Jordan, G., and J. D. Mollon. "A Study of Women Heterozygous for Colour Deficiencies." *Vision Research* 33, no. 11 (1993): 1495–1508.

Juul, Jesper. *Half-Real: Video Games Between Real Rules and Fictional Worlds.* Cambridge, MA: MIT Press, 2005.

Kahneman, Daniel. *Thinking, Fast and Slow.* London: Allen Lane, 2011.

Kaya, Naz., and Helen H. Epps. "Color–Emotion Associations: Past Experience and Personal Preference." In *AIC 2004 Color and Paints, Interim Meeting of the International Color Association, Proceedings* 5 (2004): 31–34.

Keysers, Christian, Jon H. Kaas, and Valeria Gazzola. "Somatosensation in Social Perception." *Nature Reviews* 11 (2010): 417–428.

King, Geoff, and Tanya Krzywinska. "Film Studies and Digital Games." In *Understanding Digital Games*, edited by Jason Rutter and Jo Bryce, 112–128. London: Sage, 2006.

Kiousis, Spiro. "Interactivity: A Concept Explication." *New Media & Society* 4, no. 3 (2002): 355–383.

Kitayama, Shinobu, Sean Duffy, Tadashi Kawamura, and Jeff T. Larsen. "Perceiving an Object and its Context in Different Cultures: A Cultural Look at New Look." *Psychological Science* 14, no. 3 (2003): 201–206.

Kivikangas, J. Matias, Guillaume Chanel, Ben Cowley, Inger Ekman, Mikko Salminen, Simo Jarvela, and Niklas Ravaja. "A Review of the Use of Psychophysiological Methods in Game Research." *Journal of Gaming and Virtual Worlds* 3, no. 3 (2011): 181–199.

Kramer, Mette, and Torben Grodal. "Partner Selection and Hollywood Films." In *The Psychology of Love. Volume 2: Emotion and Romance*, edited by Michele E. Paludi, 3–22. Santa Barbara: Praeger, 2012.

Kutner, Lawrence, and Cheryl K. Olson. *Grand Theft Childhood: The Surprising Truth About Violent Video Games and What Parents Can Do.* New York: Simon & Schuster, 2008.

Landa, Edward, and Mark Fairchild. "Charting Color From the Eye of the Beholder." *American Scientist* 93 (2005): 436–443.

Lang, Peter J., Margaret M. Bradley, and Bruce N. Cuthbert. "Emotion, Attention, and the Startle Reflex." *Psychological Review* 97, no. 3 (1990): 377–395.

Langacker, Ronald W. *Concept, Image, and Symbol: The Cognitive Basis of Grammar.* 2nd ed. Berlin: Mouton de Gruyter, 2002.

Lasseter, John. "Principles of Traditional Animation Applied to 3D Computer Animation." *ACM Siggraph Computer Graphics* 21, no. 4 (1987): 35–44.

Laurel, Brenda. *Computers as Theatre.* Reading, MA: Addison-Wesley, 1993.

Le Grice, Malcolm. *Abstract Film and Beyond.* London: Studio Vista, 1976.

Leslie, Alan M. "ToMM, ToBY, and Agency: Core Architecture and Domain Specificity." In Hirschfeld and Gelman, 119–148.

Livingston, Paisley. "On the Appreciation of Cinematic Adaptations." *Projections* 4, no. 2 (2010): 104–127.

Livingston, Paisley, and Carl Plantinga, eds. *The Routledge Companion to Philosophy and Film.* Routledge Philosophy Companions. London and New York: Routledge, 2009.

Machin, Anna J., and Robin I. M. Dunbar. "The Brain Opioid Theory of Social Attachment: A Review of the Evidence." *Behaviour* 148, no. 9–10 (2011): 985–1025.

Malabou, Catherine. *What Should We Do with Our Brain?* Translated by Sebastian Rand. Perspectives in Continental Philosophy. New York: Fordham University Press, 2008.

Malmo, Robert B. *On Emotions, Needs and Our Archaic Brain.* New York: Holt, Rinehart & Winston, 1975.

Mandler, Jean Matter. *The Foundations of Mind: Origins of Conceptual Thought.* Oxford Series in Cognitive Development. New York: Oxford University Press, 2004.

Marchant, Paul, David Raybould, Tony Renshaw, and Richard Stevens. "Are You Seeing What I'm Seeing? An Eye-Tracking Evaluation of Dynamic Scenes." *Digital Creativity* 20, no. 3 (2009): 153–163.

Marr, David. *Vision: A Computational Investigation into the Human Representation and Processing of Visual Information.* San Francisco: W. H. Freeman, 1982.

Martin, Rod A. *The Psychology of Humor: An Integrative Approach.* London: Elsevier, 2007.

Massumi, Brian. *Parables for the Virtual: Movement, Affect, Sensation.* Durham, NC: Duke University Press, 2002.

Masuda, Takahiko, Richard Gonzalez, Letty Kwan, and Richard E. Nisbett. "Culture and Aesthetic Preference: Comparing the Attention to Context of East Asians and Americans." *Personality and Social Psychology Bulletin* 34, no. 9 (2008): 1260–1275.

Masuda, Takahiko, and Richard E. Nisbett. "Attending Holistically Versus Analytically: Comparing the Context Sensitivity of Japanese and Americans." *Journal of Personality and Social Psychology* 81, no. 5 (2001): 922–934.

———. "Culture and Change Blindness." *Cognitive Science* 30, no. 2 (2006): 381–399.

Mathews, Kenneth E., and Lance Kirkpatrick Canon. "Environmental Noise Level as a Determinant of Helping Behavior." *Journal of Personality and Social Psychology* 32, no. 4 (1975): 571–577.

Matin, Ethel. "Saccadic Suppression: A Review and an Analysis." *Psychological Bulletin* 81, no. 12 (1974): 899–917.

Matravers, Derek. "Art, Expression, and Emotion." In *The Routledge Companion to Aesthetics,* edited by Berys Gaut and Dominic McIver Lopes, 445–456. 2nd ed. London and New York: Routledge, 2005.

May, Jon, Michael P. Dean, and Philip J. Barnard. "Using Film Cutting Techniques in Interface Design." *Human–Computer Interaction* 18, no. 4 (2003): 325–372.

McCall, Anthony, and Andrew Tyndall. "Sixteen Working Statements." *Millennium Film Journal* 1, no. 2 (1978): 29–37.

McDonald, John J., Wolfgang A. Teder-Sälejärvi, and Steven A. Hillyard. "Involuntary Orienting to Sound Improves Visual Perception." *Nature* 407 (2000): 906–908.

McGonigal, Jane. *Reality Is Broken: Why Games Make Us Better and How They Can Change the World.* New York: Penguin, 2011.

McGurk, Harry, and John MacDonald. "Hearing Lips and Seeing Voices." *Nature* 264, no. 5588 (1976): 746–748.

McManus, I. C., Amanda L. Jones, and Jill Cottrell. "The Aesthetics of Colour." *Perception* 10, no. 6 (1981): 651–666.

McMillan, Sally J. "Exploring Models of Interactivity from Multiple Research Traditions: Users, Documents, and Systems." In *The Handbook of New Media: Updated Student Edition,* edited by Leah A. Lievrouw and Sonia Livingstone, 205–229. London: Sage, 2006.

———. "A Four-Part Model of Cyber-Interactivity: Some Cyber-Places Are More Interactive Than Others." *New Media Society* 4, no. 2 (2002): 271–291.

Mellen, Joan. *The Waves at Genji's Door: Japan Through Its Cinema.* New York: Pantheon, 1976.

Menary, Richard, ed. *The Extended Mind.* Life and Mind: Philosophical Issues in Biology and Psychology Series. Cambridge, MA: MIT Press, 2010.

Messaris, Paul. *Visual Literacy: Image, Mind, and Reality.* Boulder: Westview Press, 1994.

Metzinger, Thomas. *The Ego Tunnel: The Science of the Mind and the Myth of the Self.* New York: Basic Books, 2010.

Miller, Geoffrey. "Arts of Seduction." In Boyd, Carroll, and Gottschall, 156–173.

Miller, Jared E., Laura A. Carlson, and J. Devin McAuley. "When What You Hear Influences When You See: Listening to an Auditory Rhythm Influences the Temporal Allocation of Visual Attention." *Psychological Science* 24, no. 1 (2013): 11–18.

Mishra, Jyoti, Marla Zinni, Daphne Bavelier, and Steven A. Hillyard. "Neural Basis of Superior Performance of Action Videogame Players in an Attention-Demanding Task." *Journal of Neuroscience* 31, no. 3 (2011): 992–998.

Mital, Parag K., Tim J. Smith, Robin L. Hill, and John M. Henderson. "Clustering of Gaze During Dynamic Scene Viewing is Predicted by Motion." *Cognitive Computation* 3, no. 1 (2011): 5–24.

Mittell, Jason. *Complex TV: The Poetics of Contemporary Television Storytelling.* Pre-Publication Edition: MediaCommons Press, 2012–2013.

———. "Narrative Complexity in Contemporary American Television." *The Velvet Light Trap* 58 (2006): 29–40.

Moeller, Thomas G. *Youth Aggression and Violence: A Psychological Approach.* New York: Routledge, 2001.

Mullarkey, John. *Refractions of Reality: Philosophy and the Moving Image.* Houndmills: Palgrave Macmillan, 2009.

Munsell, A. H. *A Color Notation.* 5th ed. New York: Munsell Color Company, 1919.

———. "A Pigment Color System and Notation." *American Journal of Psychology* 23, no. 2 (1912): 236–244.

Münsterberg, Hugo. *The Photoplay: A Psychological Study.* New York: D. Appleton, 1916.

Murch, Walter. "Foreword." In *Audio-Vision: Sound on Screen.* By Michel Chion. Edited and translated by Claudia Gorbman, vii–xxiv. New York: Columbia University Press, 1990.

———. *In the Blink of an Eye: A Perspective on Film Editing.* 2nd ed. Los Angeles: Silman-James Press, 2001.

Nagy, Allen L., Donald I. A. MacLeod, Nicholas E. Heyneman, and Alvin Eisner, A. "Four Cone Pigments in Women Heterozygous for Color Deficiency." *Journal of the Optical Society of America* 71, no. 6 (1981): 719–722.

Nannicelli, Ted. "Why Can't Screenplays Be Artworks?" *Journal of Aesthetics and Art Criticism* 69, no. 4 (2011): 405–414.

Neale, Steve. *Genre and Hollywood.* London: Routledge, 2000.

Neisser, Ulric. *Cognition and Reality. Principles and Implications of Cognitive Psychology.* San Francisco: W. H. Freeman, 1976.

Neitz, Maureen, Timothy W. Kraft, and Jay Neitz. "Expression of L Cone Pigment Gene Subtypes in Females." *Vision Research* 38, no. 21 (1998): 3221–3225.

317

Nelson, Robin. *State of Play: Contemporary "High-End" TV Drama.* Manchester: Manchester University Press, 2007.

Newman, Michael Z. "Characterization as Social Cognition in *Welcome to the Dollhouse.*" *Film Studies: An International Review* 8 (2006): 53–67.

Newman, Michael Z., and Elana Levine. *Legitimating Televsion: Media Convergence and Cultural Status.* New York: Routledge, 2012.

Noton, David, and Lawrence Stark. "Scanpaths in Eye Movements During Pattern Perception." *Science* 171, no. 3968 (1971): 308–311.

Nyström, Marcus, and Kenneth Holmqvist. "Effect of Compressed Offline Foveated Video on Viewing Behavior and Subjective Quality." *ACM Transactions on Multimedia Computing, Communications, and Applications (TOMCCAP)* 6, no. 1 (2010): 1–16.

Oatley, Keith. *Such Stuff as Dreams: The Psychology of Fiction.* Chichester: Wiley-Blackwell, 2011.

Oliver, Mary Beth, and Anne Bartsch. "Appreciation of Entertainment: The Importance of Meaningfulness via Virtue and Wisdom." *Journal of Media Psychology* 23, no. 1 (2011): 29–33.

Overeem, Sebastiaan, Walter Taal, E. Öcal Gezici, Gert Jan Lammers, and J. Gert Van Dijk. "Is Motor Inhibition During Laughter Due to Emotional or Respiratory Influences?" *Psychophysiology* 41, no. 2 (2004): 254–258.

Palmer, Jerry. *The Logic of the Absurd: On Film and Television Comedy.* London: BFI, 1987.

Palmer, Stephen E., and Karen B. Schloss. "An Ecological Valence Theory of Human Color Preference." *Proceedings of the National Academy of Sciences of the United States of America* 107, no. 19 (2010): 8877–8882.

Panksepp, Jaak. *Affective Neuroscience: The Foundation of Human and Animal Emotion.* New York: Oxford University Press, 1998.

Pannasch, Sebastian, Daniel S. Seldon, Boris M. Velichkovsky, and Bruce Bridgeman. "Apparent Phi-Motion in Sequences of Eisenstein's *October.*" *Gestalt Theory* 33, no. 1 (2011): 69–80.

Pashler, Harold, ed. *Attention.* Studies in Cognition. Hove, UK: Psychology Press, 1998.

Pearce, Celia, and Artemesia. *Communities of Play: Emergent Cultures in Multiplayer Games and Virtual Worlds.* Cambridge, MA: MIT Press, 2011.

Pellis, Sergio, and Vivien Pellis. *The Playful Brain: Venturing to the Limits of Neuroscience.* London: Oneworld, 2010.

Peng, Kaiping, and Richard E. Nisbett. "Culture, Dialectics, and Reasoning About Contradiction." *American Psychologist* 54, no. 9 (1999): 741–754.

Pepperman, Richard D. *The Eye is Quicker: Film Editing: Making a Good Film Better.* Los Angeles: Michael Wiese Productions, 2004.

Perron, Bernard. "A Cognitive Psychological Approach to Gameplay Emotions." DIGRA Conference, Vancouver, 2005.

———. "From Gamers to Players and Gameplayers." In Wolf and Perron, 237–258.

Pessoa, Luiz, Sabine Kastner, and Leslie G. Ungerleider. "Attentional Control of the Processing of Neutral and Emotional Stimuli." *Cognitive Brain Research* 15, no. 1 (2002): 31–45.

Peterson, James. *Dreams of Chaos, Visions of Order: Understanding the American Avant-Garde Cinema.* Detroit: Wayne State University Press, 1994.

Pilling, Jayne. "Introduction." In *A Reader in Animation Studies*, edited by Jayne Pilling, ix–xviii. Sydney: John Libbey, 1997.

Pinker, Steven. *The Better Angels of Our Nature: Why Violence Has Declined*. New York: Viking Adult, 2011.

——. *The Blank Slate: The Modern Denial of Human Nature*. London: Allen Lane, 2002.

——. *How the Mind Works*. New York: W. W. Norton, 1997.

Pinker, Steven, and Paul Bloom. "Natural Language and Natural Selection." In Barkow, Cosmides, and Tooby, 451–493.

Plantinga, Carl. "Art Moods and Human Moods in Narrative Cinema." *New Literary History* 43, no. 3 (2012): 455–475.

——. "Cognitive Film Theory: An Insider's Appraisal." *Cinémas: Journal of Film Studies* 12, no. 2 (2002): 15–37.

——. "'I Followed the Rules, and They All Loved You More': Moral Judgment and Attitudes Toward Fictional Characters in Film." *Midwest Studies in Philosophy* 34, no. 1 (2010): 34–51.

——. *Moving Viewers: American Film and the Spectator's Experience*. Berkeley: University of California Press, 2009.

——. *Rhetoric and Representation in Nonfiction Film*. Cambridge Studies in Film. Cambridge: Cambridge University Press, 1997.

Plantinga, Carl, and Greg M. Smith, eds. *Passionate Views: Film, Cognition, and Emotion*. Baltimore, MD: Johns Hopkins University Press, 1999.

Poggioli, Renato. *The Theory of the Avant-Garde*. Cambridge, MA: Harvard University Press, 1981.

Polan, Dana. *The Sopranos*. Durham, NC: Duke University Press, 2009.

Porges, Stephen W. *The Polyvagal Theory: Neurophysiological Foundations of Emotions, Attachment, Communication, Self-Regulation*. New York: Norton, 2011.

Pramaggiore, Maria. "Seeing Double(s): Reading Deren Bisexually." In *Maya Deren and the American Avant-Garde*, edited by Bill Nichols, 237–260. Berkeley: University of California Press, 2001.

Prince, Stephen. *Classical Film Violence: Designing and Regulating Brutality in Hollywood Cinema, 1930–1968*. Piscataway, NJ: Rutgers University Press, 2003.

——. *Digital Visual Effects in Cinema: The Seduction of Reality*. Piscataway, NJ: Rutgers University Press, 2012.

Provine, Robert. *Laughter: A Scientific Investigation*. New York: Penguin, 2000.

Provine, Robert, and Kenneth R. Fischer. "Laughing, Smiling and Talking: Relation to Sleeping and Social Context in Humans." *Ethology* 83, no. 4 (1989): 295–305.

Pylyshyn, Zenon W. "Computation and Cognition: Issues in the Foundations of Cognitive Science." *Behavioral and Brain Sciences* 3, no. 1 (1980): 111–132.

Quigley, Cliodhna, Selim Onat, Sue Harding, Martin Cooke, and Peter König. "Audio-Visual Integration During Overt Visual Attention." *Journal of Eye Movement Research* 1, no. 2 (2008): 1–17.

Ramachandran, V. S. *The Tell-Tale Brain: A Neuroscientist's Quest for What Makes Us Human*. New York: W. W. Norton, 2011.

Ramachandran, V. S., and W. Hirstein. "The Science of Art: A Neurological Theory of Aesthetic Experience." *Journal of Consciousness Studies* 6, no. 6–7 (1999): 15–51.

Raney, Arthur A. "Expanding Disposition Theory: Reconsidering Character Liking, Moral Evaluations, and Enjoyment." *Communication Theory* 14, no. 4 (2004): 348–369.

——. "The Role of Morality in Emotional Reactions to and Enjoyment of Media Entertainment." *Journal of Media Psychology* 23, no. 1 (2011): 18–23.

319

Ravaja, Niklas, Timo Saari, Mikko Salminen, Jari Laarni, and Kari Kallinen. "Phasic Emotional Reactions to Video Game Events: A Psychophysiological Investigation." *Media Psychology* 8, no. 4 (2006): 343–367.

Rayner, Keith, Xingshan Li, Carrick C. Williams, Kyle R. Cave, and Arnold D. Well. "Eye Movements During Information Processing Tasks: Individual Differences and Cultural Effects." *Vision Research* 47, no. 21 (2007): 2714–2726.

Raz, Gal, Boaz Hagin, and Talma Hendler. "E-Motion Pictures of the Brain: Recursive Paths Between Affective Neuroscience and Film Studies." In Shimamura, 285–313.

Rensink, Ronald A., J. Kevin O'Regan, and James J. Clark. "To See or Not to See: The Need for Attention to Perceive Changes in Scenes." *Psychological Science* 8, no. 5 (1997): 368–373.

Richardson, Alan, and Ellen Spolsky, eds. *The Work of Fiction: Cognition, Culture, and Complexity*. Aldershot: Ashgate, 2004.

Richie, Donald. *Ozu: His Life and Films*. Berkeley and Los Angeles: University of California Press, 1974.

Ridley, Matt. *The Origins of Virtue: Human Instincts and the Evolution of Cooperation*. London and New York: Penguin, 1997.

Rimé, Bernard. "Emotion Elicits the Social Sharing of Emotion: Theory and Empirical Review." *Emotion Review* 1, no. 1 (2009): 60–85.

Rimmon-Kenan, Shlomith. *Narrative Fiction: Contemporary Poetics*. New Accents. 2nd ed. London and New York: Routledge, 2002.

Ritterfeld, Ute, Michael Cody, and Peter Vorderer, eds. *Serious Games: Mechanisms and Effects*. New York and London: Routledge, 2010.

Roberts, John M., Malcolm J. Arth, and Robert R. Bush. "Games in Culture." *American Anthropologist* 61, no. 4 (1959): 597–605.

Roberts, Robert C. *Emotions: An Essay in Aid of Moral Psychology*. Cambridge: Cambridge University Press, 2003.

Robinson, Jenefer. *Deeper Than Reason: Emotion and Its Role in Literature, Music, and Art*. Oxford: Oxford University Press, 2005.

Rodowick, D. N. "An Elegy for Theory." *October* 122 (2007): 91–109.

Ross, Lee. "The Intuitive Psychologist and His Shortcomings: Distortions in the Attribution Process." In *Advances in Experimental Social Psychology, Vol. 10*, edited by Leonard Berkowitz, 173–220. New York: Academic Press, 1977.

Ryan, Marie-Laure. *Narrative as Virtual Reality: Immersion and Interactivity in Literature and Electronic Media*. Baltimore, MD: Johns Hopkins University Press, 2001.

Ryan, Marie-Laure, ed. *Narrative Across Media: The Languages of Storytelling*. Lincoln: University of Nebraska Press, 2004.

Sachs, Oliver. *Hallucinations*. New York: Vintage, 2012.

Saeed, John I. *Semantics*. 3rd ed. Malden, MA: Wiley-Blackwell, 2009.

Salt, Barry. *Film Style and Technology: History and Analysis*. 2nd ed. London: Starword, 1992.

———. "Statistical Style Analysis of Motion Pictures." *Film Quarterly* 28, no. 1 (1974): 13–22.

Samuels, Richard. "Massively Modular Minds: Evolutionary Psychology and Cognitive Architecture." In *Evolution and the Human Mind: Modularity, Language and Meta-Cognition*, edited by Peter Carruthers and Andrew Chamberlain, 13–46. Cambridge, UK: Cambridge University Press, 2000.

Schanda, J. "CIE Colorimetry." In *Colorimetry: Understanding the CIE System*, edited by János Schanda, 25–76. Hoboken, NJ: John Wiley & Sons, 2007.

Scherer, Klaus R. "What are Emotions? And How Can They Be Measured?" *Social Science Information* 44, no. 4 (2005): 695–729.

Schwartz, Sophie, Aurelie Ponz, Rositsa Poryazova, Esther Werth, Peter Boesiger, Ramin Khatami, and Claudio L. Bassetti. "Abnormal Activity in Hypothalamus and Amygdala During Humour Processing in Human Narcolepsy with Cataplexy." *Brain* 131, no. 2 (2008): 514–522.

Sepinwall, Alan. *The Revolution Was Televised: The Cops, Crooks, Slingers and Slayers Who Changed TV Drama Forever.* New York: Touchstone, 2012.

Shammi, Prathiba, and Donald T. Stuss. "Humour Appreciation: A Role of the Right Frontal Lobe." *Brain* 122, no. 4 (1999): 657–666.

Shimamura, Arthur P., ed. *Psychocinematics: Exploring Cognition at the Movies.* Oxford and New York: Oxford University Press, 2013.

Shimamura, Arthur P., and Stephen E. Palmer, eds. *Aesthetic Science: Connecting Minds, Brains, and Experience.* New York: Oxford University Press, 2012.

Silvia, Paul J. "What is Interesting? Exploring the Appraisal Structure of Interest." *Emotion* 5, no. 1 (2005): 89–102.

Simons, Jon S., Richard N. A. Henson, Sam J. Gilbert, and Paul C. Fletcher. "Separable Forms of Reality Monitoring Supported by Anterior Prefrontal Cortex." *Journal of Cognitive Neuroscience* 20, no. 3 (2008): 447–457.

Simons, Ronald C. *Boo! Culture, Experience, and the Startle Reflex.* Series in Affective Science. New York: Oxford University Press, 1996.

Sinclair, Robert C., and Melvin M. Mark. "The Influence of Mood State on Judgment and Action: Effects on Persuasion, Categorization, Social Justice, Person Perception and Judgmental Accuracy." In *The Construction of Social Judgments*, edited by Leonard L. Martin and Abraham Tesser, 165–193. Hillsdale, NJ: Lawrence Erlbaum Associates, 1992.

Sinnerbrink, Robert. *New Philosophies of Film: Thinking Images.* London and New York: Continuum, 2011.

——. "Re-enfranchising Film: Towards a Romantic Film-Philosophy." In *New Takes in Film-Philosophy*, edited by Havi Carel and Greg Tuck, 25–47. Houndmills: Palgrave-Macmillan, 2011.

——. "*Stimmung*: Exploring the Aesthetics of Mood." *Screen* 53, no. 2 (2012): 148–163.

Slater, Mel, and Sylvia Wilbur. "A Framework for Immersive Virtual Environments (FIVE): Speculations on the Role of Presence in Virtual Environments." *Presence: Teleoperators and Virtual Environments* 6 (1997): 603–616.

Smith, David Livingstone. *Less Than Human: Why We Demean, Enslave, and Exterminate Others.* New York: St. Martin's Press, 2011.

Smith, Greg M. *Film Structure and the Emotion System.* Cambridge: Cambridge University Press, 2003.

——. "What Is Interactivity?" In Greg M. Smith, *What Media Classes Really Want To Discuss: A Student Guide*, 135–153. Abingdon and New York: Routledge, 2011.

Smith, Murray. "Consciousness." In Livingston and Plantinga, 39–51.

——. "Darwin and the Directors: Film, Emotion, and the Face in the Age of Evolution." In Boyd, Carroll, and Gottschall, 258–269.

——. "Darwin and the Directors: Film, Emotion, and the Face in the Age of Evolution." *The Times Literary Supplement* (February 7, 2003): 13–15.

——. "Empathy, Expansionism, and the Extended Mind." In Coplan and Goldie, 99–117.

——. *Engaging Characters: Fiction, Emotion, and the Cinema.* Oxford: Clarendon Press, 1995.

———. "Film and Philosophy." In *The SAGE Handbook of Film Studies*, edited by James Donald and Michael Renov, 147–163. London: Sage, 2008.

———. "Gangsters, Cannibals, Aesthetes, or Apparently Perverse Allegiances." In Plantinga and Smith, 217–238.

———. "Just What is it That Makes Tony Soprano Such an Appealing, Attractive Murderer?" In *Ethics at the Cinema*, edited by Ward E. Jones and Samantha Vice, 66–90. New York: Oxford University Press, 2011.

———. *Trainspotting*. BFI Modern Classics. London: British Film Institute, 2002.

———. "Triangulating Aesthetic Experience." In Shimamura and Palmer, 80–106.

Smith, Tim J. "The Attentional Theory of Cinematic Continuity." *Projections: The Journal for Movies and the Mind* 6, no. 1 (2012): 1–27.

———. "An Attentional Theory of Continuity Editing." Ph.D. dissertation, University of Edinburgh, 2006.

———. "Watching You Watch Movies: Using Eye Tracking to Inform Cognitive Film Theory." In Shimamura, 165–191.

Smith, Tim, and John Henderson. "Attentional Synchrony in Static and Dynamic Scenes." *Journal of Vision* 8, no. 6 (2008): 773.

Smith, Tim J., Daniel Levin, and James E. Cutting. "A Window on Reality: Perceiving Edited Moving Images." *Current Directions in Psychological Science* 21, no. 2 (2012): 107–113.

Smith, Tim J., and Parag K. Mital. "Attentional Synchrony and the Influence of Viewing Task on Gaze Behaviour in Static and Dynamic Scenes." *Journal of Vision* 13, no. 8 (2013). DOI: 10.1167/13.8.16

Spelke, Elizabeth S. "Core Knowledge." *American Psychologist* 55, no. 11 (2000): 1230–1233.

Spelke, Elizabeth S., and Katherine D. Kinzler. "Core Knowledge." *Developmental Science* 10, no. 1 (2007): 89–96.

Spence, Charles, and Jon Driver. "Audiovisual Links in Exogenous Covert Spatial Orienting." *Perception and Psychophysics* 59, no. 1 (1997): 1–22.

Spolsky, Ellen. "Darwin and Derrida: Cognitive Literary Theory as a Species of Post-Structuralism." *Poetics Today* 23, no. 1 (2002): 43–62.

Stampe, Dave. "Heuristic Filtering and Reliable Calibration Methods for Video-Based Pupil-Tracking Systems." *Behaviour Research Methods, Instruments, and Computers* 25, no. 2 (1993): 137–142.

Steen, Francis F., and Stephanie A. Owens. "Evolution's Pedagogy: An Adaptationist Model of Pretense and Entertainment." *Journal of Cognition and Culture* 1, no. 4 (2001): 289–321.

Steinkuehler, Constance, Kurt Squire, and Sasha Barab, eds. *Games, Learning, and Society: Learning and Meaning in the Digital Age*. Learning in Doing: Social, Cognitive and Computational Perspectives. Cambridge and New York: Cambridge University Press, 2012.

Steinvall, Anders. "Colors and Emotions in English." In *Anthropology of Color: Interdisciplinary Multilevel Modeling*, edited by Robert E. MacLaury, Galina V. Paramei, and Don Dedrick, 347–362. Amsterdam and Philadelphia: John Benjamins, 2007.

Stelmach, Lew B., Wa James Tam, and Paul J. Hearty. "Static and Dynamic Spatial Resolution in Image Coding: An Investigation of Eye Movements." In *Human Vision, Visual Processing, and Digital Display II* (Proceedings of SPIE), edited by Bernice E. Rogowitz, Michael H. Brill, and Jan P. Allebach, 147–152. San Jose, 1991.

Steuer, Jonathan. "Defining Virtual Reality: Dimensions Determining Tele-presence." In *Communication in the Age of Virtual Reality*, edited by Frank Biocca and Mark R. Levy, 33–56. LEA's Communication Series. Hillsdale, NJ: Lawrence Erlbaum Associates, 1995.

Suckfüll, Monika. "Films That Move Us: Moments of Narrative Impact in an Animated Short Film." *Projections* 4, no. 2 (2010): 41–63.

Tallis, Raymond. *Aping Mankind: Neuromania, Darwinitis and the Misrepresentation of Humanity*. Durham, UK: Acumen, 2011.

———. *The Kingdom of Infinite Space: A Fantastical Journey Around Your Head*. London: Atlantic, 2008.

———. *The Knowing Animal: A Philosophical Inquiry into Knowledge and Truth*. Edinburgh: Edinburgh University Press, 2005.

Talmy, Leonard. *Toward a Cognitive Semantics*. Cambridge, MA: MIT Press, 2000.

Tan, Ed S. *Emotion and the Structure of Narrative Film: Film as an Emotion Machine*. Mahwah, NJ: Lawrence Erlbaum Associates, 1996.

———. "The Empathetic Animal Meets the Inquisitive Animal in the Cinema: Notes on a Psychocinematics of Mind Reading." In Shimamura, 337–367.

———. "Entertainment is Emotion: The Functional Architecture of the Enter-tainment Experience." *Media Psychology* 8, no. 1 (2008): 28–51.

———. "Film Induced Affect as a Witness Emotion." *Poetics* 23 (1995): 7–32.

Tan, Ed S., and Nico H. Frijda. "Sentiment in Film Viewing." In Plantinga and Smith, 48–64.

Tan, Ed S., Elena Skoutaki, and Floor K. Beemsterboer. "An Empirical Study of Virtual Action Tendencies in Response to Narrative Film: Film Viewers Act in Response to Narration." Paper presented at "24 Hours of Com-munication Science" Conference, Leuven University, Leuven, Belgium, February 9–10, 2012.

Tatler, Benjamin W., Nicholas J. Wade, Hoi Kwan, John M. Findlay, and Boris M. Velichkovsky. "Yarbus, Eye Movements, and Vision". *i-Perception* 1, no. 1 (2010): 7–27.

Taylor, T. L. *Play Between Worlds: Exploring Online Game Culture*. Cambridge, MA: MIT Press, 2009.

Thagard, Paul. *Mind: Introduction to Cognitive Science*. 2nd ed. Cambridge, MA: MIT Press, 2005.

Thomas, Frank, and Ollie Johnston. *The Illusion of Life: Disney Animation*. New York: Hyperion, 1995.

Thompson, Kristin. *Breaking the Glass Armor: Neoformalist Film Analysis*. Princeton, NJ: Princeton University Press, 1988.

Thompson, Robert J. *Television's Second Golden Age*. New York: Continuum, 1996.

Thomson-Jones, Katherine J. "Sensing Motion in Movies." In Shimamura, 115–132.

Tolstoy, Leo. "What is Art?" In Cahn and Meskin, 233–242.

Tomasello, Michael, Malinda Carpenter, Josep Call, Tanya Behne, and Henrike Moll. "Understanding and Sharing Intentions: The Origins of Cultural Cognition." *Behavioral and Brain Sciences* 28, no. 5 (2005): 675–691.

Tooby, John, and Leda Cosmides. "Does Beauty Build Adapted Minds? Toward an Evolutionary Theory of Aesthetics, Fiction, and the Arts." In Boyd, Carroll, and Gottschall, 174–183.

———. "Foreword." In *Mindblindness: An Essay on Autism and Theory of Mind*, by Simon Baron-Cohen, xi–xviii. Cambridge, MA: MIT Press, 1997.

323

―――. "The Psychological Foundations of Culture." In Barkow, Cosmides, and Tooby, 19–136.

Tosi, Virgilio, Luciano Mecacci, and Elio Pasquali. "Scanning Eye Movements Made When Viewing Film: Preliminary Observations." *International Journal of Neuroscience* 92, nos. 1–2 (1997): 47–52.

Tsakiris, Manos, Gita Prabhu, and Patrick Haggard. "Having a Body Versus Moving Your Body: How Agency Structures Body-Ownership." *Consciousness and Cognition* 15, no. 2 (2006): 423–432.

Tsakiris, Manos, Simone Schütz-Bosbach, and Shaun Gallagher. "On Agency and Body-Ownership: Phenomenological and Neurocognitive Reflections." *Consciousness and Cognition* 16, no. 3 (2007): 645–660.

Turvey, Malcolm. "Can Scientific Models of Theorizing Help Film Theory?" In Wartenberg and Curran, 21–32.

―――. *Doubting Vision: Film and the Revelationist Tradition.* Oxford and New York: Oxford University Press, 2008.

―――. *The Filming of Modern Life: European Avant-Garde Film of the 1920s.* Cambridge, MA: MIT Press, 2011.

―――. "Theory, Philosophy, and Film Studies: A Response to D. N. Rodowick's 'An Elegy for Theory.'" *October* 122 (2007): 110–120.

Valdez, Patricia, and Albert Mehrabian. "Effects of Color on Emotions." *Journal of Experimental Psychology: General* 123, no. 4 (1994): 394–409.

Van der Burg, Erik, Christian N. L. Olivers, Adelbert W. Bronkhorst, and Jan Theeuwes. "Pip and Pop: Nonspatial Auditory Signals Improve Spatial Visual Search." *Journal of Experimental Psychology: Human Perception and Performance* 34, no. 5 (2008): 1053–1065.

Van Hooff, Jan. "A Comparative Approach to the Phylogeny of Laughter and Smiling." In *Non-Verbal Communication*, edited by Robert A. Hinde, 209–241. London: Cambridge University Press, 1972.

Vatikiotis-Bateson, Eric, Inge-Marie Eigsti, Sumio Yano, and Kevin G. Munhall. "Eye Movement of Perceivers During Audiovisual Speech Perception." *Perception and Psychophysics* 60, no. 6 (1998): 926–940.

Vilaró, Anna, Andrew T. Duchowski, Pilar Orero, Tom Grindinger, Stephen Tetreault, and Elena di Giovanni. "How Sound is the Pear Tree Story? Testing the Effect of Varying Audio Stimuli on Visual Attention Distribution." *Perspectives: Studies in Translatology* 20, no. 1 (2012): 55–65.

Võ, Melissa L.-H., Tim J. Smith, Parag K. Mital, and John M. Henderson. "Do the Eyes Really Have It? Dynamic Allocation of Attention When Viewing Moving Faces." *Journal of Vision* 12, no. 13 (2012): 1–14.

von Wright, Georg Henrik. *Explanation and Understanding.* Cornell Classics in Philosophy. Ithaca, NY: Cornell University Press, 1971.

Vroomen, J., and B. de Gelder. "Sound Enhances Visual Perception: Cross-Modal Effects of Auditory Organization on Vision." *Journal of Experimental Psychology: Human Perception and Performance* 26, no. 5 (2000): 1583–1590.

Wardrip-Fruin, Noah, and Pat Harrigan, eds. *First Person: New Media as Story, Performance, and Game.* Cambridge, MA: MIT Press, 2004.

Wartenberg, Thomas E., and Angela Curran, eds. *The Philosophy of Film: Introductory Text and Readings.* Malden, MA: Blackwell, 2005.

Weiss, Paul. "Beauty and the Beast: Life and the Rule of Order." *Scientific Monthly* 81, no. 6 (1955): 286–299.

Wertheimer, Max. "Experimentelle Studien über das Sehen von Bewegung" ["Experimental Studies on Seeing of Motion"]. *Zeitschrift für Psychologie* 61, no. 1 (1912): 161–265.

Wheatley, Thalia, and Jonathan Haidt. "Hypnotic Disgust Makes Moral Judgments More Severe." *Psychological Science* 16, no. 10 (2005): 780–784.

Williams, Linda. *On the Wire*. Durham, NC: Duke University Press (forthcoming 2014).

Witkin, Herman A. "A Cognitive-Style Approach to Cross-Cultural Research." *International Journal of Psychology* 2, no. 4 (1967): 233–250.

Wittgenstein, Ludwig. *Philosophical Investigations*. 2nd ed. Translated by G. E. Anscombe. Oxford: Blackwell, 1958.

Wolf, Mark J. P., ed. *The Medium of the Video Game*. Austin: University of Texas Press, 2001.

Wolf, Mark J. P., and Bernard Perron, eds. *The Video Game Theory Reader*. New York and London: Routledge, 2003.

Wolfe, Jeremy M., and Todd S. Horowitz. "What Attributes Guide the Deployment of Visual Attention and How Do They Do It?" *Nature Reviews Neuroscience* 5 (2004): 495–501.

Wollheim, Richard. *Painting as an Art*. Princeton, NJ: Princeton University Press, 1987.

Wrangham, Richard, and Dale Peterson. *Demonic Males: Apes and the Origins of Human Violence*. New York: Houghton Mifflin Company, 1996.

Wypijewski, JoAnn. *Painting by Numbers: Komar and Melamid's Scientific Guide to Art*. Berkeley: University of California Press, 1997.

Yarbus, Alfred L. *Eye Movements and Vision*. Translated by Basil Haigh. New York: Plenum Press, 1967.

Zajonc, Robert B. "Attitudinal Effects of Mere Exposure." *Journal of Personality and Social Psychology Monograph Supplement* 9, no. 2, part 2 (1968): 1–27.

Zeki, Semir. *Inner Vision: An Exploration of Art and the Brain*. Oxford: Oxford University Press, 1999.

Zerubavel, Eviatar. *Social Mindscapes: An Invitation to Cognitive Sociology*. Cambridge, MA: Harvard University Press, 1997.

Zillmann, Dolf. "Basal Morality in Drama Appreciation." In *Moving Images, Culture and the Mind*, edited by Ib Bondebjerg, 53–63. Luton: University of Luton Press, 2000.

Zunshine, Lisa. *Why We Read Fiction: Theory of Mind and the Novel*. Columbus: Ohio State University Press, 2006.

films and television

127 Hours. Director Danny Boyle. Los Angeles: Fox Searchlight Pictures, 2010.

2001: A Space Odyssey. Director Stanley Kubrick. Beverly Hills: Metro-Goldwyn-Mayer, 1968.

Alexander Nevsky. Directors Sergei Eisenstein and Dmitri Vasilyev. Moscow: Mosfilm, 1938.

Armani Fashion Show. Emporio Armani—Spring–Summer 2010 Fashion Show, produced by Milano Moda Donna, 2009. The Ultimate Fashion Channel. www.youtube.com/watch?v=ui0FvW68cSg (accessed August 18, 2013).

The Artist. Director Michel Hazanavicius. Paris: Studio 37/Orange Studio, 2011.

At Land. Director Maya Deren. 1944.

Avatar. Director James Cameron. Los Angeles: Twentieth Century Fox, 2009.

Battleship Potemkin. Director Sergei Eisenstein. Moscow: Goskino, 1925.

Baywatch. Created by Michael Berk, Gregory J. Bonann, and Douglas Schwartz. Los Angeles: GTG Entertainment, 1989–1990.

Blood Diamond. Director Edward Zwick. Burbank: Warner Brothers, 2006.

Boardwalk Empire. Created by Terence Winter. New York: Home Box Office, broadcast September 19, 2010–present.

Borat: Cultural Learnings of America for Make Benefit Glorious Nation of Kazakhstan. Director Larry Charles. Beverly Hills: Four by Two Films, 2006.

Boss. Created by Farhad Safinia. Meridian, CO: Starz, 2011–2012.

Breaking Bad. Created by Vince Gilligan. New York: AMC, 2008–present.

Bridget Jones's Diary. Director Sharon Maguire. New York: Miramax, 2001.

Bringing Up Baby. Director Howard Hawks. Los Angeles: RKO Radio Pictures, 1938.

Cat People. Director Jacques Tourneur. Los Angeles: RKO Radio Pictures, 1942.

A Clockwork Orange. Director Stanley Kubrick. Burbank: Warner Brothers, 1971.

Dexter. Developed by James Manos, Jr. New York: Showtime, 2006–present.

Die Hard. Director John McTiernan. Los Angeles: Twentieth Century Fox, 1988.

Double Indemnity. Director Billy Wilder. Los Angeles: Paramount Pictures, 1944.

Early Summer. Director Yasujiro Ozu. Japan: Shôchiku Eiga, 1951.

Fantasia. Directors James Algar, Samuel Armstrong, Ford Beebe Jr., Norman Ferguson, Jim Handley, T. Hee, Wilfred Jackson, Hamilton Luske, Bill Roberts, Paul Satterfield, and Ben Sharpsteen. Burbank: Walt Disney Company, 1940.

Fellini Satyricon. Director Federico Fellini. Italy: Produzioni Europee Associati, 1969.

Free Willy. Director Simon Wincer. Burbank: Warner Brothers, 1993.

Friends. Created by David Crane and Marta Kauffman. Burbank: Warner Brothers Television, 1994–2004.

The Great Dictator. Director Charles Chaplin. Hollywood: Charles Chaplin Productions, 1940.

Groundhog Day. Director Harold Ramis. Culver City: Columbia Pictures Corporation, 1993.

Iron Man. Director Jon Favreau. Los Angeles: Paramount Pictures, 2008.

Look Who's Talking. Director Amy Heckerling. Culver City: TriStar Pictures, 1989.

Lost. Created by J. J. Abrams, Jeffrey Lieber, and Damon Lindelof. Burbank: ABC Studios, 2004–2010.

Lost in Translation. Director Sofia Coppola. Universal City: Focus Features, 2003.

Mad Men. Created by Matthew Weiner. New York: AMC, 2007–present.

Memento. Director Christopher Nolan. Los Angeles: Newmarket Films, 2000.

Monty Python's Flying Circus. Created by Graham Chapman, John Cleese, Terry Gilliam, Eric Idle, Terry Jones, and Michael Palin. London: BBC, 1969–1974.

Much Ado About Nothing. Director Joss Whedon. New York: Bellwether Pictures, 2012.

Mulan. Directors Tony Bancroft and Barry Cook. Burbank: Walt Disney Company, 1998.

Murder, My Sweet. Director Edward Dmytryk. Los Angeles: RKO Radio Pictures, 1944.

The Music Box. Director James Parrott. Beverly Hills: Metro-Goldwyn-Mayer, 1932.

Nim's Island. Directors Jennifer Flackett and Mark Levin. Los Angeles: Walden Media, 2008.

North by Northwest. Director Alfred Hitchcock. Beverly Hills: Metro-Goldwyn-Mayer, 1959.

The Notebook. Director Nick Cassavetes. Los Angeles: New Line Cinema, 2004.

Ocean's Twelve. Director Steven Soderbergh. Burbank: Warner Brothers, 2004.

October (Ten Days That Shook the World). Directors Grigori Aleksandrov and Sergei Eisenstein. Moscow: Sovkino, 1928.

Oklahoma! Director Fred Zinnemann. St. Louis: Magna Theatre Corporation, 1955.

Planet Earth. Director Alastair Fothergill. Featuring David Attenborough. London: BBC, 2006.

Raiders of the Lost Ark. Director Steven Spielberg. Hollywood: Paramount Pictures, 1981.

Ran. Director Akira Kurosawa. London: Greenwich Film Productions, 1985.

Rear Window. Director Alfred Hitchcock. Hollywood: Paramount Pictures, 1954.

Rebecca. Director Alfred Hitchcock. Culver City: Selznick International Pictures, 1940.

The Rescuers Down Under. Directors Hendel Butoy and Mike Gabriel. Burbank: Walt Disney Company, 1990.

The Ruins. Director Carter Smith. Universal City: DreamWorks SKG, 2008.

Schindler's List. Director Steven Spielberg. Universal City: Universal Pictures, 1993.

The Shield. Created by Shawn Ryan. Dallas: FX, 2002–2008.

The Silence of the Lambs. Director Jonathan Demme. Strong Heart/Demme Production, 1991.

Singin' in the Rain. Directors Stanley Donen and Gene Kelly. Beverly Hills: Metro-Goldwyn-Mayer, 1952.

Sleep. Director Andy Warhol. 1963.

Snow White and the Seven Dwarfs. Directors William Cottrell, David Hand, Wilfred Jackson, Larry Morey, Perce Pearce, and Ben Sharpsteen. Burbank: Walt Disney Company, 1937.

Sons of Anarchy. Created by Kurt Sutter. Dallas: FX, 2008–present.

The Sopranos. Created by David Chase. New York: Home Box Office, original broadcast January 10, 1999–June 10, 2007.

Star Wars Episode IV: A New Hope. Director George Lucas. San Francisco: Lucasfilm, 1977.

The Sting. Director George Roy Hill. Los Angeles: Zanuck/Brown Productions, 1973.

Strangers on a Train. Director Alfred Hitchcock. Burbank: Warner Brothers, 1951.

Toy Story. Director John Lasseter. Emeryville: Pixar, 1995.

Ugetsu. Director Kenji Mizoguchi. Tokyo: Daiei Studios, 1953.

Umrao Jaan. Director Muzaffar Ali. Integrated Films, 1981.

Valse Triste. Director Bruce Conner. San Francisco: Canyon Cinema, 1978.

The Walking Dead. Created by Frank Darabont. New York: American Movie Classics, 2010–2013.

Welcome to the Dollhouse. Director Todd Solondz. Argentina: Lider Films, 1995.

The Wire. Created by David Simon. New York: Home Box Office, 2002–2008.

The Wizard of Oz. Director Victor Fleming. Beverly Hills: Metro-Goldwyn-Mayer, 1939.

Zorns Lemma. Director Hollis Frampton. 1970.

video games

Angry Birds. Video Game. Developer Rovio Entertainment. Redwood City, CA: Chillingo/Electronic Arts, 2009.

Call of Duty. Video Game. Developer Infinity Ward and Others. Santa Monica: Activision, 2003–2012.

Donkey Kong. Video Game. Developer Nintendo and Others. Kyoto: Nintendo, 1981.

The Elder Scrolls V: Skyrim. Video Game. Developer Bethesda Game Studios. Rockville, MD: Bethesda Softworks, 2011, 2013.

Grand Theft Auto. Video Game. Developer Rockstar North. New York: Rockstar Games, 1997–2012.

Halo. Video Game. Developer Bungie, Ensemble Studios, and 343 Industries. Redmond, WA: Microsoft Studios, 2001–2013.

Minecraft. Sandbox Indie Game. Developer Mojang. Redmond, WA: Mojang/Microsoft Studios, 2011.

Wii Sports. Developer Nintendo EAD Group No. 2. Kyoto: Nintendo, 2006.

websites/internet

"Audiovisual Correspondences in Alexander Nevsky." DVClab account on YouTube. http://www.youtube.com/watch?v=KBKRSFP9KUM.

Baillargeon, Renée. "The Acquisition of Physical Knowledge in Infancy: A Summary in Eight Lessons." In *Blackwell Handbook of Childhood Cognitive Development*, edited by Usha Goswami. Blackwell Reference Online, 2004. http://au.wiley.com/WileyCDA/WileyTitle/productCd-1405191163.html (accessed July 4, 2013).

Baird, Robert. "Startle and the Film Threat Scene." *Images* 3. http://www.imagesjournal.com/issue03/ features/startle1.htm (accessed November 19, 2011).

Bordwell, David. "Common Sense + Film Theory = Common-Sense Film Theory?" *Observations on Film Art*. Blog post, May 2011. http://www.davidbordwell.net/essays/ commonsense.php (accessed May 27, 2013).

——. *Observations on Film Art*. Blog post, 2008. http://www.davidbordwell.net/blog/2008/02/13/hands-and-faces-across-the-table/ (accessed February 4, 2013).

——. "Pandora's Digital Box: Pix and Pixels." Blog post. http://www.davidbordwell.net/blog/2012/02/13/pandoras-digital-box-pix-and-pixels (accessed February 13, 2012).

Burton, Charlie. "Directed by Brainwave." *Wired.co.uk*. http://www.wired.co.uk/magazine/archive/2011/10/play/directed-by-brainwave (accessed November 19, 2011).

Cinemetrics. www.cinemetrics.lv (accessed August 28, 2013).

Common Sense Media. http://commonsensemedia.org.

Des Marais, Christina. "Video Game Uses Brain to Control Action." *TechHive*. http://www.pcworld.com/article/241993/video_game_uses_brain_to_control_action.html (accessed November 19, 2011).

Fodor, Jerry. "Letter to Benjamin Martin Bly." Letters, *London Review of Books* 22, no. 1, 2000. http://www.lrb.co.uk/v21/n19/jerry-fodor/diary (accessed November 19, 2011).

"Genre and International Box Office." *Film Victoria Australia* website. http://www.film.vic.gov.au/_data/assets/pdf_file/0006/969/AA6_Genre_and_Intenational_BO.pdf (accessed May 27, 2013).

Gilligan, Vince. "Interview with Vince Gilligan: Traverse City National Writers Series Guest and Creator of AMC's dark hit 'Breaking Bad.'" Interview by Beth Milligan. February 3, 2012. MyNorth.com. http://www.mynorth.com/My-North/February-2012/Traverse-City-National-Writers-Series-Vince-Gilligan-Breaking-Bad/ (accessed May 27, 2013).

Heeter, Carrie. "Interactivity in the Context of Designed Experiences." *Journal of Interactive Advertising* 1, no. 1 (2000). http://www.jiad.org/article2 (accessed July 4 2013).

Helm, Bennet. "Friendship." 2009. In *Stanford Encyclopedia of Philosophy*. Stanford University. http://plato.stanford.edu/entries/friendship/ (accessed May 22, 2013).

Helmer, Edmund. "Oranges and blues." Blog post. http://www.boxofficequant.com (accessed January 15, 2013).

"Industry Facts." Entertainment Software Association. http://www.theesa.com/facts (accessed July 1, 2013).

Johnson, Ben. "Scientists Turn Brain Activity into Moving Images." *Slate* 24, no. 9 (2011). http://slatest.slate.com/posts/2011/09/24/scientists_turn_brain_activity_into_moving_images.html (accessed November 19, 2011).

Keysers, Christian. *The Empathetic Brain: How the Discovery of Mirror Neurons Changes Our Understanding of Human Nature*. Kindle E-book: Social Brain Press, 2011.

Lehrer, Jonah. "The Truth Wears Off." *New Yorker*. December 13, 2010, http://www.newyorker.com/reporting/2010/12/13/101213fa_fact_lehrer (accessed July 2, 2012).

McGinn, Colin. "Can the Brain Explain Your Mind?" *New York Review of Books*. http://www.nybooks.com/articles/archives/2011/mar/24/can-brain-explain-your-mind/ (accessed November 19, 2011).

Motluk, Alison. "Mirror Neurons Control Erection Response to Porn." *New Scientist*, June 16, 2008. http://www.newscientist.com/article/dn14147-mirror-neurons-control-erection-response-to-porn.html (accessed November 19, 2011).

Newton, Sir Isaac. *Opticks: Or, a Treatise of the Reflections, Refractions, Inflections and Colors of Light*. 1704. 4th ed. http://www.gutenberg.org/files/33504/33504-h/33504-h.htm (accessed July 15, 2013).

Oliver, Mary Beth, and Anne Bartsch. "Appreciation as Audience Response: Exploring Entertainment Gratifications Beyond Hedonism." *Human Communication Research* 36, no. 1 (2010): 53–81. http://onlinelibrary.wiley.com (accessed May 27, 2013).

Papineau, David. "Naturalism." In *The Stanford Encyclopedia of Philosophy*, edited by Edward N. Zalta. 2007 ed. http://plato.stanford.edu/entries/naturalism (accessed April 24, 2013).

Perron, Bernard. "A Cognitive Psychological Approach to Gameplay Emotions." In *Changing Views: Worlds in Play*, DiGRA 2005 International Conference. Vancouver: Simon Fraser University, 2005. http://www.digra.org/digital-library/publications/a-cognitive-psychological-approach-to-gameplay-emotions/ (accessed July 4, 2013).

"Pleistocene Epoch." *Encyclopaedia Britannica Online*. http://www.britannica.com/EBchecked/topic/464579/Pleistocene-Epoch (accessed May 21, 2013).

Silver, Curtis. "Neurocinema Aims to Change the Way Movies are Made." *Wired.com*. http://www.wired.com/geekdad/2009/09/neurocinema-aims-to-change-the-way-movies-are-made/ (accessed November 19, 2011).

Simons, Jan. "Narrative, Games, and Theory." *Game Studies* 7, no. 1 (2007). http://gamestudies.org/0701 (accessed July 4 2013).

Supreme Court of the United States, *Brown v. Entertainment Merchants Assn.*, 08–1448, Supreme Court of the US, http://www.supremecourt.gov/opinions/10pdf/08-1448.pdf (accessed July 2, 2012).

THX. *THX Tech Pages*. Viewing Distance Requirements. 2012. http://www.cinemaequipmentsales.com/athx2.html (accessed February 13, 2012).

YouTube clip. "Laughing Gas Funniest Video Ever." January 16, 2009. http://www.youtube.com/watch?v=_Ha-ZrUPJ_E (accessed February 13, 2012).

contributors

Daniel Barratt is a postdoctoral researcher at the Department of International Business Communication, Copenhagen Business School, Denmark, and the Centre for Cognitive Semiotics, Lund University, Sweden. He has a Ph.D. in cognitive film theory from the University of Kent, UK (awarded in 2005) and did three years of postdoctoral research in cognitive and experimental psychology at the University of Copenhagen (completed in 2009). His research interests include visual communication and film, visual attention and eye movements, theories and models of emotion, and the influence of culture on cognitive processes.

Kaitlin L. Brunick is a graduate student in Psychology at Cornell University. She received B.A. degrees in Psychology and Linguistics from the College of William and Mary. Her research focuses on how perception and development influence children's ability to understand visual media. She is a Cornell University Sage Fellow and received a National Science Foundation Graduate Research Fellowship.

Margrethe Bruun Vaage is Lecturer in Film Studies at the University of Kent, UK. Her main area of research is the spectator's engagement with fictional films and television series, and more specifically the imagination, the emotions, and the moral psychology of fiction. She has published papers in journals such as the *British Journal of Aesthetics*, *Midwest Studies in Philosophy*, and *Screen*. She is currently working on a book exploring how and why we as spectators engage with morally bad main characters in recent American television series.

Noël Carroll is Distinguished Professor of Philosophy at the Graduate Center of the City University of New York. His previous Routledge publications include *The Philosophy of Horror* (1990), *The Philosophy of Art: A Contemporary Introduction* (1999), and *On Criticism* (2009).

James E. Cutting is Susan Linn Sage Professor of Psychology at Cornell University. He has published three books, the most recent of which is *Impressionism and Its Canon* (University Press of America, 2006), and over one hundred articles on the perception of motion and space. His interests in the relations among culture, high art, and popular art led him to the study of Hollywood film.

Dirk Eitzen is the director of the Film & Media Studies program at Franklin & Marshall College. He has published film theoretical essays on topics ranging from the nature of non-fiction to the impact of comedy and recently edited a special issue of *Projections: The Journal of Movies and Mind* 7.1 (Summer 2013) on the topic "Entertaining Violence." He has also produced more than a dozen documentaries on topics ranging from suburban sprawl to African American abstract expressionist art. Eitzen is deeply committed to non-violence but thoroughly enjoys some very violent entertainments, resulting in some cognitive dissonance that his chapter in this volume is in part an attempt to resolve.

Andreas Gregersen is Associate Professor at the Department of Media, Cognition and Communication at the University of Copenhagen. His research focuses on the manifold connections between cognitive theory, embodiment, computer and video games, audiovisual media, and genre theory.

Torben Grodal is Professor Emeritus in the Department of Media, Cognition, and Communication at the University of Copenhagen. His books include *Moving Pictures* (Oxford University Press, 1997) and *Embodied Visions* (Oxford University Press, 2009), (in Danish) *Filmoplevelse* (Samfundslitteratur, 2003), and (as co-editor) *Visual Authorship* (Museum Tusculanum Press, 2004), and he has published articles on film, emotions, narrative theory, art films, video games, and evolutionary film theory.

Patrick Colm Hogan is a professor in the English Department and the Program in Cognitive Science at the University of Connecticut. He is the author of sixteen books, including *Understanding Indian Movies: Culture, Cognition, and Cinematic Imagination* (University of Texas Press, 2008) and *Narrative Discourse: Authors and Narrators in Literature, Film, and Art* (Ohio State University Press, 2013).

Ted Nannicelli is Lecturer in Film and Television Studies at the University of Queensland, Australia. He is the author of *A Philosophy of the Screenplay* (Routledge, 2013).

Carl Plantinga is Professor of Film and Media at Calvin College. Among his books are *Moving Viewers: American Film and the Spectator's Experience*, and as co-editor (with Greg M. Smith), *Passionate Views: Film, Cognition, and Emotion*. Plantinga is current president of the Society for Cognitive Studies of the Moving Image.

William Seeley (Ph.D., CUNY—The Graduate Center) is Visiting Assistant Professor of Philosophy at Bates College. His current research in cognitive science and aesthetics includes studies of the influence of selective attention, expert knowledge, and motor simulation in audience engagement with film, dance, and visual art, and in perception more generally. He also has an M.F.A. (Columbia University) in sculpture. His welded steel constructions and mobiles have been exhibited in New York City and at a number of colleges and universities, including a solo exhibition of outdoor works in Ezra Stiles College at Yale University.

Greg M. Smith is Professor of Moving Image Studies in the Department of Communication at Georgia State University. His books include *What Media Classes Really Want To Discuss: A Student Guide* (Routledge, 2010), *Beautiful TV: The Art and Argument of Ally McBeal* (University of Texas Press, 2007), *Film Structure and the Emotion System* (Cambridge University Press, 2003), and (with Carl Plantinga) *Passionate Views: Film, Cognition, and Emotion* (Johns Hopkins University Press, 1999).

Murray Smith is Professor of Film Studies at the University of Kent, UK, where he has taught since 1992. He is a founding member of the Society for Cognitive Studies of the Moving Image, on whose advisory board he has served since 1995. His research focuses on the psychology and philosophy of film; his current projects include a work on the naturalized aesthetics of film. His publications include *Engaging Characters: Fiction, Emotion, and the Cinema* (Clarendon Press, 1995), *Film Theory and Philosophy* (co-edited with Richard Allen) (Clarendon Press, 1998), *Contemporary Hollywood Cinema* (co-edited with Steve Neale) (Routledge, 1998), *Trainspotting* (British Film Institute, 2002), and *Thinking through Cinema* (co-edited with Thomas E. Wartenberg) (Blackwell, 2006).

Tim J. Smith (B.Sc. Hons, Ph.D.) is a lecturer in the Department of Psychological Sciences, Birkbeck, University of London. He applies empirical methods in cognitive psychology to questions of film cognition and has published on the subject both in psychology and film journals.

Paul Taberham is Lecturer in Animation Studies at Arts University, Bournemouth, UK. He has published in *Projections: The Journal for Movies and Mind*, *Animation Journal* and *The Routledge Encyclopedia of Film Theory*. In addition to cognitive media theory and avant-garde film, his research interests include animation, humor, and film sound.

Ed S. Tan is Professor of Media Entertainment at the University of Amsterdam. He has published on emotion and cognition in film viewing and taught at various departments of media and arts. Current research interests include absorption in film viewing, moral engagement, genre categorization, and development of games for mental health.

Malcolm Turvey teaches film studies at Sarah Lawrence College and is an editor of *October*. He is the author of *Doubting Vision: Film and the Revelationist Tradition* (Oxford University Press, 2008) and *The Filming of Modern Life: European Avant-Garde Film of the 1920s* (MIT Press, 2011), and co-editor, with Richard Allen, of *Wittgenstein, Theory and the Arts* (Routledge, 2001). He is currently at work on a book titled *Play Time: Jacques Tati and Comedic Modernism.*

about the american
film institute

The American Film Institute (AFI) is America's promise to preserve the history of the motion picture, to honor the artists and their work, and to educate the next generation of storytellers. AFI provides leadership in film, television, and digital media, and is dedicated to initiatives that engage the past, the present, and the future of the motion picture arts. The *AFI Film Readers Series* is one of the many ways AFI supports the art of the moving image as part of our national activities.

AFI preserves the legacy of America's film heritage through the **AFI Archive**, comprised of rare footage from across the history of the moving image, and the *AFI Catalog of Feature Films*, an authoritative record of American films from 1893 to the present. Both resources are available to the public via AFI's website.

AFI honors the artists and their work through a variety of annual programs and special events, including the **AFI Life Achievement Award**, **AFI Awards**, and **AFI's 100 Years . . . 100 Movies** television specials. The **AFI Life Achievement Award** has remained the highest honor for a career in film since its inception in 1973; **AFI Awards**, the Institute's almanac for

the 21st century, honors the most outstanding motion pictures and television programs of the year; and **AFI's 100 Years . . . 100 Movies** television events and movie reference lists have introduced and reintroduced classic American movies to millions of film lovers. And as the largest non-profit exhibitor in the United States, AFI offers film enthusiasts a variety of events throughout the year, including the longest running international film festival in Los Angeles and the largest documentary festival in the U.S., as well as year-round programming at the **AFI Silver Theatre** in the Washington, DC metro area.

AFI educates the next generation of storytellers at its world-renowned **AFI Conservatory**—named the number one film school in the world by *The Hollywood Reporter*—offering a two-year Master of Fine Arts degree in six filmmaking disciplines: Cinematography, Directing, Editing, Producing, Production Design, and Screenwriting.

Step into the spotlight and join other movie and television enthusiasts across the nation in supporting the American Film Institute's mission to preserve, to honor, and to educate by becoming a member of AFI today at AFI.com.

AFI

American Film Institute

Robert S. Birchard
Editor, *AFI Catalog of Feature Films*

index

index

index